THE MIRROR & THE MASK

PORTRAITURE
IN THE AGE OF
PICASSO

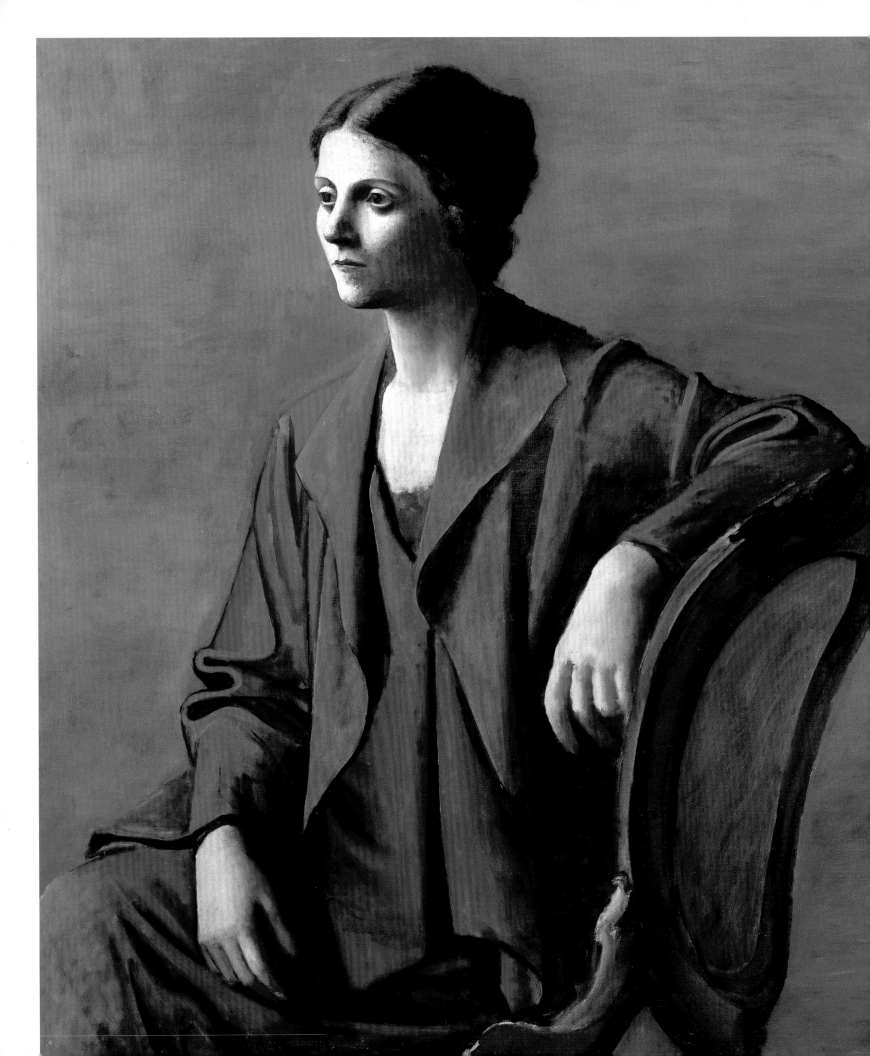

THE MIRROR & THE MASK

PORTRAITURE
IN THE AGE OF
PICASSO

Paloma Alarcó
Malcolm Warner

With essays by
Francisco Calvo Serraller
John Klein
William Feaver

Madrid
6 February to 20 May 2007

Museo Thyssen-Bornemisza

Fundación Caja Madrid

Fort Worth
17 June to 16 September 2007

Kimbell Art Museum

Yale University Press in association with the Kimbell Art Museum,
the Museo Thyssen-Bornemisza, and the Fundación Caja Madrid

Cat. 69
Pablo Picasso
Portrait of the Artist's Wife (Olga),
1923
(detail)

Lenders to the Exhibition

Argentina
Buenos Aires Malba-Collection Costantini

Austria
Vienna Leopold Museum
 Museum Moderner Kunst Stiftung Ludwig Wien

Canada
Fredericton, N. B. Beaverbrook Art Gallery
Montreal The Montreal Museum of Fine Arts

Denmark
Copenhagen Ordrupgaard
Humlebæk Louisiana Museum of Modern Art

France
Le Cateau-Cambrésis Musée Départemental Matisse
Lyon Musée des Beaux-Arts de Lyon
Marseille Musée Cantini
Paris Centre Pompidou. Musée national d'art moderne/
 Centre de création industrielle
 Musée de l'Orangerie
 Musée Picasso

Germany
Berlin Berlinische Galerie, Landesmuseum für Moderne Kunst,
 Fotografie und Architektur
 Brücke-Museum
Bremen Paula Modersohn-Becker Stiftung
Cologne Käthe Kollwitz Museum Köln
Dusseldorf Kunstsammlung Nordrhein-Westfalen
 Museum kunst palast
Frankfurt Städel Museum
Hamburg Hamburger Kunsthalle
Ludwigshafen Wilhelm-Hack-Museum
Osnabrück Felix-Nussbaum-Haus Osnabrück mit der Sammlung
 der Niedersächsischen Sparkassenstiftung
Wuppertal Von der Heydt-Museum

The Netherlands
The Hague Gemeentemuseum
Rotterdam Museum Boijmans Van Beuningen

Norway
Oslo Astrup Fearnley Museum of Modern Art
 Munch Museum

Spain
Barcelona MNAC. Museu Nacional d'Art de Catalunya
 Museu Picasso
Bilbao Museo de Bellas Artes de Bilbao
Figueres Fundació Gala-Salvador Dalí
Madrid Art Collection Caja Madrid
 Museo Nacional Centro de Arte Reina Sofía
 Carmen Thyssen-Bornemisza Collection, on loan to the
 Museo Thyssen-Bornemisza
 Museo Thyssen-Bornemisza
Málaga Museo Picasso
Valencia IVAM. Institut Valencià d'Art Modern, Generalitat
 Valenciana

Switzerland
Martigny Collection Fondation Pierre Gianadda
Riehen/Basel Fondation Beyeler
Winterthur Kunstmuseum Winterthur
Zurich Kunsthaus Zürich

United Kingdom
Belfast Ulster Museum, National Museums and Galleries
 of Northern Ireland
Cambridge The Syndics of the Fitzwilliam Museum
Edinburgh Scottish National Gallery of Modern Art
Liverpool National Museums Liverpool, Walker Art Gallery
London Arts Council Collection, Hayward Gallery,
 South Bank Centre
 British Council
 National Portrait Gallery
 Tate
Manchester The Whitworth Art Gallery, The University of Manchester
Southampton Southampton City Art Gallery

United States
Austin Harry Ransom Center, The University of Texas at Austin
Cincinnati Cincinnati Art Museum
Dallas Raymond and Patsy Nasher Collection
Detroit The Detroit Institute of Arts
Fort Worth Kimbell Art Museum
 Modern Art Museum of Fort Worth
Hartford Wadsworth Atheneum Museum of Art
Houston The Museum of Fine Arts, Houston
New Haven Yale Center for British Art
New Orleans New Orleans Museum of Art
New York Ronald Feldman Fine Arts
 Solomon R. Guggenheim Museum
 Paul Kasmin Gallery
 The Metropolitan Museum of Art
 The Museum of Modern Art
 Private collection. Courtesy Neue Galerie
 Van de Weghe Fine Art
Philadelphia Philadelphia Museum of Art
Saint Louis Saint Louis Art Museum
San Francisco San Francisco Museum of Modern Art
Washington, D.C. National Gallery of Art
 The Phillips Collection

Private Collections
Juan Abelló Collection
Chrisalis Trustees (Guernsey) Limited as Trustee of the Magic Trust
E. Fernández Miró Collection
Anna Gamazo Hohenlohe Collection
Grupo Urvasco
Courtesy of Leon Kossoff and the LA Louver Gallery
Marlborough International Fine Art
Marquès de la Romana Collection
A. Surroca Collection
Thyssen-Bornemisza Collections

And others who wish to remain anonymous

The exhibition *The Mirror and the Mask: Portraiture in the Age of Picasso* is the fruit of two projects devised more than 5,000 miles apart, the distance between Madrid and Fort Worth. Despite their geographical separation, the Kimbell Art Museum and the Museo Thyssen-Bornemisza have much in common: both are relatively young museums founded through the generosity of private collectors committed to public access; both have rich holdings covering a range of periods and styles up to the twentieth century; and both are relatively small collections but ones that contain works of outstanding quality.

The curators of the exhibition, Paloma Alarcó, curator of modern painting at the Thyssen, and Malcolm Warner, senior curator at the Kimbell, had been working independently for some time on exhibitions about modern portraiture when they discovered the parallelism of their endeavors and decided to combine forces. A collaborative agreement between the two museums (and with Fundación Caja Madrid regarding the Madrid showing) has made this ambitious and timely exhibition possible.

The dual origin of the project reveals a considerable amount about current interest in the portrait, which finds its place in the history of twentieth-century art as one of the traditional genres that thrived with the advent of modernism. The most recent exhibition at the Thyssen was devoted to two painters, John Singer Sargent and Joaquín Sorolla, whose images represent the last peak of splendor of the traditional portrait. Around 1900, the foundations of the painted and sculpted portrait seemed to have been totally undermined.

Commissioning a portrait as a social statement—the ritual of lengthy sittings and the requirement of capturing a lifelike depiction—appeared to have lost all meaning following the invention of photography and the emergence of an industrialized and increasingly egalitarian society. Apparently condemned to extinction, portraiture nonetheless went on to enjoy an unexpected afterlife, and the course of modern art is marked by masterpieces of the genre, from the portraits of Madame Cézanne or the postman Roulin to those of Olga Khokhlova and Dora Maar.

The present exhibition brings together some of the finest portraits painted by the greatest modern artists, including Cézanne and van Gogh, Picasso and Matisse, Schiele and Kokoschka, Beckmann and Dix, and Bacon and Freud. *The Mirror and the Mask* is more than an assemblage of dazzling masterpieces, however. The portrait survived into the twentieth century by undergoing a dramatic mutation that altered its very essence. The truth as mimesis (in traditional imagery the mirror) was replaced by the multiple values of the mask. The mask is enigmatic in nature and possesses an expressive eloquence (as Oscar Wilde remarked, "a mask tells us more than a face") as well as a magic, apotropaic power. It has a primeval, archetypal significance that enables the artist to say, in W. B. Yeats's words, "I'm looking for the face I had / Before the world was made." By exploring the bold metamorphoses that portraiture underwent at the hands of modern artists—and preeminently Picasso, the artist who best exemplifies them—the exhibition brings into focus one of the most surprising and understudied aspects of twentieth-century art.

Guillermo Solana
Chief Curator, Museo Thyssen-Bornemisza

Timothy Potts
Director, Kimbell Art Museum

The Mirror and the Mask: Portraiture in the Age of Picasso is about an ancient artistic genre in modern times. Focusing mainly on European, avant-garde paintings and sculpture from 1890 to 1990, with the portraits of Picasso as its recurrent theme, the exhibition shows the survival and transformation of portraiture through a period of radical change in art.

As photography took over the role of recording likenesses—and artists questioned the idea of naturalistic representation, as well as traditional artist-patron relationships—one might have thought portraiture a genre doomed to decline. But it has been (and continues to be) a vital force. Almost all of the most important artists of the twentieth century experimented with portraiture, and many made it a central feature of their work.

It was in this period that portraiture broke free of the traditional contract between artist and sitter. Its most progressive exponents no longer felt committed to the conventional "good likeness" and offered equivalents and alternatives. They could embrace models in the art of the past or resist them; they could penetrate the identities of their sitters or reinvent them. As the commissioned portrait became more the province of specialists working in conservative styles, avant-garde portraiture developed as an affair between artists, their friends, and—with the proliferation of self-portraits—their own selves. The attitudes of artists toward portraiture were further complicated and enriched by the questioning, so germane to the modern experience, of old ideas about identity. Were likeness and character really the absolutes they had been assumed to be?

We chose the title *The Mirror and the Mask*, borrowed from a story by Jorge Luis Borges, to highlight this issue of identity and its bearing on modern portraiture. African masks were the source of many of the formal traits of twentieth-century European "primitivism." But in a more general sense the mask was a potent metaphor for identity as a changeable thing, created and recreated for the occasion. For Picasso, Matisse, and others, the excitement of discovering the art of Africa was not only its appearance but also the suggestiveness of the ritual mask as an agent of magical transformations.

The other keynote idea represented in the title of the exhibition, that of the mirror, points up the means by which artists usually make self-portraits but also, again figuratively, the tendency of the modern artist's style and sensibility to dominate even when the sitter is another person. The modern portrait is typically more of a reflection of its creator than a window onto its subject. As the artist Basil Hallward remarks prophetically in Oscar Wilde's novel *The Picture of Dorian Gray* (1890), "Every portrait that is painted with feeling is a portrait of the artist, not of the sitter."

The exhibition builds on a number of outstanding recent books and exhibitions dealing with themes in modern portraiture and the work of individual portraitists. The great *Picasso and Portraiture* exhibition at the Museum of Modern Art, New York, and the Grand Palais, Paris (1996–1997), showed vividly how much there was to learn from considering the work of one artist from the point of view of portraiture. In the present exhibition and its catalogue we hope to have brought some of the same insight to modern portraiture as a whole.

We would like to express our gratitude to all the lenders to the exhibition, both public and private. For their various kindnesses, we would mention in particular the following colleagues in other museums: Anne Baldassari of the Musée Picasso, Paris; Edgar Peters Bowron of the Museum of Fine Arts, Houston; Stephen Bonadies of the Cincinnati Art Museum; John Bullard of the New Orleans Museum of Art; Lisa Dennison and Carmen Giménez of the Solomon R. Guggenheim Museum, New York; Jay Gates of the Phillips Collection, Washington; Pierre Georgel of the Musée National de l'Orangerie, París; Léonard Gianadda of the Fondation Pierre Gianadda, Martigny; Rudolf Leopold and Michael Fuhr of the Leopold Museum, Vienna; Rosa María Malet of the Fundació Joan Miró, Barcelona; Ana Martínez de Aguilar and María García Yelo of the Museo Nacional Centro de Arte Reina Sofía,

Madrid; Paul Moorhouse of the National Portrait Gallery, London; Ray Nasher and Steven A. Nash of the Nasher Sculpture Center, Dallas; Renée Price of the Neue Galerie, New York; Sylvie Ramond of the Musée des Beaux Arts de Lyon; Bernard Riordan of the Beaverbrook Art Gallery, Fredericton; Sabine Schulze of the Städelsches Kunstinstitut und Städtische Galerie; Dominique Szymusiak of the Musée départemental Matisse, Le Cateau-Cambrésis; Michael Taylor of the Philadelphia Museum of Art; Gary Tinterow of the Metropolitan Museum of Art, New York; Javier Viar of the Museo de Bellas Artes de Bilbao; Christoph Vitali and Philippe Büttner of the Fondation Beyeler, Basel; Roslyn Walker of the Dallas Museum of Art; Kenneth Wayne of the Heckscher Museum of Art, Huntington; Olivier Weber-Caflisch and Marina Saura of the Archives Antonio Saura; Wolfgang Werner of the Paula Modersohn Becker Stiftung, Bremen; and Armin Zweite of the Kunstsammlung Nordrhein-Westfalen, Düsseldorf.

For their invaluable help with loans from private collections, we are indebted to Joseph Baillio; Mercedes Beldarrain; Ivor Braka; Christopher Eykyn; Evelyne Ferlay; Deborah Gage; Elvira González; Peter Goulds; Berta Giménez-Arnau; Inmaculada González; William Jeffett; Heather Kowalski; Jan Krugier, of the Galerie Jan Krugier & Cie, Geneva; María López; Nicholas Maclean; Massimo Martino; Richard Nagy; Rafael Pérez Madero; Conchita Romero; Marina Saura; Martine Stroo; Maurice Tuchman; Emma Ward; Christophe Van de Weghe; and Wolfgang Wittrock.

We thank our fellow catalogue contributors both for their essays and, in the case of William Feaver and John Klein, for their help in the selection of works and the negotiation of loans. Francisco Calvo Serraller provided encouragement and counsel throughout.

In shaping the exhibition we have benefited enormously from conversations with Guillermo Solana, chief curator at the Thyssen, his predecessor Tomàs Llorens, and Timothy Potts, director of the Kimbell. All three have supported the project generously. We have relied on the incomparable professionalism of our colleagues at both of the organizing institutions. At the Thyssen, we would mention in particular Marta Ruiz del Árbol, curatorial assistant of modern painting, who has coordinated the exhibition with a devotion beyond the call of duty, as well as helped with research for the catalogue; Nerea Sagredo, Publications Department, who has directed the realization of this catalogue so calmly and capably; and Lucia Cassol, registrar, who organized the transport arrangements with her usual efficiency, assisted by Beatriz Blanco. We would also like to thank Montserrat Perero, Azucena González, and Clara Pozo for their help with documentation for the catalogue; Josefina Blanca and Paloma Martin for their help in the coordination of the exhibition's installation in the Fundación Caja Madrid; and Laura Andrada for administrative support.

At the Kimbell, Samantha Sizemore, curatorial coordinator, handled every organizational complication with her usual skill and timely attention to detail. We are also much indebted to Patty Decoster, registrar; Michelle Gibson, assistant registrar; and Wendy Gottlieb, manager of publications and public access.

Paloma Alarcó
Curator of Modern Painting, Museo Thyssen-Bornemisza

Malcolm Warner
Senior Curator, Kimbell Art Museum

Contents

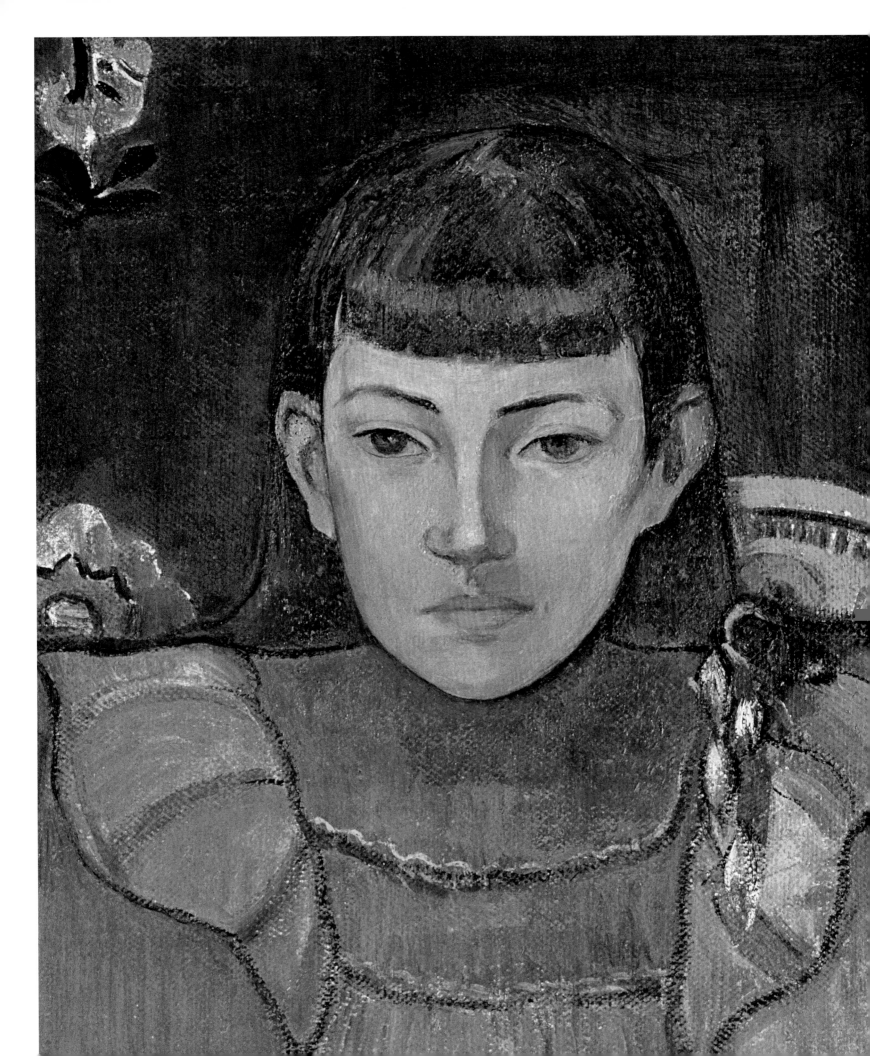

THE SPIRIT BEHIND THE MASK

Francisco Calvo Serraller

A good beginning might be to remind ourselves of the Latin tag "Facies pulchra non semper est speculum animi" ("A pretty face is not always the mirror of the soul"). Despite the optimism of the "not always," the saying contains all the elements that we are interested in looking at here—not just regarding the artistic genre of portraiture, which, as we will see, goes beyond the simple image of a face, but specifically regarding the modern portrait, or, better said, the contemporary portrait. The idea that a pretty face is not always the mirror of the soul presents us with the whole drama of the issue together in one sentence: the lurking contradiction between the exterior and the interior of a human being, between the ineluctable body and the adventitious soul. Going back to the dawn of time we can see that, as far as artistic representation is concerned, the human body is the essential element. Although the earliest surviving testimonies to prehistoric artistic creation include representations of the human body, none of them has individualizing features of a psychological nature, i.e., referring to states of mind. We have to wait many more centuries before depictions of the body, not to say the face, acquire this aspect. Without it we cannot speak of the artistic portrait as such, be it the earliest type of simple funerary mask or, in a more evolved phase, an attempt to individualize the features of a particular face, either attractive or ugly. As we approach the subject of the portrait we find ourselves confronting the history of its "animation," in the sense of its acquiring life and spirit, and the complexities that this involves. The issue of whether or not physical beauty is deceptive has a historically important role—albeit much less so as we enter our own age, which has left the matter to cosmetic surgery and the gym.

Before we directly tackle the subject at hand, I think it would be useful to make some brief and summary clarifications of a historical nature as to the meaning of the act of portrayal and the artistic portrait. We should remember, for example, the fact that it was the Greeks who were the first to create individualized portraits and that they did so, as Gisela M. A. Richter has pointed out, around the first half of the fifth century BC. Greek portraiture shows several phases of development, "always moving in the direction of realism in step with the general tendency of art; and finally, in the first century BC, acquiring new force with Roman portraiture." In his essay "Faces for Eternity" Carlos García Gual explains the panegyric and commemorative intent of early Greek portraits. They were individualizing in character because they were the sculptural images of mortal heroes, previously a relatively rare function and one that reflected the secularized nature of Greek culture. Gual quotes a text by a Greek orator of the first century AD that explains the original function of these public statues:

> Men need wreaths, statues, seats of honor in order to be recorded, and many, of course, have even died for this—to achieve a statue or inscription or other similar honor and to leave to posterity an illustrious reputation and image of themselves. . . . It is because the monument and the fact that it is erected in bronze are, it would seem, a noble emblem for virtuous men. That their names do not disappear with their bodies, nor become the same as those who have never existed, but leave some mark or sign behind of their uprightness, is a worthy reward.

The author notes that what has now become a widespread and even over-abused practice was totally exceptional in the past.

Looking at the origins and historical development of the individualized portrait, we should take account of two telling features. The first is the secularization of the portrait, which is no longer the ideal transposition of the human soul in order

3

for it to enter eternity but the earthly record of a dead person whose hope was to remain in the memory of surviving fellow mortals or future generations. In other words, there is a shift of viewpoint, with posterity now prevailing over eternity. Secondly, we find the conversion of the human portrait into something memorable from a moral viewpoint, assuming the role hitherto assigned to gods and mythical heroes. Once this step had been taken in Greece, it can be said that the portrait had come into being as a genre, with its own distinct personality, but equally that it could not diverge from this direction without losing its way and disappearing altogether.

The fact that the Greeks established portraiture as a genre does not mean that the act of artistic portrayal had already exhausted all its possibilities. I do not refer just to its formal possibilities but also, and above all, to its aesthetic ones. In this regard I think it is essential to make a number of etymological observations on the origins and meaning of the term "portray," which derives from the Latin *protrahere*, meaning "to draw forth or reveal," i.e., the appearance of someone or something. Traditionally "portray" was used for the making of images of both people and things. Hence the polemical distinction that art theoreticians from the sixteenth century onward made between the ideas of "portrayal" and "imitation," the first being understood as a mere copy of reality as such and the second as a selection from what we see. According to traditional criteria based on classical precepts, to imitate involved greater difficulty and artistic merit than merely to portray; the latter was the simple operation of making a copy or reproduction, which required skill and technique but no critical faculty. Ultimately, this explains the low esteem traditionally accorded to portraiture as the reproduction of the individual features of a person, at least until the rise of the so-called middle-class, realist portrait.

Before moving on from this distinction between portrayal and imitation, or, as I said above, between mere indiscriminate copying and selective imitation, I think it worth looking a little deeper into this much-debated *topos*, directing our attention away from art theory in general and toward portraiture in particular. I refer not just to the most obvious point: that a portrait was most appreciated when most "historiated," in other words, when the sitter's symbolic significance was emphasized in the means of artistic representation. An example of this would be the so-called "formal portrait," a label that refers not only to the fact that the sitter is dressed in all the signs of rank and office and located in an appropriate setting, but also to the complex symbolism underlying the whole. Without invalidating the above, I want now to consider portraiture as the result of a tension between two divergent historical tendencies—on the one hand toward individualization and on the other toward the ideal. There is the investigation of unique physical and psychological characteristics of the sitter, without which the subject of the portrait could not be identified, and there is the emphasis on his or her function as social exemplar. The latter cannot be limited simply to the ornamental and symbolic, but also requires the "improvement" of any chance, unattractive physical features that would hinder its acceptance. In order to resolve these contradictory requirements, which on the one hand call for the most strictly lifelike depiction of the sitter and on the other for an attempt to camouflage it, a compromise was reached between the portrait as mere copy (or portrayal) and as interpretative selection (or imitation). In my view its starting-point was to focus the act of portrayal on the description of the sitter's features per se and the act of imitation on his or her exemplary values.

The respective strategies of "portrayal" and "imitation" also differ from a formal viewpoint. The search for individualization involved in creating a portrait, which, if faithful, must capture the most unique features of the person depicted, engages with the idea of expression and thus with the instantaneous and fleeting. On the other hand, the search for the essence and the exemplary involved in imitation takes the image toward the canonical and the timeless. Merely by stating the above, we grasp the historical development of the portrait, particularly as we reach the modern period. Modern thought has been crucially affected by the notion of the temporal, which has become the only absolute value; as such it tends paradoxically to fade and diminish everything, including, of course, itself. It is the value that has given rise to nihilism and the reign of the relative. While this issue is an important one in general, particularly in defining the background against which the modern portrait should be located, I am not going to enter into it in depth at the present time. I would simply indicate that the secularization of the portrait served to democratize it, focusing on its expressiveness as a vehicle for the fleeting and instantaneous. The dynamic of modern portraiture indeed merits the label "instantaneous"—a term obviously

associated with photography, like "shot" when used, aptly enough, for the action of portrayal.

Before addressing the vital question of the present exhibition, which focuses on twentieth-century portraiture, I should pause here to clarify other matters of definition with regard to the portrait. As it has evolved in the modern age, portraiture has focused so much on the depiction of the face that we almost unconsciously assume a portrait to imply that part of the body. In fact a portrait can encompass the entire body and, more important still, a state of mind, depending not only on the physiognomy but also on the "gesture." It is clear that a mere look, any distortion of the gaze, is expressive—but also that body gestures can be meaningful independently of the face. Human gesture has been the subject of anthropological and artistic studies. The latter are exceptionally important, not just for our knowledge of the symbolic background of a depicted action or story, but, as realistic individualization came to prevail over the strictly allegorical, in order to delve into the intention or psychology of the figures. It is obvious that body-language crucially completes the information conveyed in a portrait, which loses force if it is limited to the face or if the face is represented in an inanimate way. To show the face as immobile and hieratic is to show it without a soul. Portraiture involves both the face and the rest of the body, some parts of the body being of particular expressive importance—above all the hands, whose presence or absence may testify to the importance and merit of a given portrait. While any of the parts of the body can be represented in isolation and still fall within the category of portraiture as a genre, the most appropriate and ideal situation is to see them all as a whole—including the way they work together in a particular action, which can include an emotion. The autonomous expressiveness of each of the different parts of the human body means not only that these can be depicted in isolation, but that each can reveal in itself and for itself the key elements of personality. This is clearly the case with the face, which we can divide into three parts: forehead and eyes, the most spiritual part; nose, the most sensitive; and mouth, the most sensual. But it also applies to the body in general, which in turn can be subdivided into head, torso, and stomach, corresponding respectively to spirituality, intellect, and instinct. I need hardly say that such ideas were the object of systematic categorization and precisely regulated codification within the field of art.

From ancient Greece to the fifteenth century we can establish a nonlinear evolution of the Western portrait marked by the increasing individualization of the subject, or, expressed more simply, by the progress of realism. This is at least the opinion of Tzvetan Todorov in his recent and admirable book *In Praise of the Individual: An Essay on Flemish Renaissance Painting*. The historical process at work within the long tradition of the portrait in Western art, spanning more than twenty centuries, was characterized, as I have said, by a dialectic whose initial opposing extremes were those of commemoration and celebration; the lifelike and exact description of the sitter was at a premium in the first case, and the ideal goodness of his or her deeds or role in life in the second. Portraiture tended to emphasize the most material or corporeal aspect of the sitter in the first case and the most spiritual or conceptual in the second. This dialectic continued beyond the fifteenth century and at least until the start of the modern age—which saw the start of a profound transformation of the portrait, a revolutionary process still far from complete.

Didactic guides to physiognomy, from Giovanni Battista della Porta to Charles Le Brun, which codified the geography of the face for the use of artists, continued in use almost up to the start of the modern age. This definition of physical traits was accompanied by a definition of moral ones— inspired by Theophrastus's *Characters*, but also by the literary corpus of fables, in the work of classical and modern authors from Aesop to Lafontaine, with their striking analogies between the animal and human worlds. This physiognomical and psychological system provided an inventory of features, gestures, characters, and temperaments of great richness and weight, a repertoire one had to know in order to understand the meaning of traditional portraits. But by the eighteenth century the system had entered into an irreversible crisis, under threat both from a new anthropological attitude derived from science and from artistic practice itself. Intuitively art started to reject what it considered an ever more constraining and inadequate repertoire in light of the new horizons opening up in human emotion and sentiment. At this point we should mention Franz Anton Mesmer, with his theory of animal magnetism, and above all Kaspar Lavater, whose *Physiognomische Fragmente* (1775–1778) caused an enduring sensation. Lavater's text took as its starting-point the correspondence between the physical and the mental, and determined types of

Francisco Calvo Serraller

character, emotion, and state of mind simply on the basis of an examination of the skull. It was a biological fatalism that even granted itself the power to foretell an individual's future criminal acts. Mesmer and Lavater advocated a vision of man as a being subject to obscure and completely uncontrollable physical and psychological forces. It is hardly necessary to point out that this intellectual tendency persists today (if not the actual theories) and that of course it completely revolutionized "the position of man in the cosmos"—to use the celebrated formula of the twentieth-century anthropologist Max Scheller. Its consequences for the portrait were enormous, since the role of mankind looked, from this new perspective, to be so insignificant. The effort to individualize him physiognomically seemed a derisory one as it stripped him of all moral gravity.

As I noted above, by the eighteenth century some artists, with or without direct knowledge of these contemporary scientific advances, had intuitively arrived at the same conclusion. As a result they radically reconsidered physiognomical representation and portraiture. We need only remember the "expressive heads" created by William Hogarth (1697-1764), Franz-Xavier Messerschmidt (1736-1783), and Louis-Léopold Boilly (1761-1845), English, German, and French artists respectively. All three opted for a caricatural representation of faces, a way of saying that "distortion" or "disfiguring" had penetrated the sacred realm of art and would not be abandoning it in the future. In relation to the dichotomy between the "realist" and "idealizing" tendencies within the traditional portrait, it cannot be said that the trend towards caricatural depiction in the present age has resulted in the triumph of one over the other. This is because essentially it revolutionized both to an equal degree. It intermingled them in such a violent and abrupt manner that the result was a literally monstrous new physiognomic type. The caricatural tendency created a form of portraiture in which detailed, realistically depicted features acquire an animation so expressively distorted that it paradoxically cancels out its individualizing power—or in which idealized features are accompanied by such a wealth of individualizing detail as to bring to mind the proverbial hero with feet of clay. To sum up, it is as if the "action," now conceived as a sort of energy, had deformed the features and that these, in turn, had oppressed the action.

Overall, then, how can we deny that our own age has been the golden age of the portrait? From a quantitative viewpoint this is unquestionable: never have so many portraits been made, for so many different reasons and in so many different media. In a way, it could be said that the genre of portraiture became the principal democratizing agent of art. Having one's portrait made became something socially and materially within the reach of everyone (think of photography). It could also be said that the trivialization of the portrait transformed its identity, i.e., quantity affected quality. Whatever the case, the huge dissemination of portraiture cannot be described as an aesthetic simplification, even from a strictly sociological viewpoint. In fact, it has sharpened the artistic portrait and made it more sophisticated, whatever the medium in which it is created. Whether under the influence of its widespread social use, or for other more strictly aesthetic reasons, contemporary portraiture has widened its conceptual and practical horizons. Above all, it has transformed itself into an infinitely more complex genre. Having reached this point, I should make a short interjection to emphasize something normally passed over—the fact that all the changes that have come about in portraiture during our own age have not necessarily invalidated traditional practices. The painted portrait is alive and well, for instance, having evolved creatively just as much as portraiture in newer techniques.

Returning to what most concerns us, the aesthetic revolution within contemporary portraiture resulted in the first place from the very different concept of mankind and his place in the cosmos that our age has developed. Secondly, it resulted from the very different idea that we now have of what life is and what it means per se. It is no longer possible to locate mankind as the center of anything but himself—nor, however, can his body or soul be dealt with separately or reduced to an ideal, closed prototype. From whatever angle the question is considered—physical, biological, or psychological—we cannot reduce man's identity and thus the representation of his image to his exterior, morphological features. Nor do these fit within an interpretation that is not an ongoing, dynamic one. The philosopher Georg Simmel touched on this idea when he wrote of Rembrandt's modernization of the portrait:

Rembrandt's portraits embrace the mobility of the interior life, whereas the classical portrait is not just timeless in the sense that art in general is timeless, i.e., independent of any position between a before and after in universal time, but possesses per se, in the order of its moments, an immutable timelessness. For this reason, Rembrandt's most profound and moving portraits are those of old people, as the emphasis is on the full length of life already lived. Rembrandt only achieved this once in his portraits of young people, in a painting of Titus, through a shift of dimension. In it the artist seems to accumulate future life with its potential and eventualities; it is understandable as the present of a future happening, just as the portraits of old people are understandable in terms of a temporal sequence that has already taken place.

Simmel's idea of the "temporalization" of the modern portrait reaffirms not only the instability of human identity in our own age, which is by nature fluid and changing, but also its individualizing hyper-fragmentation, which calls for an existentialist perspective or vision. The overwhelming triumph of what we might call the contemporary hyper-realist portrait, served by sophisticated visual technology, has by no means done away with the illusionistic dimension of portraiture or its "interpretative" element in a more than psychological sense. Nor has the advance of plastic surgery with the aim of artificially redesigning the face (which thus becomes the "mask of a mask") been able to limit or control life's boundless expressive fluidity—which unfailingly leaves its imponderable mark. It has not been able to do so from a psychological or social viewpoint, nor even from the more volatile aesthetic one, which is also affected by the vagaries of change for change's sake. It is not that the canon of beauty no longer exists, but that all successive models bear the fatal mark of their precariousness. Leaving these considerations aside, we might ask how portraiture has evolved as a genre in the modern age. Looking at its evolution from a social perspective, we find that during an initial phase, spanning roughly the second half of the eighteenth century and the first half of the nineteenth, portraiture became more widespread than ever before, to the point of becoming the preeminent speciality. Secondly, the dissemination of painted portraits was to decrease although that of portraits in other techniques was to grow exponentially. Thirdly, the massive diffusion of portraiture would establish a new distinction between the portrait as mere document and the portrait as art, the latter including not only painted portraits but works realized in any medium with a critical, interpretative, or "creative" intent.

What interests me here is to follow the fortunes of the painted portrait during our own age, not only because it has survived in an aesthetic sense up to the present but also because it has influenced the artistic portrait in other media. The consolidation and diffusion of the portrait in our time cannot be explained solely by obvious sociological reasons (the democratization of art and the importance placed on individualism by the new bourgeois ruling classes). They came about because the genre of portraiture could be used to express a new anthropological concept of identity. Considered in this light, the Romantic portrait focused its attention to a disproportionate degree on the unfathomable profundity of the face; its expressive animation was limited to capturing the model's gaze. This was the case with the German painter Philip Otto Runge and the French painter Théodore Géricault, who were also the first artists to project the force of such a psychic abyss in portraits of children. In his late series of marginalized characters based on patients in his friend Dr. Georget's clinic, Géricault also established a new and close relationship with insanity.

We should also bear in mind the revolutionary expansion of iconographic types in modern portraiture, in which eighteenth-century English art played a crucial role. It was not merely the integration of the portrait into the landscape, in which British artists were consummate masters, but also a highly innovative reinterpretation of the group portrait, which evolved into the interesting sub-genre of the "conversation piece." Within the framework of a family or domestic group, such paintings proposed a catalogue of social prototypes and a surprising variety of situations. As well as greatly contributing to the development of the caricature, British artists, from Hogarth to George Stubbs, were important pioneers in the invention of "expressive heads." To appreciate the greatly increased range of options available to the portraitist, it may be useful to look at the current exhibition that deals with portraiture of an earlier period, *Citizens and Kings: Portraits in the Age of Revolution, 1760-1830*. The exhibition is divided into ten sections: "Portraits of Sovereigns and Heads of State," "The Status Portrait," "The History Portrait," "The Cultural Portrait," "The Place for Experimentation: Artists' Portraits and Self-Portraits,"

Francisco Calvo Serraller

"The Family Portrait," "The Portrait after the Antique," "The Allegorical Portrait," "Nature and Grace: The Landscape and the Figure," and "Portraiture from 1815 to 1830: Ideal Families and Tormented Geniuses." If we compare this extensive typological classification, which in no way claims to be exhaustive, with the sparse traditional dichotomy between "formal" and "individualizing" portraits, we can fully appreciate this "explosion" of the genre.

In his introductory text to the catalogue, entitled "Portraiture: Facts Versus Fiction," the guiding figure behind this major exhibition, the late Robert Rosenblum, states the following:

> In the twentieth century, portraits became an endangered species. The conventional accounts of modern art's evolution told us that the Impressionists were so different to the people who passed before their eyes that they had no hesitation about pulverising their identities into flecks of coloured light. As for Cézanne, it was assumed that when depicting again and again his endlessly patient wife Hortense, he thought of her as nothing more that the inert equivalent of the apples or pitchers he struggled to paint, totally indifferent to her features and personality. The greater revolutions of twentieth-century art pushed the eclipse of portraiture even further. Who would ever have commissioned Mondrian or Rothko to paint a portrait? And even the more earthbound giants of modern art would pose high risks: Matisse might efface a sitter in a pool of colour; Picasso, in crystalline mountain. Portraiture seemed to recede into long-buried history, a category that evoked vain and wealthy patrons as well as unadventurous artists who chose the path of commercial vice rather that aesthetic virtue.

As Rosenblum himself notes further on in his text, this pessimistic diagnosis requires a considerable degree of qualification and does not fully reflect reality, which is much more complex. Nevertheless it does express a generally held opinion.

Is this opinion—clichéd though it may be—so remote from what has actually happened and is still happening in twentieth-century art and the art of the present day? And if it is indeed the case, how can we explain the apparently irreversible decline of the portrait, other than by invoking its obvious difficulties with an artistic language that is "abstract," "non-iconic," and "non-figurative"? The correct response would be that the portrait has died of its own success. By this I mean that, with or without an artistic intent, twentieth- and twenty-first-century mankind has been portrayed to such an infinite degree that the reproduction of his own image has become a completely trivial circumstance. As is always the case following the trivialization of any practice, however, the subject begins, paradoxically, to arouse new artistic interest. I am not referring just to already stereotyped images, whatever the reason for the interest that they attract—for example, in Pop art—but to something much more general. The mechanized graphic documentation of our faces and bodies has proliferated so widely that it is clearly difficult for us to pay more than momentary attention to them. Furthermore, the multiplication of our physical image makes us doubt that such an image contains any significant part of our interior self. Our scepticism has been greatly reinforced by the data that modern science has offered us. Science does not consider our exterior physical image truly revealing, either psychologically or biologically—it may or may not have been the subject of a superficial "make-over" or surgery, but in any case it does not offer a sufficiently individualizing element. It is not as reliable as the decoding of our DNA. So it is logical that twentieth-century art has wished to go beyond physical appearances to enter into a comparatively more significant and revealing interiority. Whatever the case, there is another dimension to this question of what I would call the "triumph-failure" of the modern portrait, particularly from the twentieth century onwards. It is the fact that, as I noted earlier, art "changes" but does not "progress": despite everything noted above, the artistic portrait did not disappear at any point during the twentieth century and is not doing so now. The painted portrait has not disappeared, nor has the portrait realized through any other technical means of whatever nature. The "realist" figurative portrait has not disappeared—while we have become sufficiently familiar with the genre to be able to extract the necessary information from portraits that at one point we might have considered less "specific," or more "reductive" or "caricatural." The classical dichotomy that I referred to earlier between "portrayal" and "imitation" has been recreated in these categories, in other words, between the faithful copy of reality and its interpretation. With this in mind we can reply to the amusing condemnation of Cézanne's portraits of his wife, as paraphrased by Robert Rosenblum, shifting that artist's aesthetic stance to fall within the analytical line begun by Ingres and continued in his own way by Degas. Ingres's famous portrait of *Monsieur Bertin* can be seen as the faithful reproduction of the image of this

gentleman as well as the insertion of a cone into a cylinder, which would not just inspire what Picasso did seventy years later in his portrait of Gertrude Stein but also the development of Cubism. To sum up: the artistic portrait has not lost ground during the twentieth or twenty-first century, a statement that can be made without having to mention at length the thousands of portraits that have been produced up to the present time.

Having reached this point, which literally closes the issue and indicates that my text is happily reaching its end, it only remains for me to look at something I referred to at the outset—the classical tag "a pretty face is not always the mirror of the soul," which serves to emphasize once more the tension between the "exterior" and "interior" of our appearance. Has our revolutionary era ended or blocked off this tension between the physical and psychological dimension of the human image? Can we speak of complete "transparency" between ourselves and others? If this were the case, the numerous techniques of the industry of the image would not have prospered as they have, embracing all levels of corrective manipulation of our natural appearance. More than ever today we are cured of ourselves—of our supposed unattractive physical deformities and also of our own psyche and imperfect social image. In reality, we believe today in our "visual potential" to such an extent that it could be said that we never stop portraying ourselves and that we cannot because it is a literally endless task or one that only ceases at the moment of our deaths (without forgetting that dead bodies are also made-up and embalmed). What is clear is that today we are less transparent than ever before; the tension between the interior and exterior of our own image endures, as does the idea that "a pretty face is not always the mirror of the soul." As a result we are still exposed to capture in portraiture.

Francisco Calvo Serraller

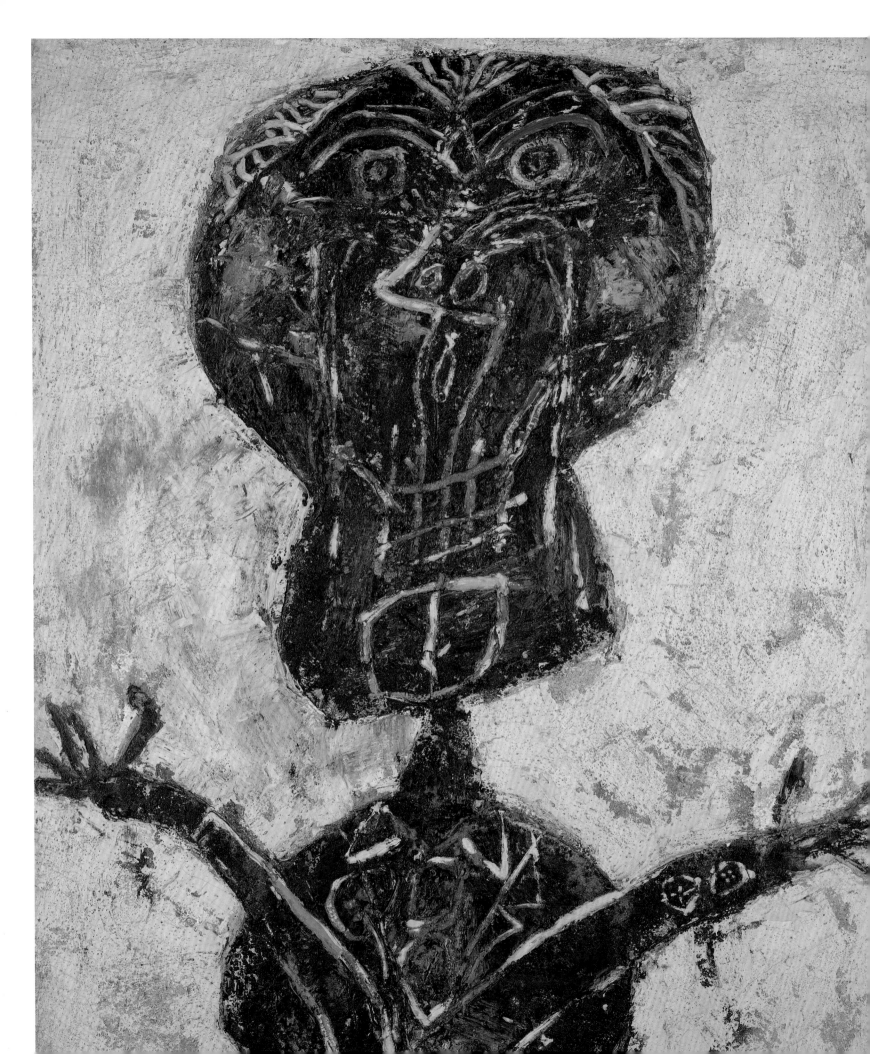

PORTRAITS ABOUT PORTRAITURE

Malcolm Warner

Against the Good Likeness

Although they still had their own specialists, traditions, and status, by the nineteenth century the old categories of art known as the genres—portraiture, landscape, still life, and so on—were breaking down. Gustave Courbet, Edouard Manet, and other progressive artists mixed different genres together in the same painting as part of an offensive against all received artistic ideas. Yet the idea of the genres proved resilient, not only among more conventional artists but also among the avant-garde. Each genre had its own story of transformation and survival in the later nineteenth and twentieth centuries. While landscape played a vital role in the growth of abstraction, the traditions of portraiture were to be the main pattern, honored as much in the breach as in the observance, for modern art's engagement with the human figure.

Portraiture was the genre from which people most expected truth to life, a "good likeness." Since the Renaissance most portraits had been commissioned by sitters and their families. The patrons had to be pleased (unlike a landscape or still life, a portrait was almost impossible to sell elsewhere if rejected), and people were never more sharply critical of an artist's treatment of a subject than when they *were* the subject. After long years of dealing with clients, John Singer Sargent defined a portrait as "a likeness in which there was something wrong about the mouth."[1] In the eyes of the sitter and his or her loved ones, the good likeness normally had to be a feel-good likeness, one that flattered as much as possible short of implausibility. Portraiture dealt not with ideal beauty and noble themes like the supposed highest forms of art—scenes of allegory, myth, or ancient history—but with actual living people and their vanity. For this reason it was looked down upon by theorists as a compromised genre, not to be taken

too seriously by the most ambitious artists. Among avant-garde artists of the modern age who were not only ambitious but in rebellion against the whole idea of art as the imitation of nature, we might guess that it would have fared even worse. Surely the genre most tied to likeness was the one least likely to succeed.

But the opposite turned out to be the case. Though happy to give up the commissioned portrait to their more conservative colleagues, the modernists never abandoned portraiture as a form. It is striking how many great works of modern art show people sitting in chairs as portrait sitters had done for centuries. Modern artists went on with portraits without commissions, which to most portraitists of the past would have seemed absurd, and typically their sitters would be friends, relatives, or themselves (in the case of self-portraits), rather than paying clients. Often they would give portraits away as gifts. When they sold them, it was not necessarily to sitters or their families; it was mainly to the same dealers and collectors who bought other kinds of work. There were some age-old aesthetic reasons why they should continue with portraiture on this new footing. The painting and sculpting of portraits stemmed partly, as ever, from the urge to make art from everyday experience, including the company of others and one's own physical appearance. But there were also reasons to do with the particular tendencies of modern art, and one of these was the desire to engage in original ways with the art of the past. Having largely renounced the commission, modern artists responded with creative freedom both to their sitters and to portraiture as a genre. Far from ignoring its purposes, traditions, forms, and canons, they took them as given things with which to work.

For artists looking to challenge the conventions of representation in art, what better arena could there be than portraiture, which for most people was all about likeness? It was the most subvertible of the genres. When artists

1 See Evan Charteris, *John Sargent*, London, 1927, quoted in Ormond 1970, p. 56.

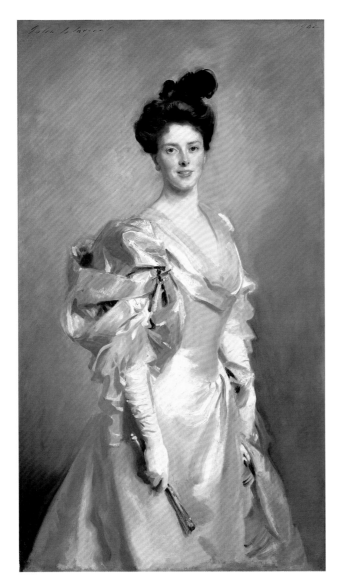

Fig. 1
John Singer Sargent
Mary Crowninshield Endicott Chamberlain
(Mrs. Joseph Chamberlain), 1902
Oil on canvas, 59 x 33 in. (150.5 x 83.8 cm)
National Gallery of Art, Washington, D.C.
Gift of the sitter, Mary Endicott Chamberlain Carnegie

couched a painting or sculpture in portraitlike form, or merely used a title containing the word "Portrait," they could count on firm expectations on the part of the viewer and flout them to effect. The surprise tactic that René Magritte deployed in *The Portrait* [cat. 97], his genre-bending portrait-as-still-life, is to be found in differing forms and lesser degrees throughout modern portraiture. All avant-gardes were founded on critiques of the art of the past, often damning generalizations that provided them with models to oppose, outrages to commit; they made the same kind of collective take on portraiture as a genre. They introduced a new self-consciousness, revealing the subjectivity and artifice of their art, playing with the likenesses of their sitters and the very idea of likeness.

The work of their close predecessors and contemporaries on the more professional side of portraiture, Sargent [fig. 1], Giovanni Boldini, and the other society portraitists of the later nineteenth and early twentieth centuries, shows a relatively un-self-conscious carrying forward of tradition. The "wriggle-and-chiffon" portraitists (as Walter Sickert dubbed them)[2] took the high glamour of aristocratic portraiture, especially that of Anthony van Dyck and his successors in Britain, and married it with a conservative mode of Impressionism. They painted their sitters' faces with a tactful smoothness but clothes and setting with pyrotechnic displays of brushwork. They were allowed to show off: they could flaunt their skill and delight in the materials of their art more and more as they worked away from the face and toward the edges of the canvas. But in the face they had to be self-effacing. The main presence, at center stage, had to be that of the sitter. Society portraiture had developed rapturous powers of flattery; portraits by Sargent were like magic mirrors in which sitters saw themselves as they would like to be, only better still.

But in modern portraiture it was the will and style of the artist that would predominate. Leaving their vanity at the studio door, sitters would have to risk disfiguration at the portraitist's hands, skin diseases that turned the face green or strangely like a mask or animal, rashes of agitated brushwork. As readily as society portraitists made their sitters look younger than they were, the modernists made them look older. At best, sitters felt a reverse flattery at work, a Dorian Gray factor, in that they could be sure they looked more attractive in person than in their portraits. As though taking every manner and custom of professional portraiture

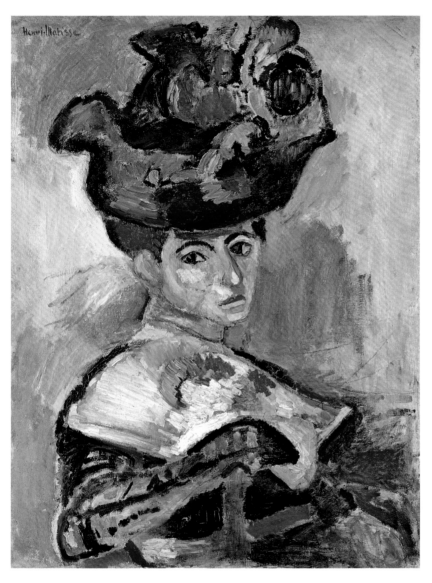

Fig. 2
Henri Matisse
Woman with the Hat, 1905
Oil on canvas, 31 x 23 in.
(80.6 x 59.7 cm)
San Francisco Museum of Modern Art.
Bequest of Elise S. Haas

2 Sickert 1947, p. 82.

3 See Jeffrey Weiss in
 Washington/Dallas
 2003–2004.

4 From *Notes du peintre*,
 Paris, 1867, quoted
 in Ottawa 1997, p. 1.

5 See Klein 2001, pp. 74–78.

and impishly doing the opposite, some artists raised un-flattery to new heights by painting themselves and their sitters naked. Given that the nude was as closely tied to ideal beauty as the portrait to the flattering likeness, nude portraits such as Stanley Spencer's [cat. 139] were doubly transgressive. In the early Cubist portraits of his mistress Fernande Olivier [cat. 57], Pablo Picasso painted the head as an *écorché* (a figure denuded even of skin, flayed to reveal the muscles) with effects of modeling and perspective that created paradox rather than clarity. It was as though he were putting together images and ideas from his training—the *écorché*, the portrait, and academic drawing techniques—in a perverse hodgepodge sure to give his teachers nightmares.[3]

Most traditional portraits showed people not just clothed but clothed so as to proclaim their wealth and status, wearing their Sunday best. The nineteenth-century critic Théodore Duret described portraiture as "the triumph of bourgeois art."[4] For avant-garde artists who disdained social conformism, this was another aspect of the genre from which to make a point of distancing themselves. At times the result would come across as ironic, even offensive. In Henri Matisse's *Woman with the Hat* [fig. 2], the artist's wife Amélie appears posed and dressed like a fine lady but painted almost as though she were a chance configuration of color dabs on his palette. As John Klein has pointed out, the work seemed to its outraged first audiences to be a mockery of portraiture and the whole social structure that it helped support.[5]

The movement against likeness, flattery, and social display in modern portraiture was an expression of bohemianism, the belief of artists that they must pursue their own ends, even into poverty, and reject the compromises involved in working for money. It was more important for a portrait to be a work of art than to show what a particular individual looked like or would *like* to look like. Stories grew around anti-conventional portraits that were so much stronger a presence than the actual sitters that the sitters and everyone else acceded to their power—with the moral that sitters should expect to imitate their portraits rather than vice versa. After the last of many sittings, Picasso repainted the head in his famous portrait of Gertrude Stein to give her a masklike appearance based on works of medieval Spanish and ancient Iberian sculpture [fig. 1 on p. 26]. Stein was pleased but others complained about the lack of likeness, at which Picasso

Francis Picabia made portraits of friends that were compositions of everyday objects and machine parts with nothing even resembling a likeness, only inscriptions referring obliquely to aspects of the subjects' lives [fig. 3 on p. 205]. One of them remarked:

> He would never explain the meaning of the portraits he did of us, always saying with a malicious smile: 'It is you who must tell me what they mean. God does not explain the creation to us. It is we who explain it to him: that this is a dog, that a tree. . . He doesn't know.[9]

Jean Dubuffet presented a whole exhibition of messy, naïve-savage images of intellectuals and artists as a mockery of traditional portraiture and likeness [cats. 111 and 112]. He announced the exhibition in the style of a sideshow barker: *Portraits of a likeness extracted, of a likeness cooked and preserved in the memory, of a likeness that burst in the memory of Mr. Jean Dubuffet, Painter.* "People are much more beautiful than they think," he wrote as an ironic slogan on the cover of the catalogue. "Long live their real looks."[10] Dubuffet meant to mock not his subjects but the conventions of beauty and dignity, pomp and circumstance, that he found ridiculous in portraiture and associated with the powers that be.

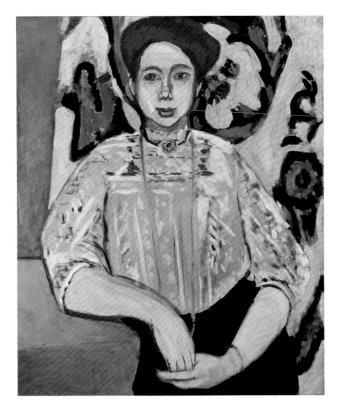

Fig. 3
Henri Matisse
Greta Moll, 1908
Oil on canvas, 36 ⅝ x 29 in. (93 x 73.5 cm)
Tate, London. Lent by the National Gallery 1997

The Sitter in the Studio

The traditional portrait practice revolved around sittings. The sitter might resent the time and tedium involved, but the ordeal was made more tolerable, even a positive pleasure, by the usually well-developed charm of the portraitist. For modern artists, sittings were less of a necessity; an artist might base some portraits on them and some not. Picasso made some of his most naturalistic without sittings and many of his most wildly anti-naturalistic with the sitter before him. On the whole, modern artists abided by the tradition of the sitting more commonly than one might expect. It is as though they felt they must pay their dues, following the process through, even if what they created in the end had little to do with observations made in the studio—even if it challenged the whole portrait tradition. "When I did the *Portrait of Madame K.* (who actually sat for it)," said Joan Miró, "I was planning to do something realistic, but then I started eliminating, eliminating . . . I was

remarked "everybody thinks she is not at all like her portrait but never mind, in the end she will manage to look just like it."[6] Matisse had his student Greta Moll sit to him for ten three-hour sessions, then completed the portrait in her absence, transforming the image that he had created from observation [fig. 3]. At first she and her husband were appalled, but they accepted the work and finally came round to its merits. "The portrait was later very much admired, even by them," Matisse recalled, "and I said to myself once more that Bonnard was right to declare that a portrait always ends up being a likeness."[7]

Likeness was an issue constantly on the mind of the modern portraitist, one on which to take a position. Picasso referred to the elements of likeness in his Cubist portraits of the art dealers Wilhelm Uhde, Ambroise Vollard, and Daniel-Henry Kahnweiler [fig. 6 on p. 33]—a particular nose, mouth, mustache, or hairstyle—as mere "attributes" or "adjectives."[8]

6 Penrose 1958, p. 116.

7 From a statement apparently made in the 1940s, Archives Matisse, Paris, quoted in Klein 2001, p. 157.

8 Gilot/Lake 1964, p. 72.

9 Juliette Roche, wife of Albert Gleizes, from an interview of 1975, quoted in Borràs 1985, p. 175.

10 For a reproduction of the catalogue cover, see Washington 1993, p. 21.

Fig. 4
Joan Miró
Portrait of Madame K., 1924
Oil and charcoal on canvas, 45 ⁷/₈ x 35 in. (116 x 89 cm)
Private collection

getting rid of any sort of pictorial influence and any contact with realism and I was painting with an absolute contempt for painting."[11] When she saw her finished portrait [fig. 4], a strange constellation of abstracted and disconnected body parts, Madame K. may well have wondered what purpose the sittings had served.

Sittings could become a performance for both artist and sitter, and at times the material of anecdote and legend. The story of the portrait that makes scant concession to conventional likeness and may even look unfinished, yet requires a large number of sittings, is another recurrent one in the literature of modern art. Paul Cézanne is said to have needed 115 sittings to paint Ambroise Vollard. Picasso is said to have had eighty or ninety sittings with Gertrude Stein before declaring "I can't see you any longer when I look" and repainting her *without* looking.[12] Alberto Giacometti had James Lord sit for a mere eighteen days, but during that time

recreated the painted James Lord at least a hundred times.[13] Changing every day as though it had a life of its own, the portrait seemed to Lord to be interminable, literally. Lucian Freud's daughter Isobel Boyt, who read the whole of Marcel Proust's *Remembrance of Things Past* during sittings for one portrait, must have felt the same.[14] Such stories underline the idea of modern portraits as perceptions or creations that developed over time, and many retain a sense of this in their final state, with obvious *pentimenti* and the rough look of works in progress.

Almost all portraits, self-evidently, show people in the act of posing for their portraits. In traditional portraiture artists played down this fact of the process and prevented it from coming through with any immediacy to the viewer. They might suggest a nervousness or weariness on the part of sitters, often under the fashionable guise of melancholia, but rarely did they allow this to read as a feeling about the trials of the sitting. For some modern artists, on the other hand, the sitting was not just a means to an end but an interesting subject in its own right. In the painted portraits of Giacometti the sitters are not just sitting but obviously doing so [cats. 114 and 116]. It is part of their austere honesty as works of art: they are about the anxieties of sitting, the discomfort and the stress of being looked at, long and hard, by another person. One of the reasons why Diego Velázquez's *Las Meninas* [fig. 5] was such a touchstone for the self-conscious portraiture of the twentieth century was that it is a portrait but also a painting of a sitting.

Sitters traditionally posed in the artist's studio but appeared in their portraits as though somewhere else, perhaps before the grand columns and curtains of an ancestral mansion (actual or symbolic), perhaps in a country park enjoying the pleasures of the outdoors. Many of the sitters in modern portraits would both pose in the studio and appear in that setting. In portraits from early Picasso to Giacometti, the columns and curtains of the past gave way to stacked-up canvases, stretchers, frames, portfolios, musical instruments, and other studio paraphernalia. The studio setting drew attention to the role reversal in which artists now chose their sitters: they undertook portraits on their own terms and on their own turf. Sitters were guests in the artist's world. In Cézanne's *Man in a Blue Smock* [cat. 1], the figure of the lady holding a parasol in the background has nothing to do with the sitter and everything to do with the artist, part of a decorated screen that was his first painting. Being inside the

11 From an interview in
La Publicitat (Barcelona), 1928,
in Rowell 1986, p. 95.

12 Stein 1933, p. 65.

13 Lord 1980, p. 109.

14 From an interview in the
documentary film *Lucian Freud
Portraits*, directed by Jake
Auerbach, produced by Jake
Auerbach and William Feaver,
2004.

Malcolm Warner

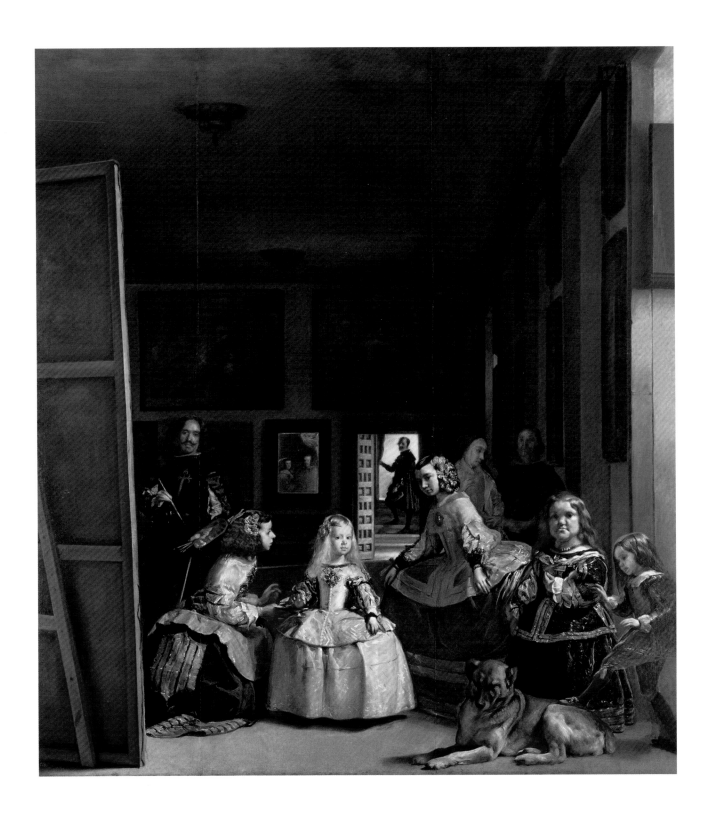

studio suggests the idea of being inside the artist's mind, full of images and memories, in which the present portrait arises as a new conception.

The prospect of entering the artist's world partly explains why, given the not especially sitter-friendly nature of much modern portraiture, people remained willing to sit for portraits and even occasionally to commission them. Sometimes things went badly wrong. But even if paying sitters had to forego the good likeness and status symbolism of a conventional kind, they could enjoy the prestige of being associated—for all time, especially if the work entered a museum—with a great and famous artist. As Kirk Varnedoe pointed out, an artist's style might be unflattering to a sitter's looks yet very flattering to his or her position in the world as a person of culture and advanced taste: "the sitter's image is primarily meaningful in terms of the stylistic elements of which it is built, rather than in terms of such traditional factors as wealth and occupation, since the particular modern style serves as the bearer of values and status."[15] The pleasure of having an Andy Warhol portrait of oneself lay in becoming part of Warhol's world in some sense—just as the patron shown in a "donor portrait" in a fifteenth-century altarpiece became part of the company of heaven.

For centuries people have displayed portraits in relation to other portraits, whether in the family home (among relatives and ancestors) or in more public places such as council chambers and boardrooms (among other office holders, past and present). The purpose is to show each sitter as part of an impressive group or tradition. Portraits by avant-garde artists, by contrast, are usually displayed so as to speak for the artists rather than the sitters. In her home in Paris Gertrude Stein hung Picasso's portrait of her above Matisse's portrait of his wife, the *Woman with the Hat*, which Stein also owned.[16] She did this not to make a social point in the traditional way but to invite comparisons between the artists. Maybe the contrasting personalities of these great works of modern portraiture helped inspire Stein, who made much play with the concepts of portraiture and identity, to write her literary portraits of friends; these were couched "in all manners and in all styles," and among the first of her subjects were none other than Picasso and Matisse.[17] Stein's way of displaying the Picasso and the Matisse is representative of the way in which the modern artist's attitude toward portraiture has become an attitude among the owners of modern portraits. With only some rare exceptions, collectors and museums think of them as works of art first and likenesses second (or not at all), and display them in ways that make sense as art history rather than dynastic or social history.

There is another way in which our usual experience of modern portraits differs from that of older works in the same genre. One of the pleasures of most portraiture is the feeling of being in the presence of people from the past, a feeling that no verbal description can match, however much more information it may give. But the effect depends on the assumption of transparency: we may know that all art is artifice and not to be confused with reality in the raw, but before the work of a skilled portraitist we suspend disbelief. This only works when we can feel we are seeing through the portrait to the sitter in person—in other words, when the style and personality of the artist do not come between and demand our attention. The dominant presence of the artist makes most modern portraiture resistant to nostalgia.

Changing Identities

Beyond capturing a likeness, most portraitists of earlier cultures and periods wished to affirm a distinct identity for the people they represented: the powerful ruler, the brave soldier, the pious cleric, the fashionable beauty, the man of business, the inspired author. As the idea of human individuality deepened in European thought in the sixteenth and seventeenth centuries, and portraiture burgeoned as a result, artists found ever more sophisticated ways of suggesting identity, a command of nuances to distinguish the individual within the type. By the nineteenth century, artists and writers on art had begun to believe that the best portraits not only addressed such matters as looks, occupation, social position, and the sitter's face to the world, but laid bare his or her very soul. Cézanne thought that Velázquez had been forced into court portraiture against his will, despised his sitters, and punished them by exposing their inner corruption: "He avenged himself terribly. He painted them with all their flaws, their vices, their decadence. His hatred and his objectivity were one and the same."[18] The art historian Bernard Berenson wrote of true portraiture as showing "the individuality of the inner man"; if it showed only the social being, it was a mere "effigy."[19] Though persistent to the point of cliché, the idea is a questionable one. What does it mean to say that Velázquez revealed a deep darkness inside his sitters if neither they nor

15 See Kirk Varnedoe in New York 1976, p. XVIII.

16 For a photograph of the paintings hanging together, see Stein 1933, opp. p. 56.

17 Stein 1933, p. 140.

18 From Joachim Gasquet, *Cézanne*, Paris, 1921, quoted in Doran 2001, p. 154.

19 Berenson 1948, p. 199.

Malcolm Warner

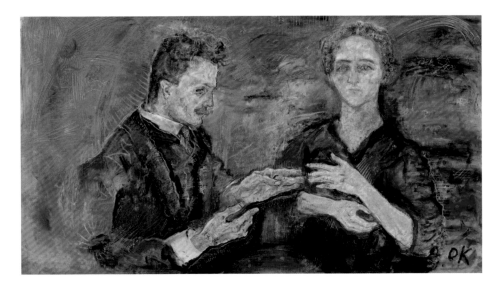

Fig. 6
Oskar Kokoschka
Hans Tietze and Erica Tietze-Conrat, 1909
Oil on canvas, 30 ⅛ x 53 ⅝ in.
(76.5 x 136.2 cm)
The Museum of Modern Art, New York.
Abby Aldrich Rockefeller Fund (651.1939)

person, and to recreate in my own pictorial language the distillation of a living being that would survive in my memory.[20]

But the attitude most characteristic of the modern portraitist—arising perhaps from doubts about identity as an integral and fixed thing, perhaps from a lack of interest in other people's souls—has been that to delve into the sitter's inner being is either impossible or not especially desirable. As Gertrude Stein wrote of Picasso,

the souls of people do not interest him, that is to say for him the reality of life is in the head, the face and the body and this is for him so important, so persistent, so complete that it is not at all necessary to think of any other thing and the soul is another thing.[21]

anyone else seem to have noticed at the time? How much of the inner man is it really possible to show in a painting or sculpture? It may be closer to the truth to say that Velázquez, Rembrandt, and the other great portraitists of the past were able to suggest the living presence of their sitters so strongly, especially through calculated ambiguities of expression, that we are constantly led into thinking we actually know them.

Though dubious from the point of view of common sense, a belief in the soul-penetrating capability of portraiture has inspired great works of art, as well as great writings on art, and it did so among some of the progressive artists of the twentieth century, especially in Austria and Germany. With their neurotic body language and strange emanations of color and line, the sitters in Oskar Kokoschka's early portraits appear to hover between body and disembodiment, as though the artist had indeed seen through to their essence [fig. 6].

When I paint a portrait [he wrote] I am not concerned with the externals of a person—the signs of his clerical or secular eminence, or his social origins. . . . What used to shock people in my portraits was that I tried to intuit from the face, from its play of expressions, and from gestures, the truth about a particular

Giacometti put the same point of view in down-to-earth terms when he told James Lord: "I have enough trouble with the outside without bothering about the inside."[22] For Dubuffet the subversion of conventional ideas about identity was an important part of the subversiveness of his portraits in general: "Those who have spoken about my portraits as an undertaking aimed at psychological penetration have understood nothing at all . . . the portraits were anti-psychological, anti-individualistic."[23]

Long before the twentieth century there were people, especially rulers, who had their portraits made often. Their painted and sculpted features might age a little over time, but the portraitist rarely made any deep change to the identity they presented to the world. Portraiture was based on the idea that an individual's identity was fairly definite and unchanging, and that the portraitist's task was to bring out its distinctive qualities. Many modern artists portrayed the same sitter repeatedly with a different identity each time. Sometimes, as with Picasso's serial portraits of the women in his life, a favorite sitter was like an actor for whom the artist created a succession of roles. When a number of such works are collected together we might read them as showing different aspects of the given sitter's personality, or different moods, and there may be some truth in this; each character an actor-sitter plays will probably draw upon aspects of his or her real personality and experience. But this is not essential to the meaning of the work. Tellingly, some artists preferred that their sitters be paid models. Sitter and model used to be distinct categories but in modern portraiture they commonly

20 From *My Life*, London/New York, 1974, quoted in New York/Hamburg 2002, p. 12.

21 Stein 1938, p. 14.

22 Lord 1980, p. 38.

23 Limbour 1953, pp. 91–92.

Fig. 7
Diego Velázquez
Pope Innocent X, 1650
Oil on canvas, 55 x 46 ⅞ in. (141 x 119 cm)
Galleria Doria Pamphilj, Rome

Fig. 8
Francis Bacon
Study for Portrait I, 1953
Oil on canvas, 59 ⅞ x 46 in. (152.1 x 118.1 cm)
Collection Denise and Andrew Saul

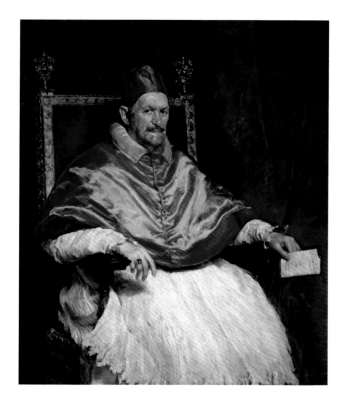

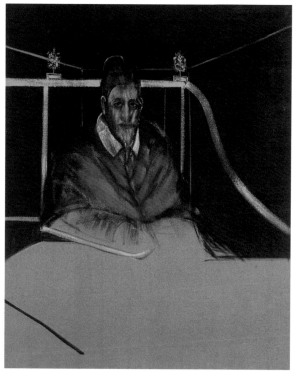

fused together. Unlike a paying client or member of the artist's own circle, a model was someone to whose looks, identity, and supposed inner being the artist need feel no obligation.

The modern artist who played most provocatively with identity, as with other key concepts of traditional portraiture, was Picasso. Speaking to Françoise Gilot about his *Vollard Suite* he "identified" a figure in one of the plates as Gilot even though he etched it some ten years before they met, and the figure of a man in a ruff as either Rembrandt or Balzac.[24] On occasion he would conflate different people (and people and animals) in the same portrait, or decide whom a portrait represented only after working on it for some time. He would meld people of the present with figures from paintings of the past: his daughter Paloma could become the Infanta María Margarita from *Las Meninas*, or vice versa. Of his allusion to J. A. D. Ingres's portrait of Madame Moitessier in a portrait of his mistress Marie-Thérèse Walter, Robert Rosenblum wrote that "such quotational portraiture has a magical, almost voodoolike flavor, as if the ghost of the Old Master painting had been miraculously reincarnated through the presence of a living person in Picasso's life."[25] The same kind of reincarnation

occurred in the first of Francis Bacon's series of papal portraits of 1953: a portrait of his friend the art critic David Sylvester morphed, at about the fourth sitting, into a variation on Velázquez's portrait of Pope Innocent X [figs. 7 and 8].[26]

One of the commonplace sayings associated with portraiture is that the eyes are the windows of the soul. In the modern age a different metaphor predominates, that of the portrait as a mask, a likeness and identity created for the occasion and changeable. In this sense modern portraiture is a panorama of masks—like all portraiture to some degree, perhaps, but different in that it is openly and self-consciously so.

Through the Looking-Glass

"Every portrait that is painted with feeling is a portrait of the artist, not of the sitter," says the fictional artist Basil Hallward in Oscar Wilde's *The Picture of Dorian Gray*. "The sitter is merely an accident, the occasion. It is not he who is revealed by the painter; it is rather the painter who, on the colored canvas, reveals himself."[27] By the later nineteenth century the

24 Gilot/Lake 1964, p. 49.

25 Robert Rosenblum, "Picasso's Blond Muse: The Reign of Marie-Thérèse Walter," in New York/Paris 1996–1997, p. 359.

26 See Hugh Davies in San Diego 2001, p. 14.

27 Oscar Wilde, *The Picture of Dorian Gray*, first publ. 1890. See Bristow 2005, vol. 3, p. 7.

Fig. 9
William Orpen
Self-Portrait, c. 1910
Oil on canvas, 40 ⅛ x 33 ⅛ in.
(101.9 x 84.1 cm)
The Metropolitan Museum of Art, New York
Gift of George F. Baker, 1914 (14.59)

idea that portraiture was more about artists than sitters was common currency—certainly among artists, if not sitters. For Cézanne modern portraiture was a success because, free from the demands of the paying client, the artist could discover the resonance between himself and his sitter, in effect a way of seeing the sitter as himself: "We are always successful with our portraits, because in them we are one, you see, with the model."[28] Modern artists have interpreted the work of favorite predecessors along the same lines. Francis Bacon said that in front of portraits by a great master of the past, "I don't think about his sitters, I think about him. I think about Rembrandt, I think about Velázquez. I think people believe that they're painting other people, but they paint out their own instincts."[29] Given the value modern artists placed on the element of self in portraits of others, it is not surprising that the self-portrait, in which artist and sitter are one and the same, takes on a special importance in their work. It is modern portraiture in arguably its most representative form.

Since the Renaissance artists have normally used mirrors to make self-portraits, in most cases correcting for the reversal of the image in order to avoid appearing left-handed when in fact right-handed or vice versa. Some chose not to disguise the mechanics of self-portraiture but to use them as the basis for clever conceits, reminding the viewer of the power of art to create an illusion and, at the same time, the fact of its being an illusion. They might paint themselves holding a palette with dabs of paint that both represent dabs of paint and actually are dabs of paint, suggesting the raw material from which the rest of the image was made. As a tour-de-force, an artist might paint a self-portrait in a mirror that was convex [fig. 7 on p. 233], in which case the distortions in the image made the viewer inescapably aware of the process involved, the status of the work as a painted image of a mirror image. Artists painted self-portraits that showed them painting self-portraits [fig. 1 on p. 47]. One of the effects of self-portraits based on such conceits is to prime us, whenever we know a portrait to be a self-portrait, to consider the role the mirror played in its creation and feel its presence even if it is not there in the image. At some level we think of the work as a portrait of the artist gazing into a mirror; at another we realize that where the artist once stood before the mirror, we now stand before the canvas or panel. Self-portraiture was by definition about artists and by tradition about the magic at their command.[30]

Fig. 10
Max Beckmann
Self-Portrait as Clown, 1921
Oil on canvas, 39 ⅞ x 23 in.
(100 x 59 cm)
Von der Heydt-Museum, Wuppertal

In the twentieth century the self-consciousness of self-portraiture became more pronounced even among relatively conservative artists such as William Orpen. In some of his self-portraits [fig. 9] he teases the viewer with three realities in one—himself, his reflection in a mirror, and the painting as an object; here I am, he announces, and here is how I painted myself. In her *Three Generations* [cat. 102], a self-portrait with her son and a sculpted head of her father, Charley Toorop shows no mirror but implies that the whole image is a mirror image; it is as though she had painted not from a mirror but *on* one. Lucian Freud painted self-portraits from mirrors on the floor and propped up in a window frame [cats. 131 and 132]. David Hockney made his self-portrait an "unfinished" painting within a painting, each part in a different style [cat. 157]. In various ways artists worked into the self-portrait a sense of its making, often some form of mirror-consciousness. What had been largely a *jeu d'esprit* or display of illusionism among self-portraitists of the past fed naturally into the modern idea of making portraits that were about portraiture.

The urge of modern portraitists to be freely creative with identity comes through all the more clearly in their portraits of themselves. Many relished the chance to adopt or invent an identity for the occasion. Marcel Duchamp made a self-portrait in the form of a wanted poster, with deadpan mug-shots of himself and a litany of aliases. Max Beckmann portrayed himself as, among other things, a clown [fig. 10]. Picasso made self-portraits in the guise of El Greco and Velázquez—as though possessed by these great painters of the past, and equally possessing them. Artists picked up on the elements of role-playing in certain self-portraits of the past, especially Rembrandt's. In his *Self-Portrait at the Age of 34* [fig. 11], the Dutch master pictures himself, with some degree of tongue-in-cheek perhaps, as an Italian gentleman sitting to Titian or Raphael. We might imagine him getting into costume in the studio and arranging his clothes and features in the mirror. It was this play with identity in Rembrandt that most appealed to avant-garde painters of the twentieth century, rather than the supposed soul-penetration of popular cliché. More than any other artists of the past, and in ways that they could never have predicted themselves, Velázquez and Rembrandt provided the conceptual precedents for modern portraiture.

One of the novel developments of modern portraiture was the work made from an existing image and deliberately made

28 From Joachim Gasquet,
 Cézanne, Paris, 1921, quoted
 in Doran 2001, p. 155.

29 San Diego 2001, p. 34.

30 On the nature and history of
 self-portraiture, see London/
 Sydney 2005–2006.

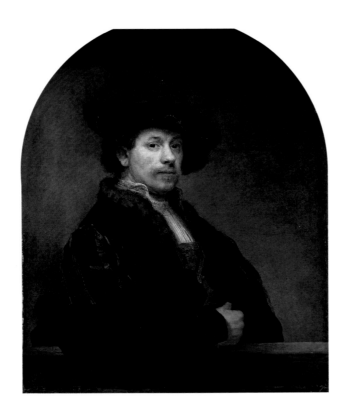

Fig. 11
Rembrandt van Rijn
Self-Portrait at the Age of 34, 1640
Oil on canvas, 40 ⅛ x 31 in.
(102 x 80 cm)
The National Gallery, London

to appear as such, the portrait of a portrait. Commonly the original was photographic. Painting on a large scale and in a bravura technique redolent of old-master tradition and luxury, the society portraitists made sure that their work was a thing apart from the supposedly rival art of the portrait photograph. But avant-garde artists embraced photography and made a visible point of using it. Picasso made drawings from "found" photographs of Renoir, Diaghilev, and (improbably enough) the family of Napoleon III. Sickert made portraits of celebrities from photographs clipped from newspapers and made his method evident in a still-visible grid of lines used for the transfer, as well as an obvious lack of definition taken over from the source material. Like Sickert, Andy Warhol made photography-based portraits to be understood not so much in relation to the given celebrities as in relation to how they appeared in the media. The qualities of his portraits are those of the popular "image," glamorous, artificial, superficial, and reproducible.

The self-consciousness of modern portraiture, its tendency to play off other portraits and portraiture as a genre, also comes to the fore in some portraits of *painted* portraits. Francis Bacon's many variations on Velázquez's portrait of Pope Innocent X seem to remove all restraint from the sitter and allow suppressed emotion and pain to break out. The *Study for Portrait I* is the beginning of a series in which the pope twists, covers his mouth, laughs, speaks, screams, and makes an obscene gesture. The effect depends on the viewer's knowledge of the original: a powerful, self-possessed man from a world of order becomes deranged and nasty. Bacon responded to the Velázquez (in a photographic reproduction) as a portrait calling out for a modern interpretation, an artistic psychoanalysis. In this he anticipated the variations that Picasso painted on the portrait of the past that has most fired the modern imagination, *Las Meninas*.

Given the interest of modern portraitists in the tradition of the self-portrait based on a conceit, it is natural that they should look to the greatest work of this kind as to an oracle. *Las Meninas* is a portrait in reverse, a sitter's-eye view of the artist and his studio. Velázquez stands before a large canvas on which he is presumably painting a royal group portrait. King Philip IV and Queen Mariana, or portraits of them on the canvas, are reflected in the mirror behind him, and in the foreground the handmaidens who give the work its title are attending to the Infanta María Margarita. The mirror serves the narrative, albeit ambiguously; it also reminds us of the

Fig. 12
Pablo Picasso
Las Meninas, after Velázquez, 1957
Oil on canvas, 76 ³/₈ x 102 in. (194 x 260 cm)
Museu Picasso, Barcelona

process of self-portraiture, and introduces some symbolic undertones since traditionally mirrors could represent the idea of truth or the sense of sight. What Velázquez intended in this enigmatic work has been the subject of much speculation among critics and artists, and part of his intention was no doubt enigma and speculation.

Picasso's variations on *Las Meninas* are part homage, part takeover bid.[31] Their wry humor lies in the translation of a painting admired for its verisimilitude into a series of Picassos, and in the particular points of comparison between them and the original. The modern master is both interpreter and parodist. In the first and largest work in the series [fig. 12], truly a *Las Meninas* through the looking-glass, he takes possession of the space, recasts the figures in pictorial modes of his own, opens the studio windows to the light, and installs his own pet dachshund, Lump, in place of the large dog in the original. He makes the artist, armed with two palettes, so tall that his head touches the ceiling. This giant looming over the studio is at once Velázquez and Picasso himself. He is neither servant nor courtier but king in his own right, possessed of the divine right of creation—a more important and complex figure than the actual king, who appears as a jokey face in the mirror. Perhaps, like Cézanne, Picasso believed that Velázquez had intended such subversions of authority in the original. In making a *Las Meninas* so raucously his own, he gave form to an idea that runs throughout modern portraiture, that of tradition as a theme ripe for variation.

31 For a thought-provoking account of the series, see Galassi 1996, pp. 148–184.

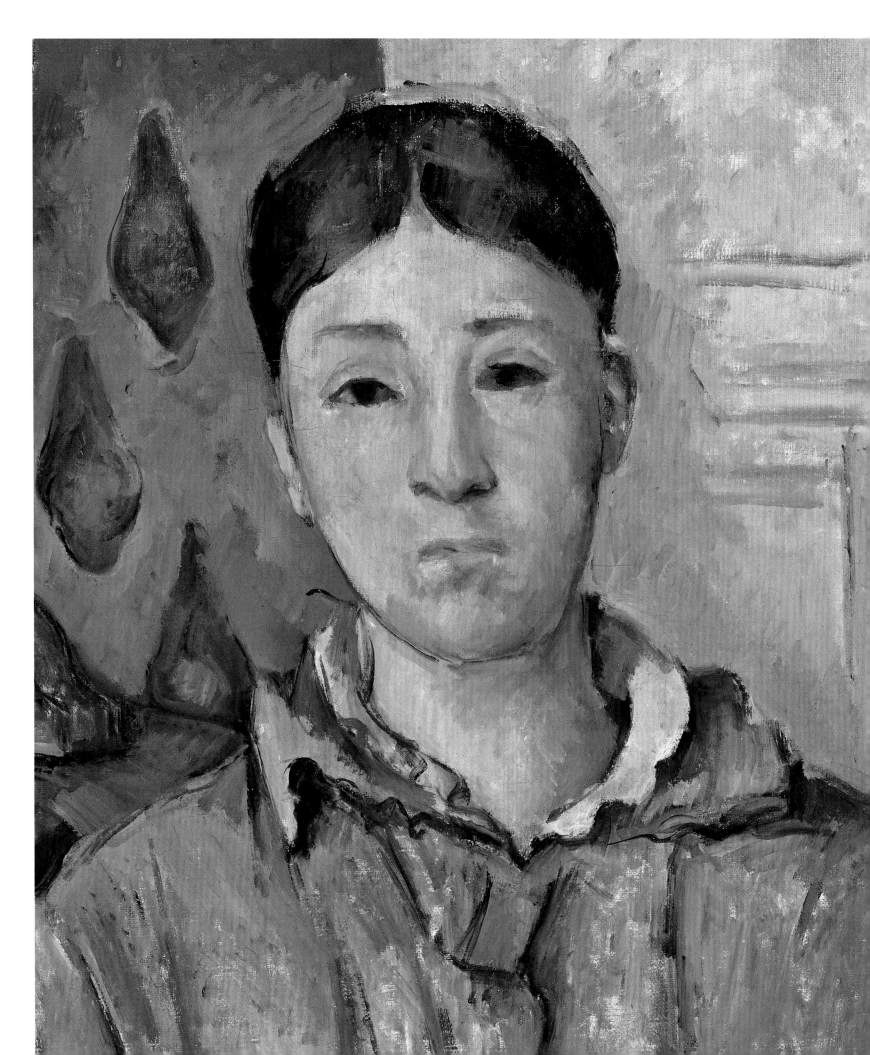

THE MASK AS IMAGE AND STRATEGY

John Klein

Shortly after finishing his large antiwar painting *Guernica* in 1937, Picasso confided to his friend André Malraux as he had never done before. Speaking of *Les Demoiselles d'Avignon* (1907; The Museum of Modern Art, New York) as his "first exorcism-painting"—and speaking in this way surely because he thought of *Guernica* in these terms also, though with different demons—Picasso reminisced about visiting the "old Trocadéro," the ethnographic museum in Paris. The place horrified him but he stayed to absorb its atmosphere of otherness. The objects that he found most compelling were the African masks:

> [They] weren't just like any other pieces of sculpture. Not at all. They were magic things. . . . [These] Negro pieces were *intercesseurs*, mediators; ever since then I've known the word in French. They were against everything—against unknown, threatening spirits. . . . I too believe that everything is unknown, that everything is an enemy! . . . [The masks] were weapons. To help people avoid coming under the influence of spirits again, to help them become independent.[1]

Here Picasso had his anthropology right—or at least in keeping with current thinking about the role of masks in tribal ritual—even if he expressed the ultimate purpose of mask-wearing in the West African cultures represented at the Trocadéro in his own, European, avant-garde vocabulary of independence from influences. He had long shown his desire to escape from the European tradition of realism in painting, in which he excelled to the point of alienation. By his account, with *Les Demoiselles d'Avignon* he exorcised this representational tradition. In the *Demoiselles* and many other paintings and sculptures from 1906 and 1907, Picasso experimented with the organization and abstraction of facial features as he tried to make alternatives to the truth value of European representational art. In doing this he was also

challenging the accepted truth value of portraiture. And this leads to another story about Picasso and the power of a mask, one in which the "exorcism" that the mask facilitates is brought about in the making of a portrait.

Picasso's portrait of Gertrude Stein [fig. 1] was said to require eighty or more sittings.[2] Part of the reason the work took so long is that Picasso was so fascinated by Stein. She was an independent, willful woman, a fellow creator, and a foreigner in Paris like himself. He admired her collection of modern art, which included great works by Cézanne, Matisse, and others, and he wanted his portrait to measure up against their paintings on the walls of Stein's apartment. He also took pains to achieve the right effect in his portrait of her, to convey her complexity in visual form. Over the course of three months these two stubborn creative personalities were locked in a daily negotiation for control of the image Picasso was making of a woman who was more nearly his equal than any he had known, but who was also replete with otherness for him—not only was she a woman, she was a writer, she was homosexual, and she had independent means.

Perhaps because of the strength he sensed in her, Picasso figured his sitter in the image of a well-known icon of masculine authority—the portrait by Ingres of the influential newspaper publisher Louis-François Bertin (Musée du Louvre, Paris), done in Paris over seventy years earlier. (Stein herself equated genius with masculine force.) In both portraits, the physical bulk of the sitter is translated by a skilled artist into an image of implacable assertiveness. In the work of Ingres generally, Picasso found some of the classical simplicity and solidity he sought in his own art, and which he was especially concerned to impute to his portrait of Stein. But he could not seem to finish the portrait, could not come to a resolution of all he had learned of her in the course of the many sittings. "Spring was coming," Stein wrote later, "and the sittings were coming to an end. All of a sudden one day Picasso painted

1 Malraux 1976, pp. 10-11.

2 For a full account of the Stein portrait in context, see Richardson 1991, chaps. 26-30.

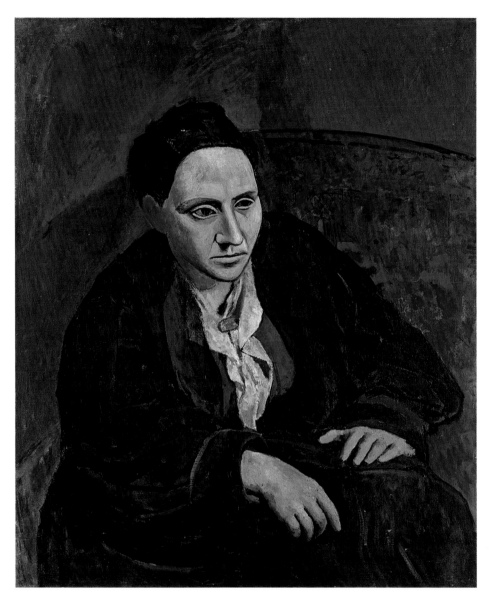

out the whole head. *I can't see you any longer when I look*, he said irritably. And so the picture was left like that."[3]

He left the portrait like that—faceless, without identity—while he went to Spain for the summer. After having struggled to establish himself in the foreign metropolis of Paris, Picasso was in search of his roots. He had already been fascinated by recently excavated examples of ancient Iberian stone sculpture that had been put on display in the Louvre. Now he spent the summer of 1906 in the remote Pyrenees village of Gósol and in Barcelona, where he encountered impressive medieval sculpture from the region, as well as people he considered to be the living embodiment of the "primitive" qualities he admired in the carved Iberian heads he had seen in Paris.

When he returned to Paris at the end of the summer, Picasso finished the portrait of Stein without seeing her again. The masklike face he peremptorily substituted for her features certainly helped him to "become independent," as he would later say of the "Negro" masks he saw at the Trocadéro. He asserted his will through a process of effacement and substitution. With this act he finished the portrait and dispatched the burden of its execution. He used the mask, harsh and impenetrable in appearance, as an agent of mastery over his sitter, protecting him from obligation to Stein's features and forceful personality.

The complex derivation of his mask had nothing to do with Gertrude Stein directly (these things were not her interests) and everything to do with finding an intercessor so he could finish his portrait. As in the later *Demoiselles*, Picasso needed the mask to intercede for him against the Western tradition of realism. He deployed the idea of the mask in the *Demoiselles* both as an image of otherness and as a strategy in his ongoing desire to find alternative languages of visual representation.[4] He had used the masking idea in both of these ways in the portrait of Stein as well, but the difference between the work of art done from imagination and the portrait of a particular individual is crucial. The short arc traced by these two paintings is dense with implications for the artistic use of the idea and physical characteristics of a mask when executing a portrait of an individual sitter. But the mask used either as an exotic substitute for the sitter's face—the mask as image—or as a mediating term—the mask as strategy—does somehow protect the artist; it preserves his or her integrity and aids in negotiating the transaction between artist and sitter at the

3 Stein 1961, p. 53.

4 The literature on modernist primitivism is too vast to cite adequately here, but William Rubin, in New York 1984, Torgovnick 1990, and Barkan/Bush 1995 are essential. Considerations of the idea of the mask in modern portraiture include Brilliant 1991, pp. 112–116; Marcia Pointon, "Kahnweiler's Picasso; Picasso's Kahnweiler," in Woodall 1997; Shearer West, "Masks or Identities?," in Berlin 1997, and West 2004, pp. 206–210.

Fig. 1
Pablo Picasso
Gertrude Stein, 1906
Oil on canvas, 39 ⅜ x 32 in. (100 x 81.3 cm)
The Metropolitan Museum of Art, New York.
Bequest of Gertrude Stein, 1946; 47.106

Other useful studies of the
modern portrait include Kirk
Varnedoe, in New York 1976
and Norbert Lynton, "Portraits
from a Pluralist Century," in
London 2000. With specific
reference to Picasso and
masks, see Pierre Daix,
"Portraiture in Picasso's
Primitivism and Cubism," in
New York/Paris 1996–1997 and
the critical response by Hilton
Kramer to this publication and
exhibition (Kramer 1996).
Stepan 2006 offers new
precision on the subject
of Picasso's familiarity with
African and Oceanic art in this
period. The recent *Picasso,
l'homme aux mille masques*
(Geneva 2006), despite
interesting essays by Jean Paul
Barbier-Mueller and Pierre Daix,
is more suggestive than
analytical. I owe this reference
to Trina Van Ryn, who helped
with the research for this essay.

5 Thus I believe that Picasso
 benefited from his exposure to
 African masks in a deeper way
 in 1906–1907 than as a
 "reservoir of forms," as Yve-
 Alain Bois characterizes it, while
 allowing that the most
 profound transformation
 licensed by African sculpted
 masks did not occur in
 Picasso's art until several years
 later—and then not in
 portraiture (Bois 1990,
 pp. 69–72, 81).

6 This is done with particular
 eloquence by Tamar Garb
 (New York 2004, pp. 49–50).
 See also Pointon, in Woodall
 1997, p. 197.

7 For the following discussion of
 the function and significance
 of masks I have especially
 benefited from Edson 2005,
 Napier 1986, Nunley/McCarty
 1999, and Pernet 1992.

heart of making a portrait.[5] Many writers have observed that in its generic quality—or, to put this another way, in its abstraction of facial features—the mask is the direct opposite of the portrait, which conventionally requires that specificity be foremost.[6] Yet the relationship between the portrait and the mask in modern art is an extremely productive one, precisely because of the mask's power to evoke otherness and to disrupt received ideas about identity.

The image of the mask and the strategy of the mask: there is generally not a hard line between the two. Picasso's art offers especially thickly layered examples of masking, and in a general way he may have been the artist of the twentieth century most engaged in general practices of masking and even mask-making. He would become a designer of masks and costumes for several ballet productions, and masks of his own invention were a regular source of amusement, as the many photographs taken in the 1950s by David Douglas Duncan of Picasso and his friends wearing silly pieces of cardboard attest. In the brazenness and inventiveness of his appropriation from non-Western visual cultures Picasso is the most conspicuous primitivist among modern artists. But the deployment of masks or masklike substitutes for the face is a key feature of modernist artists' challenge to both representation in general and portraiture in particular.

The fascination Picasso and other modern painters and sculptors felt for masks and masking is inseparable from the primitivist appropriation of exotic material culture that is such a key component of visual modernism, masking practices within the Western tradition notwithstanding. There is no doubt that modernist primitivism gave a new dimension to the role of the mask in portraiture. In a sense the African or Melanesian mask was to the portrait what so-called primitive art was to visual modernism in general. This is not a matter of appropriation only. Modern artists used the figural arts of tribal people as a means to critique but ultimately to invigorate the realist traditions of European representation. Likewise the mask, seemingly the portrait's opposite, could be used to effect a transformation of the portrait through a critique of it. This critique was tied to the conviction that identity itself may not be innate and static, but is situational and could be performed. The particularly modern idea of identity as performative licensed Picasso and others to take advantage of the alterity offered by the exotic mask to preserve portraiture in the face of the threat to the portrait's traditional reality effect. Portraiture's defense and renewal entailed enlisting what its practitioners in Europe saw as the abstract or even conceptual qualities of the mask against the attempted overthrow of representation by politically, philosophically, or spiritually motivated abstraction.

. . .

Masks conceal. The concealment may be literally protective, as when the steelworker shields the face from heat and other dangers on the mill floor, or figuratively protective, as with the daytime bank robber whose ski mask ensures anonymity. In the latter case and its like the obvious goal is to hide the identity of the wearer, an acknowledgment of the degree to which facial features are tied in with cultural conventions of visual identification, conventions that inform the history of portraiture. In these cases of mask-wearing the mask conceals and protects the wearer from imminent or potential threat without altering his or her identity. Such masks cover but they do not substitute for the face.[7]

Masks first conceal, but they may do more than this. Masks also reveal: a more nuanced idea of the mask is that it may liberate, not hide, the wearer. The bank robber's or kidnapper's mask, let alone the steelworker's, does not engage a concept of identity; it only conceals what is assumed to be a singular, unitary identity whose authority is not in question. But if an individual may be understood to have multiple identities, masks allow substitution of one for another. The mask stands for the potential to reject public, generally recognized identity as a social construction and to reveal a person's inner, "true" self, an identity that is normally suppressed by convention or social constraint. Such a release of an inner identity may be seen in carnival traditions of masking, or, more sinisterly, the hoods of such groups as the Ku Klux Klan. In these cases, a normally suppressed identity comes to the fore in exceptional behavior. The mask does not incarnate what is usually hidden; we might say that it is a catalyst, allowing transformation without actually assuming any authority of its own.

Both the mask as concealer and the mask as revealer posit a "true" identity of the wearer. Each function "protects" the mask-wearer by acknowledging the integrity of the individual and preserving it. But identity may be borrowed as well. Another way of thinking about the relationship between concealment and revelation is that masks allow the wearer to perform an identity. This performative function is the basis of

the theatrical tradition of mask-wearing in the West, of which the Italian *commedia dell'arte* is a prominent example. In theater such substitute identities are typically conventionalized as stock characters, or even broadly defined emotional states: the classic laughing and sad masks of comedy and tragedy are practically the universal logo for the dramatic arts of the West.

The principal contexts for the mask as a vehicle for the performance of identity, however, are the cultures of non-Western peoples—cultures that were the object of European modernist primitivism and informed Picasso's conception of the mask as intercessor. In these cultures masks are often associated with transitional states.[8] The transitions may involve a form of full embodiment, as in tribal cultures in which wearing a mask of an animal or a deity imparts to the mask-wearer the beneficial characteristics of the new entity—ferocity, predictive powers, or the like. Bearing an archetypal image that is culturally prescribed for the occasion, the mask enables the wearer to negotiate an important change in life by assuming the identity the mask projects.

In this projective category of masking, then, masks perform an ontological role and have a cultural, not only an instrumental, purpose. The interaction of their concealing, revealing, and projecting functions, and the impossibility of clearly separating them, is part of what makes masks so fascinating as an expression of cultural ideas about the self. Precisely this three-way flow between appearance, repression, and projection informs the history of portraiture. The traditional goals of describing the surface (the outer truth) and penetrating that surface to reveal character (the inner truth) reached a sustained high point in the nineteenth century—an era of bourgeois individualism that fostered the market for portraiture—while the projection of identity (and the relativity of its truths) is a more distinctly modern contribution.

It is no coincidence that modernist artistic primitivism, European countries' importation of tribal art from their colonies, the development of the science of ethnography, and the transformation of portraiture through the mask as idea and object occurred in the same period.[9] Both the scientific basis of modern anthropology and the projection of imperial power into colonial spheres were products of nineteenth-century empiricism and nationalism. The sociological or anthropological study of masks intensified toward the end of the nineteenth century, as did the closely allied study of fairy

tales, myths, and other popular traditions. The period loosely bracketed by the 1880s and the 1930s was the time of the most active investigation of the function and meaning of masks in ritual contexts, both European and non-Western.[10]

When Picasso believed that in the people of the Pyrenees region he was witness to living equivalents of the ancient sculptures he admired, he was unwittingly adopting the evolutionist perspective then being theorized in the field of anthropology. Contemporary "primitives," in this view, were a living embodiment of an earlier stage in the evolution of modern Europeans.[11] Picasso's portrait of Stein expresses this evolutionist theory by collapsing historical and contemporary conceptions of the face into each other and imposing them on the modernist avant-garde in the person of Stein herself. He would also do this in his self-portraits of around the same time.

The abstract qualities of the mask come into productive conflict with the portrait's specificity, its very "tendency . . . to resist abstraction."[12] So much modern portraiture that deploys the idea of the mask exploits this tension between the general and the specific, between the mask and the individual. The tribal mask, moreover, brings the quality of radical otherness to the relationship. Both the portrait and the "primitive" are resistant to the spiritualist or idealist abstract tendencies of the early twentieth century in part because of their materiality, but also because of their qualities of illusionism or deception. If modernism may be understood as a dialectic of materialism and transcendence, a constant shifting tension between the reality of objects and the conceptual quality of abstractions, then the mask is a capsule of this dialectical relationship. The portrait and the mask were complementary, if unexpected, allies in the hands of modern artists determined to retain and renew a representational function for art.

· · ·

At the risk of stating the obvious, artists who deploy the mask as either a mediating device or as an image with particular cultural resonance do not paint or sculpt a mask that is then overlaid on a painted or sculpted face, like an actual mask on an actual face. In art the artist substitutes the mask for the face, or transforms the face into a mask. With actual masking, whether ritual or theatrical, the viewer or audience may be acutely aware that there is an individual behind the mask. In portraiture that engages the category of the mask,

8 Napier 1986, pp. 15–16.

9 The contrast between mask as object and idea, which has significant parallels to the dual notion of image and strategy proposed here, was made by Marcia Pointon (Pointon 1997, p. 198).

10 Pernet 1992, pp. 1–2.

11 Pernet 1992, pp. 3–4.

12 Shearer West, "Masks or Indentities?," in Berlin 1997, p. 70.

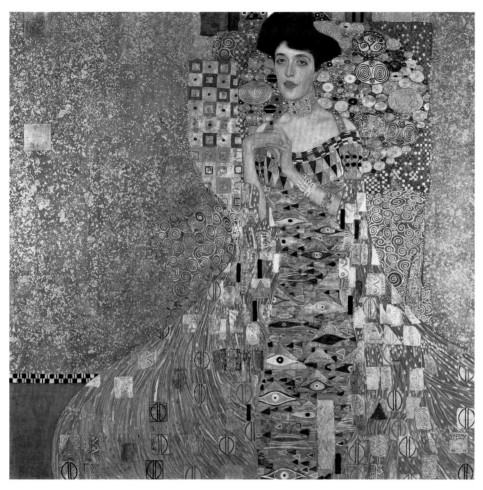

Fig. 2
Gustav Klimt
Adele Bloch-Bauer I, 1907
Oil, silver and gold on canvas, 55 ⅛ x 55 ⅛ in.
(140 x 140 cm)
Neue Galerie, New York.
This acquisition made available in part through the generosity
of the heirs of the Estates of Ferdinand and Adele Bloch-Bauer

13 Richardson 1991, p. 455.

the mask becomes the face and there is no implied, hidden alternative. This irrevocable substitution of one face for another in such portraiture has implications that were neatly summed up when, informed that many people did not think Stein's portrait looked much like her, Picasso replied "never mind, in the end she will manage to look just like it."[13]

Picasso was not, of course, the first modern artist to exploit the idea of the mask in portraiture. Masks were an important visual and conceptual currency for a preceding generation of Symbolists, for example. The challenge to an empirical basis for understanding the world represented by Symbolism and other late nineteenth- and early twentieth-century tendencies included a growing interest in the fluidity and performative potential of personal identity. This interest was there even when it did not express itself in the language of masking, especially in the portraits of the more Expressionist artists of the period, and the sensation of the sitters performing their own identities without masks is sometimes unavoidable.

Among Symbolists, indeed in general, Paul Gauguin was the archetypal primitivist, an artist who actually tried to assimilate an exotic culture by living and working in it for extended periods. He was fascinated by the material culture of ritual in Tahiti and the Marquesas Islands, and masks and masking play a distinct role in his art. But his portraiture was not transformed by his direct exposure to a culture of masking. Polynesian figural sculpture may have served as a model for how to represent living individuals in his paintings of Tahitians, but in portraiture he used such indigenous types as often as not as counterpoints to his portraiture in a style that was essentially already formed before his exposure to the Polynesian exotic. In general Gauguin's portraits may be clearly understood in the context of a Symbolist concern for inner life, the individual's private yearnings, brought to the surface in a species of psychological analysis. Such a motive for portraiture is also generally true of the early twentieth-century Austrian Expressionists, such as Egon Schiele and Oskar Kokoschka. The expressive distortions and searching expressions in their portraits imply the sitters' active engagement with an interior reality, a psychological depth and vitality in which the mask has no part.

Other artists invert the terms of the relationship between the primitive and the realistic in portraiture. In the portraits of Gustav Klimt, decoration assumes the role of the non-naturalistic element taken in the work of Picasso and other primitivists by the mask.

Fig. 3
James Ensor
Old Woman with Masks (Portrait of Neel Doff?), 1889
Oil on canvas, 21 ¼ x 18 ¾ in. (54 x 47.5 cm)
Museum voor Schone Kunsten, Ghent

The effect of a Klimt portrait depends, in fact, on how the face functions as an anti-mask. In his *Adele Bloch-Bauer I* [fig. 2], for instance, all parts of the picture are highly stylized or abstracted *except* the face, which shines out from but also is gripped in an embrace of decorative pattern. By comparison with its surroundings the face projects alertness and a strong human presence despite the sensation of disembodiment. In Klimt's portraits, the face's particularity and expression of vitality may be the opposite of a mask, but often everything else in the portrait is a stylized pattern, locking the individuality of the sitter into a decorative scheme of the artist's invention.

Among modern artists, the most obsessed with masks and other human substitutes such as puppets and figurines was James Ensor. Whether derived from the *commedia dell'arte*, the masked ball, carnival traditions (especially the raucous Flemish kind), or Mardi Gras, masks pervasively haunt his work. Rather than employ the mask in the theatrical or ritual sense of a demonstrative performance of identity, however, Ensor distorted its features into an image, sometimes a rictus, of death. Although he was not a prolific portraitist, people and masks often cohabit his paintings,

and portraits of individuals and masks, whether on figures or hung on walls, are sometimes compared to elicit parallel grotesqueries. Just as often, though, the subjects of his portraits are to be understood as the vital opposite of the morbid masks that sometimes crowd around the sitter, even as their contrast and proximity point to the traditional northern theme of *vanitas* [fig. 3]. In his many self-portraits, too, Ensor counterposed his own image to an array of masks that seem to push forward, seeking recognition [cat. 5], suggesting that his activity as an artist, even as it generates these effigies, is what keeps their implications of mortality at bay.

Ensor's lavish and expressive use of the mask forged a path taken occasionally by other twentieth-century artists of the grotesque, particularly among northern European Expressionists, and we may also see an elision of human specificity and generic effigy in the paintings of Max Beckmann, George Grosz, Otto Dix, and other German artists throughout the interwar decades. These and other Expressionists, even when employing masklike images, continue to stress the emotional and psychological states of their portrait subjects, imparting a dynamism to these portraits that resists some of the transformative potential of the mask. Especially in his self-portraits, Beckmann used masked and costumed figures to play with performativity and identity. Typically he placed greater emphasis on costumes than on masks, emphasizing their theatrical, even at times farcical, quality more than the ontological state of the sitters. The flavor of caricature in Dix's and Grosz's portraits ensures some particularity of feature and gesture, but these artists also treat their sitters as types, players in the great social and political spectacle of the Weimar Republic. The masking element, though present, is secondary, in part because such a combination of disguise and projection runs counter to these artists' desire to provide a running commentary on the individual in society.

Artists with little apparent interest in masks as cultural artifacts may nevertheless adopt the category of the mask to mediate the portrait transaction. A dominant feature of Paul Cézanne's portraits is the impassivity of their subjects, a stoicism, even an inexpressiveness that approaches the stilled and emotionally neutralized condition of a mask. Sometimes only a slight tilt of the head or the barest hint of life within the deep orbits of the eyes, indicates the presence of a living person behind a blank face. It is not merely a matter of

Fig. 4
Henri Matisse
Madame Matisse (The Green Line), 1905
Oil on canvas, 16 x 12 ¾ in. (40.5 x 32.5 cm)
Statens Museum for Kunst, Copenhagen.
J. Rump Collection

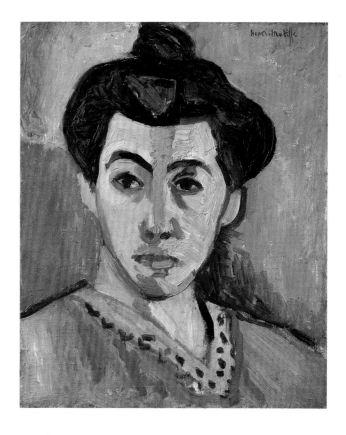

Cézanne objectifying his human subject to the condition of an apple, an inert still-life object, as has often and simplistically been suggested.[14] There is no evidence that Cézanne took any significant interest in masks themselves, or in the theater or other masking contexts. The masklike faces of so many sitters in his portraits are the residue of a process of mediation, a defense against the close human engagement that discomfited this socially awkward artist. He nevertheless required this personal, empirical contact, and sometimes a lot of it, in order to make a portrait. He famously demanded many sittings from the sometimes bored acquaintances and family members who agreed to have their portraits painted. The impassive faces of his sitters derive their blankness from the necessity of Cézanne's own artistic practice, not from an external model of any kind.

Insofar as the ambitious artists of the twentieth century who contended with the portrait inclined either to expressive deformation or abstracted stylization, either exaggerating the particular or distilling to types the specific visual and temperamental qualities of their subjects, it is possible, in principle, to discern masklike features in the portraiture of an immense range of artists. Yet the mask as image and strategy is given its most forceful potential through the expressions of modernist primitivism.

In some ways the most "Cézannian" artist of this period, Henri Matisse was also one of the most deeply primitivist. Picasso's counterpart in terms of prominence and impact in the Paris art world in the first decade of the century, Matisse did not "Africanize" or otherwise impose an exotic image on his portrait subjects as much as Picasso did, but his assimilation of non-Western facial representation was just as thorough. The combination of mutual regard and competitiveness they shared made them acutely aware of each other's work at any given time, and their almost simultaneous interest in African art in Paris in 1906 was decisive for both of them.

One of the impulses for Picasso to make his portrait of Gertrude Stein was the pair of portraits Matisse had made of his wife Amélie in the previous year, 1905. The first was the notorious *Woman with the Hat* [fig. 2 on p. 13], which caused such scandal at the Salon d'Automne that fall. Matisse's response to the criticisms of incoherence and savagery leveled at him for this freely brushed portrait was to produce a careful, thickly painted, sober-looking image that turns Madame Matisse's face into an impassive mask. In *Madame Matisse (The Green Line)* [fig. 4], as its conventional subtitle suggests, a green stroke of paint is a prominent feature, dividing the face in half at the bridge of the nose. The dominant role of color rather than tonal modeling that follows from this mark, and the consequent emphasis on the surface arrangement of color zones, contribute to the sensation of disembodiment and inexpressiveness in the face. Its hermetic and masklike appearance counters and stabilizes the fluctuant qualities of *Woman with the Hat*. At the same time Amélie Matisse seems present with an intensity that the earlier portrait lacks. This tension between human intimacy and masklike impersonality is central to the riveting effect of the portrait.

In the next few years, Matisse tended to take some of the emphasis off the face in his portraits, experimenting with visually arbitrary and provocative formal elements that dominate the representation of the sitter [cat. 30], or integrating the face into a field of pattern, as in *The Girl with Green Eyes* [cat. 29]—in which the sitter's face is compared, in various kinds of visual rhyming and punning, to the objects around her. Such an approach brings Matisse surprisingly

14 A recent instance is Norbert Lynton, "Portraits from a Pluralist Century," in London 2000, p. 11.

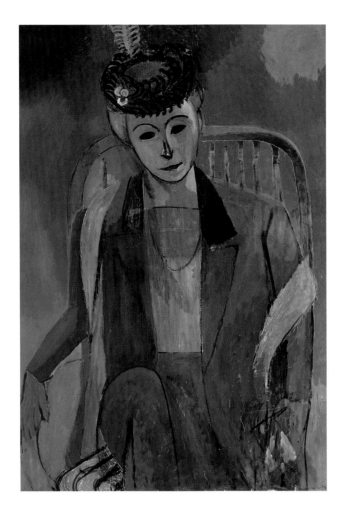

Fig. 5
Henri Matisse
Madame Matisse, 1913
Oil on canvas, 57 ½ x 38 ½ in. (146 x 97.7 cm)
The State Hermitage Museum, Saint Petersburg

and incarnation indicates the potential mobility of the mask as a sign of the human, as well as its role in mediating the portrait transaction with his wife, removing the emotional quality of direct confrontation that was so prominent in his portraits of her from the Fauve period.

Then, in his commissioned portrait of a shy young woman from Brazil, *Yvonne Landsberg* [cat. 51], Matisse intervened more radically with the idea of the mask than in any other portrait he made. Chalky gray, like the face of Amélie Matisse, but more starkly impersonal, with black eyes yielding no expression, Mlle Landsberg's mask is part of the artist's act of *deus ex machina* to finish a difficult portrait commission. With no concern to make an ingratiating image, he committed a shocking act of aggression against Landsberg's features, in the bargain making an arbitrary formal extension beyond the face's contours in the arc from forehead to shoulder, incised on the surface like all the others in this painting with the butt end of the paintbrush. This space-shattering move integrates sitter with background and snaps everything into the shallow force field the artist created by the definitive addition of the countless carefully repeated arcs that swell around the figure, expanding it into space, and the thick, rigid black lines that traverse the interior contours. Matisse's extraordinary mask—as well as, perhaps, his final treatment of the figure—is once again clearly related to his interest in non-Western art, an interest broadly expressed in the portraits of others of his contemporaries at this time, such as André Derain [cat. 50]. Whatever "sources" in African or other non-Western art may have activated these portraits, Matisse—like Picasso in his portrait of Gertrude Stein—assimilated them so thoroughly that they became part of his own visual vocabulary. Their example was nevertheless important for reinforcing the strategic value of the mask, in these specific circumstances, as a solution to a crisis in representation.

For Picasso's part, although the obvious "Africanizing" quality of his facial representations became less prominent after 1907, he continued to investigate the idea of the mask in his portraiture. This was most explicit in the small bronze *Mask of a Woman* of 1908 [cat. 47], which eerily evokes a death mask. But a strategic masking operates in an especially profound way in his Cubist portraits of 1909–1910, which by contrast are filled with scintillation and life. In his portrait of Daniel-Henry Kahnweiler [fig. 6], for example, he gives only hints of the sitter's identity, and these do not cohere in an

close to the aesthetic of Klimt's *Adele Bloch-Bauer I*, stressing how much both artists strove to integrate portrait and decoration at this time, an ambition to which the mask as a category has little to contribute. Several years later, however, in 1913 and 1914, Matisse made some of his most masklike portraits, with striking analogies to African masks from Gabon or Ivory Coast that were circulating in Paris in this period.[15] In *Madame Matisse* of 1913 [fig. 5], what apparently began as a portrait of a lively and fashionably dressed woman achieved resolution in a gray, expressionless mask that is nevertheless strikingly alert, seeming to incorporate into its inexpressive premise some residual liveliness of the sitter herself. The critic André Salmon acknowledged this duality implied by the mask when he commented that Matisse's sitter "wears a wooden mask smeared with chalk . . . a figure in a nightmare."[16] The subtle oscillation between impersonality

15 Jack Flam, "Matisse and the Fauves," in New York 1984, vol. 1, p. 231.

16 Quoted in Klein 2001, p. 85.

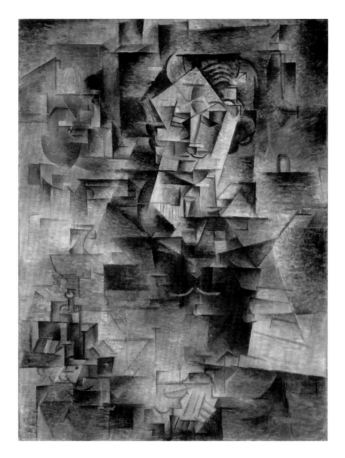

integrated facial field, yet Kahnweiler's subjectivity seeps
through a veil of disintegrated form. (Cubist portraits by other
artists tend to be clearer and more firmly masklike; see
cats. 61, 62, and 65) The shifting planes of Picasso's
passages from light to dark and from figure to ground are
the superficial formal expression of what Marcia Pointon has
characterized as an "oscillation" between face and mask that
stands for the portrait's oscillation between the subjectivity of
the sitter and the subjectivity of the artist.[17] As in his portrait
of Gertrude Stein, Picasso has proceeded as a *bricoleur*,
gathering and adhering to his painting a seemingly arbitrary
collection of signs, using the idea of the mask but distributing
its tokens across the surface. This porous mask projects the
identities of both sitter and artist through a constant shifting
between presence and absence.

Among twentieth-century artists who, like Picasso and
Matisse, engaged with portraiture as a crucial challenge, one
of the outstanding figures is Amedeo Modigliani. Portraiture
was central to Modigliani's artistic project. It was for him a

means of reinforcing an artistic community that consisted in
the main of immigrants like himself, gathered in the melting
pot of Montparnasse. As has routinely been noted,
Modigliani's portraits have a consistency, a generic quality, as
if he imposed a consistent formula—a mask—on each of his
sitters. This formulaic approach, in Modigliani's case, has the
apparently paradoxical effect of intensifying slight differences
among his sitters.[18] Like Picasso, Modigliani appropriated the
stylizations of African masks and other sculpture, but instead
of using them to reassess the entire structure of visual
representation, he produced an abstract template that could
then receive fine adjustments to particularize the features of
his sitters. For him, the mask was more a starting point than
a conclusion, and more an image than a strategy.

Like Cézanne, Alberto Giacometti exasperated his sitters
with the great number of sittings he required, the many
effacements and rebuildings of a portrait image. Like
Cézanne, Giacometti depended on intimates, such as
his brother Diego or his wife, Annette, for the bulk of his
portraiture. Also like Cézanne, Giacometti's goal in portraiture
was an elusive concept of realization, attained through a
painstaking process of knowing the surface well enough
to allow him to penetrate to an essence within. Neither
artist, however, was particularly interested in revealing (or
constructing) "character" in portraiture; rather they allowed the
process of creating the portrait, played out discontinuously
over time, to fix an image of the sitter, creating a masklike
countenance in the end. Whether in painting or sculpture,
Giacometti's portraits have the added feature that the
masklike appearance, with its thousand-yard stare, seems
to arise from within the sitter rather than being assimilated
from another source. The immobility of his sitters' faces is
a consequence of the numbing quantity of posing sessions.
Despite such an endurance test, sometimes the sitters end
up looking profoundly intense rather than merely blank, with
deep-set eyes fixed in a probing stare. This self-generated
mask is of the mediating kind, another example of the mask
as a strategic element in negotiating the portrait transaction—
in this case by allowing the cumulative effect of the sittings,
interpolated with the rest of life, to transform and intensify
the sitter's appearance.

Possibly the polar opposite of Giacometti's sober, almost
moral approach to his brand of realism in portraiture, the
Dada portrait as often as not dispenses altogether with the
gravity and ontological status of personal identity, in playful

17 Pointon, in Woodall 1997,
p. 193.

18 Emily Braun has persuasively
argued that Modigliani paid
close attention to cultural and
ethnic differences and carefully
encoded them in his portraits
(New York 2004).

Fig. 7
Kasimir Malevich
Perfected Portrait of Ivan Kliun, 1913
Oil on canvas, 44 ⅛ x 27 ½ in. (112 x 70 cm)
State Russian Museum, Saint Petersburg

critiques of the representational function of portraiture and the position of the individual within society. Masks were an important element of the general Dada critique of the European tradition during and after the First World War. Masks evoking the extreme otherness of New Britain ritual sculpture made by the Romanian Marcel Janco—some identified as portraits—and worn in performances at the Cabaret Voltaire allowed the artists to subsume their identities in the group provocations that characterized the early, idealistic Dada activities. In a logical extension of the substitution of the mask for the face, some artists replaced the entire head with a new identity.

Perhaps the most extreme depersonalization of the portrait, a phenomenon related to the opposition to the individuality of the face posed by the mask, is the replacement of the individual by the machine. With the primitive, the machine is the other essential modernist trope for transforming the human body and face, as in the mechanistic figures that characterize much Russian art in the wake of Cubism; when Kasimir Malevich envisioned his friend and fellow artist Ivan Kliun, he "perfected" him in machine form [fig. 7]. Machine imagery would seem to be culturally opposed to primitivism, but such Dada artists as Hannah Höch, Man Ray, and Sophie Taeuber drew freely on these two spheres in their collages, photographs, and sculptures. For the human presence of her acquaintances, Taeuber substituted a machined shape, a lathe-turned, wood, hat-blocker's head form, in a characteristic Dada elision of the human and the mechanical [fig. 8]. Instead of facial features, Taeuber painted abstract patterns derived from Polynesian tapa or Northwest Coast bird masks, melding primitivist and machine abstraction. Neither Francis Picabia's machine portraits, which are relatively humanized through humor and direct personal reference to his subjects, nor Marcel Janco's masks, which bring human association in through his use of everyday materials, can match these Taeuber portrait heads in the thoroughness of their substitution of broad archetypes for individual particularity.

· · ·

These late nineteenth-century and early twentieth-century examples of how artists invigorated the genre of portraiture with the mask that performs identity were broadly influential on later portrait practice, not in terms of style but in terms

of strategy. The triumph of identity politics in public life and popular culture in the late twentieth century brought a new relevance to a genre that many had written off following the Second World War. In postmodern portraiture, the idea of projecting an identity is therefore virtually a given. This emphasis returns the focus in the portrait to the surface, where it all began. And there was no more astute observer of the surface than Andy Warhol.

Warhol made masks from his subjects' own images. These were recorded in the photographs he used as the starting point for portraits that comment both on the fleeting nature of celebrity, as in his portraits of Elizabeth Taylor and Marilyn Monroe, and on the power of the image in the media—borne out in the famous propaganda photograph of Mao Zedong, which Warhol appropriated repeatedly [fig. 8 on p. 43]. Garish colors, the elimination of middle registers

Fig. 8
Sophie Taeuber
Dada Head (Portrait of Hans Arp), 1918–1919
Oil on turned wood, height 13 ⅜ in. (34 cm); diameter 7 ⅞ in. (20 cm)
Centre Pompidou, Paris
Musée national d'art moderne/Centre de création industrielle.
Gift of Marguerite Arp-Hagenbach, 1967

of tone, and the artist's deliberate misregistration of his silkscreened imagery produce a grotesque parody of stage makeup, all surface and no substance, emphasizing the brittleness of the public persona. (His portraits playfully remind us of the common etymological root of mask and mascara.) Warhol's portraits are so widely known as imagery and sometimes so controversial as art precisely because of this emphasis on the superficial. His overall artistic project, with portraiture at its heart, is still a lightning rod for the debate over whether art should idealize or tell truth, rise above or wade into the scrum of society, ennoble the human spirit or mirror people's base natures. The significance of Warhol's embrace of the superficial is that it may reveal a profound understanding of the society of the spectacle.

Portraiture, once the presumptive victim of the historical avant-garde's move to abstraction owing to its emphasis on the real, persisted through the early twentieth century with the transforming mask as its ally. With this intercessor, the portrait did not merely survive the challenges to its own ontological status, but reemerged in the 1980s as a site of articulation for some of the central concerns of postmodernism. The line from Warhol to Cindy Sherman's "History Portraits," Chuck Close's fingerprint images, the "skin tone" portraits of Byron Kim, or Marcus Harvey's *Myra* may not be direct but it is also not very long. That what the mask represents could become an ironic strategy is central to the portrait's postmodern condition.

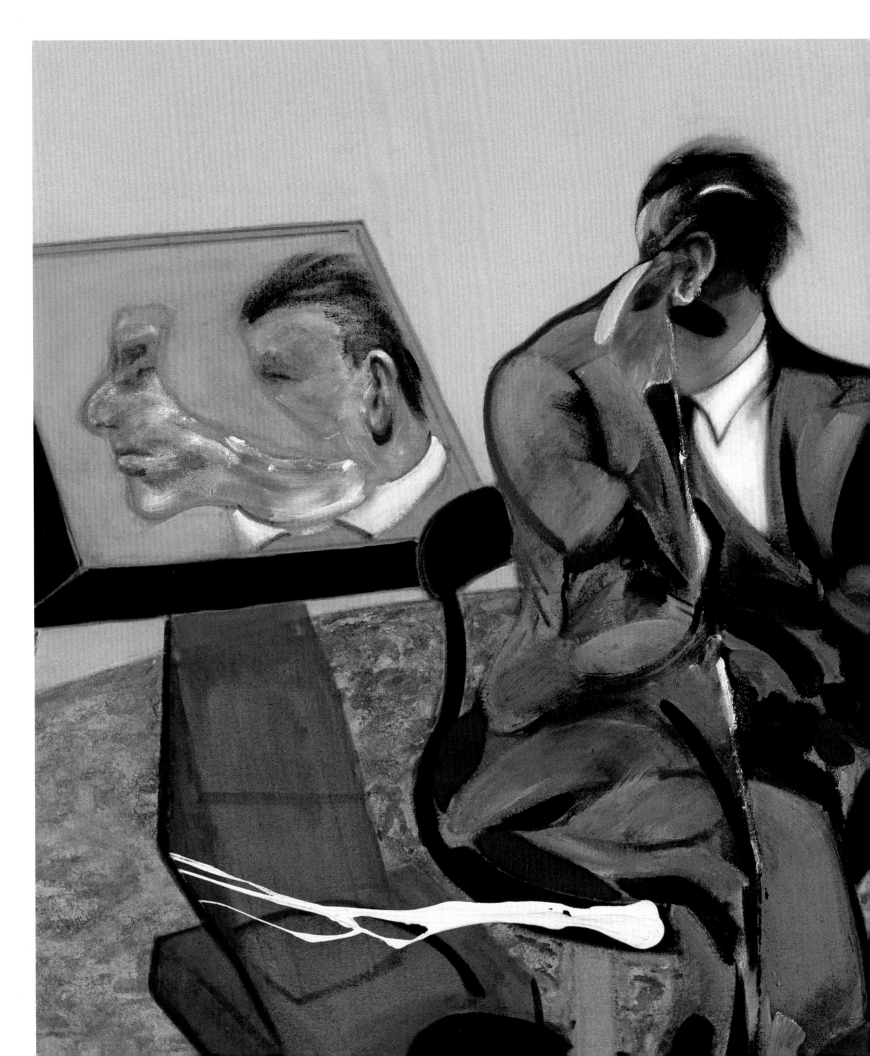

"A NAME, A WRETCHED PICTURE & WORSE BUST":

FROM PICASSO'S STALIN
TO WARHOL'S MAO

William Feaver

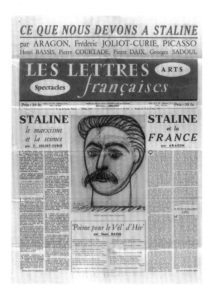

Fig. 1
Pablo Picasso
Portrait of Stalin, 1953
Published in *Les Lettres
françaises* 456
(12 March 1953)

As soon as it became known that Stalin had died, Louis Aragon asked his friend Pablo Picasso to do a drawing of him for *Les Lettres françaises*. As a favor to Aragon, who had just become editor of the weekly paper, Picasso obliged. The drawing was published a few days later on the front page of the 12 March 1953 issue under the headline "Ce Que Nous Devons à Staline" ("What We Owe Stalin") [fig. 1].

Picasso felt beholden, to some degree, to the ardor of the system personified by Stalin. The Communists had been conspicuous in the Resistance and he liked to think that he had been with them in spirit through the war years; he actually joined the party after Liberation in 1944. But what sort of portrait did he owe the comrades? His initial idea was to garland the image or to do a statuesque Stalin, even naked perhaps, in the antique manner. On second thought he depicted him rejuvenated. He drew a youthful head composed of clean-cut Romanesque ellipses—a ceramic

prototype conceivably, hot from the kiln at Vallauris and suitable for newspaper reproduction across two columns.

Aragon had wanted his scoop to be the tribute of one great dictator to another—very much a Picasso, a quick one obviously, not an overnight *Guernica* maybe but at least an image everybody recognized: fatherly Stalin ("Man of Steel"), eyebrows arched, eyes twinkling shrewdly, thick gray hair brushed back, terrific mustache. Instead he and the readers, and a wider world keen to see what the artist had made of so signal yet uncharacteristic a subject, were shocked and disappointed. Picasso's habitual admirers thought the drawing banal and the French Communist party line was to condemn it as a travesty: a belittling of their icon by one whose work was irredeemably bourgeois in perspective.

Picasso derived his Stalin from a photograph taken in 1903, long before Josef Visarionovitch Djugashvili promoted himself under a new name to tyranny and personality cult. Though clearly done without much deliberation (there was a tight deadline), the image proved significant—not for what commentators have deemed its startling ineptitude (possibly deliberate, some suggest), but for its nonchalant conflation of egocentric perspectives.

Stalin was only two years older than Picasso—both were in their early seventies in 1953—and to Picasso, in that week before the Ides of March, he was very much his contemporary. Roll back the decades to "pre-Stalin" days and he reverted to the ardent, possibly heroic, young man fresh out of the seminary and already seditious. The one-time Pablo Ruiz y Picasso from Málaga could identify with the vigor and ambition. He could imagine an aspirational overlap and consider the fact that by 1953 each in their different spheres had been in power about twenty-five years. Both indeed were figureheads. His *Stalin* shows more about him than about Stalin. It's very much a modified self-image: not so much Josef Visarionovitch the Georgian, more

Fig. 2
Pablo Picasso
Yo Picasso, 1901
Oil on canvas, 29 x 23 ⅞ in. (73.5 x 60.5 cm)
Private collection

Pablo the Andalucian who, newly arrived in Paris in the spring of 1901, had hailed himself *Yo Picasso*, a self-portrait to which, looking back, the elegiac *Stalin* has a certain resemblance [fig. 2].

After Liberation, in August 1944, Picasso had made himself available to admiring journalists and GIs in his studio on the rue des Grands-Augustins; he was, Pierre Daix of *Les Lettres françaises* said, "treated as a symbol of art's resistance.to the Nazis"[1] and photographed accordingly: bright-eyed, miraculously preserved, emerged from the obscurity of the Occupation years to become the most recognized face in modern art. In 1972, nearly twenty years after Stalin's death and nine months before he himself died, he was to draw himself several times over as a fearful portrait bust reduced to little more than an unshaven skull [fig. 3]. From flashback to anticipation, from imperial Stalin to the ultimate private self, the portraits spell out how much is owed to Picasso, most of all, the liberation of fact from appearance and the tweaking of recognizability.

"You can use your intent to make anything seem like anything," Lucian Freud has remarked. "Picasso's a master at being able to make a face feel like a foot."[2] For Picasso metaphor went without saying; in the paintings of a goat skull and candle, of Dora Maar as a gasping fish, of Françoise Gilot flowering or Jaume Sabartès as a short-sighted Spanish courtier not knowing which way to look, image out-performs description. He loved to ventriloquize, snappy transference giving rise to staring breasts and vaginal eyes. Quoting himself from thirty years or so earlier, he produced portraits modeled, by the look of them, on his *Glass of Absinthe* of 1914, jaunty hats substituting for the sugar strainer spoon with its perforated tongue.

"You should constantly try to paint like someone else," Picasso said,[3] meaning—beyond the obvious—that the act of painting plays on memory, tests every resource, and can become, as exhaustion sets in and reckless instinct takes over from deliberation, something like an out-of-body experience. That someone else was often himself previously, and in this sense his *Stalin* was a retrieval.

By the late 1940s Picasso was a legend casting around for stimuli. His Communist solidarity stance (surely an instinctive move) proved less fulfilling than the concept of himself as burly little magician of the Côte d'Azur conjuring sculpture from scrap and shapely women from Vallauris jugs. The idea of his trying every look he could think of was propagated through photos of him in action: Picasso being *Picasso*. Artistically his influence waned as he aged into what was widely perceived, by the 1960s, to be an honored irrelevance.

. . .

Since the period when Stalin and Picasso were young, the age of image proliferation has seen notions of fame and celebrity confirmed more and more by photography. Latterly the iconic studio portrait has become to an unprecedented degree the human face of the global brand. Stalin in his day, Mao and Marilyn in theirs, and artists too, from Picasso to Warhol, came to represent ultimate authority, glamour, genius, or whatever. Screened, screen-printed, cheapened by T-shirt piracy and coarsened or spiced in caricature, each in contrived characteristic pose, they have served as the lofty norm, elevated yet familiar. At the same time commissioned

1 Daix 1990.

2 Feaver 2002.

3 Parmelin 1965.

Fig. 3
Pablo Picasso
Self-Portrait, 1972
Wax crayons, 25 ⅞ x 19 ⅞ in.
(65.7 x 50.5 cm)
Fuji Television Co. Gallery, Tokyo

4 The original, which he avoided
 seeing, is in the Galleria Doria
 Pamphilj, Rome.

5 Sylvester 1975.

early photographers to ensure rigidity during exposure. Where Picasso treated his portrait subjects like flowers to be plucked and trimmed and plonked in the vase, Giacometti created space around them, dislocating scale and compacting the features. His paintings represent, in effect, sculptural situations. The viewer is drawn in, past the framing and into magnetic proximity. The portrait sculptures, too: even when, initially, they appear to be little more than frugally caked armatures they prove themselves and hold themselves like souls preserved, each a tense focal triumph, minutely animate.

Those who photographed Giacometti could never resist showing how strikingly he resembled his work. Henri Cartier-Bresson caught him crossing the street in the rain, using his coat as a hood: a parody Giacometti. Jean Dubuffet, by contrast, went for roadkill flattening and sprawl, reflecting the animal images discovered during the war by schoolboys in the caves at Lascaux. Concocting scratchy heads as though domesticating alleyway graffiti, he was, in every aspect, more the stylist than the self-determined Existentialist.

Francis Bacon, on the other hand, was a stylist who policed himself to suppress lapses into glibness. He became readily—too readily—deemed a tortured postwar soul railing against such things as father figures. More convincingly, for him the buzz was impact. He liked to be way over the odds, dashing light on dark in winning streaks. From a photo-reproduction of Velázquez's *Pope Innocent X* [fig. 7 on p. 19][4] he aimed to seize the elements that struck him as marvelous: harsh eyes, satin and frills, the hint of electric chair. He painted in the wake of Picasso, diverging, as his confidence grew, into a world of cul-de-sacs where single figures or oddly matched pairs vented balletic frustration.

There's a relish in every painterly disfigurement visited by Bacon on his portrait characters, whether himself or his associates. The *Self-Portrait* of 1956 [cat. 125] has him half-seated, half-crouched on the edge of a bed. He "isn't himself exactly," as the smug reproof goes; drunk or hungover, he paints as he feels or felt, teetering between befuddlement and sudden out-of-body perception. He regarded explanations as excuses and avoided them. Why spoil things? "One brings the sensation and the feeling of life over the only way one can," he said, when pressed.[5]

Bacon's achievement was to invest portraiture with urgency. His best paintings summarize, swiping images swiped from photographs and exposing (behind picture

portrait painting has remained, on average, platitudinous. Clients' requirements—pleasing likeness, dignified appearance—impose conformity; the urge that underwrites the genre is, as Lord Byron sneers in *Don Juan*, "To have, when the original is dust, a name, a wretched picture, & worse bust."

That in itself is, of course, incitement to reinvent. In the age of Picasso the history of true portraiture—portraiture that enlivens—is one of reclamation. Portrait formats (head and shoulders, half length, full length) being more or less invariable and inescapable, the pressure has been to accentuate individuality in style or touch and in comprehensive ambition.

The most notable alternative to Picasso in Paris after the Second World War was Giacometti, who in his studio off the rue Hyppolyte-Maindron treated his few sitters as rarities, each posed as though clamped to the sort of brace used by

Fig. 4
Walter Richard Sickert
H. M. King Edward VIII, 1936
Oil on canvas, 72 ¹/₄ x 36 ¹/₄ in.
(183.4 x 92.1 cm)
The Beaverbrook Art Gallery / The
Beaverbrook Canadian Foundation,
Fredericton (in dispute 2004);
The Beaverbrook Art Gallery,
Fredericton, New Brunswick,
Canada

and pinching a boy's cheek; Stalin takes the salute and squints at the military chiefs he distrusts; Churchill, cigar at the ready, scowls crowd-pleasing defiance. For audiences and propaganda ministries in the pre-television age, these were stirring alternatives to the fixed images. And they fed into portraiture. Bacon was attracted by the freeze frame. In 1955 Picasso allowed himself to be filmed in animated drawing mode for Henri-Georges Clouzot's *Le Mystère Picasso*; for him, working behind a large pane of glass, the set-up was a novelty self-portrait format.

Others, less dashing, attempted to work into their portraits a sense of motion picture beyond the scope of the photograph. Graham Sutherland, commissioned to paint an 80th-birthday portrait of Churchill, tried representing him as a rheumy political grandee—his lower legs less realized than the rest of his body, as though slurred by the wrong shutter speed. An attempt to emulate the spontaneity of the best Bacons, it was so badly received by the sitter that Lady Churchill had the painting destroyed. This was encouraging in a way, for it proved that portraits, stiff official portraits even, could still get under the skin.

Primarily a landscape painter, Sutherland depicted the face of the newspaper baron Lord Beaverbrook as a lump of fissures wearing the expression of a puzzled forest creature [cat. 124]. Walter Sickert's Beaverbrook [cat. 86] was lifted from a photograph, with a seaside backdrop inserted regardless of the subject. This high-handed treatment was a Sickert demonstration of the advantages of reprocessing the found image, suppressing half the half tones, casting the Beaver (as he was nicknamed) as a bossy stand-up comic. Commenting on Sickert's habit of using newspaper photographs and Victorian wood-engravings as readymade compositions, Frank Auerbach talked about his "grand, living and quirky forms."[6] Sickert used second-hand images partly for convenience (he was getting old and infirm and had his wife and other assistants at hand to do some of the paint work) but more because he was smitten with their arresting qualities. They were like his earlier, music-hall subjects in which stage lighting exaggerated contrasts and the performers, brighter in the limelight than ordinary people, came across as amplified characters. Photographs, particularly newspaper ones degraded through reproduction, gave him ideas. And a head start when he wanted to paint, for example, royalty. Edward VIII attends some ceremony and, alighting from a limousine in lieu of a horse, shies away,

glass) the moment someone flinches or whinnies and the mirror reveals the vulnerability of the bared neck.

Photographs fed Bacon's imagination. They were a convenience in that they could be torn from magazines and used as prompts, if not brush-wipes, then trodden underfoot. Their chanciness excited him; their tones appealed. Suddenly he would find, for example, that a shot of Woodrow Wilson walking along like a passing character from *The Waste Land* was just what he needed to fill the vacant slot in the left-hand panel of a triptych [cat. 130].

Wilson was one of the first world leaders to be recorded by the movie camera. Although to Bacon half a century later he was nothing more than a stock authority figure with top hat, others more charismatic than he were featured in newsreel footage as actors playing the lead roles and lapsing, on occasion, out of assumed character. Hitler, normally shown adulated whilst haranguing, is last seen shuffling along a line of child soldiers, dishing out medals

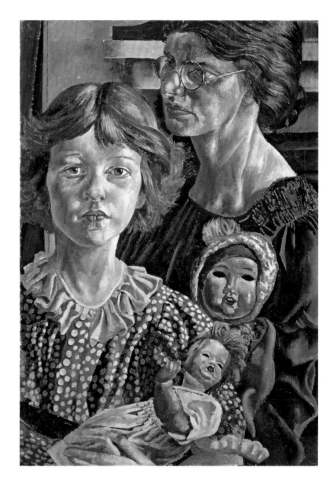

holding his big bearskin headgear like a protective muff [fig. 4]. Sickert catches the evasiveness of this pasty-faced king, not yet crowned and (not that he knew it) soon to abdicate.[7]

Part of the fascination exerted by effective portraits is their priming of curiosity as to what happens next. They carry stories and embody histories. Never more so than in the paintings of Stanley Spencer, notably *Portrait in a Garden (Patricia Preece)*, 1936, a tight, dry study of his beloved [cat. 89]. Under the peonies near the garden fence she sits. Her name is Patricia, and to Spencer, living in a secluded village by the Thames, she represents glamour and sophistication. Judging by the embroidery, her rather low-cut dress was bought on their recent trip to Switzerland. He has been painting her a lot, and her expression barely changes from picture to picture. Clearly she's peevish. Not just bored with sitting but resentful about being got at. Clothed or naked makes little difference. In *Self-Portrait with Patricia Preece* [cat. 139], where Spencer has inserted himself like a supplicant donor on a Renaissance altarpiece, she pointedly ignores him. Here the peonies droop and she looks away, the cast in her left eye signaling a perhaps too obvious vexation. Stanley may be famous but she regards him as a "miserable little man."[8]

Spencer believed that high among the values enshrined in Giotto's frescoes in the Arena Chapel, Padua, were those of pageantry and narrative. It followed that portraiture, to him, was essentially anecdotal. He believed in composition informed by observation and gossip.[9] Portraits were therefore, in part, what can be read into them. In his 1937 painting of his ex-first wife and daughter, *Family Group: Hilda, Unity and Dolls* [fig. 5], executed shortly after the divorce, Hilda looks away, Unity watches her father. The dolls loll blankly. For Spencer the painting was an argument and a plea for understanding. Emotional insistence and all, it was Neue Sachlichkeit with a Pre-Raphaelite bent. "All one had to do," he wrote, "is put down what one saw."

"Reality is more than the thing itself," Picasso said. Ditto the concept of realism, a sort of ideal constantly updated and reasserted as outlooks change. Historically, realism became super-realism (thence Surrealism); Neue Sachlichkeit degenerated into Socialist realism; photo realism had its moment in the 1970s, as did dirty realism in the 1980s. Indeed throughout the twentieth century every generation had its own particular brand of new realism. In portraiture especially, realism denotes more than fact. A few months before his death in 1950 Max Beckmann, feeling himself to be a stranger still in the United States, put down what he saw with dour self-possession in *Self-Portrait in a Blue Jacket* [cat. 85]. Here he stands, in the same pose as decades before, manifestly the expatriate restating himself with emphatic outline, cigarette to mouth and hand in pocket. This at the time when the New Art for the New World was proclaimed a new reality, when the vastnesses of Jackson Pollock and Barnett Newman and the sublime moodscapes of Mark Rothko were poised to be regarded as deep-seeking self-portraits.

· · ·

"Every portrait that is painted with feeling is a portrait of the artist, not of the sitter," said Oscar Wilde.[10] "Everything is a portrait," Lucian Freud insists.[11]

7 Two versions exist of *H. M. King Edward VIII*, 1936 (Beaverbrook Art Gallery, Fredericton, New Brunswick, and the Welsh Guards, London). Prime Minister Edward Heath remembered as a youth noticing one of these paintings hanging on a washing line in the artist's garden at St. Peter's-in-Thanet, Kent (conversation with author 1990).

8 The infatuated Spencer had notions of assembling a *ménage à trois* involving his future ex-wife Hilda Carline, who came from an arty Hampstead background. Preece, a colonel's daughter and Bloomsbury Group camp follower, considered herself to be his social superior. She too was a painter, but the paintings —portraits mainly—that she exhibited under her name were actually painted by her girlfriend-partner Dorothy Hepworth. Preece and Spencer married at Maidenhead Registry Office in May 1937 and went on honeymoon, with Hepworth, to Cornwall, where Spencer (having floated the idea of a *ménage à quatre*) was dismissed. She remained married to Spencer in name, rank (eventually Lady Spencer), and financial dependance.

9 Presumably he knew that as a 17-year-old schoolgirl the then Ruby Preece was, to some degree, responsible for the death of W. S. Gilbert, the comic opera librettist. He had a heart attack saving her from drowning in a lake; gossip had it that this was a cover-up to avoid scandal.

10 Oscar Wilde, *The Picture of Dorian Gray*, first publ. 1890. See Bristow 2005, vol. 3, p. 7.

11 See London 2002.

Fig. 6
David Hockney
The Student: Homage to Picasso, 1973
Etching (edition: 90), 29 ¼ x 22 ¼ in. (57.2 x 43.5 cm)
National Portrait Gallery, London

Fig. 7
David Hockney
Artist and Model, 1974
Etching (85/100), 29 ¾ x 22 ⅜ in. (75.6 x 56.9 cm)
Musée Picasso, Antibes

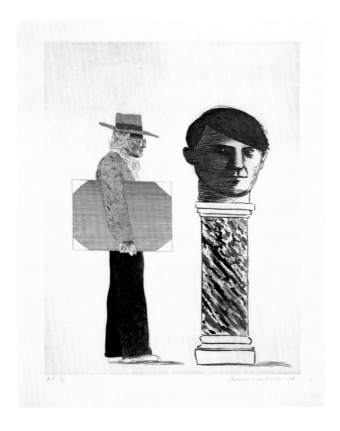

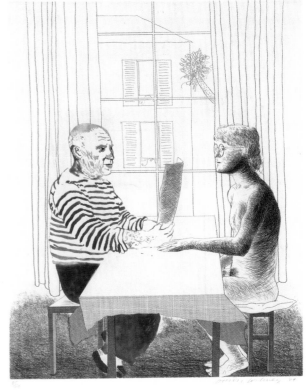

When Freud sat for his father-in-law Jacob Epstein in 1948 he was rendered faunlike, a potential satyr [cat. 142]. The bust of "the spiv," as Epstein referred to him when the marriage to his daughter Kitty ended,[12] coincided with *Girl with Roses* [cat. 91]. The contrast is striking, the sculpture so generic, the painting so detached from contemporary norms. Inspired by the Flemish masters, Freud was intent on achieving fidelity, the handling of a miniature painter (with unavoidable metaphysical undertones) but on a large enough scale to make the presence felt. A year or so later his wife posed again, for *Girl with a White Dog* [cat. 141], in which the fidelity has turned chilly. The detailing of skin and pelt, toweling and mattress ticking, is the opposite of what Bacon was then striving to achieve. Freud admired Bacon but felt that he could not possibly succeed in intensifying expression similarly. For him the task was to feel his way minutely, putting window reflections in the eyes, getting the toenails individually right.

Fifteen or so years later, when his own methods had become emboldened, Freud remembers setting some students a task:

I said you'll be dead very soon and I want you to make self-portraits and I want you to put in everything you feel is relevant, to do with your life and how you feel about yourself. . . . I want you to try and make it the most revealing, telling and believable object. Something really shameless, you know.[13]

Reflection with Two Children (Self-Portrait) [cat. 132] of 1965 combines strong foreshortening (the artist is looking down at his reflection in a mirror on the floor) with the quasi-domestic touch of the images of the small son and daughter, like snapshots tucked into a mirror frame over a mantlepiece. Forty years on, in *The Painter Is Surprised by a Naked Admirer* [cat. 146], the shamelessness becomes oddly poignant as painter and sitter are discovered arranged in a tableau that refers backwards and forwards, from mirror image to picture reflection within the picture of a painted reflection. This is a self-portrait representing zest and apprehension, virtually a lifetime away from *Girl with a White Dog*. It is a double portrait that contains trace elements from Vermeer, Velázquez, Giacometti, and Picasso, yet is free of quotation marks—an image with

12 Quoted in Gardiner 1992.

13 Quoted in Venice 2005.

Fig. 8
Andy Warhol
Mao, 1973
Silkscreen ink and polymer paint on canvas,
176 ½ x 136 ½ in. (448.3 x 346.7 cm)
The Art Institute of Chicago, Mr. and Mrs. Frank G. Logan
Purchase Prize and Wilson L. Mead Fund (1974.230)

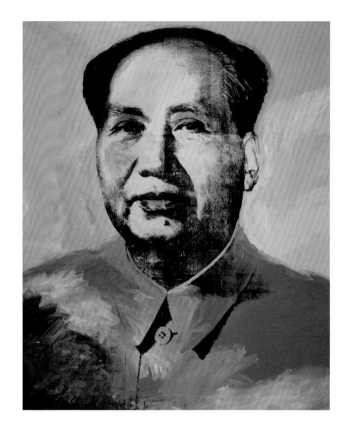

a distanced feel and the awkwardness of a complication viewed from an alien angle.

David Hockney has always had the urge to investigate maltreated conventions from idiosyncratic angles. In his *Portrait Surrounded by Artistic Devices* [cat. 154], from the mid-1960s, the chap in a suit finds himself wondering what he is doing there, seated amidst a clutter of pricey Cubistic leftovers. Time and again, as in *Model with Unfinished Self-Portrait* [cat. 157], the artist places himself in such positions, showing himself puzzling things out, entertaining himself by graphically questioning received opinion. Hockney's portraits range from the confessional to near-hero-worship. In 1973–1974 he drew himself both as a mature student studying a bust of the late Picasso [fig. 6] and in *Artist and Model* as a fellow draftsman, seated across a table from him, dumbstruck if not paralyzed in the presence of his idol [fig. 7].

Portraits, Hockney told me recently with the air of one who knows that idiots may think otherwise, are the only thing. This is not to say that all the other genres are exactly sideshows. He meant that there is no getting away from how we look, no subject more important than who, indeed what, we are.

When Frank Auerbach was a student at the Royal College of Art in London in the early 1950s, a tutor, Ruskin Spear, who did would-be Sickerts, paused behind him one day as he worked on a figure painting and said, more in wonder than despair, "You are doing *everything* as part of the landscape." Auerbach was pleased. This is what portraiture should be. In his words, "Images which don't leak into other images." The portrait proper is how someone is: not simply how they appear but how immediate they are. The image has to have both independent existence and a sense of belonging, the figure breathing landscape air. Auerbach's paintings, and indeed Leon Kossoff's, which are shaped by similar impulses and aspirations, look suddenly arrived at, each a coup, a moment seized, verified with flashes of intuition.

When Picasso died in April 1973, Andy Warhol was busy producing Maos [fig. 8]. For him the Great Helmsman was an impressive item, a gratifyingly well-received transplant from the Chinese context to the commodity market of Western civilization. He gave his other successful lines in venture portraiture (*Elvis, Troy, Marilyn, Jackie, Liz*) and his bespoke

portraits similar treatments, each screened photo-image personalized slightly with Warhol touches: tracings, texturings, Abstract Expressionistic colorway. Star treatment in Warhol usage was deadpan; the image had to be so processed that nothing much remained, beyond the Warhol look, but head and shoulders and stare. He posed himself, finger to mouth, figuring how to be intriguing [cat. 160]. For him there was no image more profound than that of the shadow.

Just as Picasso's *Stalin* was tyrant turned classical, Warhol's *Mao* was tyrant turned Supreme Everyman. Presiding as he did over about a quarter of the world's population he became, in overshadowing effigy, Man of the Century.

"Homo sum; humania nihil a me alienum puto," wrote Terence, the Roman poet and dramatist and one-time slave. "I am human; to me nothing human is alien." His portrait bust from the second century BC survives, faintly smiling.

THE MIRROR & THE MASK

THE EXHIBITION

Paloma Alarcó

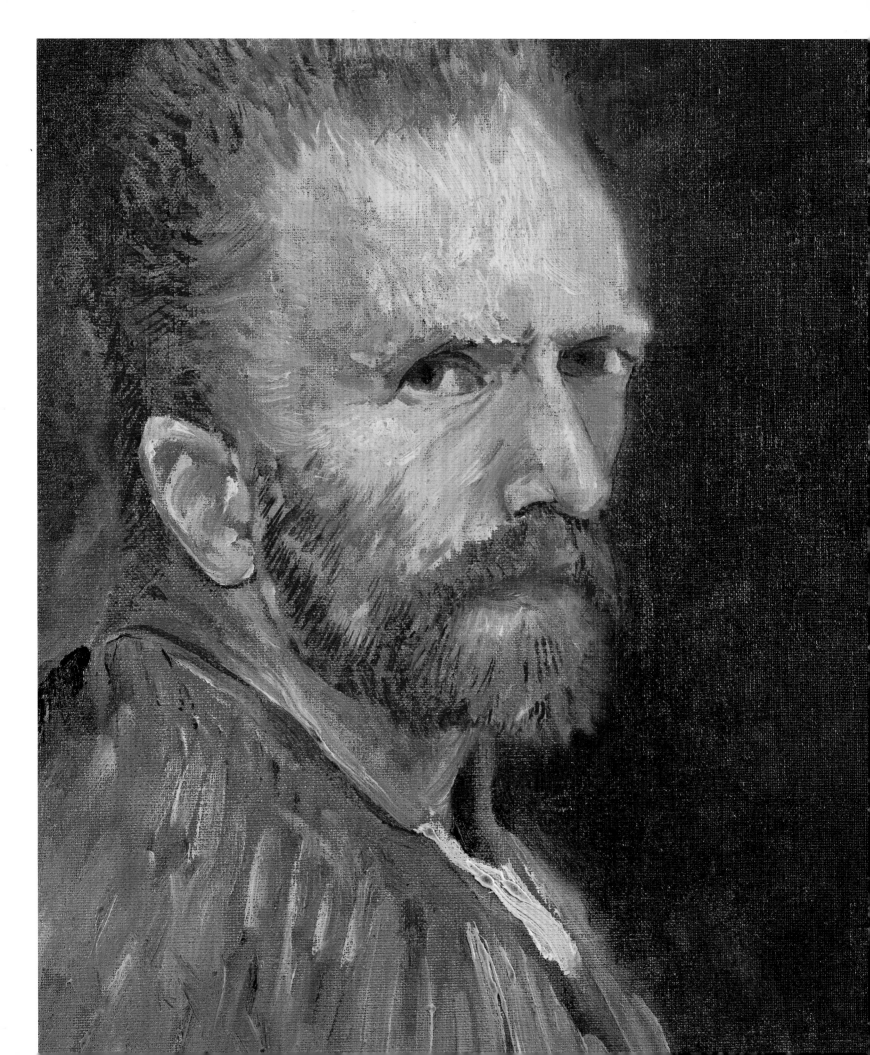

1 BEFORE THE MIRROR

Fig. 1
Johannes Gumpp
Self-Portrait, 1646
Oil on canvas, 34 ⅞ x 35 in. (88.5 x 89 cm)
Galleria degli Uffizi, Florence

and artist through the metaphor of the mirror is endless. As Pascal Bonafoux wrote, "these looks that are looked at, these mirrors experienced through mirrors, lead to a *mise en abîme* that opens onto infinity."[1]

If, as George Steiner affirmed, the self-portrait represents the artist's attempt "to achieve mastery over the forms and meanings of his very self,"[2] it is not surprising that some artists' obsession with painting themselves should be motivated by a need to delve into their life experience, their changing mental states. What is more, Romantic individualist ideals that were revived at the end of the nineteenth century resulted in the transformation of the traditional image of the artist, who ascended to the category of visionary hero, outside of society and against established norms.[3] His isolation and suffering, the consequence of his new and tragic destiny, became an essential source of his art. For this reason it is understandable that at the moment of painting himself the artist no longer restricted himself to the image that was returned by the mirror; he turned to a wide variety of masks to offer a subjective interpretation of his own existential dilemma and validate his new artistic intentions. In this regard, we should bear in mind that photography, a new tool for artists who wished to go beyond the limits of the mirror, considerably expanded the possibilities of self-representation.

This first section of the exhibition brings together highly expressive self-portraits by Cézanne, van Gogh, Gauguin, Munch, Ensor, Beckmann, and Picasso. In addition to immortalizing these painters as images of the modern artist, the works reveal their intellectual and aesthetic aspirations. The eldest of them, Paul Cézanne, who freed painting from its conventional means of mimicking reality, made use of the portrait and the self-portrait to validate his new, analytical pictorial language. More interested in the formal problems of painting and in constructing the visual essence of his

1 Pascal Bonafoux, "Or tout Paraît: Essai de définition d'un genre, l'autoportrait," in Paris 2004, p. 37. On this issue, see also Nancy 2000.

2 Steiner 1989.

3 The evolution of the image of the artist from the 18th century to the present was recently the subject of the exhibition *Rebels and Martyrs*, London, National Gallery, 2006.

The mirror is the origin of the self-portrait. In other types of portrait, the artist faces the sitter directly and tries to reveal the mystery of the other; in the self-portrait he is before a mirror dealing with the challenge of capturing his own elusive identity [fig. 1]. Once the painting is completed, the mirror gives way and the painting sets in motion a fascinating exchange of gazes: between the artist and his reflected image; between us and the artist, who returns it. Given that our gaze coincides with another gaze, i.e., the mirror's, perhaps we can also speak of an encounter with our own reflection, our own self-portrait. This intertwining of spectator

Paloma Alarcó

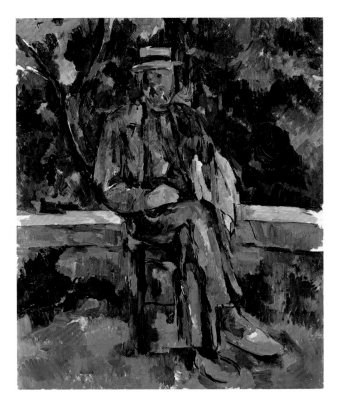

Fig. 2
Paul Cézanne
Portrait of a Farmer, 1905–1906
Oil on canvas, 25 ⅜ x 21 ½ in. (64.8 x 54.6 cm)
Museo Thyssen-Bornemisza, Madrid

As Cézanne's friend the poet Joachim Gasquet noted, the artist's total empathy with his sitters led him, imaginatively and literally, to exchange positions with them. Gasquet tells us that on occasions one of his peasant models was ill and could not come,

> so Cézanne himself posed in front of the mirror dressed in some old rags, and through a strange transferral, a mystical or perhaps deliberate substitution, the features of the old man and those of the artist mingled together on the dark canvas, while the lives of both had the same void and the same immortality.[6]

Inspired by the dramatic intensity of one of the last portraits of Vallier, Lionello Venturi wrote: "Cézanne observes the old gardener with such a weight of painful compassion that ultimately he is revealing himself and creating, we might say, a sort of self-portrait"[7] [fig. 2].

Cézanne was interested in his own image, but as a visual reality in no way different from any other motif in his painting. But for others such as Paul Gauguin, the self-portrait became a symbolic representation of the artist's destiny. Following Symbolist ideas, Gauguin abandoned the idea of the portrait as a pictorial representation of a sitter or model and reconceived it as the expressive equivalent of a thought. His self-portraits, which are always imbued with great theatricality and drama, bring us into the realm of his personal mythology. In a letter of 1888 to Emile Schuffenecker, he described his *Self-portrait: "Les Misérables"* [fig. 3], which he had sent to van Gogh before his planned visit to Arles, as "a total abstraction."[8] In fact what Gauguin had done was to portray himself symbolically transformed into another character, that of Jean Valjean, the exile in *Les Misérables* by Victor Hugo, one of Gauguin's favorite authors. Even more significantly, as he revealed to van Gogh, Gauguin wished to personify the modern artist—a "badly dressed bandit" but one who was "noble and gentle inside."[9]

Some years earlier, in what appears to be his first self-portrait, painted in Copenhagen in the winter of 1885 [cat. 3],[10] Gauguin depicted himself in the role of artist in order to involve us in his determination to become a painter against the wishes of his family.[11] Following his failed career as a businessman, and equally unsuccessful in his married life, Gauguin shut himself away to devote himself to what was known in his house as *cette maudite peinture*.[12] We see him "disguised" as a painter before he had actually become one;

4 See Heather McPherson, "Cézanne: Self-portraiture and the Problematics of Representation," in McPherson 2001, pp. 117–144.

5 See Rewald 1996, vol. I, no. 826, p. 495.

6 Gasquet 1991, p. 132.

7 Venturi 1991, p. 123.

8 Paul Gauguin, Letter to Emile Schuffenecker, 8 October 1888, in Merlhès 1984, vol. I, p. 249.

9 Paul Gauguin, Letter to Vincent van Gogh, Pont-Aven, 1 October 1888, in Merlhès 1984, vol. I, p. 234.

10 In Wildenstein 2002, II, no. 165. Dated between the winter and early spring of 1885.

models than in reproducing their individual features, he made the power of the image impose itself over the subject. By questioning the mimetic theories on which portrait painting had been based for centuries, he became one of the forerunners of the modern revolution within the genre.[4] At the end of his life, at his retreat in the Midi, he repeatedly painted the few sitters who were willing to pose for him, such as his gardener Vallier or the peasant whom we see in *Man in a Blue Smock* of around 1897 [cat. 1]. The same man is depicted standing and smoking his pipe in two versions of *The Card Players* of 1890–1892.[5] Despite his simple Provençal dress, with its characteristic peasant smock and red scarf tied around the neck, the figure takes on monumental proportions and occupies most of the surface of the canvas. He is seated in a three-quarter pose, his heavy laborer's hands on his lap, possessed of a dignity worthy of the great portraits of the Renaissance.

Fig. 4
Vincent van Gogh
Self-Portrait Dedicated to Paul Gauguin (Bonze), 1888
Oil on canvas, 24 x 19 ¹/₄ in. (61 x 50 cm)
Fogg Art Museum, Harvard University Art Museums, Cambridge.
Bequest of the Collection of Maurice Wertheim, Class of 1906

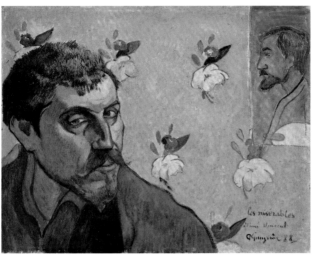

Fig. 3
Paul Gauguin
Self-Portrait: "Les Misérables," 1888
Oil on canvas, 17 ³/₄ x 21 ⁷/₈ in. (45 x 55 cm)
Vincent van Gogh Museum, Amsterdam
(Vincent van Gogh Foundation)

11 See Guillermo Solana, "El despertar del fauno: Gauguin y el retorno de lo pastoral," in Madrid 2004–2005, pp. 15–63; and Anne–Birgitte Fonsmark, *"Représentant de Commerce* in Copenhagen," in Copenhagen/Fort Worth 2005–2006, pp. 232–255.

12 Paul Gauguin, Letter to Camille Pissarro, May 1885, in Merhlès 1984, vol. I, p. 108.

13 Gauguin P. 1937, p. 38.

14 See Douglas W. Druick and Peter Kort Zegers, "The Exchange of Self-Portraits," in Chicago/Amsterdam 2001–2002, pp. 147–155.

15 Artaud 1947.

16 See Bogomila Welsh-Ovcharov, "Vincent van Gogh, His Paris Period 1886–88," PhD thesis, University of Utrecht, and George Shackelford, "Van Gogh in Paris: Between the Past and the Future," in Detroit/Philadelphia/Boston 2000, pp. 87–125.

he presents a symbolic image of himself as the suffering artist, alienated and despairing in the midst of a bourgeois society that rejects him. He sits before his easel holding the traditional attributes of the painter in a pose compressed by the sloping ceiling of a tiny attic room. As his son Pola Gauguin recounted years later, "he saw himself confined to the back quarters of his own house; he and his painter's tools were relegated to a small room . . . its only natural light was a small skylight . . . the only model available to him was himself."[13] As with most of his self-portraits, instead of looking straight ahead toward the mirror in which he could see his own face, he twists his gaze in an elusive way that expresses possible distrust in the face of an uncertain future. In later self-portraits that gaze would become challenging, even arrogant, as Gauguin depicted himself as the great hero of his new artistic language.

Gauguin had painted *Les Misérables* as a gift for his friend Vincent van Gogh, who responded by sending him his self-portrait as a *bonze* [fig. 4]. The symbolic strategies of the two portraits are different. Gauguin, a heroic outsider, dramatizes the problem of the artist's alienation in society. Van Gogh, a tormented romantic, offers a programmatic solution,[14] depicting himself in the role of a Buddhist monk, symbol of one who shows others the way. In 1892, after van Gogh's suicide, the writer and critic Octave Mirbeau published his novel *Dans le ciel,* in which he narrated the history of the early and tragic death of the painter Lucien, who could well be intended as a literary version of van Gogh. But the tragic aspects of van Gogh's personal life—"suicided by society" as Antonin Artaud called him[15]—are best reflected in the numerous self-portraits that he created in his brief career. In them he reveals his vulnerable and suffering personality in the most explicit way.

When van Gogh arrived in Paris in February 1886 he was thirty-three and had barely four more years to live. In Paris he met Gauguin and Emile Bernard and made an effort to absorb the artistic innovations taking place around him. Influenced by Japanese prints and by Seurat's Divisionist technique, his palette became more luminous and colorful. The tenebrism of his Dutch period was transformed into a bolder and anti-academic type of painting. The two years that he spent in Paris coincided with his most intense period of self-scrutiny and search for answers to his internal struggles through the representation of his own image—a time also of experimentation with new pictorial techniques.[16] The self-portrait in the exhibition [cat. 2] forms part of a group of self-portraits against a blue background, painted during the summer of 1887, in which the artist repeats

Paloma Alarcó

Fig. 5
Rembrandt van Rijn
Self-Portrait, after 1665
Oil on canvas, 32 ½ x 25 ⅝ in. (82.5 x 65 cm)
Wallraf Richartz-Museum/Fondation Corboud, Cologne

17 In his article on "the sinister"
 (1919), Sigmund Freud
 recounts a similar anecdote
 in which, during a train journey,
 he was upset to discover that
 the strange person looking
 at him was in fact his own
 reflection.

18 Quoted in Iris Müller-
 Westermann, "1922–44: The
 Hermit of Ekeley," in
 Stockholm/Oslo/London 2005,
 p. 153.

19 According to an annotation
 in his notebook *Liber veritatis*,
 The Art Institute of Chicago.
 See Ollinger-Zinque 1976.

20 Tricot 1992, vol. II, no. 673.

21 Ensor 1944, p. 141.

in a mirror on a sleepless night in his house in Ekeley near Kristiania, where he lived until his death.[17] The solitary old man, standing by a piano, contemplates his reflection through eyes sunk into their dark sockets. The startled expression on his face seems to exaggerate his grimacing mouth, which age has started to weigh down, creating a curve in the opposite direction to a smile. The artist's pose and expression suggest the anxiety created by solitude. Both the shadow seen through the window and the electric lighting of the domestic interior serve to increase the tension of the image. As in his last paintings, Munch's handling is carelessly hasty, which enhances the troubling effect that he wishes to convey. The colors also contribute to the creation of a somber atmosphere, one that has led some to compare the painting to one of Munch's favorite paintings of the past, one of the late self-portraits of Rembrandt [fig. 5], with its similar sense of defeat and exhaustion. The entire composition of Munch's painting is a metaphor for the emotional instability in which the artist found himself submerged at that date. "The second half of my life," he wrote, "has been a battle to keep myself upright. My path has led me to the edge of a precipice, a bottomless pit."[18]

The self-portraits with masks of the Belgian painter James Ensor typify his strange and troubling personal iconography. Ensor came across masks in his parents' shop, where they were sold for the traditional carnivals in Ostend, his native city, and he used them obsessively in his painting as a metaphor for the loneliness of the individual in the new society of the masses. He was an avid reader of Edgar Allan Poe, and any of the isolated figures among the multitudes in his paintings might be the main character in Poe's story *The Man in the Crowd*, submerged in the anonymous, teeming streets of London. *My Portrait with Masks* [cat. 5], begun in 1936 and completed in December 1937,[19] is the second version with slight variations of another canvas of 1935.[20] Standing by his easel in his studio, with only the company of his trademark masks, Ensor looks at us with a certain disdain over his glasses while he seems to be pronouncing his own words: "I wish to tell the entire world the marvelous story of me, Myself, the universal I, the only I, the stout I of the great verb to be: I am, we are, you are, they are."[21]

While Ensor's diabolical and caricatural masks refer metaphorically to man's solitude, Pablo Picasso made use of them to adopt a range of different *alter egos*, expressions

a similar composition. He appears in a three-quarters position, with his penetrating gaze directed over his shoulder toward the viewer while he addresses himself in the mirror. Here van Gogh breaks away from the rigidity of Pointillism and his earlier works; the background becomes more uniform, while the blue shirt, by contrast, is painted with extremely free, parallel brushstrokes.

Like those of van Gogh, the tormented self-portraits of the Norwegian artist Edvard Munch have become symbols of human suffering. Influenced by the writings of Henrik Ibsen and August Strindberg, Munch sought to give form to the anxiety and mysteries of the human psyche and to express his emotions in the face of a world in which everything seemed to have been called into doubt. In *Self-Portrait: The Night Wanderer* of 1923–1924 [cat. 4], he recalls the surprise that he experienced on seeing his image reflected

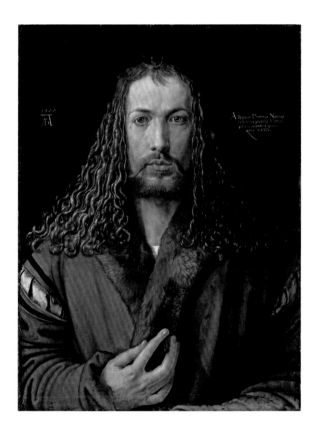

Fig. 6
Albrecht Dürer
Self-Portrait, 1500
Oil on panel, 26 ⅞ x 19 ¼ in. (67.1 x 48.9 cm)
Alte Pinakothek, Munich

22 Palau 1975, p. 34.

23 See Vergo 1992, no. 1,
 pp. 30–31.

24 See, among others, Phillippe
 Junod, "(Auto)portrait de
 l'artiste en Christ," in Lausanne
 1985, and Starobinski 2004.

25 See Kirk Varnedoe in New York
 1976, p. XIX.

26 Arthur Rimbaud, Letter to Paul
 Demeny, 15 May 1871.

of self-confidence, expressions of tragic aspects of his life. In *Self-Portrait with Wig* [cat. 7], one of his earliest self-portraits—painted in Barcelona in 1897, shortly before his trip to Madrid to study at the Real Academia de Bellas Artes de San Fernando—the fifteen-year-old painter disguises himself as an eighteenth-century gentleman, his hair concealed beneath a large white wig. As Josep Palau i Fabre noted, in this early self-portrait Picasso makes his first use of "that ability of his to transform people into characters."[22] He also reveals the first signs of his gift for modifying the ages of his models. For him this kind of self-exploration before a mirror, which has something of adolescent narcissism, was a means of artistic experimentation and also a way of imagining all the lives he might lead. His penetrating, even impertinent gaze would become one of his most obvious elements of his identity over the years.

While Picasso was taking his first steps as a painter, Max Beckmann, another artist obsessed with his own image, enjoyed early success at the Berlin Succession—along with other, already established painters such as Lovis Corinth, Max Liebermann, and Max Slevogt. Beckmann's gallery of self-portraits reflects his image hidden behind different masks, which he uses both to conceal himself and to reveal the abrupt shifts that took place in his eventful life. One of the most precocious is *Self-Portrait with Raised Hand* [cat. 6], painted during the summer of 1908 in Hermsdorf, a quarter in north Berlin where he had his studio. Here Beckmann presents a powerful image of himself at the age of twenty-four. While most of his self-portraits are full- or three-quarter-length, on this occasion he represents himself to just below the shoulders, with an extreme frontality that allows him to look straight ahead with his interrogative gaze while he raises his left hand in an expressive gesture. Some writers have related this to the act of holding the brush, although Beckmann may in fact have wished to depict himself smoking—as he would in later self-portraits, in which he arrogantly surveys his surroundings as though making an ironic comment on the boredom of modern life. Other interpretations[23] see the artist identifying himself with the figure of Christ blessing, in the tradition of self-portraits initiated by Dürer [fig. 6]. This seems highly likely in the case of Beckmann. He was an artist with an epic vision of painting, and he used the self-portrait to present himself to the world as a hero of Homeric dimensions.

During the troubled twentieth century, following in the wake of these early protagonists of modern art, the position of the artist as a cultural catalyst has gradually become more complex, while self-portraits have become less precise and intimate. On some occasions artists have externalized their interior emotions. But in general they have used symbolic associations from their own private mythology, disguised themselves by adopting a wide variety of identities,[24] or even erased their own identity by hiding behind abstractions or symbolic objects in order to reveal only a particular aspect of themselves. Responding to a double intention to define and hide the self, images of this type use the objectification of the self-portrait. The impersonal has gradually come to prevail as the primary modern medium for expressing the self[25]—a self that seems ever more clearly to express Rimbaud's celebrated paradox: "je est un autre" (I is another).[26]

Cat. 1 Paul Cézanne
 Man in a Blue Smock, c. 1897
 Oil on canvas, 32 ⅛ x 25 ½ in. (81.5 x 64.8 cm)
 Kimbell Art Museum, Fort Worth. Acquired in 1980, in memory
 of Richard F. Brown, the Kimbell Art Museum's first director,
 by the Kimbell Board of Trustees, assisted by the gifts of many friends

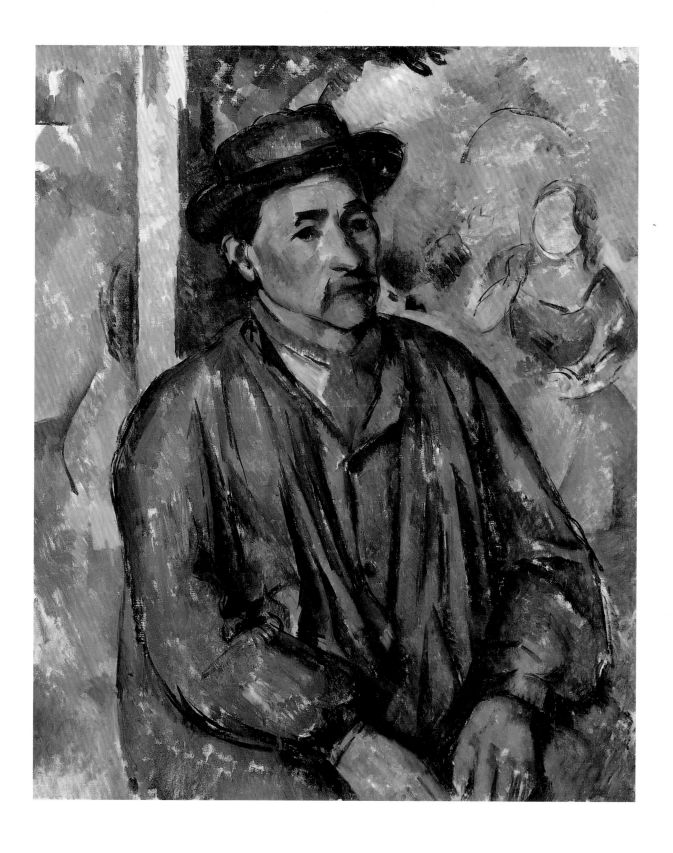

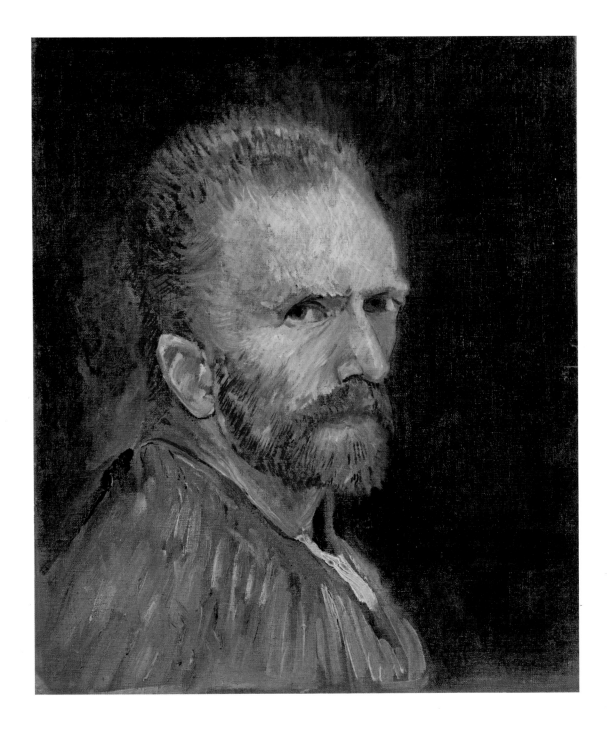

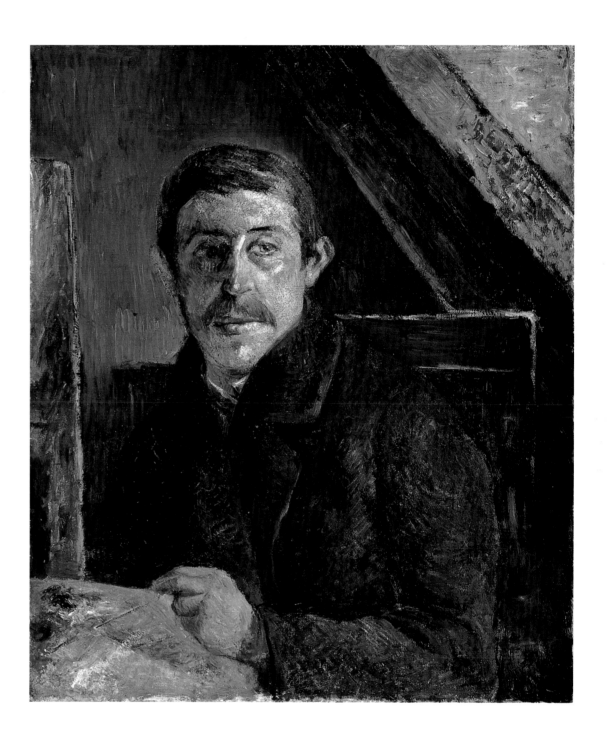

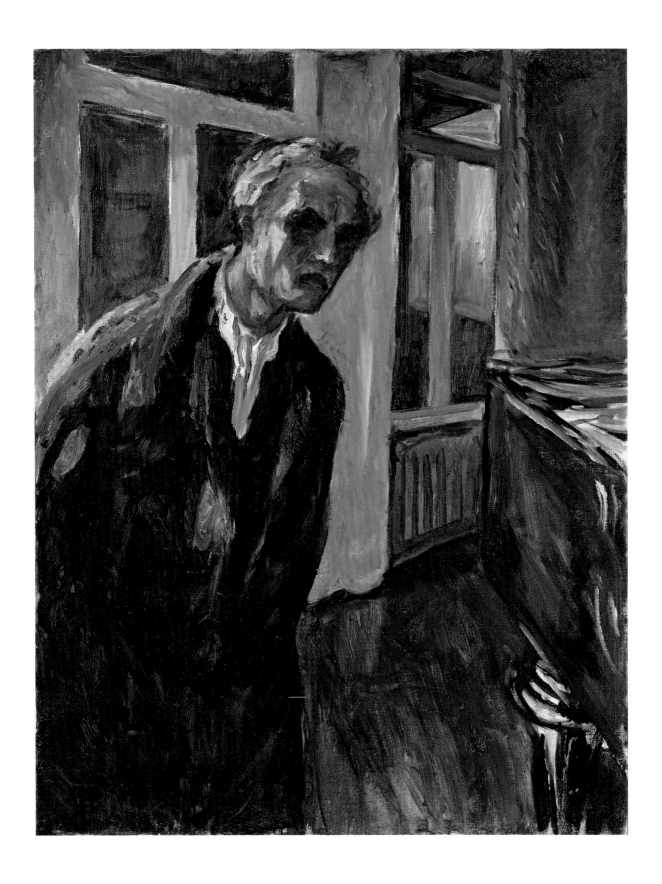

Cat. 4 Edvard Munch
Self-Portrait: The Night Wanderer, 1923–1924
Oil on canvas, 35 ¼ x 26 ⅝ in. (89.5 x 67.5 cm)
Munch Museum, Oslo

Cat. 6 Max Beckmann
Self-Portrait with Raised Hand, 1908
Oil on canvas, 21 ⅞ x 17 ¾ in. (55 x 45 cm)
Museo Thyssen-Bornemisza, Madrid

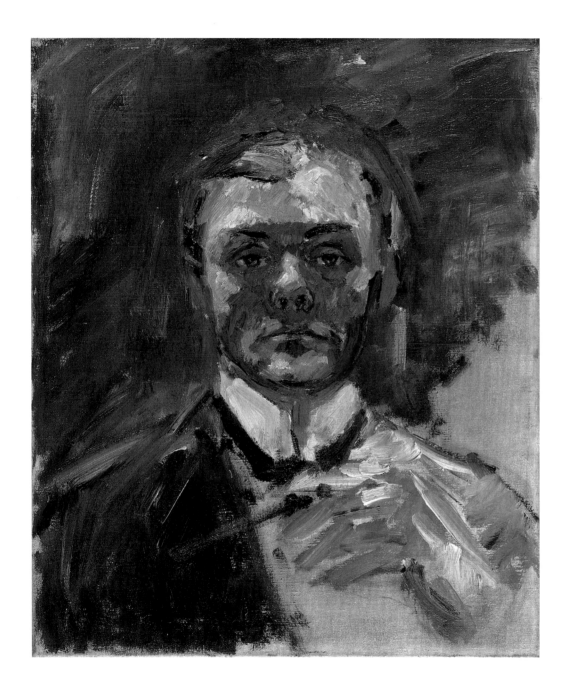

Cat. 7 Pablo Picasso
Self-Portrait with Wig, c. 1897
Oil on canvas, 22 x 16 ⅞ in. (55.8 x 43 cm)
Museu Picasso, Barcelona

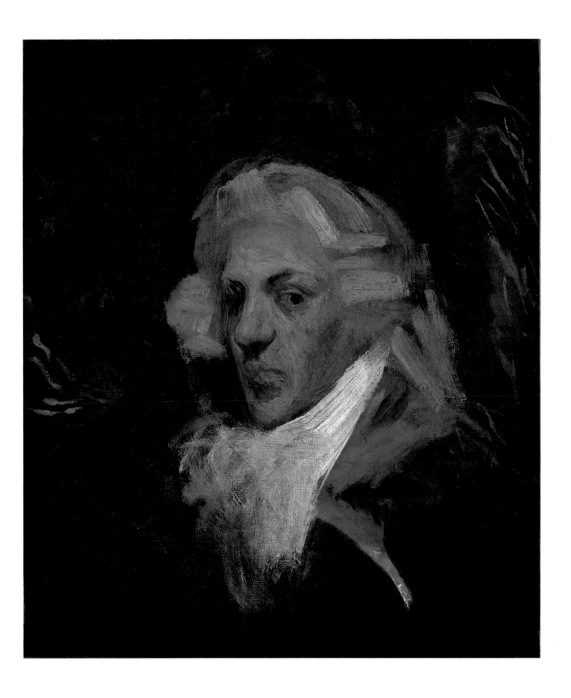

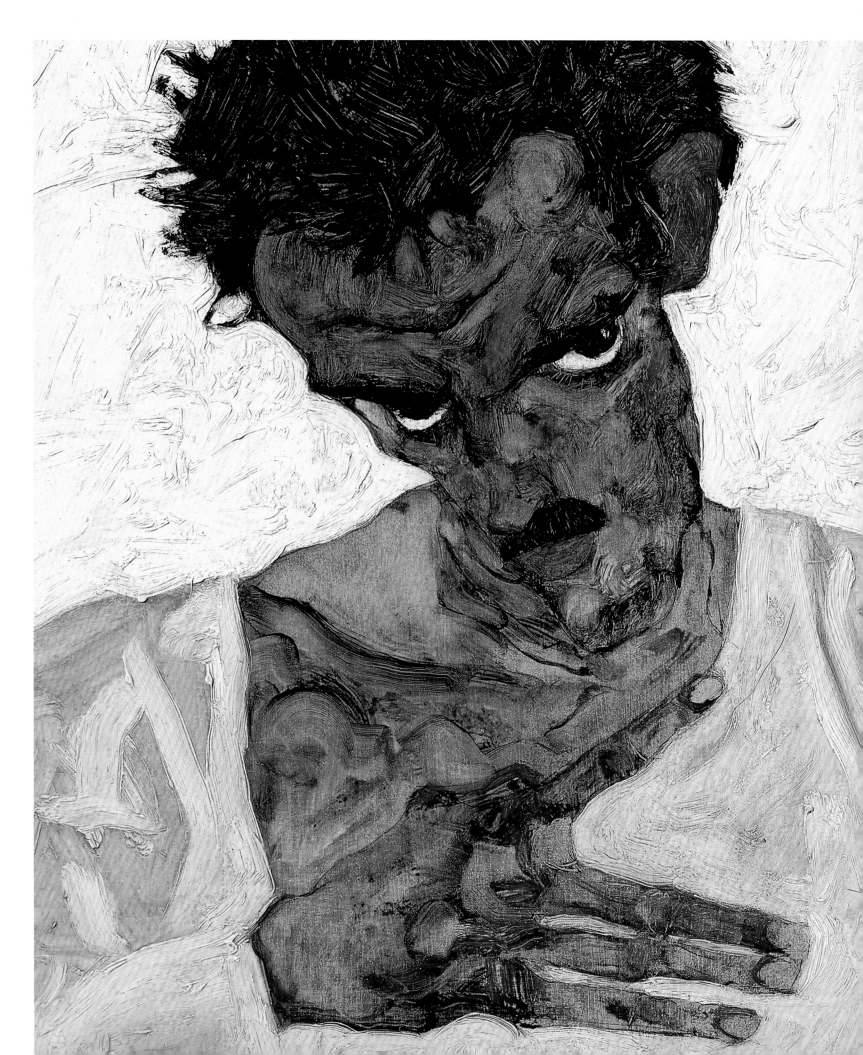

2 GESTURE AND EXPRESSION

[Cat. 11]
Egon Schiele
Self-Portrait with Lowered Head, 1912 (detail)

1 Giambattista della Porta, *De humana physiognomia* (1586).

2 Johann Kaspar Lavater, *Physiognomische Fragmente zur Beförderung der Menschenkenntnis und Menschenliebe* (1775–1778).

3 Charles Le Brun, *Méthode pour apprendre à dessiner les passions* (1698).

4 Gustav Klimt, *Ria Munk II*, 1917–1918, until 2006 in the collection of the Österreichische Galerie Belvedere in Vienna, and *Ria Munk III*, 1917–1918, in the Neue Galerie der Stadt Linz.

5 Gustav Klimt, *Serena Lederer*, 1899. The Metropolitan Museum of Art, New York.

6 Ferdinand Hodler, *The Death of Agustine Dupin*, 1909.

7 See T. Natter and M. Hollein, "The Modern Artist as Martyr," in Frankfurt/Vienna 2005, p. 267.

8 Frankfurt/Vienna 2005, p. 164.

9 See Klaus Albrecht Schröder, "Leitmotivs and Design Principles in the Works of Egon Schiele," in Vienna 2005, pp. 33–39.

Gesture has played a vital role in the narrative content of portraiture. Traditionally, artists used body movement to externalize their sitter's thoughts and feelings or to imply a particular way of being or behaving. As writers on physiognomy from Giambattista della Porta[1] to Johann Kaspar Lavater[2] codified facial features, others such as the painter and art theoretician Charles Le Brun[3] set out a repertoire of gestures and bodily signs supposed to represent the movements of the soul. With the arrival of the Expressionist movements in modern art, however, there was a radical shift whereby the gestural became exaggerated beyond all previous norms.

Early Symbolist and Expressionist portraits used color as a vehicle of emotion. There was also a tendency within Expressionism, notably in Viennese art of the early years of the twentieth century, toward various strategies of distortion and dislocation to represent the psychology of the portrait sitter. It was during this legendary period, when the final years of the moribund Austro-Hungarian Empire fostered an unprecedented cultural revival, that Freud's writings on the human unconscious revealed to artists the potential of art to penetrate the human mind.

Without doubt the leading artistic figure in *fin-de-siècle* Vienna was the painter Gustav Klimt. His portraits of the Viennese haute bourgeoisie, which deployed an expressivity hidden behind an elaborate decorative setting, were triumphantly successful for him. *Ria Munk on Her Deathbed* [cat. 8] was the first of the *post-mortem* portraits of this beautiful, suicidal young woman from the Viennese upper class that Klimt painted at the request of her father.[4] Maria (Ria) Munk (1886–1911) killed herself at the age of twenty-four. She was the daughter of Aranca and Alexander Munk and a niece of Serena Lederer, of whom Klimt had painted a portrait in 1899.[5] Like a pictorial reinterpretation of Ophelia, the face of the dead woman seems to rise up in the midst of a bed of flowers, the eyes inanimate and the lips half open. This powerful image recalls the series of paintings that Ferdinand Hodler devoted to *The Death of Augustine Dupin*[6] or Claude Monet's portrait of his dying wife [fig. 1], the execution of which was a famous moment of revelation for the artist.

The younger Viennese Expressionist artists, such as Richard Gerstl, Oskar Kokoschka, and Egon Schiele, drew much of the inspiration for their portraits from instinct, emotion, and suffering. Richard Gerstl, an unstable and emotional personality, eventually killed himself out of love for Mathilde, the wife of his friend Arnold Schönberg. An admirer of Munch and van Gogh who responded with passion to their vision of the world, Gerstl saw self-portraiture as the best vehicle by which to express the most profound emotions. To draw attention to his existential angst, in his *Self-Portrait against Blue Background* of 1904–1905 [cat. 9] he assumes the identity of the risen Christ, following a recently revived tradition that went back to Albrecht Dürer.[7] Alluding also to the iconography of the *Ecce Homo*, Gerstl depicts himself in an emphatically solemn manner, naked from the waist up and surrounded by a luminous halo, his gaze fixed on the viewer. In contrast to the hieratic nature of that work, his *Self-Portrait Nude with Palette* [fig. 3 on p. 276] of 12 September 1908—three weeks before he hanged himself in his studio in front of the mirror he used for his self-portraits—presents a spontaneous image of his body; it is as if he had been caught by surprise in the act of painting himself. One of the first fully nude, painted self-portraits, this work is devoid of any type of iconographic masking.[8] The violent handling and use of paint make it a forerunner of the gestural Expressionism of the second half of the twentieth century.

No other artist was as obsessed with his own image as Egon Schiele. His narcissism or schizophrenia[9] led him to depict himself in the widest range of ways—nude in the

Paloma Alarcó

Fig. 1
Claude Monet
Camille on Her Deathbed, 1879
Oil on canvas, 35 ⅜ x 26 ¾ in. (90 x 68 cm)
Musée d'Orsay, Paris

group of photographs of Schiele taken by his friend the photographer Anton Josef Trčka in 1914, the painter exaggerates his hand gestures in front of the lens [fig. 3]. We see such gestures in most of his self-portraits, including the *Self-Portrait with Lowered Head*, painted in 1912 [cat. 11]. On occasions, as in *Self-Portrait with Chinese Lantern Plant* of 1912 [cat. 12], the artist establishes a connection to the spectator through his penetrating gaze. Here he looks in the opposite direction to the turn of his head, increasing the sense of tension.

From 1915, the year in which Schiele married Edith Harms, a young women from a middle-class family who lived next to his studio in Vienna, his work reflects a calmer period in his life. He maintained his earlier expressivity but abandoned the exaggerations to which he previously subjected his figures. *Edith Schiele, Seated* [cat. 13], and *Edith Schiele, Standing* [cat. 14], both dated 1915, are representative examples of this new phase. The artist's young wife poses in tranquil, melancholy attitudes that bring to mind the female portraits of his master, Klimt. In both works Edith wears the striking striped dress that we see in numerous photographs of the period [fig. 4]; according to her sister Adele, it was made from some curtains in Schiele's studio. Both are notable for the delicacy and directness with which the artist paints the stripes to suggest the volume of the figure.

Of a more stable and balanced personality, Oskar Kokoschka began to paint portraits on a self-taught basis while still a young man. In his own words, he wished "to carefully observe men" but also to feel himself "truly within a society in which, at the end of the day, I had to live."[11] His portraits offer an unparalleled picture of Viennese intellectual and haute-bourgeois society, and are undoubtedly among the most original contributions to the history of the modern portrait.[12] His introspective portrait of the young Martha Hirsch [cat. 16], painted in the second half of 1909, is a perfect example of his early works in the genre. William Hirsch, an industrialist from Pilsen, commissioned Kokoschka to paint his own portrait and that of his wife. In the latter, Frau Hirsch appears surrounded by a dark blue glow. The idea that living beings radiate some form of energy was one that particularly interested the artist during these years. In his portrait of Lotte Franzos [cat. 15] the dark blue halo follows the entire outline of the body. This kind of emanation had already appeared in a number of works by Edvard Munch [fig. 5], an artist Kokoschka much admired. Here he lends it emphasis by means of

manner of a wounded Saint Sebastian or dressed in an entire repertoire of disguises and assuming the identity of a caricatural actor whose gestures verge on the grotesque. Far removed from the formal canons of beauty, the anatomy of his figures is sometimes distorted to impossible degrees in order to fit the square format of the canvas. Elsewhere it seems to defy the laws of gravity so extremely as to cause vertigo. The violent facial expressions of Schiele's figures bring to mind the exaggerations to be seen in sculptures by his compatriot Franz Xaver Messerschmidt (1736–1783) [fig. 2].

In Schiele's work the expressive importance of the face, in principle the most important vehicle of feeling,[10] is equalled by that of the hands. Painted with a loose and agitated technique, *The Poet* of 1911 [cat. 10] is an image of the semi-nude artist with his head to one side in a suffering pose, his nervous hands crossed to form an expressive right angle. Standing out against the dark background, his face and the nude parts of his body are painted in a range of vibrant colors that transform the physical nude into a psychic one. In a

10 The German sociologist Georg Simmel defined the face as a principle of order that is imbued with meaning by any change. See Georg Simmel, "Significación estética del rostro," in Simmel 1984, pp. 187–192.

11 Kokoschka 1974.

12 Madrid 2001–2002 and New York/Hamburg 2002.

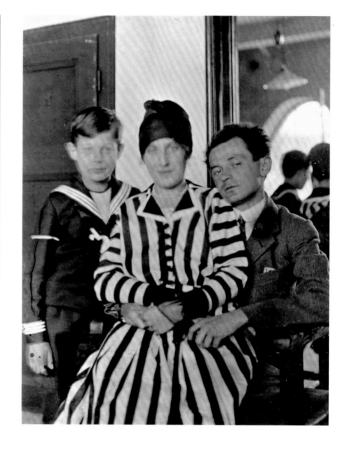

Fig. 2
Franz Xaver Messerschmidt
The Lecher, 1770–1783
Marble, height 17 ¾ in. (45 cm)
Österreichische Galerie Belvedere, Vienna

Fig. 3
Anton Josef Trčka
Egon Schiele, 1914
Bromoil print, mounted on cardboard
Albertina, Vienna

a pattern of striations, emerging from the body, that he applied with a point, perhaps the hard end of the brush.

According to the brief description of Lotte Franzos (1881–1957) provided by Johann Winkler and Katharina Erling, we know that she had studied art history and painting at Johannes Itten's academy. Notable for her elegance and good looks, she was married to the lawyer Dr. Emil Franzos, and their house was "the meeting-place for leading figures from the worlds of culture, literature, and politics."[13] Frau Franzos was a pioneer in the creation of new roles and images for women—whose conventional identity was well summed up in the memoirs of Stefan Zweig:

this was how society wanted young women at the time: stupid and uninformed, well brought up and ignorant, curious and bashful, insecure and useless, marked from the outset by an education remote from life, after which they would passively allow themselves to be led to marriage and moulded by their husbands.[14]

13 Winkler/Erling 1995, no. 34.

14 Zweig 1964.

In 1909 Kokoschka traveled to Switzerland with the architect Adolf Loos to paint Loos's wife, who was in a sanatorium for tuberculosis patients. The artist was at once moved by the suffering and resignation of the patients there, and the portraits that he made of some of them present a unique repertoire of images of human suffering—comparable only, perhaps, to Thomas Mann's *The Magic Mountain*, which was written some years later. Kokoschka shared Mann's interest in the atmosphere of the sanatorium and, like him, took it as a symbol of the disintegration of European society at the time.

Among the patients at the Swiss sanatorium were the Montesquiou-Fezensacs, a notable high-society couple, and Kokoschka painted both of them. Victoire Montesquiou-Fezensac, formerly Victoire Massena d'Essling (1888–1918), had married Joseph de Montesquiou-Fezensac in 1907. In her portrait [cat. 17], which Kokoschka painted in 1910, the exaggerated stylization of the figure, compressed into a highly artificial pose as though to fit the proportions of the canvas, accentuates the vulnerability of the sick woman.

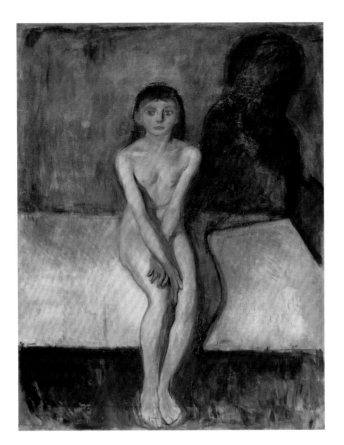

Fig. 5
Edvard Munch
Puberty, 1893
Oil on canvas, 58 ⅞ x 44 ⅛ in. (149 x 112 cm)
Munch Museum, Oslo

The hands, until this point a secondary feature in Kokoschka's portraiture, become key elements. He was fascinated by his subject and wrote in his autobiography that "the beauty of that woman moved me."[15] The empathy that he conveyed in all his portraits is in this case even more evident than usual.

On his return to Vienna, Kokoschka made contact with the firm of decorators Friedrich Otto Schmidt, established in 1854 and still in existence today, and was commissioned to paint a triple portrait of the firm's owners, the brothers Max, Carl Leo, and Hugo Schmidt [fig. 6].[16] Shortly after 1959, in somewhat mysterious circumstances, the portrait was cut into three parts, which were sold separately. The portrait of Max Schmidt [cat. 18] was at the center of the canvas and the only one of the three figures to be finished. Max Schmidt (1861–1935), who was noted for his business acumen, had made Friedrich Otto Schmidt one of the leading design firms in Vienna. Open-minded by nature and an important collector and patron of art, he kept the triple portrait from the time it was painted until his death. The portrait reveals a clear evolution within Kokoschka's style. At this point he came under the influence of the Venetian old masters, in particular Titian and Tintoretto, whose work he had seen and admired during a trip to Venice with Alma Mahler in 1913.

Kokoschka's portrait of the Swedish journalist Nell Walden, née Roslund, the second wife of the Berlin publisher and gallery owner Herwarth Walden [cat. 19], and that of the Austrian writer Karl Kraus (1874–1936) [cat. 22] show another of Kokoschka's contributions to the genre of portraiture: the invention of dynamic alternatives to the static pose. He always painted his models in movement[17] in order to make them forget that they were being observed. He wrote in his autobiography:

> My curiosity has never been directed towards obtaining personal confessions from my "victims"—as I like to call them—nor to finding out private or intimate things, but rather to forging an image of them similar to the one retained in the memory, a remembered image that one carries away, vivid and fresh, or like the one we have when we dream of a person. All this would have been impossible if I had arranged my models immobile as in front of a camera.[18]

The German painter Lovis Corinth painted Alfred Kuhn with a comparable sense of movement [cat. 23]. Kuhn was an art

15 Kokoschka 1974. Kokoschka considered this his most "worthwhile" painting, and in the autumn of 1910 it became the first by the artist to be acquired by a German museum, bought by Karl Ernst Osthaus for the Museum Folkwang in Hagen. In 1937 it was one of the paintings by Kokoschka included in the notorious *Entartete Kunst* exhibition.

16 The portraits of Leo (right-hand side) and Hugo (left-hand side) were left unfinished, and the portrait of Max Schmidt was painted three years later, on 20 March 1914. See Vergo 1992, no. 56, and Madrid 2001–2002.

17 This relates to his "five-minute drawings" in which he aimed rapidly to capture the changing appearance of his models.

18 Kokoschka 1974.

19 Kuhn 1925.

20 Quoted in Whitford 1997, p. 42.

21 For a detailed analysis of the symbolism in this painting, see Zander Rudenstein 1976, pp. 426–431.

22 Musil 1995.

Fig. 6
Oskar Kokoschka
Triple Portrait of the Schmidt Brothers,
1911–1914
Oil on canvas. In its original state

historian and collector, and the author of a book on Corinth.[19] The artist depicts him in the agitated and painterly style that characterizes his late work.

Suffering from a deep depression, a result of both the wounds he sustained from a grenade on the Ukrainian front and the end of his relationship with Alma Mahler, Kokoschka wrote to his friend Albert Ehrenstein from Dresden in 1916, "my strength and youth have left me, not to speak of my health."[20] A year later he painted a self-portrait [cat. 21] in which, paradoxically, his expression reveals nothing of his continuing anguish. Instead he presents himself as a dreamer, his head slightly inclined and his hands in an expressive pose. Shortly before leaving for the Front, however, Kokoschka had depicted himself as the *Knight Errant* [cat. 20] in a work that lays bare his inner turmoil with Expressionist fervor. Using a tense, agitated handling and a dark palette, he depicts himself as a knight in medieval armor, lying in a nocturnal landscape in which we see two figures: a bird-man, possibly a metaphor of death, and a sphinx-woman, interpreted as a symbol of Alma Mahler. In the stormy sky appear the letters "ES," which have been interpreted as a reference to Christ's last lament on the cross: "Eli, Eli, lama Sabachthani" (My God, My God, why hast thou forsaken me?). This mysterious work, replete with symbolism

that remains partly unclear[21] might be interpreted as a premonition of the dark future awaiting Europe; but it could also represent the mood and feelings of an entire era. These were summed up by Robert Musil in his novel *The Man without Qualities:*

> It was something measureless, an eruption propagated by the whole body, inflamed by burning emotions and on the point of exploding; from the rigid, erect fingers, the nervous contractions of the forehead, and the convulsions of the body irradiated an ever new feeling within the individual trembling.[22]

Among the other artists who made use of pronounced bodily gestures to give their portraits greater expression was Chaim Soutine, a Russian painter who had lived in Paris since 1913. In works of a style and character that are unclassifiable, Soutine focused largely on portraiture and used the portrait form as a means of exploring the human condition. Generally showing anonymous figures as types rather than individuals, he used the same poses repeatedly in order to avoid conveying any specific emotional content. In *Portrait of a Man with a Felt Hat* of around 1921–1922 [cat. 24], in which the exaggeratedly dynamic brushwork creates marvelous textures of paint, the model is seated in an unstable pose with his hands together on his lap. Soutine considered flesh to be the essential material of life, and his entire focus is on the representation of the flesh tones in the face and hands. As we can see in the *Woman in Red* of around 1923–1924 [cat. 25], he would occasionally twist facial features to such a degree that they are no longer aligned, achieving a powerful expressive force that seems to emanate more from the artist than from the sitter.

Around 1925 Soutine's Expressionism became notably less pronounced and his portraits more serene, even melancholy. His portrait of Madeleine Castaing [cat. 26], the *grande dame de la décoration* and Soutine's muse since he met her in the early 1920s in the Café de la Rotonde in Montparnasse, is a brilliant example of this transformation. Hitherto Soutine had used a highly individual pictorial idiom charged with an expressive use of paint that prefigured the Expressionist movements of the second half of the twentieth century. As we will see, Francis Bacon, with his bodies bruised to the point of revulsion, or Lucian Freud, with his equally physical and psychological vision of humanity expressed through flesh, were to return to the path that Soutine had opened up.

Paloma Alarcó

Cat. 8 Gustav Klimt
Ria Munk on Her Deathbed, 1912
Oil on canvas, 19 7/8 x 19 7/8 in. (50 x 50.5 cm)
Private collection. Courtesy of Richard Nagy Ltd., London

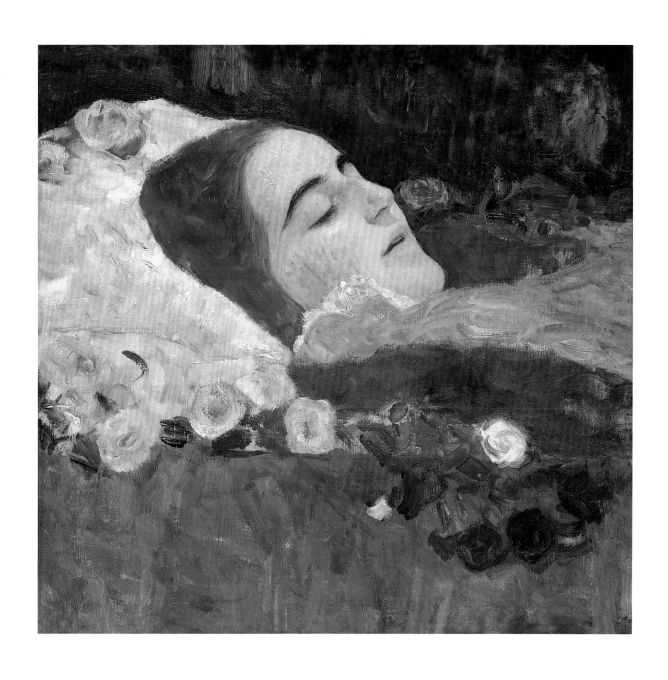

Cat. 9 Richard Gerstl
Self-Portrait against Blue Background, 1904–1905
Oil on canvas, 62 ⁷⁄₈ x 42 ⁷⁄₈ in. (159 x 109 cm)
Leopold Museum, Vienna

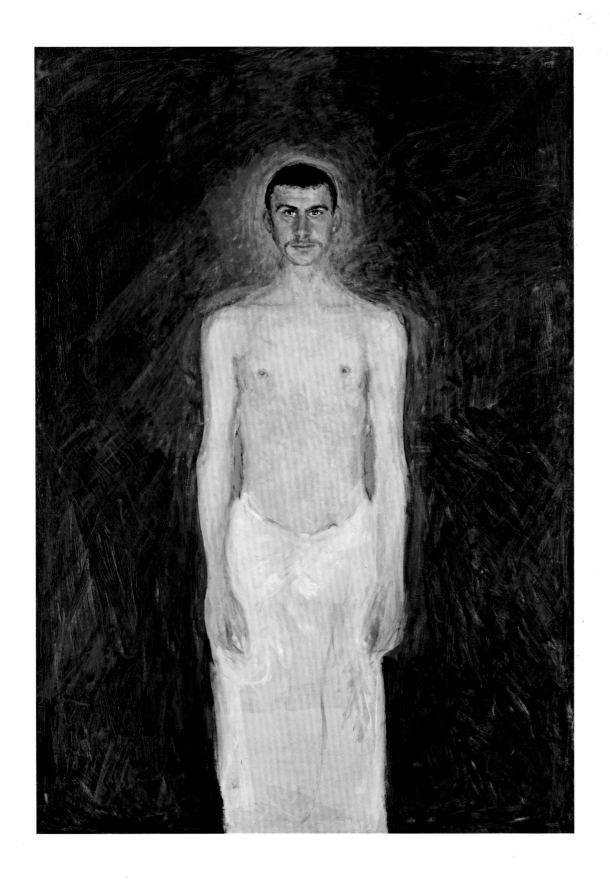

Cat. 9 Richard Gerstl
Self-Portrait against Blue Background, 1904–1905

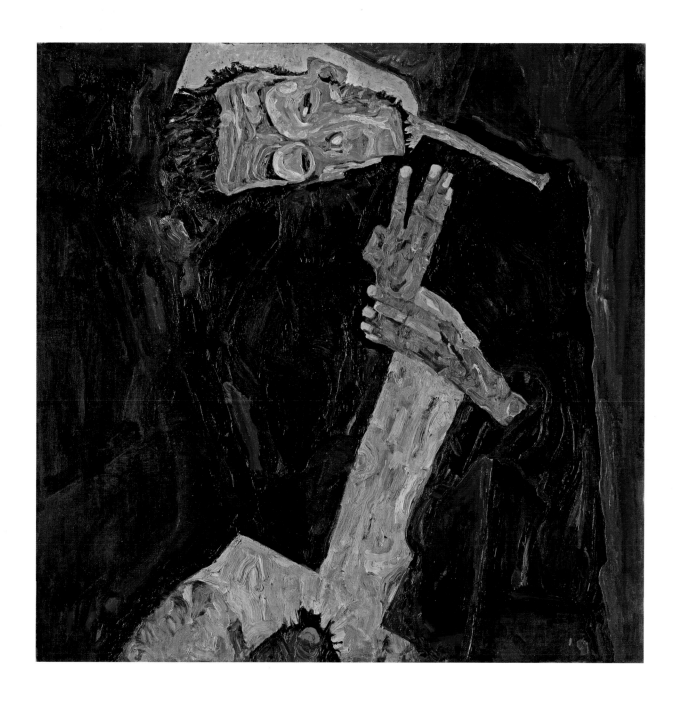

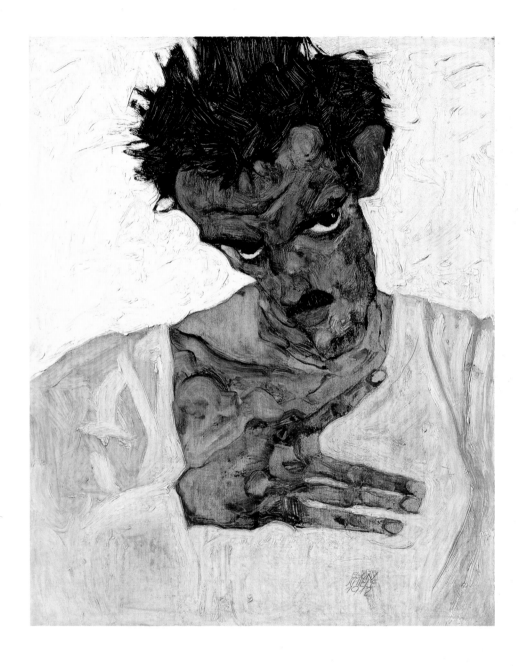

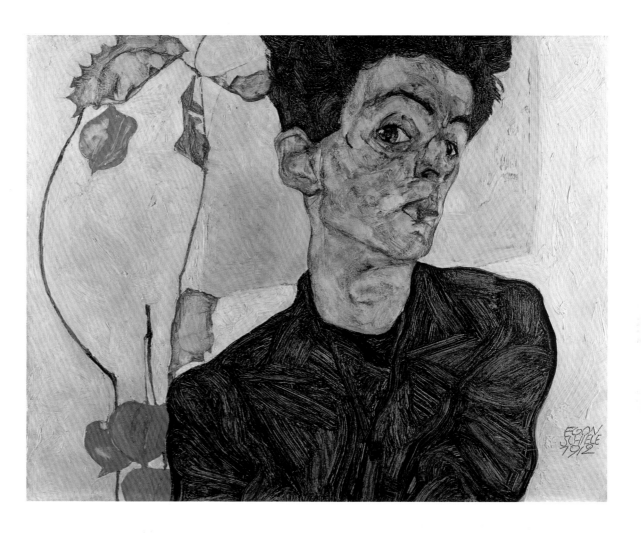

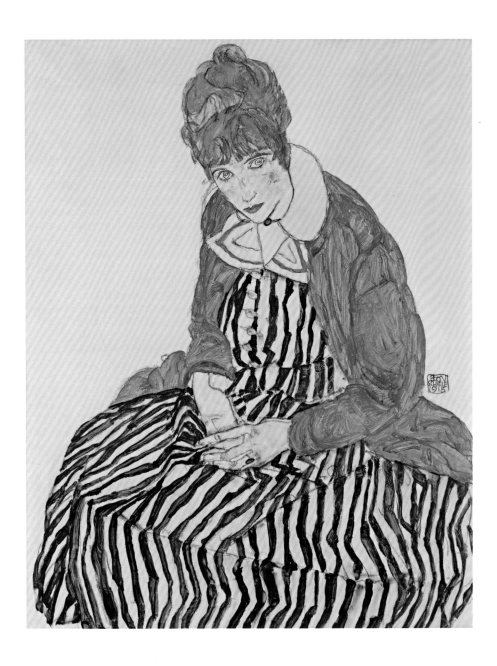

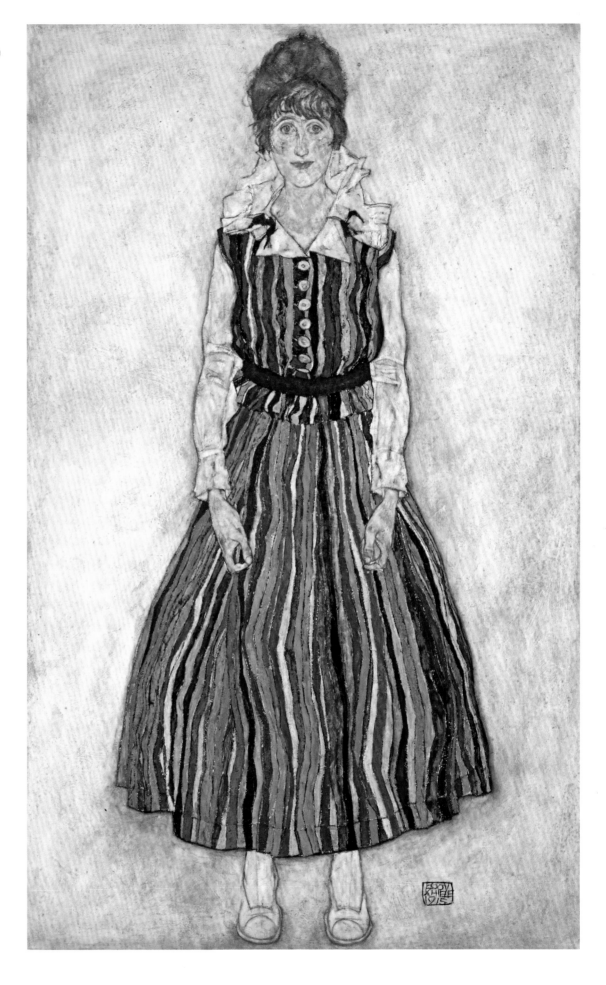

Cat. 15 Oskar Kokoschka
Lotte Franzos, 1909
Oil on canvas, 45 ¼ x 31 ¼ in. (114.9 x 79.4 cm)
The Phillips Collection, Washington, D.C.

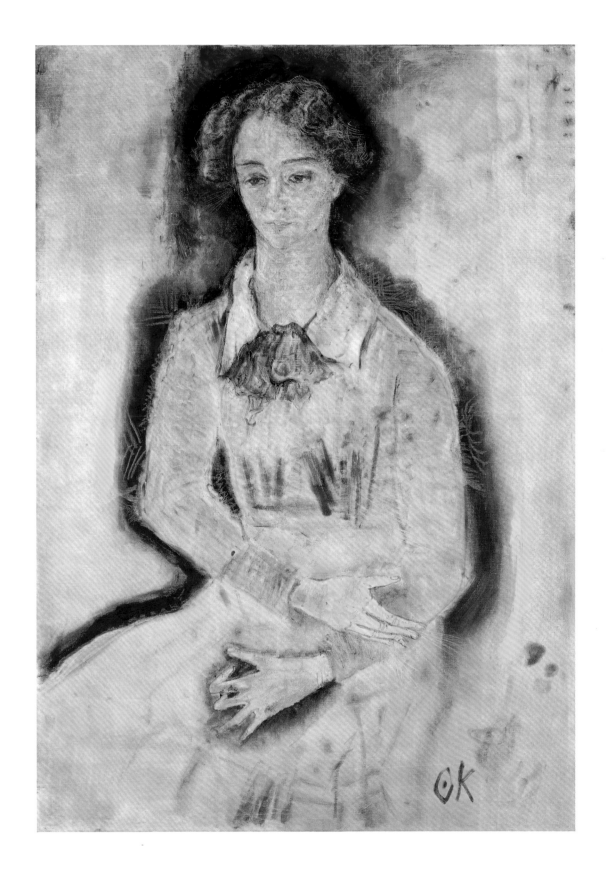

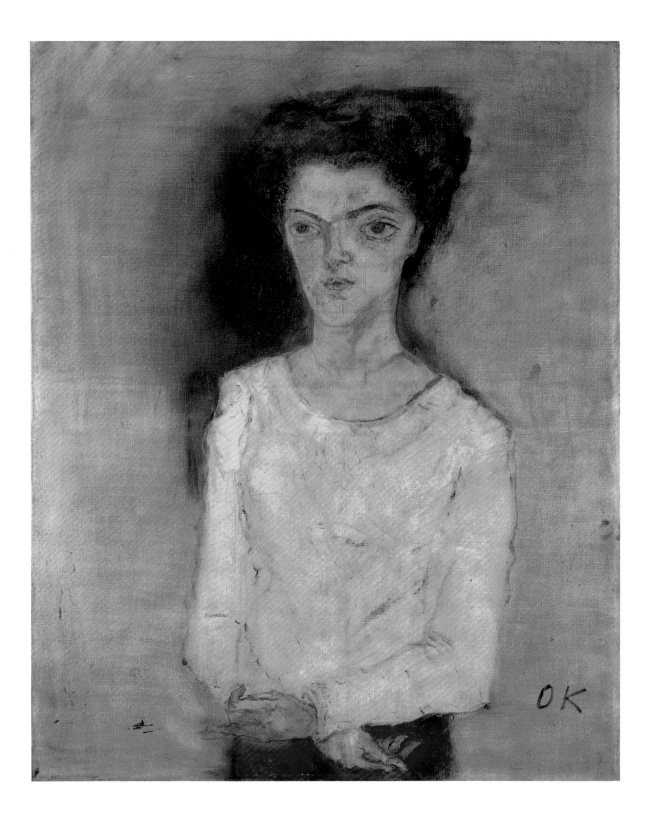

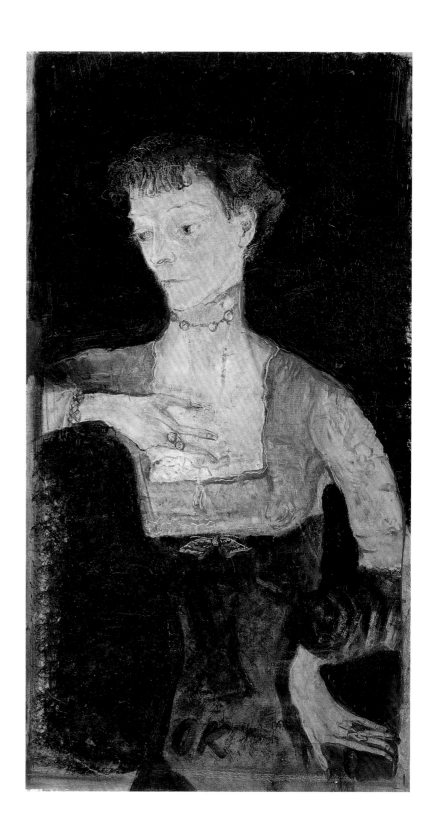

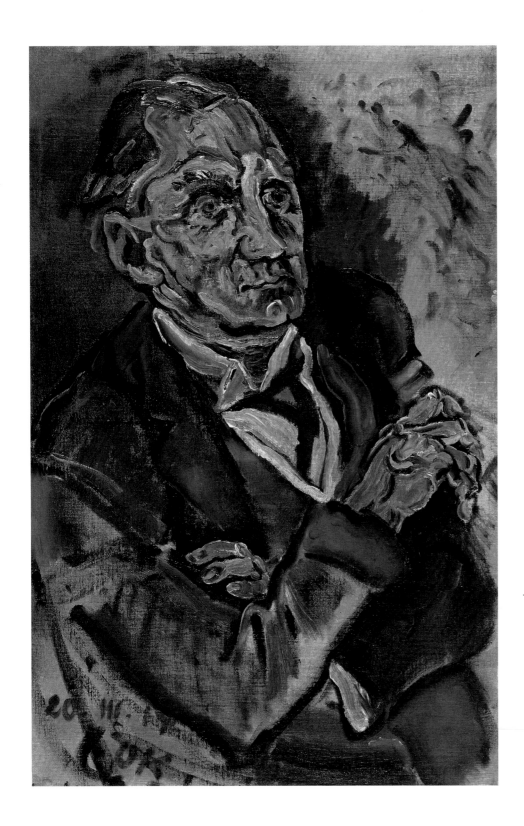

Cat. 19 Oskar Kokoschka
Nell Walden, 1916
Oil on canvas, 39 ⅜ x 31 ½ in. (100 x 80 cm)
Private collection. On deposit at the Berlinische Galerie, Landesmuseum
für Moderne Kunst, Fotografie und Architektur, Berlin

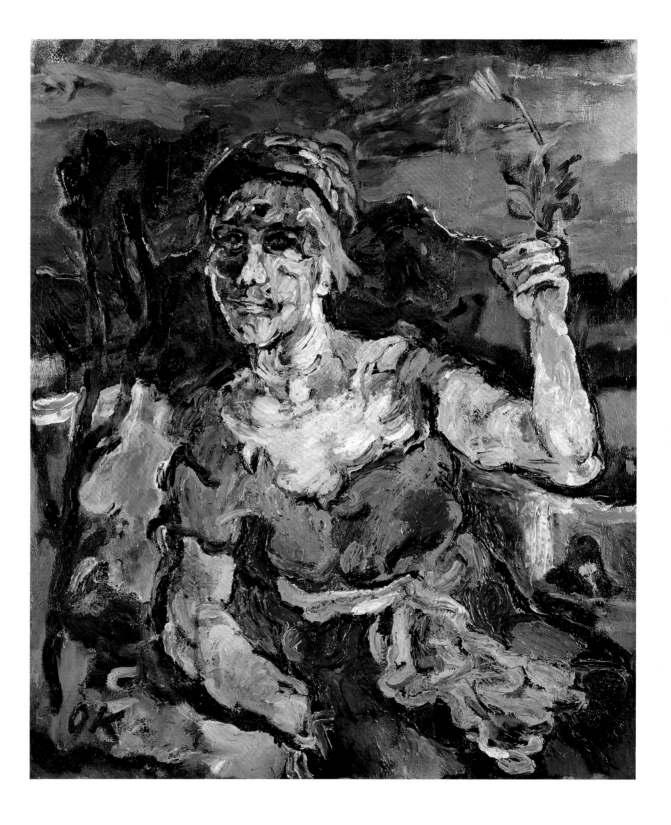

Cat. 20 Oskar Kokoschka
Knight Errant, 1915
Oil on canvas, 35 ⅞ x 70 ⅞ in. (89.5 x 180 cm)
Solomon R. Guggenheim Museum, New York
(48.1172.380)

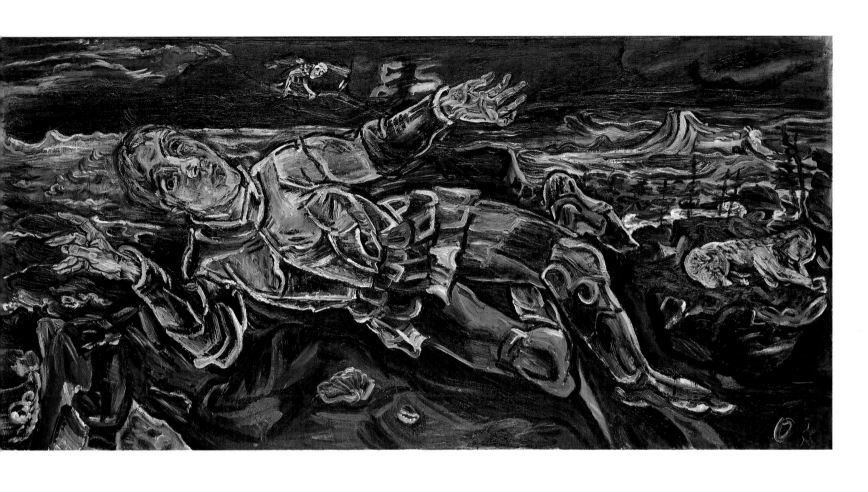

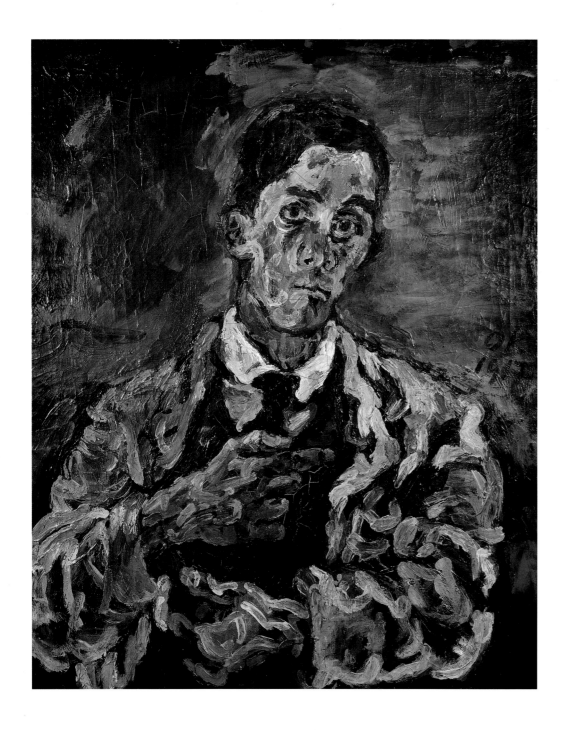

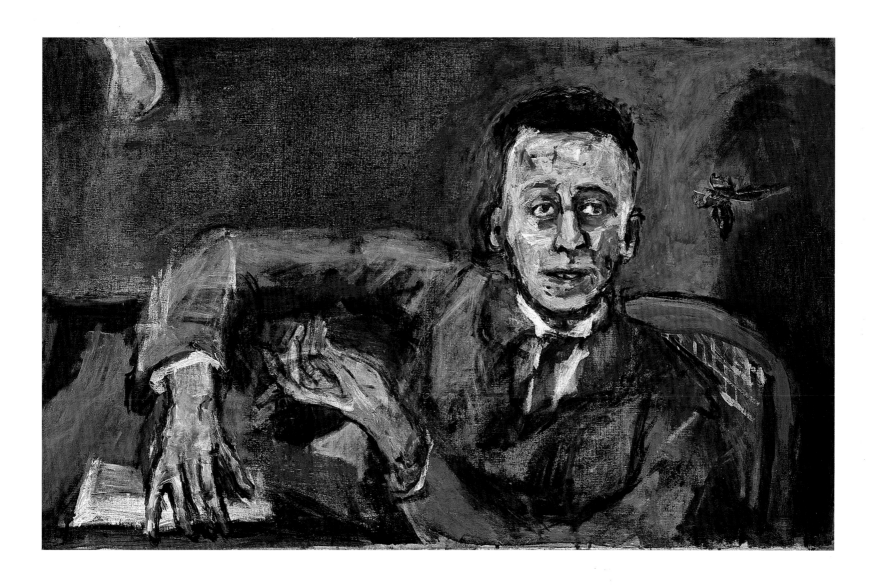

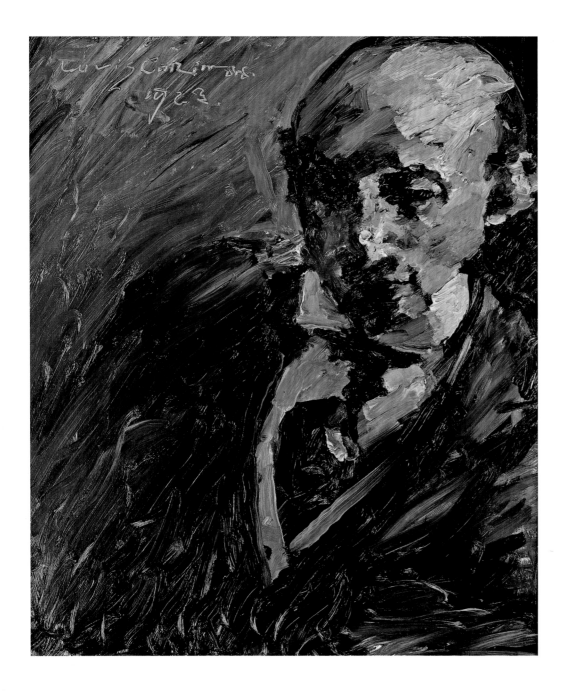

Cat. 24 Chaïm Soutine
Portrait of a Man with a Felt Hat, c. 1921–1922
Oil on canvas, 36 x 28 in. (91.4 x 71.1 cm)
Private collection, U.S.A.

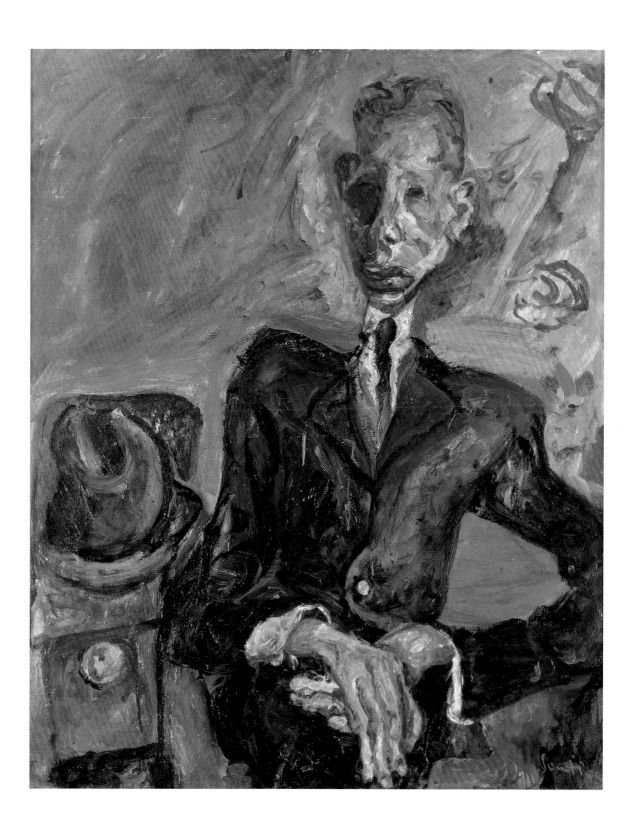

Cat. 25 Chaïm Soutine
Woman in Red, c. 1923–1924
Oil on canvas, 36 x 25 in. (91.4 x 63.5 cm)
Private collection

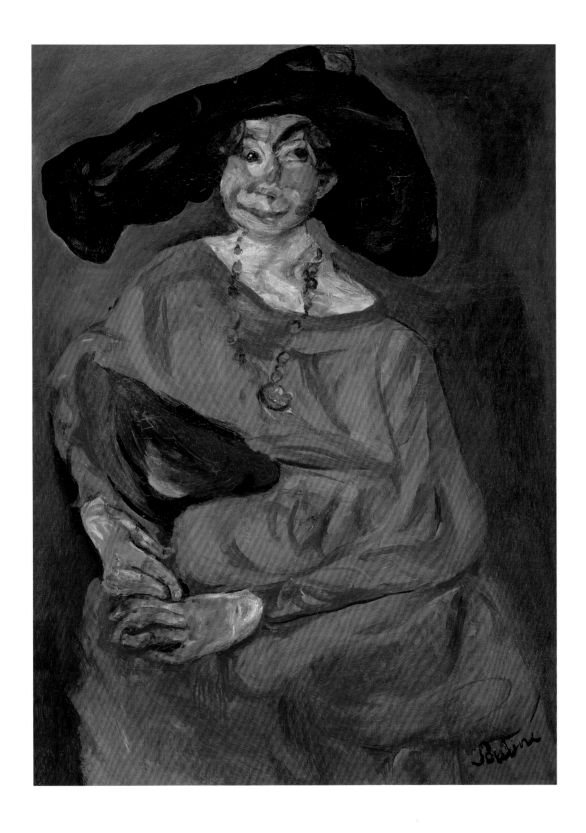

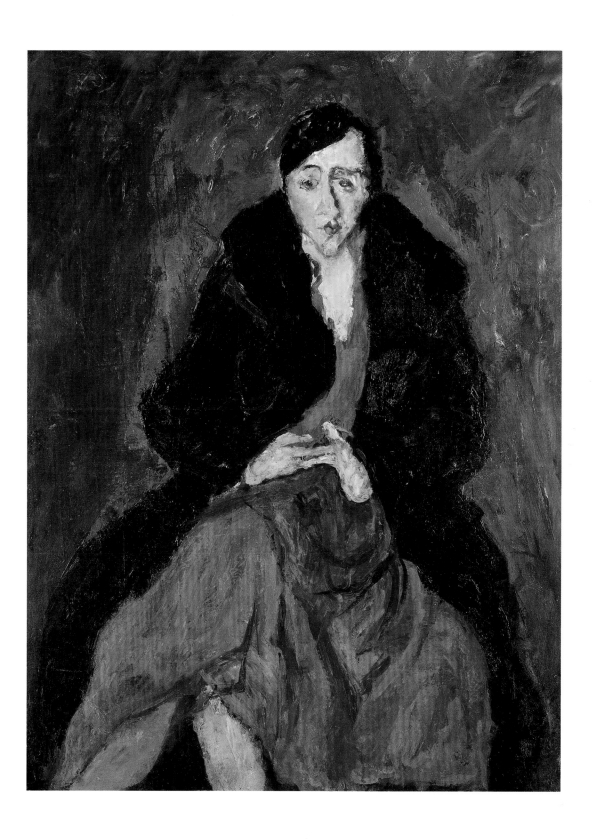

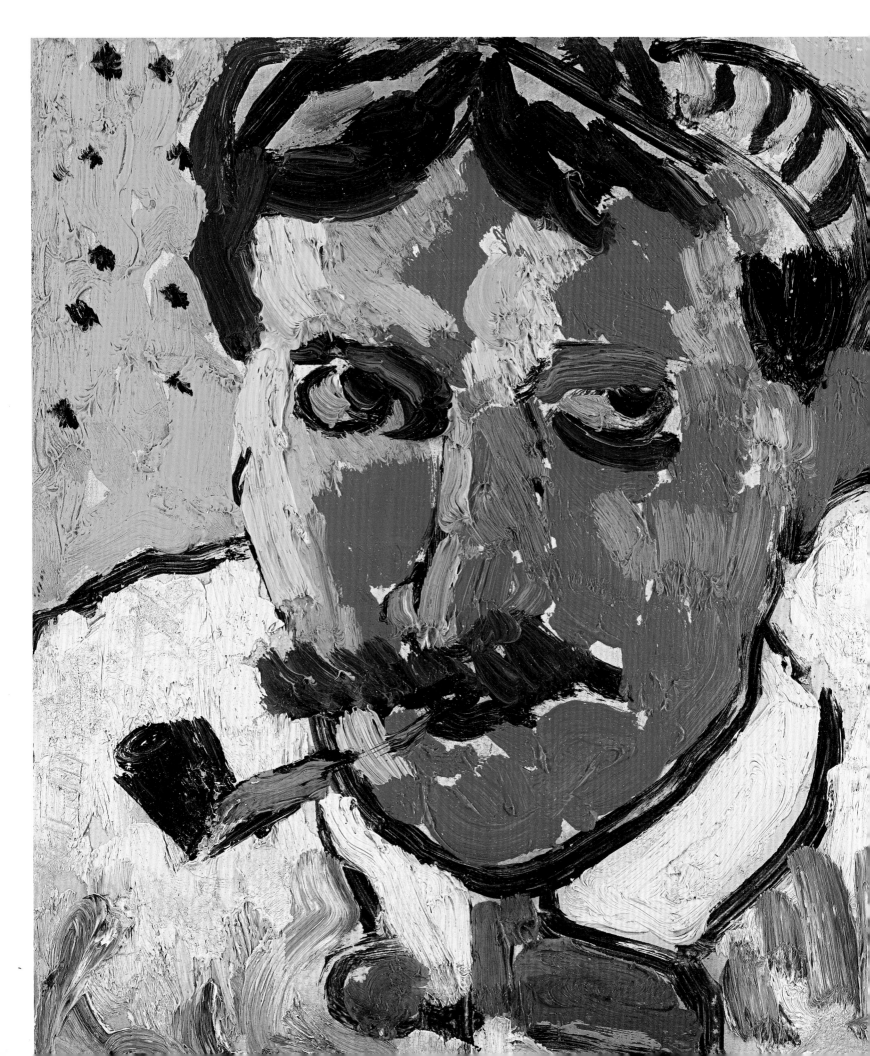

3 MODERN COLOR

Cat. 28
Maurice de Vlaminck
André Derain, 1906
(detail)

In June 1890 Vincent van Gogh wrote to his sister Wilhelmina:

> I would like to produce portraits that a hundred years from now will seem to people like apparitions. My intention is therefore not to do so through a photographic likeness but through our most intense expressions, using science and the modern taste for color as a conveying and emphasizing character.[1]

The "modern taste for color" to which van Gogh refers, his anti-naturalistic and symbolic use of color as an expressive element, combined with the rejection of realistic representation in favor of a subjective interpretation of the sitter, gradually came to prevail in portraiture. The result, in the hands of the Expressionist movements of the early years of the twentieth century, was a transformation of the genre. In 1918, in an essay on "The Problem of the Portrait," Georg Simmel referred to the still hotly debated issue of the validity of a faithful depiction of the sitter's external appearance at a time when new ways of seeing had relativized all visual perception.[2] It was in this radical shift in ways of seeing, propelled by man's new relationship with the world, that Expressionism found its particular direction with regard to portraiture.

As we noted in the first section, van Gogh and Gauguin's principal artistic concern was to go beyond visible reality. Van Gogh, who termed himself a *coloriste arbitraire*, had learned from Delacroix the way to model color with the brush to create form, making color the key element in his pictorial experimentation and symbolic conception of the portrait. When he moved to Arles in 1888, he realized his long-standing desire to become a painter of country people, and during the two years that he spent in this small town in the south of France devoted himself to painting the local citizens, putting into practice his investigations into the principles of color contrast.[3] Particularly notable among his Arles portraits are the group of portraits of the postman Roulin and his family, painted in late November 1888. Van Gogh wrote to his brother Theo in early December: "I have painted the portraits of *a whole family*; that of the postman whose head I had already painted, the man, the wife, the baby, the boy and the sixteen-year-old son; all very French in type although they seem Russians."[4] Van Gogh made use of Charles Blanc's six-pointed star[5] to establish a deliberate play of complementary colors in each of the portraits. Madame Roulin's green dress stands out against an orange background; the blue jacket of the eldest son, Armand Roulin, is contrasted against a green ground; Camille, in blue, stands out against a red and orange ground; the ultramarine uniform jacket of Joseph Roulin, the father, is contrasted against a yellow ground.[6] This portrait of the head of the family [cat. 27] was probably painted in late 1888. It presents a perfect example of the artist's use of color as a means to imbue portraiture with a symbolic aura.[7] Van Gogh was impressed by the humanity and wisdom of Roulin, the *entreposeur des postes*, and described him as a "man of sorrows, and acquainted with grief,"[8] a biblical phrase that he felt exactly fitted his character. Van Gogh depicts him to just below the shoulders in an emphatically frontal pose, albeit with the head slightly inclined to the left. Against an intense, plain yellow background (suggesting the influence of the Synthetism of Gauguin, who was at that time living with van Gogh in the Yellow House), the sitter emerges in all his humanity. The viewer's gaze is focused on the face, which is defined with loose brushstrokes of an orange tone in the brightly lit areas and green in the shadows, and framed by the blue cap and long beard. The painter also calls our attention to the gilt buttons standing out on the blue jacket with its large lapels and to the word "POSTES" embroidered in yellow on the peak of his cap.

1 Vincent van Gogh, Letter to Wilhelmina J. van Gogh, Auvers-sur-Oise, 5 June 1890, in *Van Gogh Letters* 1999, vol. III, W 22, p. 470.

2 Georg Simmel, "Das Problem des Porträts," in *Die Neue Rundschau*, no. 29, 1918. Quoted in Vienna 1991, p. 14.

3 Carol Zemel has studied the portraits painted in Arles and their utopian depiction of modern man. See Zemel 1997, p. 87ff.

4 Vincent van Gogh, Letter to Theo, Arles, 4 December 1888, in *Van Gogh Letters* 1999, vol. III, no. 560.

5 Van Gogh used Charles Blanc's *Grammaire des arts du dessin*, published in 1867, as a constant guide in his painting.

6 See Roland Dorn, "Arles Period, Symbolic Means, Decorative Ends," in Detroit/Philadelphia/Boston 2000, pp. 134–171.

7 Dorn in Detroit/Philadelphia/Boston 2000, pp. 164ff.

8 *Isaiah*, 53.3.

Paloma Alarcó

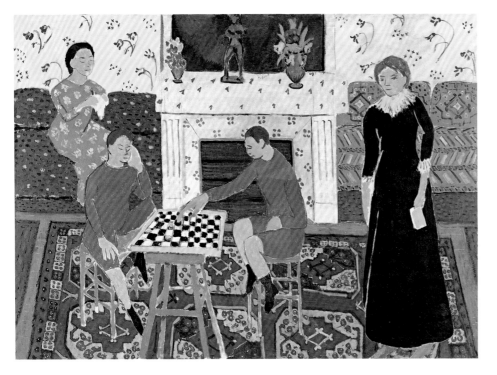

Fig. 1
Henri Matisse
The Painter's Family, 1911
Oil on canvas, 56 ⅛ x 76 ⅜ in. (143 x 194 cm)
The State Hermitage Museum, Saint Petersburg

In *The Girl with Green Eyes*[11] of 1908 [cat. 29], Matisse uses his new, more decorative approach to resolve the problem of the integration of the figure's volume into the flat plane of the canvas. The ornamental arabesques in the background and the organization of the surface of the composition derive from the influence of decorations on ceramics and Persian carpets [fig. 1]. The young woman, dressed in a red Oriental tunic, is depicted with extreme frontality. Set on her neck as though on a white pedestal, her head appears almost as one more sculpture from the decorative background. In contrast, his portrait of Olga Merson [cat. 30], painted in the summer of 1911 in Collioure, where some years before he had developed Fauve painting with his friend André Derain, offers a simplified image with none of the decorative voluptuousness and emphasis on color seen in the earlier portraits. Born in Russia in 1878, Olga Merson had enrolled as a pupil at Matisse's school in 1911[12] and seems to have had a brief affair with him. After this ended she moved to Berlin, where she was to commit suicide with the rise to power of the Nazi regime. The rigidity of her pose, with the legs pressed together and the tense hands on the skirt, is emphasized by the hardness of the outlines defined in black with the brush. The harmony of the colors, which Matisse achieves through the interplay of green and brown tones, is broken by two strange black lines that cross the figure in the form of an arch. Alfred Barr described these as "the boldest formal innovation which Matisse had achieved up to that date."[13]

It was at the van Gogh exhibition at the Galerie Bernheim-Jeune in 1901 that Matisse had met André Derain and his friend Maurice de Vlaminck. For Vlaminck, van Gogh's painting was "a painful revelation"; as John Rewald has noted, "he recognized in him a remarkable adversary"[14]—sharing the same aspirations and suffering from the same artistic deliriums. "I loved van Gogh more than my own mother,"[15] he later declared, and in his portrait of Derain of 1906 [cat. 28] the influence is clear. Despite the small format, Vlaminck depicts his friend's head almost life-size, occupying the entire surface of the canvas. The outlines of the head, the hair, the shoulders, and the neck of the shirt are outlined in black, while the features of the face are modeled using patches of the vermilion with which Vlaminck said he wanted "to burn down the Ecole des Beaux-Arts." Against the predominant red, which contrasts with touches of yellow and blue, we see a bold green brushstroke down the nose, a clear

9 For the influence of van Gogh, see Joseph J. Rishel, "The Modern Legacy of Van Gogh's Portraits," in Detroit/Philadelphia/Boston 2000, pp. 229–259.

10 Henri Matisse, *A Painter's Notes* [1908], in Matisse 1973.

11 The young woman has not been identified, although John Klein has suggested that she might have belonged to the social circle of Harriet Lane Levy, the painting's first owner. See Klein 2001, pp. 158–159.

12 Matisse's school of painting was open between 1908 and 1911.

13 Barr 1951, p. 131.

14 John Rewald, in New York 1952, p. 9.

15 Quoted in Rishel, in Detroit/Philadelphia/Boston 2000, p. 231.

Van Gogh's paintings were exhibited in Paris at the Galerie Bernheim-Jeune in 1901, and in a retrospective at the Salon des Artistes Indépendants in 1905. They profoundly moved and impressed the young artists who were labelled *fauves* when they showed their own works at the Salon d'Automne of the latter year.[9] The Fauves were also captivated by the savage primitivism of Gauguin when they saw the exhibition of his work held at the Galerie Vollard in 1903, six months after his death. With their fervent desire for change and rupture, they absorbed van Gogh and Gauguin's capacity to create forms through lines of pure color. The iconoclastic *Madame Matisse (The Green Line)* [fig. 4 on p. 31], painted in late 1905 by the wildest of these "wild ones," Henri Matisse, offered an innovative solution to conveying the identity of the model through the simplification of form and pure color's expressive violence. Matisse advocated the importance of the expressive function of color over its visual-constructive function, writing in *A Painter's Notes*, published in 1908[10]: "Color must above all aim to serve expression as much as it can."

Fig. 3
Paul Gauguin
*The Ancestors of Tehamana or Tehamana has Many
Parents (Merahi metua no Tehamana)*, 1893
Oil on canvas, 30 x 21 ⅞ in. (76.3 x 54.3 cm)
The Art Institute of Chicago (Gift of Mr. and Mrs.
Charles Deering McCormick, 1980.613)

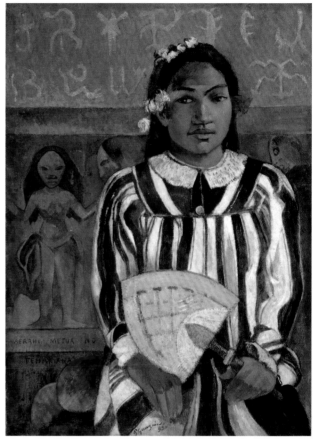

Fig. 2
Ernst Ludwig Kirchner
*Interior of the Studio of Die Brücke
at Berlinestrasse 65, Dresden
(Fränzi and a Boy)*, 1910–1911
Kirchner Museum, Davos, Switzerland

reference to the green stripe his friend Matisse had recently
applied to the face of his wife Amélie [fig. 4 on p. 31].

As is clear in his *Portrait of a Girl* of 1909 [cat. 32], Alexej
von Jawlensky was, like other Expressionist artists, more
interested in the depiction of human types than in
capturing a specific physical likeness. During the time
he spent in Paris in 1905 this Munich-based Russian artist
met Matisse and exhibited with the Fauves at the Salon
d'Automne, sharing the expressive and anti-naturalistic use
of color pioneered by van Gogh and Gauguin. *Child with
Doll (Andreas Jawlensky)* of 1910 [cat. 31] is a portrait of
Jawlensky's child with Helene Nesnakomoff. The artist's only
son, Andreas Jawlensky (1902–1984) would in turn become
a painter. Here he is depicted at the age of eight, sitting
and holding a doll, in a work painted schematically and with
a coloristic freedom highly suggestive of symbolic meaning.

The presentation of the Fauves to the Paris public
in 1905 coincided with the creation of the Expressionist group

Die Brücke in Dresden. The two movements shared the
same critical attitude against the art of the past, and
the same veneration for van Gogh and Gauguin. The formal
simplification and anti-naturalistic use of color that would
become the keynotes of the Brücke style appear full-fledged
in *Fränzi in Front of a Carved Chair* [cat. 33] by Ernst Ludwig
Kirchner. The sitter, who was around twelve when she posed
for this work, belonged to a group of girls from the working-
class quarter of Friedrichstadt in Dresden who visited the
artists of Die Brücke and posed for them [fig. 2]. Kirchner's
portrait is one of the most powerful and compelling images
of Fränzi and one of the most eloquent works of his entire
career. Wearing a printed dress and a huge collar of blue
beads, she looks fixedly out at the viewer. Her face, painted
with thicker brushstrokes than the rest of the painting,
is yellowish-green with a few touches of pink and blue;
her voluminous red lips immediately attract the eye. The
frontality of the figure suggests debts to both Munch and

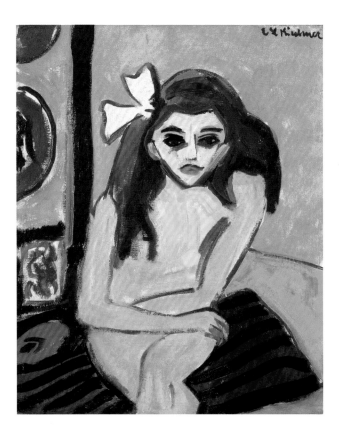

Fig. 4
Ernst Ludwig Kirchner
Marcella, 1909–1910
Oil on canvas, 29 ⅞ x 23 ⅝ in. (76 x 60 cm)
Moderna Museet, Stockholm

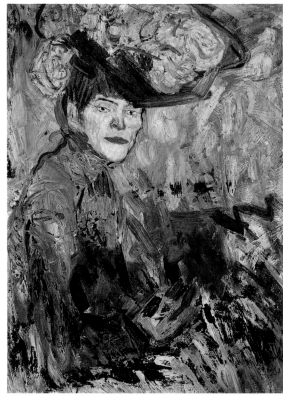

Fig. 5
Pablo Picasso
Woman on a Balcony (verso of *Absinthe Drinker*), 1901
Oil on canvas, 31 ⅞ x 23 ⅝ in. (81 x 60 cm)
Im Obersteg Foundation, on deposit at the Kunstmuseum, Basel 2004

van Gogh but above all to Gauguin. The carved female figure on the chair back, which seems to be watching Fränzi from behind, is an unmistakably Gauguinesque element. In *The Ancestors of Tehamana*, a portrait of his first Tahitian wife [fig. 3], Gauguin had used a similarly enigmatic juxtaposition, placing a wooden sculpture of a hieratic figure next to the young woman in a reference to her ancestral secrets.

Fränzi is generally associated with Marcella, another model who was frequently depicted by the Brücke artists at this period; the girls are sometimes referred to as sisters, sometimes as friends. Kirchner painted Marcella on at least two occasions: in a canvas of 1910 now in the Moderna Museet in Stockholm [fig. 4] and in *Artist: Marcella* [cat. 34]. The latter shows him responding to the tribal art that he saw in the Ethnographic Museum in Dresden, which reopened in 1910. Under this influence he made his forms more angular and his colors less strident. In the diary that he wrote retrospectively in Switzerland he noted, "in the Ethnographic Museum in Dresden . . . I found beams carved by the natives of the Palau Islands, whose figures revealed exactly the same formal language as mine."[16] In the self-

portrait that he painted in Berlin in 1914 [cat. 35], primitivism prevails almost completely over expressivity of color, and the artist's face has become a mask of schematic forms. The seductive style of the Dresden period has given way definitively to an altogether harsher treatment of both figures and faces.

The French and German Expressionist movements of the early years of the twentieth century soon left their mark on the art of other European countries. After the exhibition *Manet and Post-Impressionism*, organized by the British critic Roger Fry at the Grafton Galleries in London in 1910,[17] much avant-garde English art, particularly that of the Bloomsbury group, was created under the banner of "significant form." This idea, closely related to the theories of the Expressionists and the Fauves, was defined by the painter Vanessa Bell when she described the artist's aim as to create "certain forms and relationships of forms [that] stimulate our aesthetic emotions."[18] Her *Self-Portrait* of around 1915 [cat. 36] reveals her interest in Cézanne's approach to form and Matisse's expressive color. Some of the same Continental influences are apparent in the work of another British admirer of Post-

16 Quoted in Kornfeld 1979, p. 333.

17 The exhibition included *The Girl with Green Eyes* by Matisse [cat. 29].

18 Quoted in Judith Collins, "Bloomsbury," in London 1987, p. 102.

Fig. 7
Joan Miró
Self-Portrait, 1919 (detail)
[cat. 39]

Fig. 6
Christ Pantocrator, fresco from the
apse of the church of Sant Climent
de Taüll, c. 1123 (detail)
MNAC. Museu Nacional d'Art
de Catalunya, Barcelona.
Acquisition 1923

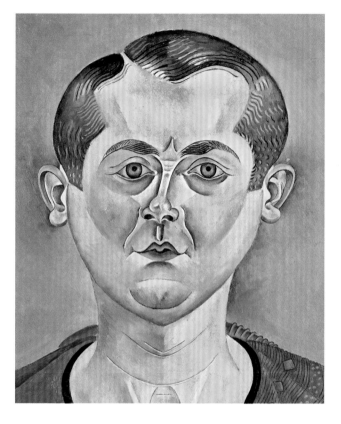

In the middle of the second decade of the century, having had moved away from the preoccupations of Catalan *noucentisme*, Miró embraced the pictorial syntax of Cézanne as well as Cubism, Fauve color, and Expressionism—which the artist had encountered thanks to the Galeries Dalmau, where his first individual exhibition was held in 1918. Among the paintings shown three years later at his first exhibition in Paris—at the Galerie La Licorne—was his portrait of Heriberto Casany [cat. 38], painted in Barcelona in 1918. Miró's friend and fellow-student, Casany is depicted seated against a flat yellow background on which hangs the image of a car, a reference to his father's business as a car dealer in Barcelona. The schematic structure recalls Catalan Romanesque paintings, whose primitive style was a further influence on Miró's painting at this period. The hieratic quality of the figure, wearing a suit, tie, and bowler hat, contrasts with the vibration of the colors and the sense of movement in the texture of his costume —in which the stripes seem to take on a life of their own. In his portraits of this date Miró aimed "to capture the immobility of a presence" and "to bring the vibration of the creative spirit to my work."[19] In his self-portrait of 1919 [cat. 39], also inspired by Catalan Romanesque frescoes [figs. 6 and 7], the handling of the brushwork has become more rigid and the chromatic range more limited, but the work retains the same frontality and the same definition of the facial features and forms of the jacket with line, revealing the Cubist influence. Miró showed this painting at the Salon d'Automne in Paris in 1920 and again a year later at the Galerie La Licorne, where it was noted as belonging to Picasso. Miró's interest in the portrait and self-portrait remains evident throughout his oeuvre—in figures that balance the abstract and dreamlike with the descriptive.

Impressionist painting, Harold Gilman. His portrait of his landlady, Mrs. Mounter [cat. 37], combines an adventurous approach to color with a highly balanced composition and an apparently total avoidance of flattery.

Picasso's early response to van Gogh's color [fig. 5] as well as Gauguin's primitivism were shared some years later by a number of Picasso's fellow-Spaniards, including Joan Miró.

Cat. 27 Vincent van Gogh
The Postman Joseph Roulin, 1888
Oil on canvas, 25 ⅝ x 21 ¼ in. (65 x 54 cm)
Kunstmuseum Winterthur. Presented by the heirs of Georg Reinhart, 1955

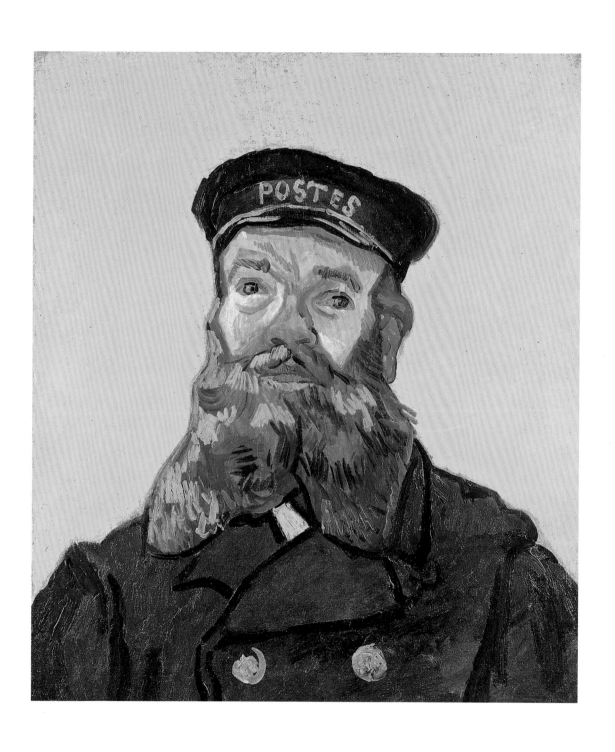

Cat. 29 Henri Matisse
 The Girl with Green Eyes, 1908
 Oil on canvas, 26 x 20 in. (66 x 50.8 cm)
 San Francisco Museum of Modern Art. Bequest of Harriet Lane Levy

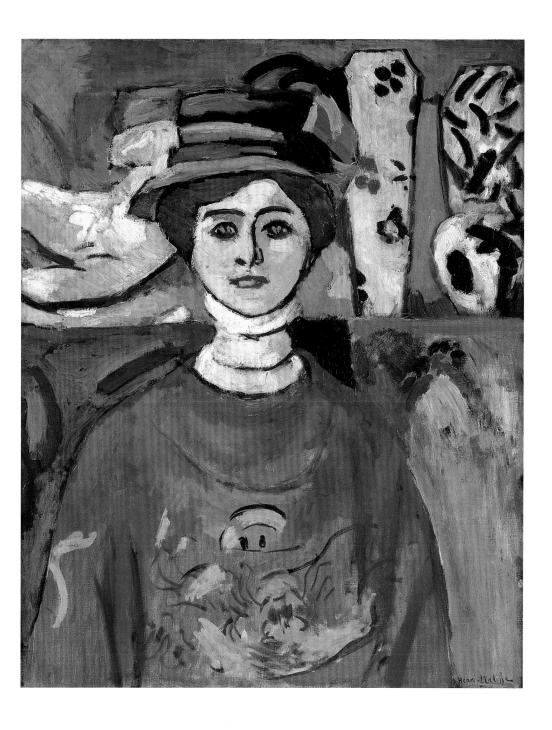

Cat. 30 Henri Matisse
Olga Merson, 1911
Oil on canvas, 39 ¼ x 31 ¾ in. (99.7 x 80.7 cm)
The Museum of Fine Arts, Houston. Museum purchase with
funds provided by the Agnes Cullen Arnold Endowment Fund

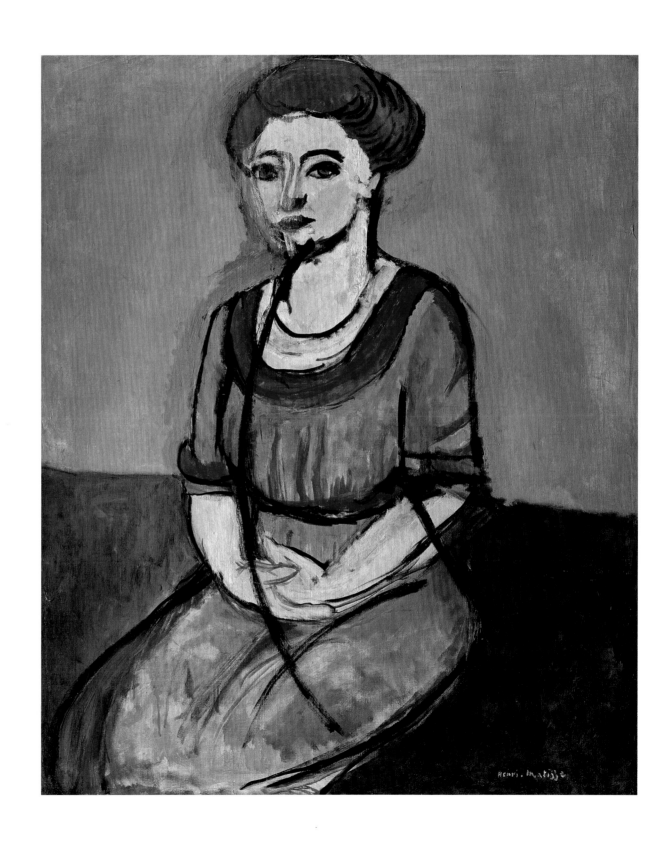

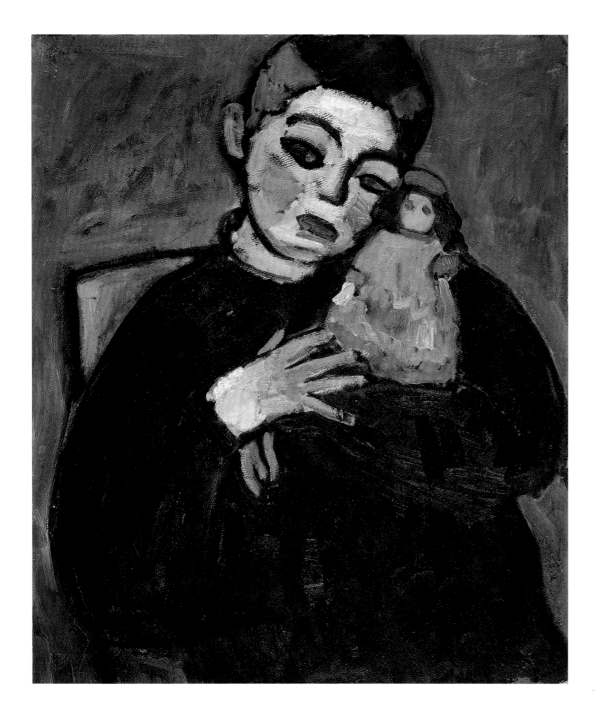

Cat. 32 Alexej von Jawlensky
 Portrait of a Girl, 1909
 Oil on cardboard, 36 ¼ x 26 ⅞ in. (92 x 67.2 cm)
 Museum kunst palast, Dusseldorf

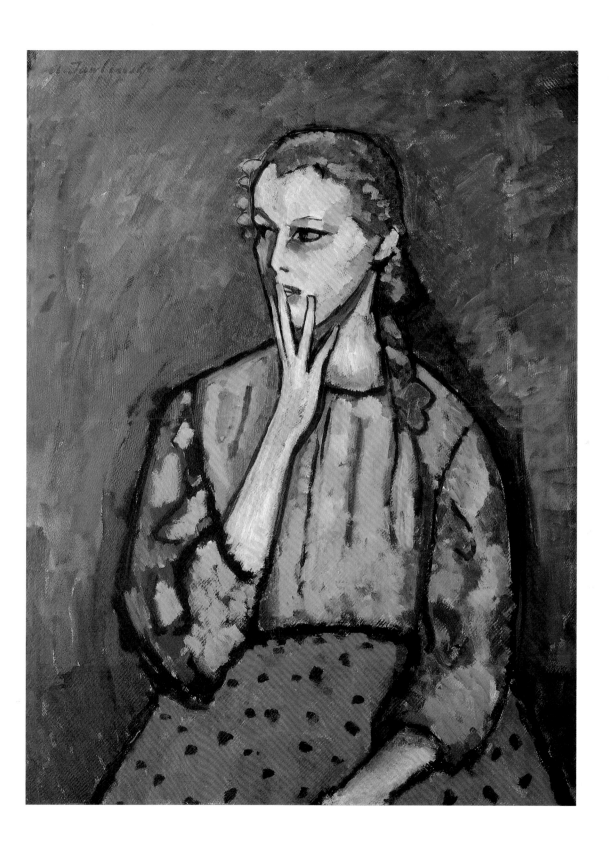

Cat. 33 Ernst Ludwig Kirchner
 Fränzi in Front of a Carved Chair, 1910
 Oil on canvas, 28 x 19 ½ in. (71 x 49.5 cm)
 Museo Thyssen-Bornemisza, Madrid

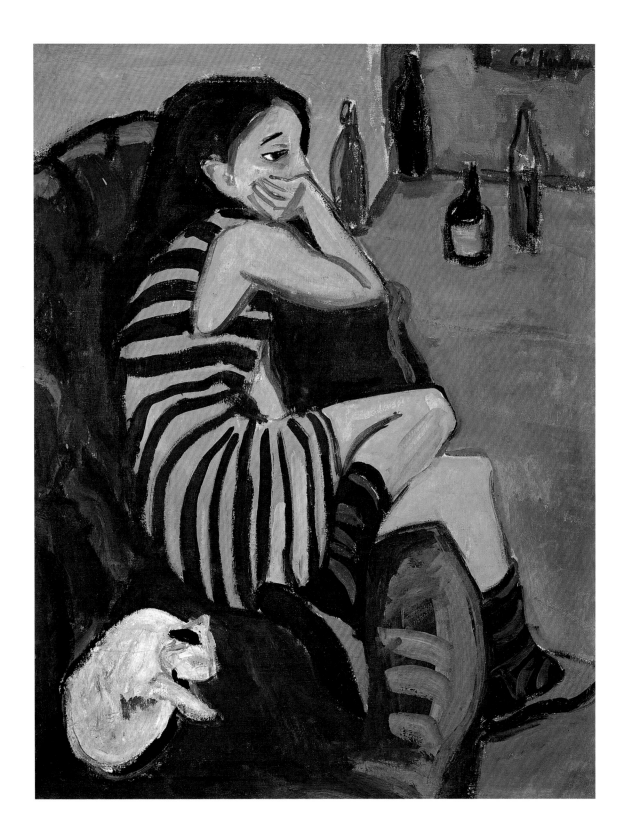

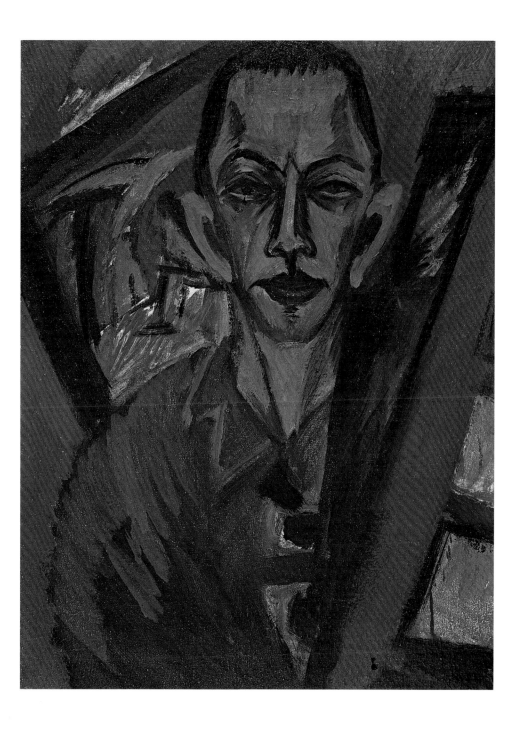

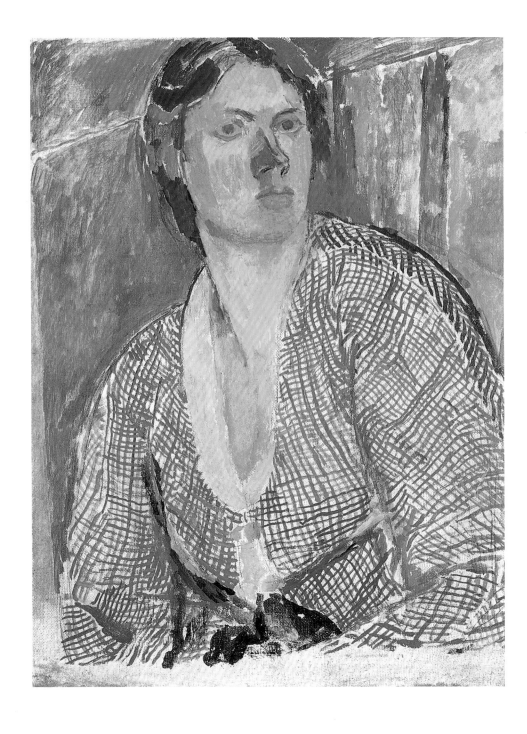

Cat. 37 Harold Gilman
Mrs. Mounter, 1916–1917
Oil on canvas, 36 ⅛ x 24 ⅜ in. (92 x 61.8 cm)
National Museums Liverpool, Walker Art Gallery

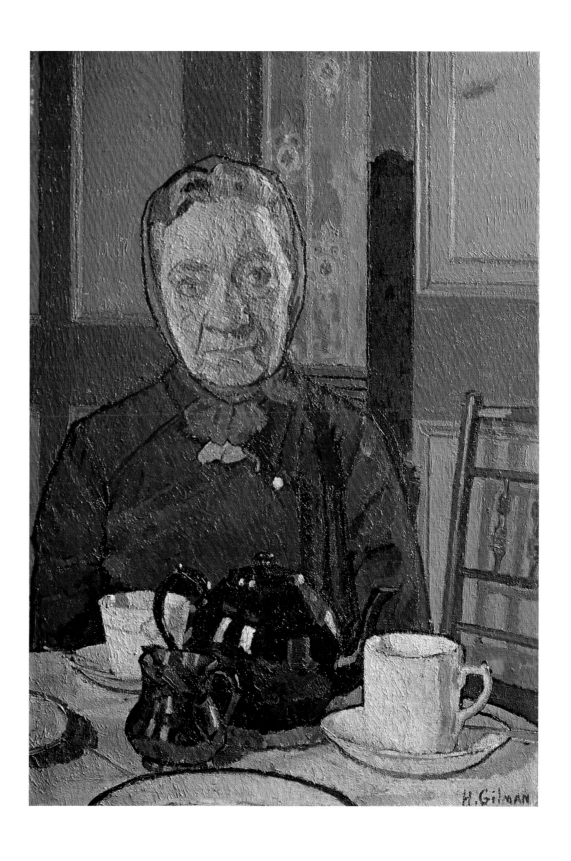

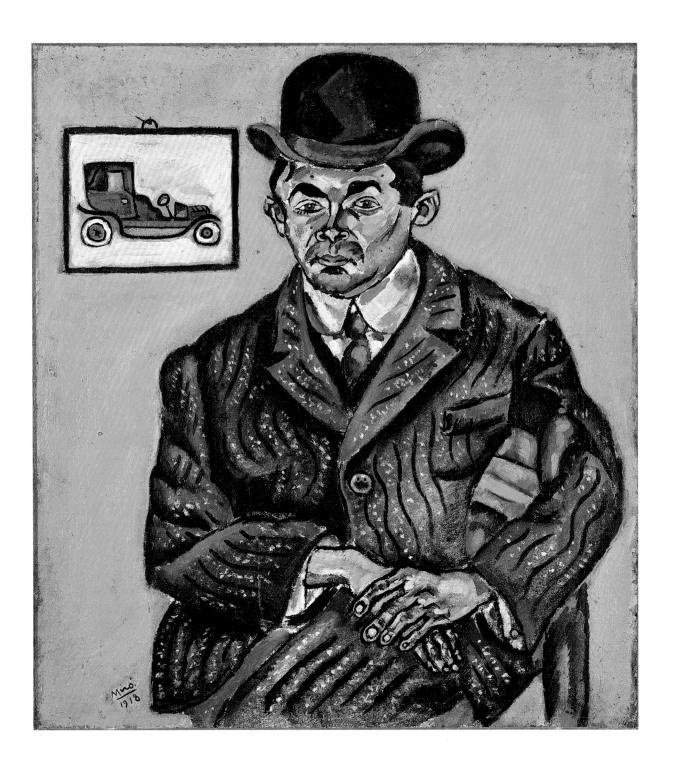

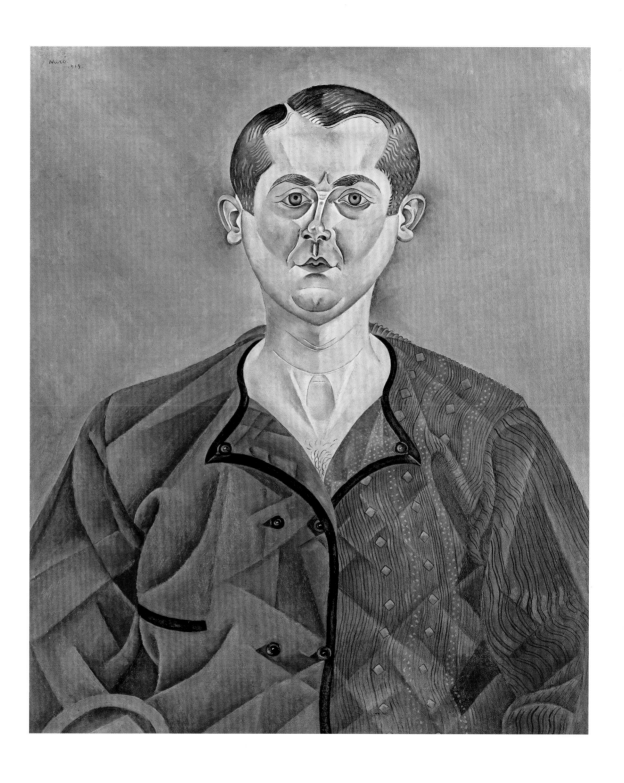

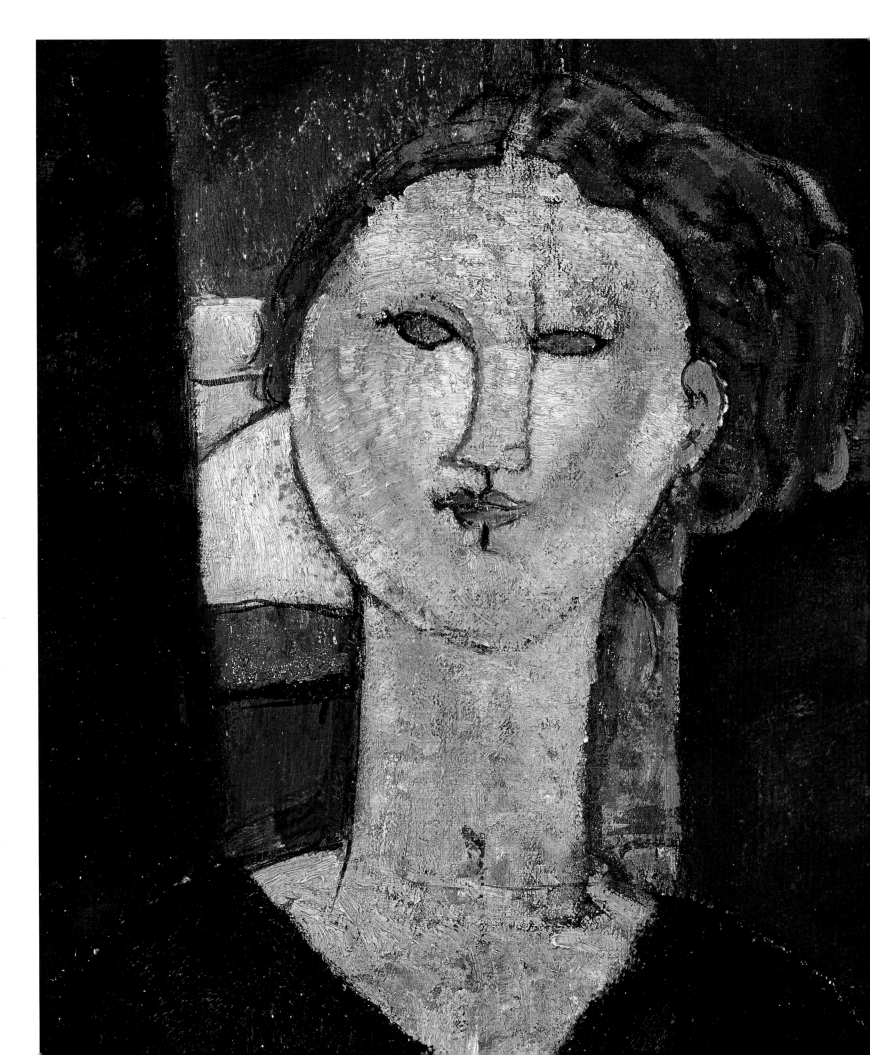

4 MASK OF THE PRIMITIVE

Cat. 54
Amedeo Modigliani
Antonia, c. 1915
(detail)

1 See William Rubin, "Reflections on Picasso and Portraiture," in New York/Paris 1996–1997, pp. 13–109.

2 Kahnweiler 1963, pp. 232–233.

3 Paul Cézanne, *Madame Cézanne in an Armchair*, 1881–1882, Foundation E. G. Bührle Collection, Zurich. Exhibited at the 1904 Salon d'Automne and acquired by Leo Stein.

4 Rewald 1996, vol. I, p. 403.

5 See Daix 1994, chap. 6, pp. 51–64, and Pierre Daix, "Portraiture in Picasso's Primitivism and Cubism," in New York/Paris 1996–1997, pp. 256–257.

6 William Rubin, "Modernist Primitivism: An Introduction," in New York 1984, vol. I, p. 11.

7 Rubin mentions that despite the fact that the Musée du Trocadero had been open since 1882 it was only discovered by artists in 1907.

8 Brassaï 1997, p. 125.

In the autumn of 1906, on his return from Gósol, where he had spent the summer, Picasso resumed work on the unfinished face in his portrait of Gertrude Stein. Working from memory and without having to see his sitter again, he converted her face into a formulaic mask inspired by the immutable simplicity of Iberian sculpture [fig. 1 on p. 26]. Picasso's iconoclastic decision deliberately to replace the individual traits of his sitter's face with a primitive mask of abstract features is almost unanimously considered the turning-point in modern portraiture. The artist no longer aimed to represent—or evoke—his sitter's appearance but to interpret it, creating his own equivalent. With this new definition of the portrait as the personal response of the artist, Picasso moved on to what William Rubin described as conceptual or transformed portraiture, in which the artist turned around the very concept of identity.[1] From this point on, identity lost its literal sense; it was no longer something predetermined but a shifting concept. As he commented to Daniel-Henry Kahnweiler, Picasso was interested in the mask primarily for its "renunciation of all imitation."[2] In addition to hiding or transforming the identity of a person, the mask allowed Picasso to break away from the mimetic purposes of portraiture up to this time.

Some months before, Picasso had begun his portrait of Stein under the influence of the portraits by Ingres exhibited at the Salon d'Automne in 1905. The pose and monumentality of the model were the artist's response to the *Portrait of Louis-François Bertin*, one of Ingres's most important portraits and perhaps one of the most memorable painted portraits of any period [see fig. 13 for related drawing]. As John Rewald has emphasized, the further parallel between Picasso's portrait of his American sitter and the majestic presence and impenetrable expression on the face of Cézanne's *Madame Cézanne in an Armchair*,[3] which hung in the apartment of Stein and her brother in Paris, cannot be mere coincidence.[4]

No doubt Picasso aimed to create a painting that could measure up to this masterpiece, but also a portrait that would not disappoint his sitter's expectations. During the long months devoted to its execution, Stein exercised a powerful intellectual influence over Picasso, an authority that, as Pierre Daix and others have pointed out, may to some extent have lain behind the crisis evident in his art from 1906.[5]

The desire to embrace the primitive, to exploit its formal and anti-mimetic possibilities—this jump back in time to the archaic that is evident in the first years of the twentieth century—was related, as William Rubin wrote in the catalogue of the exhibition *Primitivism in 20th-Century Art*, "to a fundamental shift in the nature of most vanguard art from styles rooted in visual perception to others based on conceptualization."[6] Tribal art was simple only in form, and the European artists who made use of the mask in their rebellion against prevailing canons of representation were, according to Rubin, aware of its conceptual complexity. They began to be interested in tribal objects when they realized that they coincided with their own aesthetic investigations.[7] But the reappraisal of the primitive, which acted as the catalyst for the new idioms of modern art, co-existed with a revival of interest in the work of Ingres and Puvis de Chavannes, and above all with the influence of Cézanne's analytical classicism. While it is true that the avant-garde artists appropriated primitivism in order to reject certain conventions of the European artistic tradition, in other ways they undeniably made use of that tradition.

Since Ambroise Vollard presented Cézanne's work in Paris in 1895, and above all since the artist's death in October 1906, the influence of his work on younger artists had continued to grow. Cézanne's way of looking at the world was crucial for the birth of the formalist languages of modern art. As Picasso later proclaimed: "Cézanne! He was like a father to all of us."[8] Seeking to continue Cézanne's

Paloma Alarcó

pictorial revolution, younger artists began to reduce forms to simple geometrical volumes flattened on the picture plane.

Cézanne's intention of creating a pictorial reality aside from the reality of nature meant that achieving a lifelike representation was relegated to secondary importance in his portraits. His ongoing quest for a total visual solution in which volumes, forms, and colors coexisted in complete harmony, is particularly clearly revealed in the 25 portraits that he painted of his wife, Hortense Fiquet. Cézanne had met Hortense in Paris in 1869, when she was a 19-year-old professional model, and secretly maintained a relationship with her until their marriage in 1886. Despite the fact that she almost always lived in Paris and rarely accompanied her husband during his lengthy periods in Aix, Cézanne made her one of his most important subjects. She was certainly his most patient model; as John Rewald wrote: "Hortense's only contribution to her husband's life as an artist was in posing for him repeatedly without moving or talking."[9]

Cézanne's portraits of his wife repeat the same compositional scheme with slight variations. In all of them he steered away from the requirements of a lifelike depiction of the sitter and turned her into an archetype. Though omitting almost all vestiges of spatial depth, with the result that the figure blends into the background, he presented his sitter as extremely solid—albeit lacking in any of the expressive eloquence that might enable us to interpret her psychologically. Reduced to simple geometrical volumes, her body is transformed into a block of stone while her face, also rendered extremely schematically, conveys only the mute impassivity of a mask. Cézanne treats the eyes, which generally have no gaze, in such a way as to create a deliberate asymmetry between the two sides of the face, a device that Picasso would exploit to the full.

The first of the three portraits of Madame Cézanne included in the present exhibition, dated by John Rewald to around 1888 [cat. 40], appeared at the Salon d'Automne in 1904. Typically, the artist eliminated any narrative reference and any expression in the sitter's face or her lost gaze. Madame Cézanne's blue dress with a lilac tinge contrasts with the ocher tones in the curtain and the wallpaper behind her. In *Madame Cézanne in Blue* [cat. 42] the model adopts a more expressive, slightly melancholy pose to which the blue tones undoubtedly contribute. In *Madame Cézanne in a Yellow Chair* [cat. 41], painted in the artist's apartment at 15 Quai d'Anjou in Paris between 1888 and 1890,[10] Cézanne

establishes a carefully meditated contrast between the red of the dress, the ocher of the armchair, and the greenish background. The harmony of the composition is broken by the dark molding that crosses the wall horizontally behind the sitter. For Felix Baumann, this is how Cézanne "points the way toward a questioning of the laws of linear perspective and the spatial illusionism it is meant to serve."[11]

Cézanne's death in October 1906 coincided with a major Gauguin retrospective at the Salon d'Automne. A great admirer of Cézanne, Gauguin had paid homage to him, albeit without renouncing his own Synthetist language, in his *Portrait of a Woman in Front of a Still Life by Cézanne*, painted in Brittany in 1890 [fig. 1]. The references to Cézanne are clear not just in the still life used as the background but in the way of arranging the figure and the schematic approach to the face. In the *Portrait of a Young Woman: Vaïté (Jeanne) Goupil* [cat. 43], painted in 1896 during Gauguin's second and final stay in Tahiti, Cézanne's influence is again evident in both the mask-like face and the pose—although the work's symbolism is very much Gauguin's own. Vaïté was the Maori name of Jeanne Goupil, daughter of the French lawyer Auguste Goupil, who lived with her family on a plantation near Papeete. Hers was one of the very few commissioned portraits undertaken by Gauguin. The mask to which the face has been reduced and the outline of the figure, defined with a thick blue line, emphasize the pictorial surface over any intent to create volume; the girl's hieratic figure fuses with the picture plane. The dreamy air of the painting suggests the girl's life in a paradisiacal setting far from European civilization, and repeats a composition found in earlier Tahitian portraits such as *Vahine No Te Tiare (Woman with a Flower)* of 1891 [fig. 2]. In both works the girls are absorbed in their own thoughts and dreams, which are suggested symbolically by the floral design floating over the flat background. As in the case of *Vahine No Te Tiare*, the flowers in the upper, blue part of the wallpaper in the portrait of Vaïté fall onto the lower, pink part as if they were real flowers, although in this case Gauguin did not go as far in creating a dreamlike mood as to show one of them in the girl's hand.

One of the visitors to the Cézanne exhibition held at the Salon d'Automne a year after his death, an event of enormous importance for young, avant-garde artists, was the German poet Rainer Maria Rilke (1875–1926). Profoundly moved by the exhibition, Rilke wrote a series of letters to his wife that bear witness to his highly perceptive ideas on art.[12]

9 Rewald 1986, p. 125.

10 It belongs to a group of four portraits of Hortense dressed in red. The other three are in the Metropolitan Museum of Art, New York, the Art Institute of Chicago, and the Museo de Arte, Sao Paulo. See Rewald 1986, nos. 651 [cat. 41], 652, 653, and 655.

11 Felix A. Baumann, "Portraits of Women. Woman in an Armchair," in Essen 2004–2005, p. 36.

12 Rilke 2002.

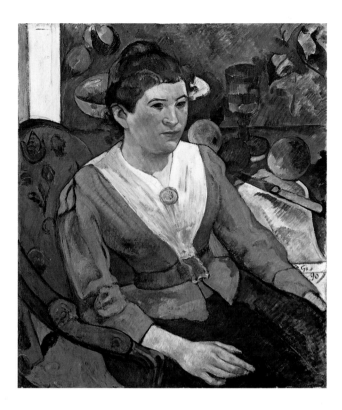

Fig. 1
Paul Gauguin
*Portrait of a Woman in Front of a Still Life
by Cézanne*, 1890
Oil on canvas, 25 ⁷/₈ x 21 ⁷/₈ in. (65.3 x 54.9 cm)
The Art Institute of Chicago, The Joseph
Winterbothan Collection, 1925.753

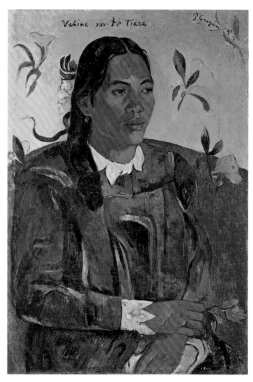

Fig. 2
Paul Gauguin
Vahine No Te Tiare (Woman with a Flower), 1891
Oil on canvas, 27 ⁷/₈ x 18 ¹/₈ in. (70 x 46 cm)
Ny Carlsberg Glyptotek, Copenhagen

Some years earlier, in 1901, Rilke's longstanding interest in the visual arts had taken him to the artists' community at Worpswede. There he had met his future wife, Clara Westhoff, as well as the painter Paula Becker, who was married to Otto Modersohn. In a small and mysterious portrait of Rilke painted by Becker in 1906 [cat. 44] during one of her trips to Paris (where Rilke worked as Rodin's secretary), we can detect the influence of both Cézanne's schematic approach to form and Gauguin's primitivism. Paula Modersohn-Becker had been drawn to Cézanne's work on her first trip to Paris six years earlier. She was the first German artist to appreciate and assimilate his painting, whose harmonies are evident in her self-portraits. These reflected an urge to affirm her artistic identity. "I am no longer Modersohn, I am no longer Paula Becker," she wrote to Rilke. "I am Myself and I hope to become ever more so."[13] The *Self-Portrait with Amber Necklace* [cat. 45] is an eloquent example of her pictorial style. In one of her most ambitious paintings, *Nude Self-Portrait with Amber Necklace II* of 1906 [fig. 4], based on a photograph taken by her sister Herma [fig. 3], the archaic style of the figure and the heavy impasto, particularly in the flesh tones, reveal certain parallels with Picasso's artistic

experiments of that year under the influence of Iberian sculpture. The highly schematic branches in the background have been related to the primitivism of Henri Rousseau, whose work she could also have seen in Paris.

The *Portrait of Monsieur X (Pierre Loti)* [cat. 46] by the unique and unclassifiable painter Henri Rousseau, nicknamed "Le Douanier" because he worked for the French Customs service, was shown at the Salon d'Automne in 1906. The identity of the sitter has been the subject of some controversy: although Wilhelm Uhde published the work with the title *Porträt des Herrn X (Pierre Loti)* in his 1914 monograph on the painter,[14] the journalist Edmond Aquille Frank stated that it was a portrait of him.[15] If it indeed depicts Pierre Loti, it may well have been based on a photograph by Eugène Atget in which Loti wears the same Turkish hat [fig. 5]. Pierre Loti was the pseudonym of Julian Viaud (1850–1923), a novelist and travel writer. Extremely popular in the North African colonies and the Far East, he became a veritable legend in the early years of the twentieth century for his life as an exile from civilization.

Painted in the simplified and primitivist technique that is characteristic of Rousseau, the portrait seems to exude

13 Paula Modersohn-Becker, letter to Rainer Maria Rilke, Paris, 7 February 1906. Quoted in Busch/Reinken 1990, p. 384.

14 Uhde 1914.

15 On the identity of the sitter, see Götz Adriani in Tubinga 2001, pp. 184–187.

Fig. 3
Photograph of Paula Modersohn-Becker
Study for *Nude Self-Portrait with Amber Necklace*
Probably made by her sister Herma Becker, Paris, early summer 1906
Paula Modersohn-Becker Stiftung, Bremen

Fig. 4
Paula Modersohn-Becker
Nude Self-Portrait with Amber Necklace II, 1906
Oil on canvas, 24 x 19 in. (61 x 50 cm)
Kunstmuseum Basel

a magical glow, the face treated as a mask of proto-Cubist angularity against which the sitter's distinctive curly black mustache stands out boldly. Wearing North African dress with a typical red fez and black jacket, Loti appears in conjunction with a number of apparently disparate elements, including a cat on a red pedestal and a landscape that is both natural and industrial in the background. With these Rousseau establishes counterpoints between nature and industry, between East and West, between man and animal. The poetic world and radical primitivism of this self-taught painter, who had exhibited at the Salon des Indépendants since 1886 and moved in Parisian avant-garde circles, made such an impression on Picasso that in late 1908 he organized a banquet in his honor at the Bateau-Lavoir.

Picasso's discovery of Rousseau's work coincided, as we have noted, with a period of experimentation based on his discovery of non-European cultures. His stay in Gósol, a small village in the Catalan Pyrenees, during part of the spring and summer of 1906—accompanied by his lover Fernande—resulted in a crucial transformation of his artistic language. In this unspoiled rural environment, which Picasso transformed into an Arcadia, the artist achieved a perfect synthesis between classicism and the archaic while also opening up the possibilities of painting Fernande as a nude. Picasso had met Fernande Olivier (1881–1966), an artists' model whose real name was Amélie Lang, in 1904, when he moved into the Bateau-Lavoir in Montmartre. During the six years of their relationship, Fernande was to be the main protagonist of his artistic experiments. Following Ingres's dictum that "painting a woman is the best way of possessing her," Picasso engaged in a visual investigation of Fernande's body and painted her nude in a wide variety of poses influenced by Ingres's *Turkish Bath*,[16] Cézanne's classicism, and the schematic primitivism of the recently discovered

16 Jean-Auguste-Dominique Ingres, *The Turkish Bath*, 1862, Musée du Louvre, Paris. This painting had not been on public display until its presentation at the Salon d'Automne of 1905.

Fig. 5
Eugène Atget
Photograph of Pierre Loti

17 Tomàs Llorens, "El desnudo, la forma, el reposo," in Madrid 2002, p. 48.

18 Pablo Picasso, *La Coiffure*, 1906. The Metropolitan Museum of Art, New York.

19 The literature on Picasso includes references to Titian's *Venus Anadyomene* (ca. 1525, National Gallery of Scotland, Edinburgh) as well as Ingres's *Venus*, 1848, Musée Condé, Chantilly.

20 See www.kimbellart.org.

21 Pierre Daix, in New York/Paris 1996–1997, p. 264.

22 The year in which Richardson considers that Picasso made his first visit to the Musée du Trocadero (now the Musée de l'Homme). See Richardson 1996, pp. 25–26.

23 Daix, in New York/Paris 1996–1997, p. 272.

water nymph, she appears against a background painted in emphatically loose brushstrokes, her features marked with an intentionally unclassical expression. The asymmetry of the mask into which Picasso has turned the face, with its pronounced arched eyebrows and disproportionately large ear, as well as the simplification and dislocation of the body, which breaches traditional canons of proportion, can be seen as a compilation of stylistic influences: Cézanne's classicism, archaic Iberian art, and the Synthetism of Gauguin's sculptures, then on show in the Gauguin retrospective at the Salon d'Automne. The painting shows clear connections to Gauguin's monumental and menacing clay sculpture *Oviri* [fig. 7], in which the artist achieved a rethinking of traditional notions of beauty and demystified the sensual appeal of the female nude. The connections are all the more evident if we bear in mind that, as is evident in x-radiographs, Picasso initially depicted Fernande with her knees drawn up.[20] Picasso's response to Gauguin's *Oviri* is still clearer in a sculpture of this period, *Woman Combing Her Hair* [fig. 8], originally created in ceramic in the studio of the sculptor Paco Durrio and shortly afterwards cast in bronze by Ambroise Vollard. Here again Picasso achieves a synthesis of elements from a wide variety of cultures and periods in order to create a timeless work. Rather than evoking a classical harmony, however, he used the nude and the portrait as means to experiment with primitivist simplification. As Pierre Daix wrote, his aim was "to go beyond immediate resemblance, beyond even the exaltation of beauty, in order to arrive at an image of a woman outside time, far removed from any fashion, an immemorial woman who would, in fact, hark back to the simplicity of the first attempts at artistic expression."[21]

Picasso gradually transformed the image of *la belle Fernande* thanks to the formal simplifications of African masks, whose impact appears in his work from the winter of 1907.[22] In *Woman with Fan* of 1908, she becomes totally geometrical, and her face takes on the aspect of a Fang mask. The portrait barely retains any references to the model and has become, in Daix's words, "a geometric abstraction, hieratic and immemorial."[23] This abstraction is also to be seen in the small bronze sculpture *Mask of a Woman* of 1908 [cat. 47] in which Fernande's face has been transformed into a death mask. For Picasso, the primitive ceased to be merely a means of changing his artistic idiom and became an exorcism that liberated him from the Western artistic tradition.

Iberian sculpture. In his chapter on the nude in the catalogue of the exhibition *Form: The Classical Ideal in Modern Art*, Tomàs Llorens emphasized that this return to the posed nude at Gósol was "the key step that allowed [Picasso] to move forward in his conquest of the Parisian avant-garde."[17]

In addition to the portrait of his friend Gertrude Stein, Picasso had left behind him in Paris another unfinished canvas indebted to Ingres. This was *La Coiffure*,[18] which he also rapidly completed in a primitivist style on his return from Gósol. Here Fernande is shown standing and arranging the hair of another young woman who looks at herself in a mirror. The other works of that autumn that show Picasso similarly simplifying his lover's face include the *Nude Combing Her Hair (Fernande)* [cat. 48], in which Fernande combs her hair in front of a mirror located in the position of the viewer. Transformed into a classical goddess emerging from the sea like a *Venus Anadyomene* [fig. 6],[19] or into a Gauguin-like

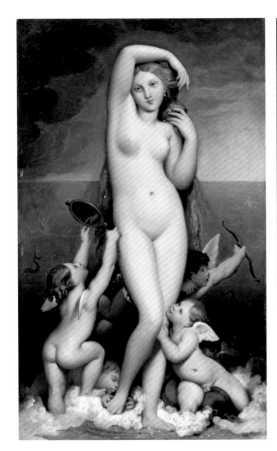

Fig. 6
Jean-Auguste-Dominique Ingres
Venus Anadyomene
Oil on hardboard, 12 ¼ x 7 ⅞ in. (31 x 20 cm)
Musée du Louvre, Paris

Fig. 7
Paul Gauguin
Oviri, 1894
Carved stoneware, 29 ½ x 7 ½ x 10 ⅝ in. (75 x 19 x 27 cm)
Musée d'Orsay, Paris

Fig. 8
Pablo Picasso
Woman Combing Her Hair, 1906
Bronze, 16 ⅝ x 10 ¼ x 12 ½ in.
(42.2 x 26 x 31.8 cm)
Musée Picasso, Paris

For the sculptor Pablo Gargallo, the mask was the means of combining formal simplification with a desire to go beyond appearance. In 1913 in Paris he sculpted a stone mask of Picasso,[24] producing an edition of several casts in terracotta and bronze, one of which is included in the present exhibition [cat. 49]. Through the grimace and the winking eye, Gargallo presents a sarcastic vision of his friend as he remembered him from their meetings at the gatherings at *Els Quatre Gats* in Barcelona. The rounded bulk and exaggeration of the closed, solid volume are surprising, emphasizing the nature of Picasso's "obsidian head," as André Malraux described it years later,[25] at a time when Gargallo had been experimenting for some time in his wrought-iron sculptures with the concept of the void. The head is generally related to the capitals on the façade of the Teatre Bosc on the Rambla del Prat in Barcelona (now a cinema), executed in 1907, for which Gargallo sculpted masks of himself and three friends: the painters Picasso and Isidre Nonell, and the *noucentista* architect Ramón Reventós.

In March 1906 Gertrude Stein and her brother took Matisse to Picasso's studio to see the portrait of Stein as it was being created,[26] and at this same period Picasso was able to see Matisse's *Le Bonheur de vivre* at the Salon des Indépendants. On the basis of these encounters, a relationship of mutual curiosity developed between the two artists, not devoid of a legendary element of competitiveness.[27] Picasso's growing interest in the primitive as a means of creating an autonomous artistic language was shared by Matisse, who in the autumn of 1906 acquired his first African sculpture. In the portrait of his wife shown at the Salon d'Automne in 1913 [fig. 5 on p. 32], described by André Salmon as a "character from a nightmare," not only has Amélie's face been turned into an impersonal Punu mask, but other vehicles of human emotion such as the hands have also been made schematic. The progressive reduction of form and color in Matisse's portraits between 1914 and 1918 was interpreted by Pierre Schneider as the artist's response to the devastation of war.[28] Despite the fact that the pose still falls within the traditional format of the full-length

24 Museu Nacional d'Art de Catalunya, Barcelona.

25 Malraux 1974.

26 Daix 1977, p. 74.

27 See John Golding, "Introduction," in London/ Paris/New York 2002–2003.

28 Schneider 2002, p. 87.

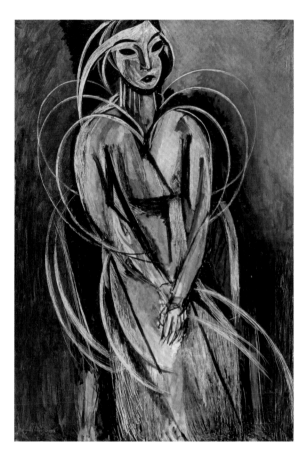

Fig. 10
Henri Matisse
Yvonne Landsberg, 1914
(cat. 51)

greater amplitude [*plus d'ampleur*] in space,"[31] have been interpreted in numerous different ways. Barr related the painting to Futurist theories and Henri Bergson's philosophy of the *élan vital*. Many subsequent writers have pursued his ideas,[32] making the Landsberg portrait one of the paintings by Matisse most discussed in the art-historical literature.

Like Picasso, Matisse painted himself on numerous occasions. In his self-portrait of 1918 [cat. 52] he depicted himself in the role of artist, seated in front of his easel in his room in the Hotel Beau-Rivage in Nice. Various everyday objects are included, such as the piece of furniture in the background with a wash basin and water jug, the towel rail with a recently used towel, and the umbrella stand with umbrella. In contrast, the way Matisse is dressed, in a formal dark green suit and black tie, gives him a professional air. The hieratic nature of the image and its construction in terms of contrasting forms recall Cézanne's approach to the figure. The restrained handling emphasizes the sculptural effect of the image (which seems almost more sculpted than painted). There is a sobriety to the work that, as John Golding remarked, Matisse had already brought to his plaster sculptures as he set about "translating Cézanne's stroke into Rodin's *métier*."[33] Cézanne's influence is also evident in the flattening of the scene, which is almost devoid of perspective, an effect heightened by the placement of the palette in parallel to the picture surface.

André Derain was a close friend of Picasso from the time they met in Montmartre in 1906. Shortly before leaving for the Front in 1914, he spent the month of July in Avignon. Picasso was also there and may at this time have acquired Derain's *Portrait of a Girl* [cat. 50]. This was a work with which he strongly identified; as Pierre Daix noted, "it was very close to the mannerism of his Blue period and also to the issues of the reconstruction of the space around a seated figure."[34] The figure of the girl, which recalls an Italian Madonna, and the face, which becomes a mask, are influenced by the tribal art in which Derain had been interested since 1906—while the unfinished effect in the painting of the white shawl, where areas of canvas remain visible, indicates lessons learned from Cézanne. On the other hand the work prefigures Derain's later attempts, in the spirit of the so-called "return to order," to revive the solidity of painting using modern means.

It was also in 1906 that Amedeo Modigliani moved from Italy to Paris, where he rapidly made contact with the

portrait, his 1914 portrait of Yvonne Landsberg [cat. 51] is a paradigmatic example of his radical primitivism in these years. The sitter was the twenty-year-old daughter of a Brazilian temporarily based in Paris. Matisse first portrayed her in pencil, a work commissioned by her brother Albert, and later painted her in oil at his own suggestion.[29] Albert Landsberg, who was present at each sitting, told Barr that the painting began as a "strikingly recognizable portrait of Yvonne, but that it moved farther and farther from physical appearances until it no longer seemed to depict her at all."[30]

The abstract and geometrical treatment of the figure and face of the young woman became the key elements in the composition. The face, transformed into a mask smeared with white, was created painstakingly. Matisse applied the paint in successive layers, into which he incised lines with the butt end of the brush, removing the paint in some areas to obtain a more aggressive effect. The incised lines, which in 1951 Matisse described to Alfred Barr as "lines of construction which I put in around the figure in such a way as to give it

29 As John Klein states, the decision to paint a work in oil was taken purely by Matisse with no prior commitment from the family to acquire the painting, which they ultimately did not do. See Klein 2001, pp. 166 and 169.

30 Barr 1951, p. 184.

31 Quoted in Klein 2001, p. 168.

32 See Klein 2001, note 45, pp. 268–269.

33 John Golding, "Introduction," in London/Paris/New York 2002–2003, p. 27.

34 Daix 1995, p. 269.

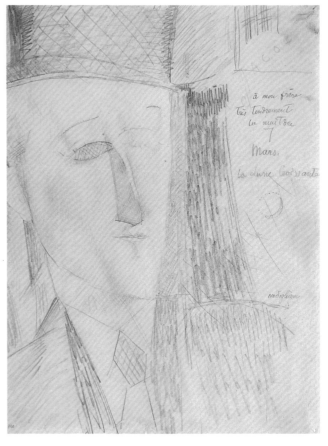

Fig. 12
Amedeo Modigliani
Preparatory sketch for the portrait of Max Jacob,
1915–1916
Pencil, 13 ⅝ x 10 ⅜ in. (34.5 x 26.5 cm)
Musée des Beaux-Arts de Quimper, France

Fig. 11
Jean Cocteau
*Max Jacob on the boulevard Montparnasse;
in the background are Picasso and Manuel
Ortiz de Zárate*
Photograph, bound in a copy of Jacob's book
of poems *Le Cornet à dès*, with a dedication
by the author and illustrations by Picasso
Musée Picasso, Paris

burgeoning avant-garde, and where the events of his
turbulent life and premature death would turn him into
a Romantic myth of the modern artist. Modigliani was
above all a portrait painter and, according to Werner
Schmalenbach, his need "to take possession of those
around him" answered to a "primary instinct"[35] deriving
from his essential nature as an artist. Always taking the
tradition of painting as his starting point, Modigliani imbued
his entire oeuvre with a classical serenity and harmony
combined with a schematic approach to form derived
from primitive sculpture and the influence of Cézanne
and Gauguin. He subjected his sitters to a pronounced
geometrical and schematic process which, combined with
an almost sacred hieratism and emotional distancing,
raised them to the category of effigies. As Tamar Garb has
aptly noted: "The power of Modigliani's portraits lies in their
capacity to render the tensions between the generic and
the specific, the mask and the face, the endemic and the
particular."[36]

In his *Antonia* of around 1915 [cat. 54], the influence of
Cubism is manifested through the representation of the
nose and the ear in profile within a face aligned frontally,
as well as in the asymmetry of the pupil-less eyes.
The frontality of the image is exaggerated through the

lengthening of the vertical format and the lines of the
stretcher of a canvas in the background. In 1916 Modigliani
made various portraits of his great friend the writer Max
Jacob (1876–1944). In the first of these, a discreetly Cubist
canvas, he depicts him in a black hat [cat. 53], like the one
that he wears in a photograph taken by his friend Jean
Cocteau [fig. 11]. Werner Schmalenbach has pointed out
that the influence of Cubism is evident in the geometrical
structuring of the face, its asymmetry, and "an emphasis
on the nose."[37] This is even more obvious in the preparatory
drawing for the painting [fig. 12]. As in all of Modigliani's
portraits, the identity of the sitter has been hidden through
an emphasis on type. The face is rendered schematically,
the eyes are asymmetrical, one of them blank and the
other green but both devoid of gaze, and the features are
transformed into signs. As though to compensate for the
relatively diminished attention paid to the model's identity,
Modigliani wrote Jacob's name across the background.

35 Werner Schmalenbach, "The
 Portraits," in Paris 2002, p. 33.

36 Tamar Garb, "Making and
 Masking: Modigliani and the
 Problematic of Portraiture," in
 New York/Ontario/Washington
 2004, p. 53.

37 Schmalenbach 1990, p. 31.

Fig. 13
Jean-Auguste-Dominique Ingres
Portrait of Louis-François Bertin, 1832
Pencil, 12 ⅜ x 9 ¼ in. (31.5 x 23.5 cm)
Musée du Louvre, Paris

Fig. 14
Pablo Picasso
Portrait of Max Jacob, 1915
Frontispiece of Jacob's *Le Cornet à dés*
Musée Picasso, Paris

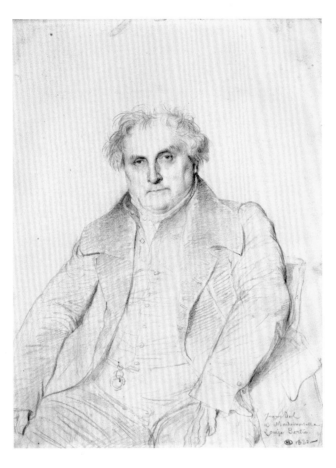

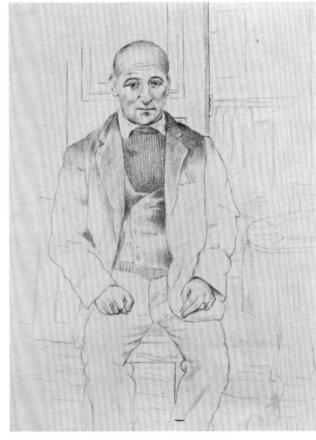

In this bust-length portrait of Jacob, the geometrical approach and manner of suggesting a sculptural volume relate explicitly to Modigliani's work as a sculptor, in which he was influenced by his friend Constantin Brancusi and by primitive masks, but also to the proto-Cubist figures of Picasso. Paradoxically, Picasso was at the same time consciously emerging from his Cubist experiments in a series of pencil portraits influenced by Ingres, including that of Max Jacob [figs. 13 and 14], which announce a new phase in his work. On January 7, 1915, Jacob wrote to Apollinaire, at that time at the Front, telling him that "I am posing in Picasso's house, in front of him; he is doing my portrait in pencil which is very beautiful, it seems at once a portrait of my grandfather, of an old Catalan peasant and of my mother."[38] Shortly after this, Cubist elements and the emphasis on sculptural volume disappear from Modigliani's work too. In the *Portrait of a Young Woman*, dated between 1918 and 1919 [cat. 55], he offers an essay in the tradition of harmonious and aristocratic female portraiture, stylizing the figure and exaggerating the length of the neck while individualizing the sitter by means of the curls on her forehead.

38 Quoted in Daix 1995, p. 751.

Cat. 40 Paul Cézanne
Madame Cézanne, c. 1888
Oil on canvas, 39 ⅝ x 32 in. (100.6 x 81.3 cm)
The Detroit Institute of Arts. Bequest of Robert H. Tannahill

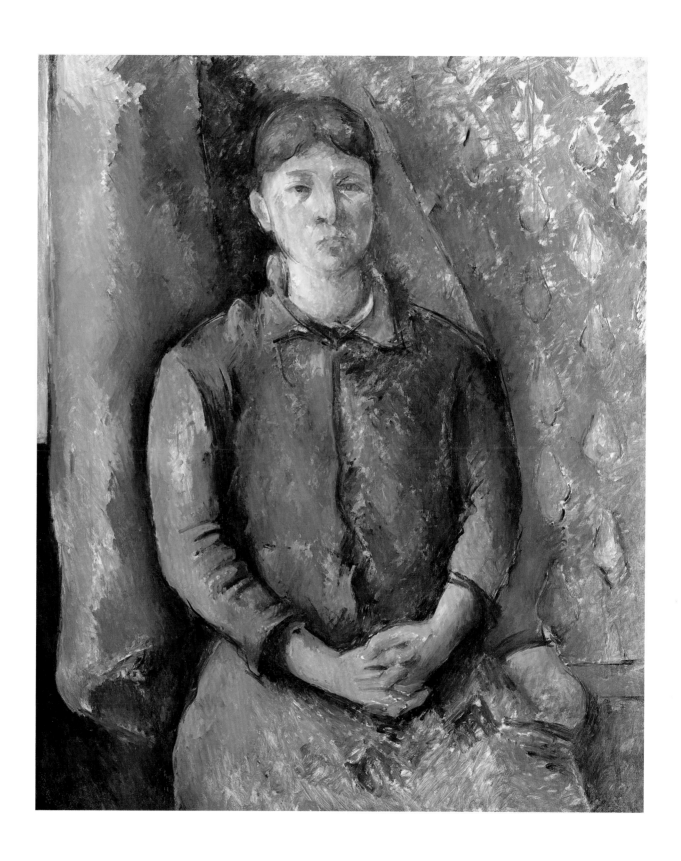

Cat. 41 Paul Cézanne
Madame Cézanne in a Yellow Chair, 1888–1890
Oil on canvas, 31 ⅝ x 25 ⅜ in. (80.2 x 64.2 cm)
Fondation Beyeler, Riehen/Basel, Switzerland

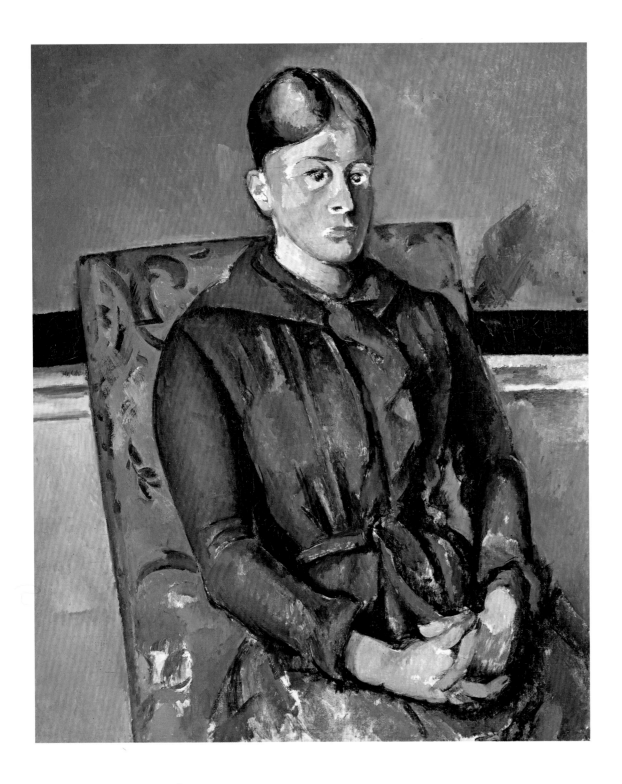

Cat. 42 Paul Cézanne
Madame Cézanne in Blue, 1888–1890
Oil on canvas, 29 ½ x 24 in. (74.1 x 61 cm)
The Museum of Fine Arts, Houston.
The Robert Lee Blaffer Memorial Collection,
gift of Sarah Campbell Blaffer

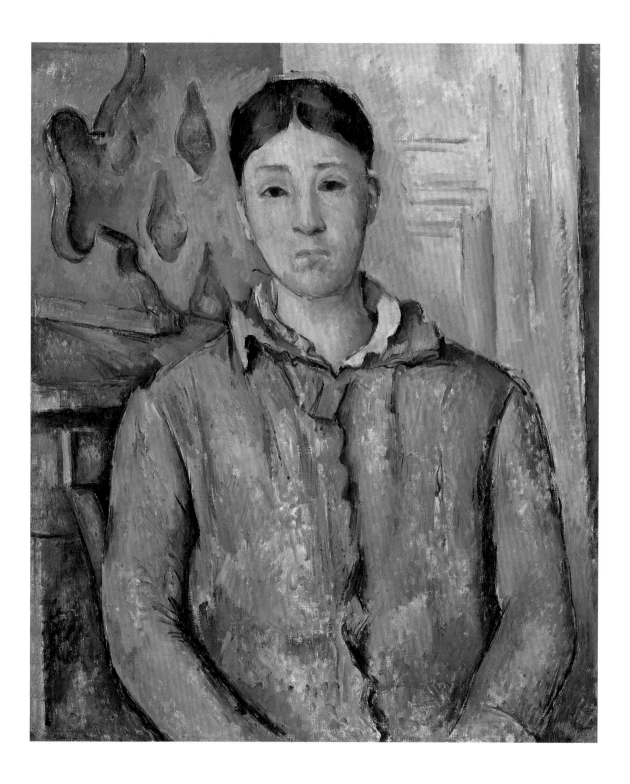

Cat. 43 Paul Gauguin
 Portrait of a Young Woman: Vaïté (Jeanne) Goupil, 1896
 Oil on canvas, 29 / x 25 / in. (75 x 65 cm)
 Ordrupgaard, Copenhagen

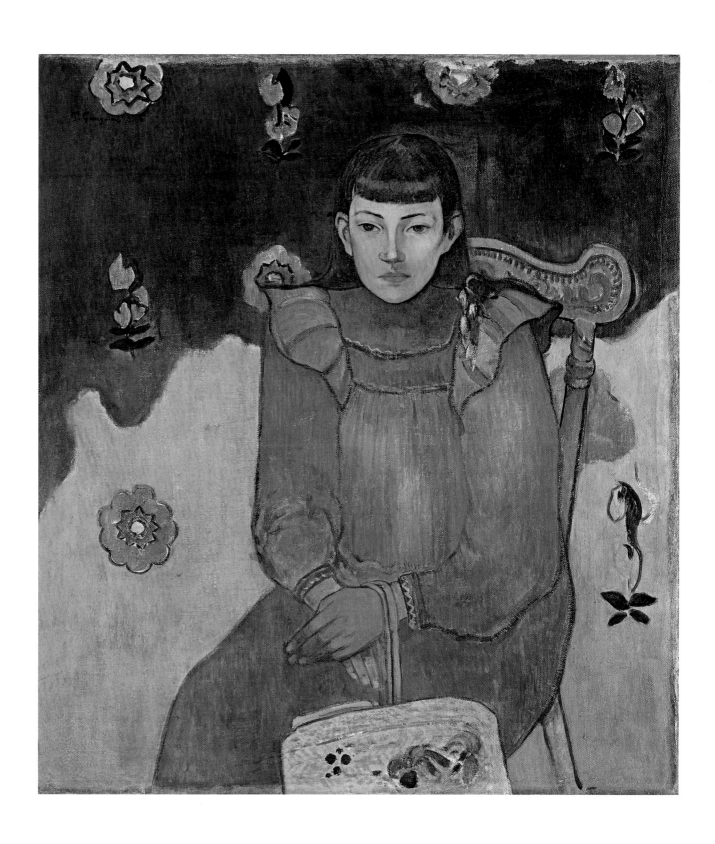

Cat. 44 Paula Modersohn-Becker
 Rainer Maria Rilke, 1906
 Oil on cardboard laid on wood, 12 ¹/₄ x 10 in. (32.3 x 25.4 cm)
 Private collection. On loan to the Paula
 Modersohn-Becker Stiftung, Bremen

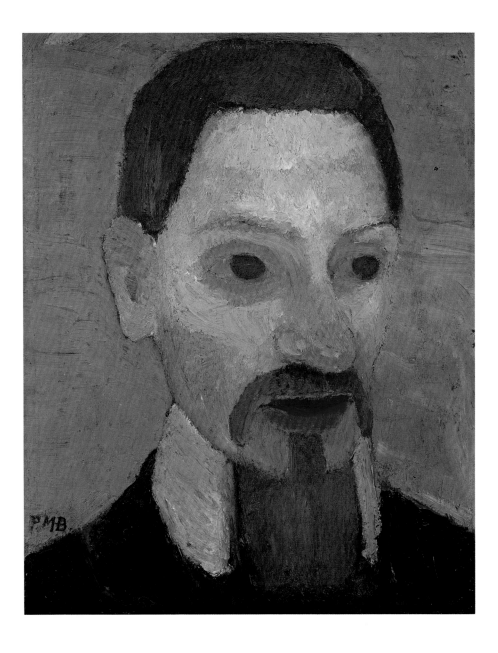

Cat. 45 Paula Modersohn-Becker
Self-Portrait with Amber Necklace, c. 1905
Oil on canvas, 13 ⅞ x 10 ¾ in. (34.5 x 27.3 cm)
Paula Modersohn-Becker Stiftung, Bremen

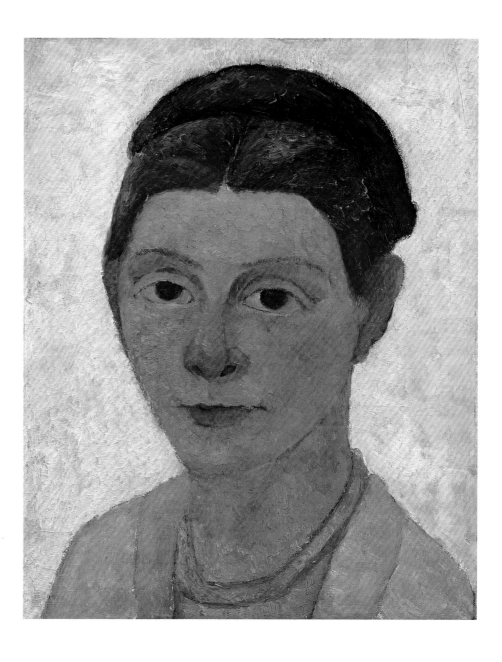

Cat. 46 Henri Rousseau
Portrait of Monsieur X (Pierre Loti), 1906
Oil on canvas, 24 x 19 ⅝ in. (61 x 50 cm)
Kunsthaus Zürich

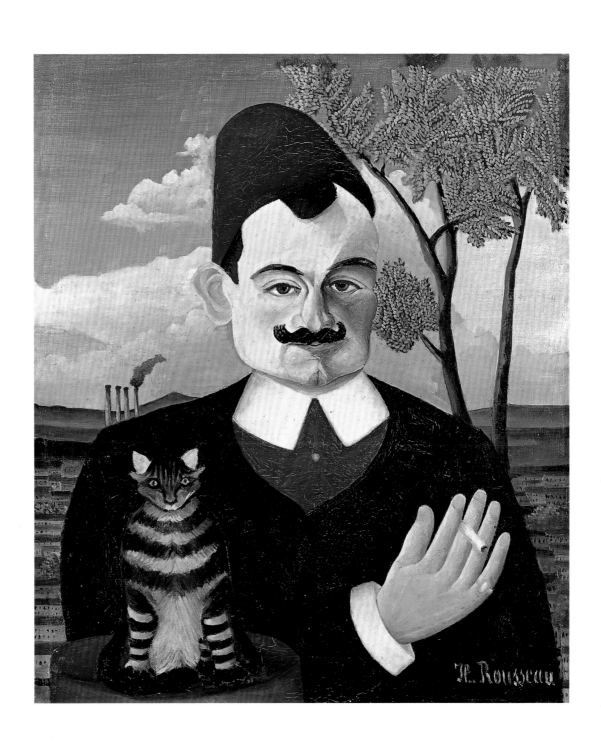

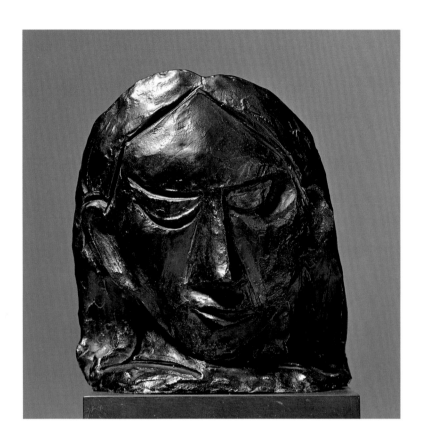

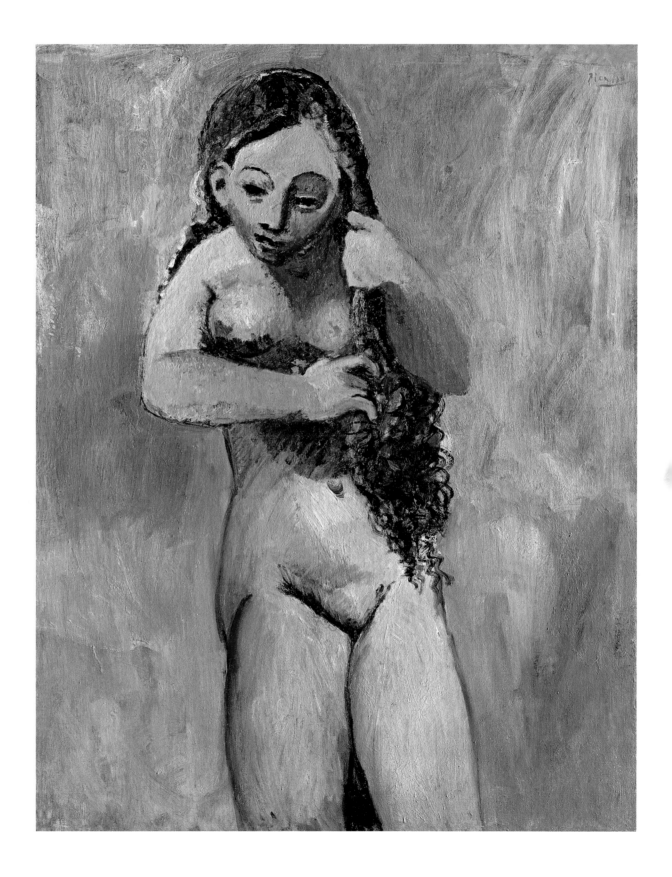

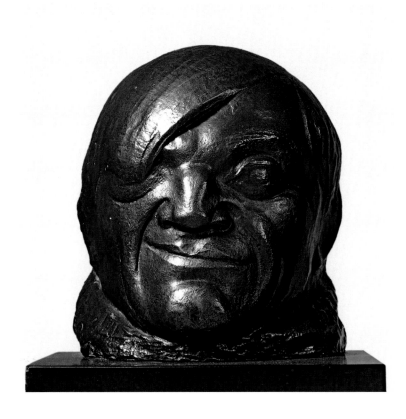

Cat. 50 André Derain
Portrait of a Girl, 1914
Oil on canvas, 24 x 19 ⁄ in. (61 x 50 cm)
Musée Picasso, Paris

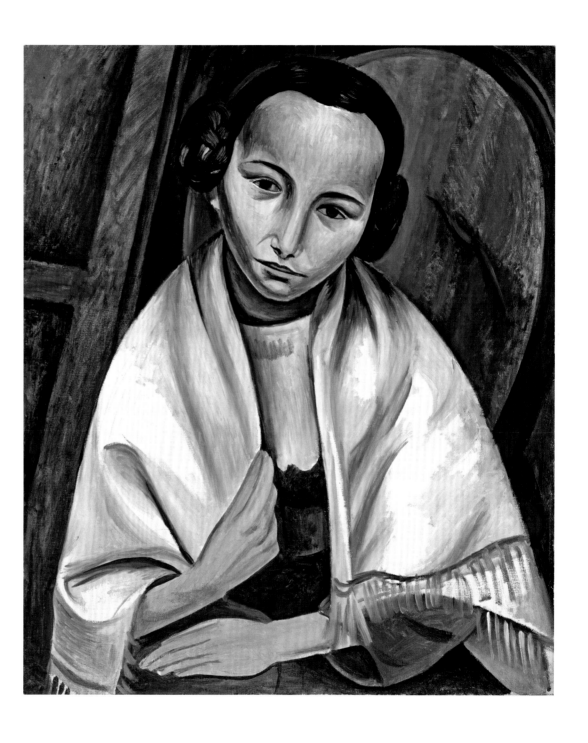

Cat. 51 Henri Matisse
 Yvonne Landsberg, 1914
 Oil on canvas, 58 x 38 ⅜ in. (147.3 x 97.5 cm)
 Philadelphia Museum of Art. The Louise and Walter Arensberg
 Collection, 1950

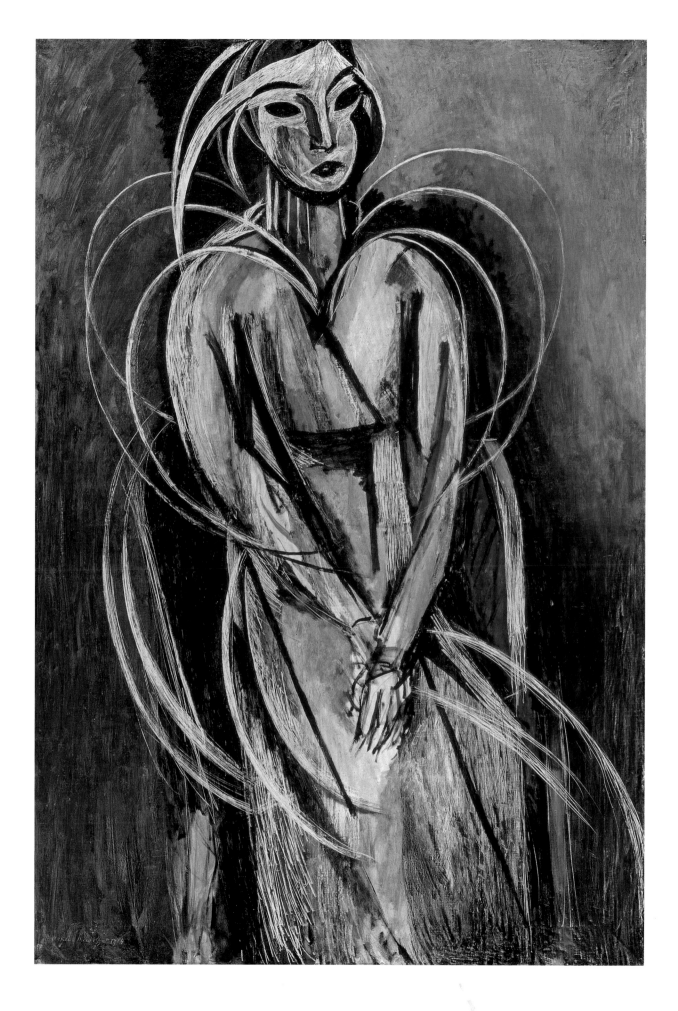

Cat. 52 Henri Matisse
 Self-Portrait, 1918
 Oil on canvas, 25 ⅝ x 21 ¼ in. (65 x 54 cm)
 Musée Départemental Matisse, Le Cateau-Cambrésis, France

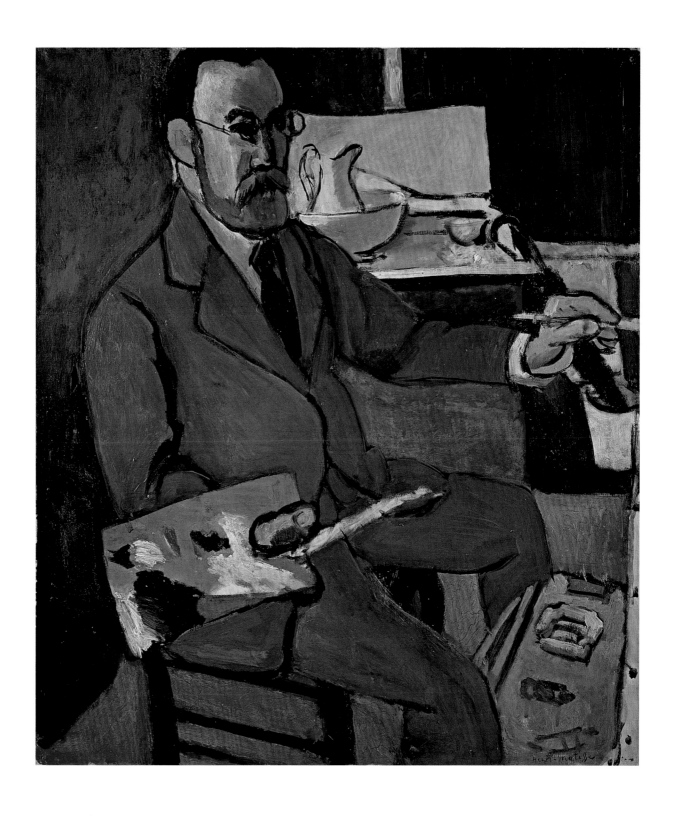

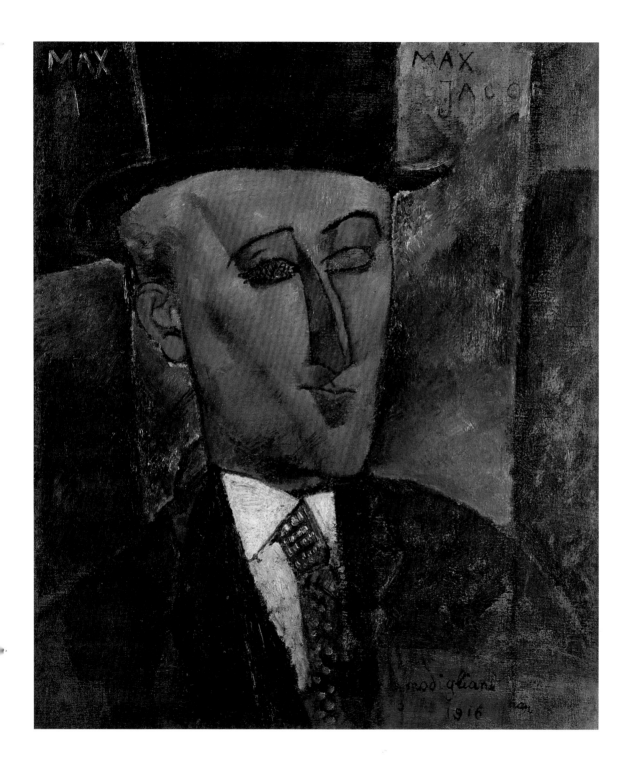

Cat. 54 Amedeo Modigliani
Antonia, c. 1915
Oil on canvas, 32 ¼ x 18 ⅛ in. (82 x 46 cm)
Musée de l'Orangerie, Paris.
Jean Walter and Paul Guillaume Collection

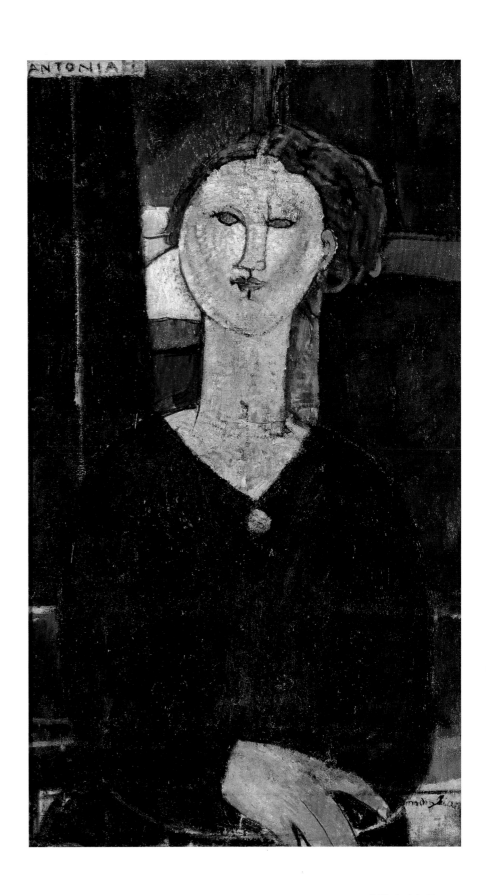

Cat. 55 Amedeo Modigliani
 Portrait of a Young Woman, 1918–1919
 Oil on canvas, 24 x 18 in. (61 x 45.8 cm)
 New Orleans Museum of Art. Gift of Marjorie Fry Davis and
 Walter Davis, Jr. through the Davis Family Fund, 92.68

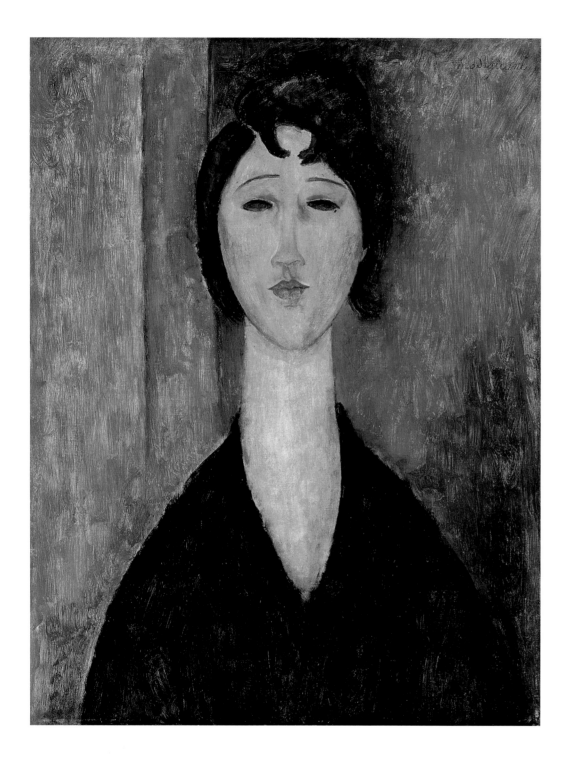

Cat. 56 Pablo Picasso
Nusch Eluard, 1941
Oil on canvas, 28 /₄ x 23 /₈ in. (73 x 60 cm)
Centre Pompidou, Paris.
Musée national d'art moderne/Centre de création industrielle.
On deposit at the Musée Picasso, Paris: 12-9-1985.
Gift of Paul Eluard, 1947

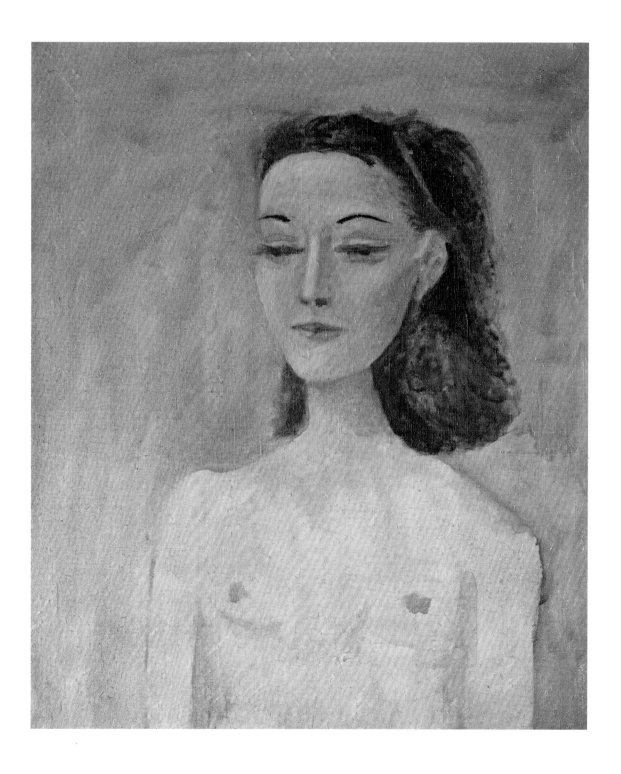

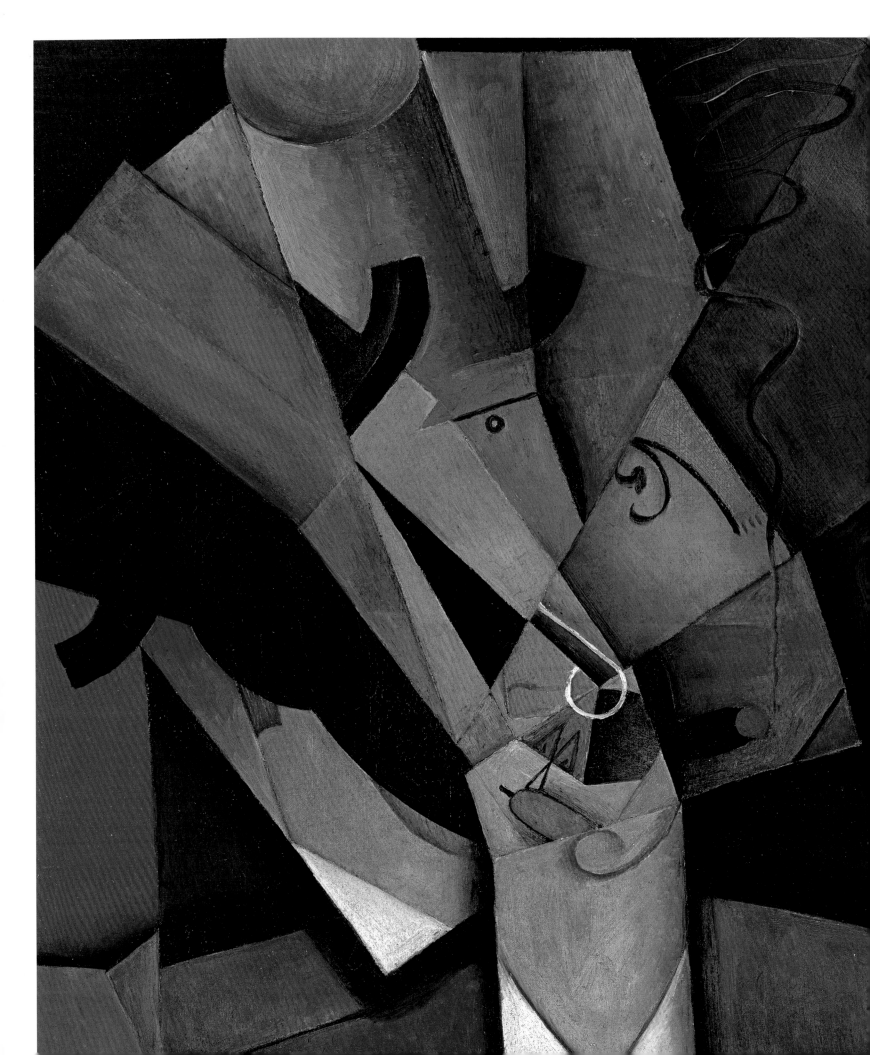

5 THE MIRROR BROKEN

Cat. 61
Juan Gris
The Smoker (Frank Burty Haviland), 1913
(detail)

1 See Jeffrey Weiss, "Fleeting and Fixed: Picasso's Fernande," in Washington/Dallas 2003–2004, p. 41.

2 See Spies 1971, p. 26.

3 On the making of this sculpture, see Valerie J. Fletcher, "Process and Technique in Picasso's *Head of a Woman (Fernande)*," in Washington/Dallas 2003–2004, pp. 166–191.

4 See Pierre Daix, "Portraiture in Picasso's Primitivism and Cubism," in New York/Paris 1996–1997, p. 278.

5 Braque, *Woman with Mandolin*, spring of 1910, Bayerische Staatsgemäldesammlungen, Munich, and Picasso, *Woman with Mandolin*, spring of 1910, private collection.

The publication in the *Mercure de France* in 1907 of Cézanne's letters to Emile Bernard, in which the artist set out his theories on art, together with the major commemorative exhibition of his work in the Salon d'Automne that year, contributed to the development of the new Cubist language based on the fragmentation and simultaneity of the representation of form. Cézanne's way of integrating background and figure through the suppression of outlines, that essential *passage* which enabled the different elements of an object or figure to fuse together, was the starting-point of Picasso's and Braque's Cubist explorations. With the aim of validating their new artistic idiom, both artists, working together on a common project, successively applied it to the various genres of painting: initially to landscape and still life and shortly afterwards to portraiture. In the realm of portraiture, the progressive abstraction of the Cubist idiom gradually imposed itself over the traditional aim of the portrait; little by little the sitter lost his or her outlines as the body, fragmented into multiple facets, blended in with the surrounding environment. Like the reflection in a broken mirror, background and figure, interior and exterior, ceased to be separate elements; painting became a complex puzzle to be solved in the viewer's gaze.

In the spring of 1909 and the winter of 1910, Fernande, who, as we noted in the previous chapter, played a key role in Picasso's development in the genre of portraiture, was the subject of a series of paintings and sculptures created using the formal disintegration of Cubism. She did not pose as she had for earlier portraits, although she was constantly at hand. In the first portraits in the series, Picasso maintained a commitment to the sitter's appearance, whereas in the final stages the trace of her image virtually disappears. Picasso replaced the capturing of a lifelike depiction with a translation of the features into signs that are repeated from composition to composition: the compressed lips, the dark eyes beneath arched brows, a certain rotation or slant of the head. Through the construction of the "Fernande prototype," even the most abstract portraits retain a degree of her persona, not just physically but also in identity or character.[1]

An intermediary phase in this process toward the suppression of the individual is to be seen in *Head of a Woman (Fernande)*, painted during the summer of 1909 in Horta de Ebro [cat. 57]. Here the largely triangular forms that create the face are mingled with the outline of the mountains of the landscape in the background, though not to the point of losing the sitter's identity. Despite the objectivization imposed by the Cubist idiom, Picasso represents Fernande with her head slightly tilted in a way that suggests a hint of melancholy and with an expressiveness that possibly relates to the illness that she was suffering from at the time. In October of that year, on their return from Horta, Picasso created his sculpted *Head of a Woman (Fernande)* [cat. 58], the first Cubist sculpture and, in Werner Spies's opinion, the turning-point in the history of modern sculpture as a whole.[2] In this life-size work Picasso dissects Fernande's head from all angles, using deep incisions that fragment the surface into different concave and convex planes. This *tête cassée*—first molded in clay in the studio of his friend the sculptor Manolo Hugué and later in two versions in plaster in preparation for the edition in bronze issued by Ambroise Vollard[3]—sums up in a single work all the viewpoints and nuances tried out in the painted portraits of Fernande.

Following a period in which landscape and still life dominated their work, the Cubists revived portraiture. According to Daix, this was triggered by the impression made on Picasso and Braque by an exhibition of *Figures de Corot* at the Salon d'Automne in 1909.[4] With a view to paraphrasing Corot, both artists painted a series of oval-format paintings of female figures[5] in which they applied Cubist procedures to the integration of the figure into its surroundings. Though less

Paloma Alarcó

Fig. 1
Pablo Picasso
*Photograph of Daniel-Henry Kahnweiler
in the Studio at 11 Boulevard de Clichy,
Paris,* autumn 1910
Musée Picasso, Paris

Fig. 2
Pablo Picasso
*Photograph of Frank Burty Haviland
in the Studio at 11 Boulevard de
Clichy, Paris,* autumn-winter 1910
Musée Picasso, Paris

6 Kahnweiler 1949, pp. 8 and 10.

7 William Rubin, "Picasso and
 Braque: An Introduction," in
 Rubin 1989, p. 21.

8 Cowling 2002, p. 227.

9 André Lhote, "Chronique des
 Arts," in *Nouvelle Revue
 Française,* 1 August 1932.
 Quoted from Cowling 2002,
 p. 228.

10 See Paris 1994, pp. 115–119, and
 Anne Baldassari, "'Heads, Faces
 and Bodies,' Picasso's Uses of
 Portrait Photographs," in New
 York/Paris 1996–1997,
 pp. 209–211.

11 See Paris 1994, pp. 123–125.

interested than Picasso in the translation of Cubism into
the genre of portraiture, Braque painted a number of figure
compositions, including *Girl with a Cross* [cat. 59]. Executed
in Paris in the spring of 1911, the image achieves a perfect
synthesis between the fragmentation of Analytical Cubism
and a certain degree of recognizability: an eye, the nose,
the curly hair, and the necklace with the cross that gives the
painting its name.

During the summer of 1911, installed in the small town of
Céret in the South of France, Picasso and Braque produced
the most important works of Analytical Cubism, which
Kahnweiler termed "hermetic" (or lyrical, from their
metaphorical similarity to poetic meter),[6] in which the
definition of space becomes yet more ambiguous. While
the repertoire of signs and fragments that define the
interwoven surface of Analytical Cubism might seem to leave
little room for portraiture, according to William Rubin, Picasso
"Yet with deft accents owed to the caricaturist's eye for the
telling detail . . . Picasso was able to make portraits that quite
remarkably catch the appearance of the individuals who sat

for them."[7] Elizabeth Cowling has pointed out musical
allusions that take these Cubist portraits beyond the
representation of particular people into the realm of
"intangible but potent moods, sensations, atmospheres, or
feelings."[8] It is as though they were portraits of the artist's
recollections of a person rather than portraits in the
conventional sense. As such they relate to Mallarmé's idea of
"art as suggestion," which led André Lhote to describe Cubist
paintings as *constructions mallarméennes.*[9]

In many of his portraits of this period Picasso was inspired
by a series of photographs of his friends that he took in his
studio on the Boulevard de Clichy during the autumn of 1910
and the winter of 1911. Rediscovered and published by Anne
Baldassari,[10] the photographs show Ramón Pichot, Max
Jacob, Guillaume Apollinaire, Frank Burty Haviland, Daniel-
Henry Kahnweiler, and Picasso himself seated in front of a
wall on which hangs a curious jumble of paintings, drawings,
masks, and musical instruments [figs. 1 and 2], some
of which make their way into the portraits. One of the works
in which Picasso made use of the photographs is *Man with a
Pipe* [cat. 60],[11] painted in Céret in the summer of 1911. As in
all the other portraits of the period, Picasso subjects the figure
to the fragmentation of Analytical Cubism but maintains the
vertical arrangement that is typical of traditional portraiture.
This helps the viewer to recognize that the work in question is
indeed a portrait, although only a few of the sitter's individual
features are in evidence, as well as to read the space in which
the figure is located. The framework of the image is
constructed through the rhythm of a few straight and curved
lines that respond to the pyramidal volumes of the buildings
in Céret. The colors are reduced to a range of ochers and
grays, with which Picasso achieves astonishing tonal
contrasts and pictorial effects through his characteristic
broken brushstrokes. Among numerous indecipherable
fragments, we can make out an eye, a mustache, a hand—
and a series of stenciled syllables: "est," which is part of the
word *Restaurant,* and "AL" on the corner of a newspaper
(from *JOURNAL*). The formal disintegration seems to invite
an abstract rather than a figurative reading of the image, and
reveals how closely Analytical Cubism was approaching
abstraction.

On his return to Paris, between the autumn of 1911 and the
winter of 1912, Picasso painted *Man with a Clarinet* [fig. 3] in
his studio on the Boulevard de Clichy. It was at this time that
Eva Gouel entered his life. Picasso had met her previously

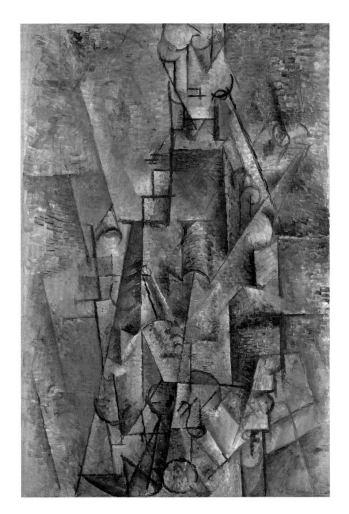

Fig. 3
Pablo Picasso
Man with a Clarinet, 1911–1912
Oil on canvas, 41 ⅞ x 27 ⅛ in. (106 x 69 cm)
Museo Thyssen-Bornemisza, Madrid

12 Pablo Picasso, *Ma Jolie*,
 autumn 1911. The Museum
 of Modern Art, New York.

13 Pablo Picasso, *Female Nude:
 "J'aime Eva,"* 1912. Columbus
 Museum of Art, Ohio.

at L'Ermitage, the meeting-place of the *bande à Picasso*
in Montmartre. His immediate fascination with Eva inspired
Ma Jolie,[12] the first of his paintings inscribed with a coded
reference to her. A year later, Picasso openly proclaimed
J'aime Eva[13] in a female nude considered the most beautiful
of his conceptual portraits, summing up all his feelings
toward his model.

As Braque and Picasso's painting evolved in step from
Analytical to Synthetic Cubism, other artists began to adopt
the Cubist idiom and Cubism triumphed as the language
of the avant-garde. In the Salon d'Automne and the Salon
des Indépendants, now veritable "Salons of Cubist painting,"
the work of a whole series of followers was to be seen. They
included Albert Gleizes, who was particularly interested in a
Cubist reinterpretation of the genre of portraiture. Gleizes did
not opt for Analytical Cubism's fragmentation of form, but
used a Synthetic language that allowed him to deploy a
geometric approach to form while retaining a basic structure.
He showed his portrait of the Parisian poet and publisher
Eugène Figuière (1882–1944) at the Salon d'Automne in 1913
[cat. 64]. He depicts him holding his volume of poems
Les Murmures, surrounded by a number of books produced
by his publishing house, including *Les Peintres cubistes* by
Guillaume Apollinaire, published that year; *Du Cubisme*, the
first study of the Cubist movement, by Gleizes and his friend
Jean Metzinger, published in 1912; *Le Sculpteur de gloire* by
the sitter's brother-in-law Jacques Nayral; and *Poème et
drame* by Henri-Martin Barzun. We also see the names of
other writers of Figuière's circle: Alexandre Mercereau, George
Polti, a specialist in the occult, the poet Paul Fort, and the
critic Gustave Kahn. The restrained tones of gray and green
are broken by a vibrant yellow, perhaps alluding to the typical
covers of the books Figuière published.

By the time Juan Gris first came to public attention at the
Salon des Indépendants in 1912, his work was already fully
Cubist and imbued with the quality of intellectual reflection
that would characterize all his painting. Although Gris devoted
most of his energies to resolving issues arising from the use
of the Cubist idiom in still life, he was also interested in the
genre of portraiture. In *The Smoker* [cat. 61], painted in
Céret in September 1913, he depicts Frank Burty Haviland
(1886–1971), a rich American friend of Leo and Gertrude Stein
who had just restored a monastery in Céret, where he kept
his important collection of African art. Haviland was a
descendant of David Haviland, the founder of a porcelain

Paloma Alarcó

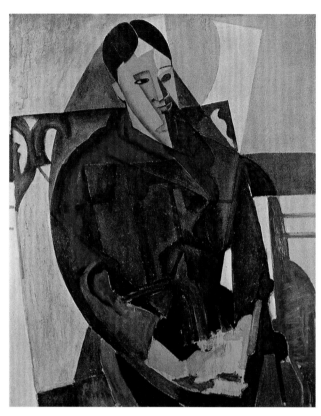

Fig. 4
Juan Gris
Madame Cézanne, after Cézanne, 1918
Oil on cardboard
Private collection

factory in Limoges in the nineteenth century. He was also an important patron of young artists in Paris, and had himself made a number of paintings under the name of Frank Burty. A preparatory drawing for Gris's portrait of him[14] bears the dedication "A mon cher ami Frank Haviland. Bien affectueusement. Juan Gris." Both the drawing and the painting emphasize elements characteristic of the sitter, such as the stiff collar, the bow tie, and the bowler hat. Haviland's dapper way of dressing is evident in the photograph of him taken by Picasso in his Paris studio in 1910 [fig. 2].

The prevailing oblique slant of the upper part of the composition contrasts with the frontality of the lower part, upon which the shoulders and collar confer a certain stability. The only discordant note within the overall geometry is the sinuous line of the cigarette smoke, which changes color as it passes across the different facets of the painting. The way in which the head is fragmented and broken down into its different parts in a fanlike shape of geometrical order responds to the direct influence of works by Picasso, in particular his *Heads*, also painted in Céret in the spring of 1913. Gris was in Céret in the French Pyrenees ("the Mecca of Cubism," as Kahnweiler termed it) from the beginning of August to the end of October, thus coinciding for a few days with Picasso—his fellow-Spaniard and neighbor from the Bateau-Lavoir, whom Gris called "maestro." What distinguishes Gris's work from that of Picasso is undoubtedly his original use of color. Such planes of green, blue, orange, and red are unlike anything in the work of either Picasso or Braque at this time.

In two portraits Gris painted of his wife, Josette, he resolved the problem that the geometrical language of Cubism presented in relation to portraiture's traditional concern with capturing a lifelike appearance by taking as his reference-point various figures painted by Corot and Cézanne. From the latter's portraits of Madame Cézanne, of which Gris painted a version [fig. 4], he adopted the geometrical structure and the arrangement of the figure slightly turned to one side with her hands in her lap. From Corot's female figures, which Gris had copied in his *Woman with a Mandolin, after Corot*,[15] he borrowed the way of composing the figure through a counterbalance of straight lines and curves, lights and darks. Gris painted the first portrait of Josette during the autumn of 1906[16] in Beaulieu, near Loches, her home town, and the second, *Seated Woman (Josette Gris)* [cat. 62], shortly afterwards.

14 Juan Gris, *The Smoker*, 1912. Charcoal, graphite, and wash. 71.8 x 59.1 cm. The Metropolitan Museum of Art, New York (Jacques and Natasha Gelman Collection, 1998).

15 Juan Gris, *Woman with a Mandolin, after Corot*, 1916, Kunstmuseum Basel.

16 Juan Gris, *Portrait of Josette*, 1906, Museo Nacional Centro de Arte Reina Sofía, Madrid.

Fig. 5
Gino Severini at the opening of his exhibition at
the Marlborough Gallery in London, 7 April 1913

year, each featuring a collage of the newspaper referred to in its title. The cutting from *L'Humanité* is from 24 July 1923 and that from the Barcelona paper *La Publicitat* is from 14 December. Dalí probably painted both in the Residencia de Estudiantes in Madrid, where he lived while studying at the Escuela de Bellas Artes de San Fernando. "I started to paint my first Cubist paintings in my room," he wrote in his *Vida secreta* [Secret Life], "directly and deliberately influenced by Juan Gris."[19] In another passage he recounts how these paintings were his entrée into Madrid's avant-garde circles: "[my fellow students from the Residencia] came as a group to admire my paintings and . . . their surprise was boundless! The idea of my being a Cubist painter was the last thing that had occurred to them!"[20]

Like all of Dalí's Cubist works, his self-portrait relates closely to the Neo-Cubist ideas that were beginning to take hold (albeit belatedly) in Madrid. Here he interprets Cubist fragmentation as a surface divided into verticals that fall in a fanlike shape from a point above the top edge of the canvas, with his own features emerging from them. He based the likeness on recent sketches of him made by the Uruguayan artist Rafael Barradas, who had met the Parisian Cubists and Italian Futurists shortly after his arrival in Europe.

Another work that falls into this Madrid context is the portrait of Ramón Gómez de la Serna painted in 1915 by the Mexican artist Diego Rivera [cat. 65], who was living in Madrid at the time. The writer Ramón Gómez de la Serna (1888–1963) played a key role in the city's artistic scene. In 1915, the year of the portrait, he founded the legendary conversation group "Pombo" and promoted the *Exposición de los Pintores Íntegros*, the first presentation of Cubist works in Madrid.

In 1917, by which time Cubism had extended its influence across all avant-garde artistic circles, Picasso went to Rome at the invitation of Sergei Diaghilev. There he discovered Mannerist painting and the classical art of Pompeii. While for him and many other avant-garde artists the Cubist experiment had reached its limit, no one could go back on the new visual possibilities that it had opened up.

The work of Gino Severini, an Italian artist based in Paris, shows a debt to Cubism inflected by the new conception of humanity, bound up with ideas about energy, movement, and vitality, that characterized Futurism. In his *Self-Portrait*, a replica painted in 1960 of a work of 1912 [cat. 63],[17] he breaks his own face down into multiple Cubist facets and at the same time imparts a typically Futurist dynamism, a formal rhythm that creates a turning effect. The most recognizable elements, such as the artist's hat and his characteristic monocle, become clues to his identity [fig. 5].

The *Cubist Self-Portrait* painted in 1923 by Salvador Dalí [cat. 66] is sometimes known as *Self-Portrait with La Publicitat*, its pendant being the *Self-Portrait with L'Humanité*.[18] The two paintings are of the same format and were painted the same

17 See Pacini 1986.

18 Santos Torroella 1994, p. 61.

19 Dalí 1942.

20 Dalí 1942.

Cat. 57 Pablo Picasso
Head of a Woman (Fernande), 1909
Oil on canvas, 25 ⅝ x 21 ⅝ in. (65 x 55 cm)
Städel Museum, Frankfurt.
Property of the Städelscher Museums-Verein e.V.

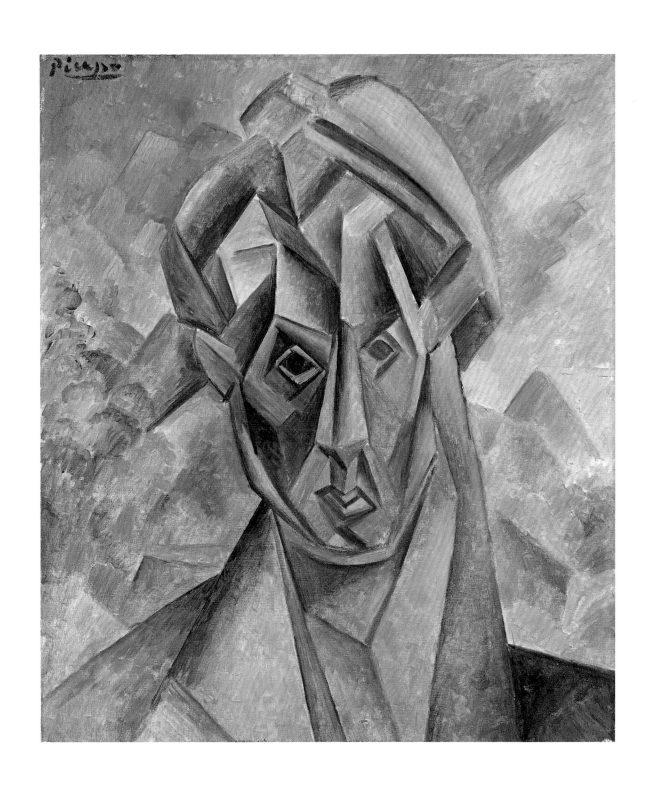

Cat. 58 Pablo Picasso
Head of a Woman (Fernande), 1909
Plaster, 18 ⅖ x 14 ⅖ x 13 ¾ in. (47 x 35.9 x 34.9 cm)
Raymond and Patsy Nasher Collection, Dallas

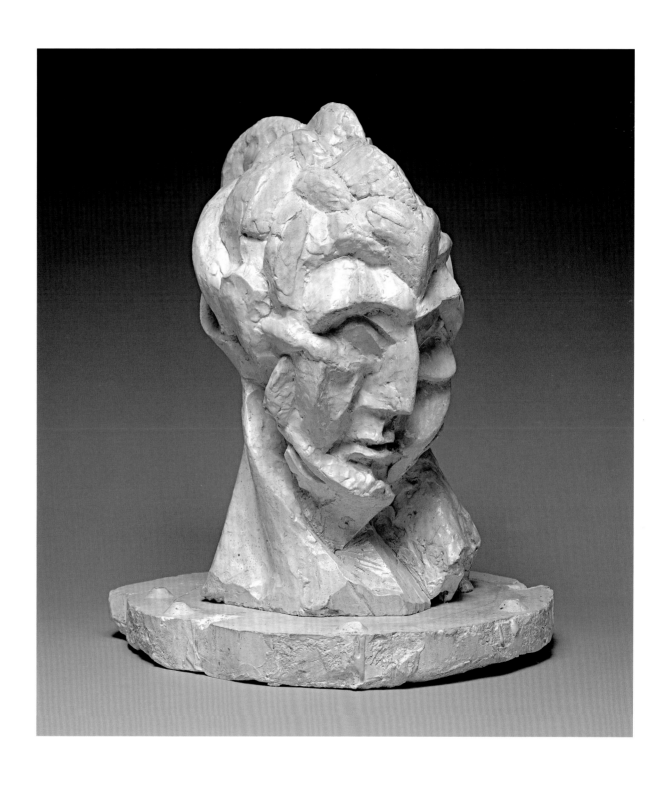

Cat. 59 Georges Braque
Girl with a Cross, 1911
Oil on canvas, 21 ⅝ x 17 in. (55 x 43 cm)
Kimbell Art Museum, Fort Worth

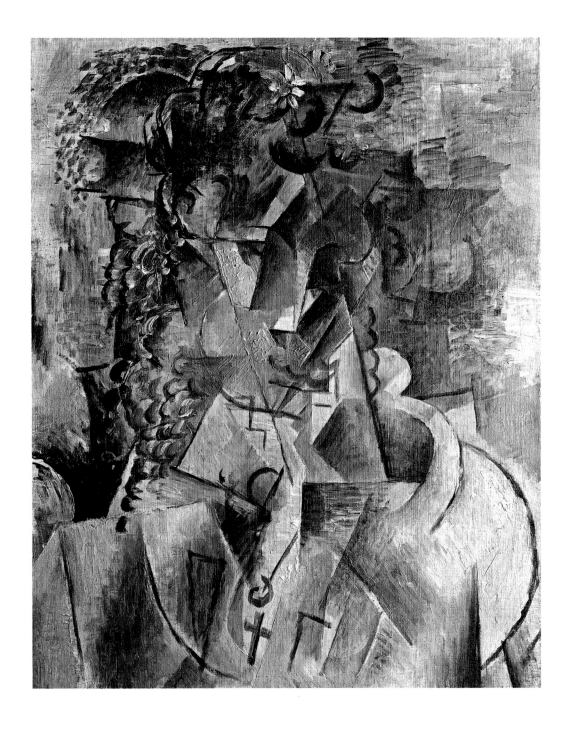

Cat. 60 Pablo Picasso
Man with a Pipe, 1911
Oil on canvas, 35 ⅟₄ x 27 ⅞ in. (90.7 x 71 cm)
Kimbell Art Museum, Fort Worth

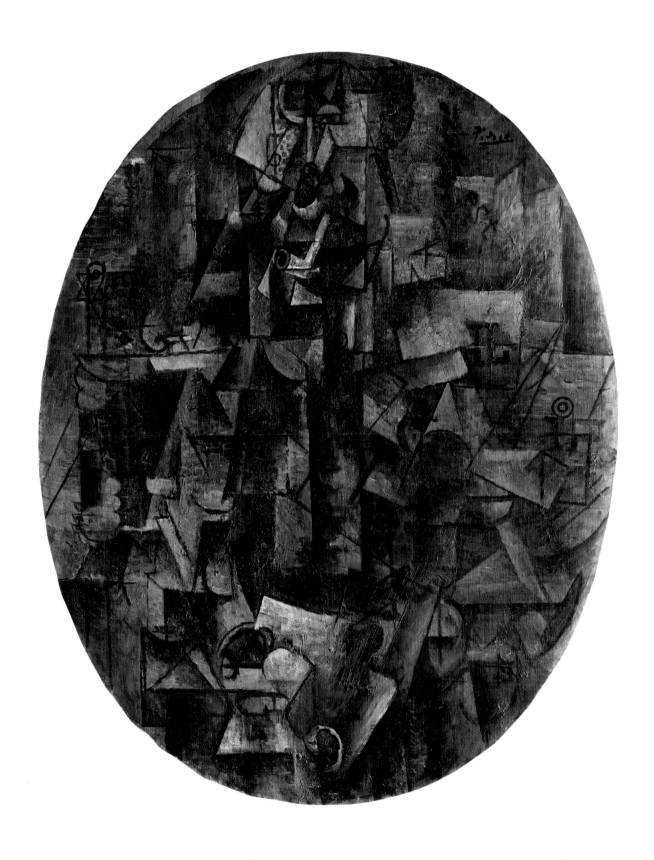

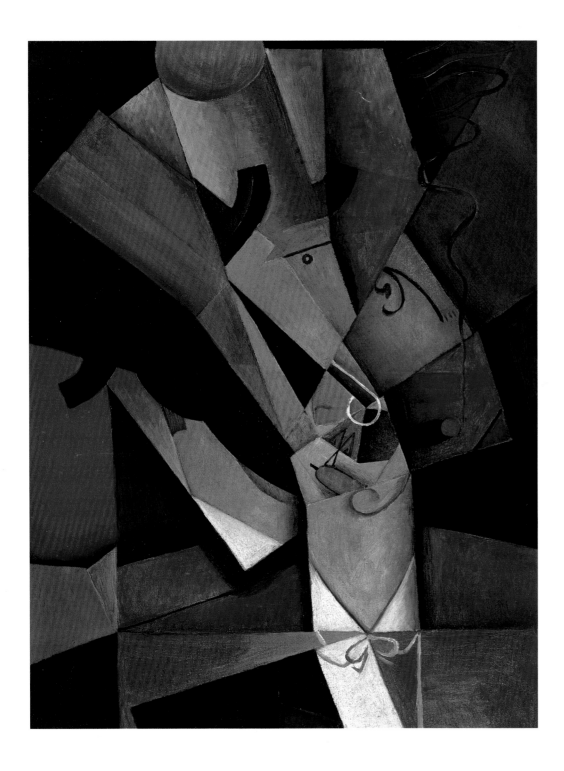

Cat. 62 Juan Gris
Seated Woman (Josette Gris), 1917
Oil on panel, 45 ¹⁄ x 28 ¹⁄ in. (116 x 73 cm)
Carmen Thyssen-Bornemisza Collection on loan
to the Museo Thyssen-Bornemisza, Madrid

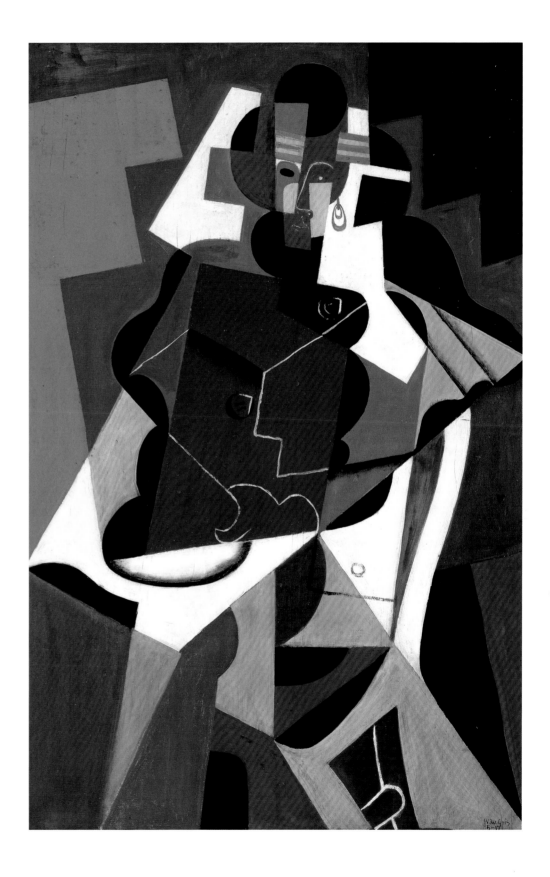

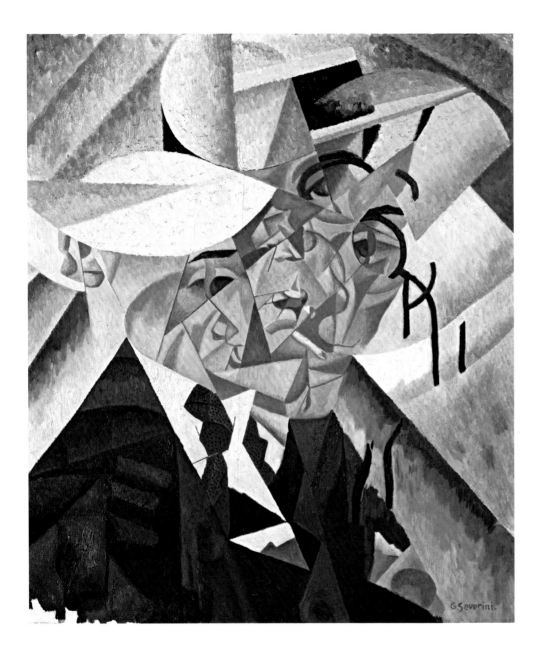

Cat. 64 Albert Gleizes
Eugène Figuière, 1913
Oil on canvas, 56 / x 40 in. (143.5 x 101.5 cm)
Musée des Beaux-Arts de Lyon

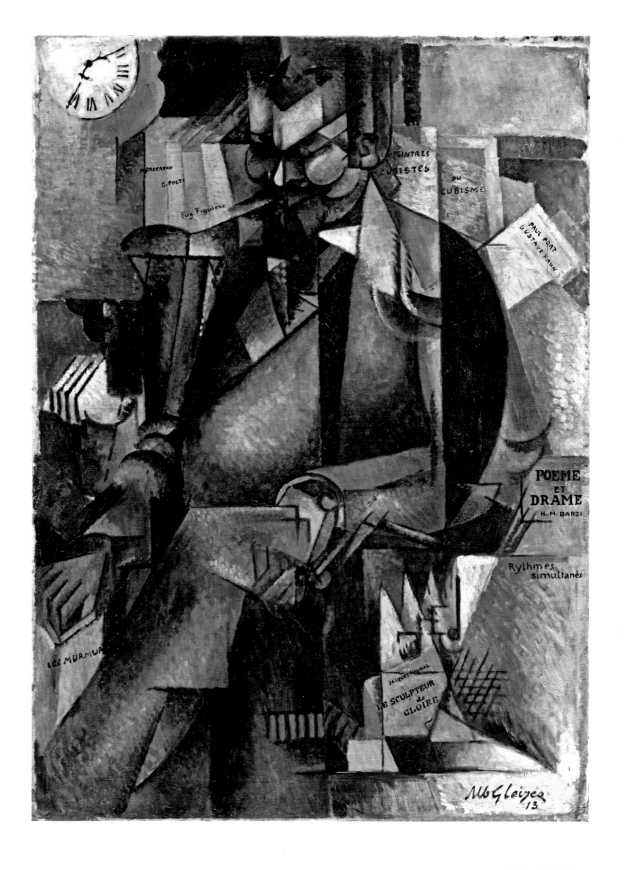

Cat. 65 Diego Rivera
Ramón Gómez de la Serna, 1915
Oil on canvas, 43 ⅛ × 35 ½ in. (109.6 × 90.2 cm)
Malba-Collection Costantini, Buenos Aires

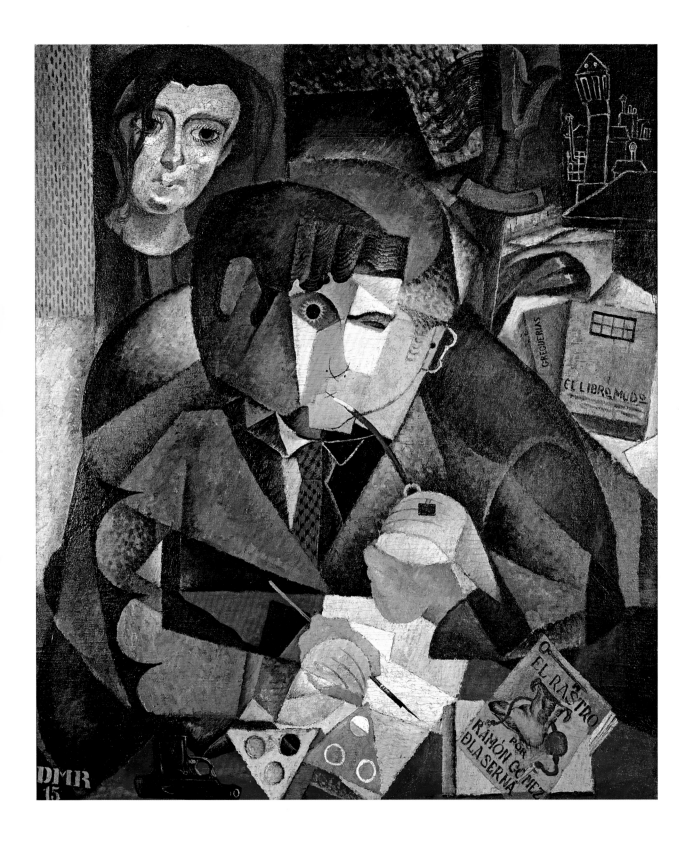

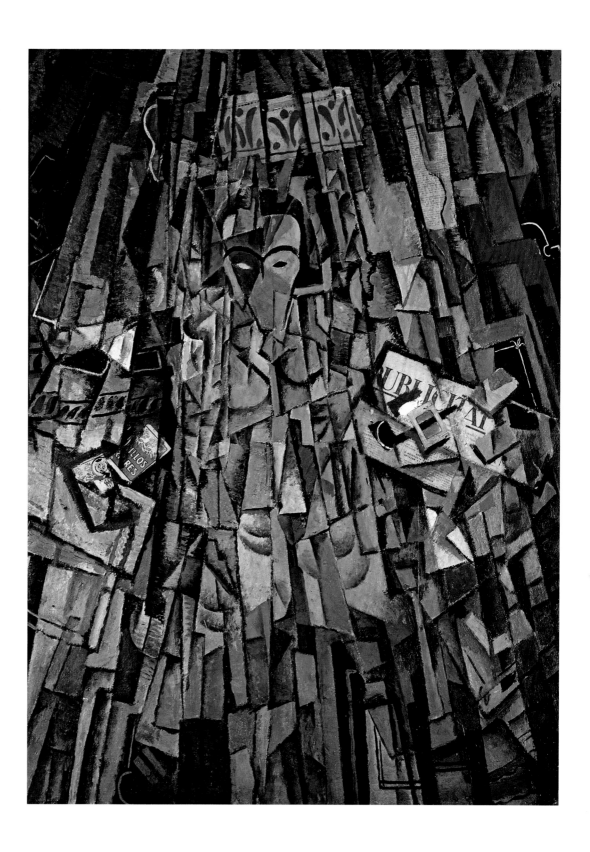

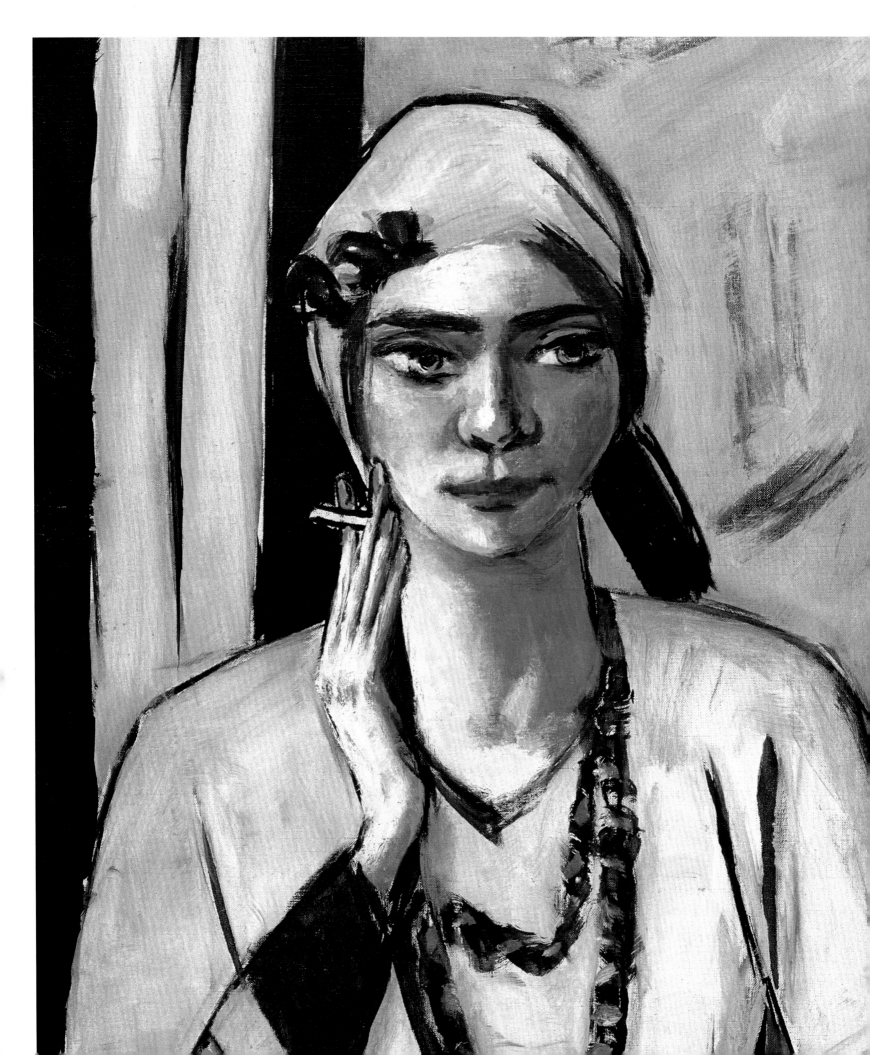

6 A PORTRAIT OF SOCIETY

Fig. 1
Pablo Picasso
Portrait of Raymond Radiguet, 17 December 1920
Reproduced in *Les Joues en feu*
Musée Picasso, Paris

The interwar period was the heyday of modern portraiture. The critical tenor of this age of political and moral revolution fostered a new desire, in the field of art, to return to a timeless of classicism art—albeit without renouncing the practices of modernism. The *rappel à l'ordre*, as Jean Cocteau termed it,[1] was upheld by the very artists who had been the pioneers of modern art. In the genre of portraiture, it implied the revival of a realistic depiction of the sitter, though inevitably with a different way of defining identity. New ideas about individuality as essentially a social phenomenon meant that the traditional vision of a unique, specific person was called into question.[2] According to the

theories of the German sociologist Max Weber, it was only possible, within the context of modern industrial society, to define individual identity through role.

Portraiture had to respond to society's fascination with exterior appearance as a sign of status, intelligence, or abilities. It had to reflect social realities and conventions of behavior. As a result, it placed new emphasis on symbols of the occupation of the sitter—engineer, writer, doctor, musician, architect, and so on.[3] Given the prevailing distrust of the idea of art as an objective image of nature, however, the visual rhetoric of realism was not going to be enough. As we will see, the new realism of the interwar years concealed within it elements of fakery and distortion that could be as subversive as the most daring avant-garde strategies.

This chapter looks at different approaches to portraiture during the period, starting with the classical tendencies of Picasso and other artists working in France, including Severini and Lipchitz. It also covers the realism of the German Neue Sachlichkeit movement, and concludes with the work of various later figures such as Balthus, Sickert, and the English painters Freud and Spencer. These artists left an unparalleled gallery of portraits, each a fragment from the society of their time.

In the early months of 1914, Picasso executed a number of classicizing portraits in pencil that mark a turning point in his work [fig. 14 on p. 119]. A few years later, he drew a portrait of Raymond Radiguet, the young companion of his friend Jean Cocteau, in the same spirit [fig. 1]. Radiguet was also the subject of a portrait by the Lithuanian sculptor Jacques Lipchitz, one of the key figures, particularly in his use of the Cubist idiom, in the development of modern sculpture. Between 1920 and 1922, Lipchitz executed six portraits that move away from the avant-garde style of previous years; they include the plaster *Raymond Radiguet* of 1920 [cat. 70]. Radiguet, who was seventeen at the time, was described by

1 Cocteau 1926.

2 Brilliant 1991, pp. 141–174.

3 On this issue, see Tomàs Llorens, "Máscaras y retratos," in Madrid 2002, and "Identidad y representación: retratos," in Madrid 2005–2006.

Paloma Alarcó

Fig. 2
Jean-Auguste-Dominique Ingres
Portrait of the Comtesse d'Haussonville, 1842
Oil on canvas, 36 ⅝ x 24 in. (93 x 61 cm)
Private collection. Courtesy Galerie
Jan Krugie & Cie, Geneva

Lipchitz as "a man of great talent and extraordinarily mature for his age."[4] The sculpture emphasizes physical characteristics—the rounded head, sensual lips, and short hair—that together give the portrait a remarkable sobriety and classicism. These are qualities that hardly seem in keeping with the future author of the novel *Le Diable au corps*, Radiguet's masterpiece, which he was to write in the summer of 1923.

In 1917 Picasso travelled to Italy with Cocteau to collaborate with Serge Diaghilev's Ballets Russes. For Picasso the trip ended a period of bitter sadness caused by the death of Eva—and it was in Rome that he met the new woman in his life, the ballerina Olga Khokhlova. He saw the work of Raphael and Michelangelo, as well as the Roman antiquities of Naples and Pompeii, and the experience resulted in a shift of focus back toward the classical tradition. The "return to order" on Picasso's part was not literal but complicated, even misleading in nature; he made use of antiquity to reinterpret traditional models but without forgetting the lessons of Cubism. As Francisco Calvo Serraller has recently noted, "not only was it far from definitive; it coincided with his beginning to use multiple styles simultaneously."[5] Cubism had given Picasso the key to representing the elements within a painting in different ways in order to overturn the laws of perspective and present various viewpoints in a single work.

Picasso himself was always laconic when asked the reason for his return to naturalism. In the opinion of some writers, including Pierre Daix, it was the urge to return to painting portraits; this encouraged him to abandon Cubism, which was inevitably leading him towards abstraction. Elizabeth Cowling, on the other hand, has emphasized that this was a natural evolution on the part of an artist who was particularly interested in the human body.[6] Whatever the case, what is clear is that during his so-called classical period Picasso executed an astonishing number of portraits—and that in them he went beyond individualized description through the idealization of the face, much as he had done earlier when he replaced Gertrude Stein's features with an Iberian mask.

During this period, and from the first sketches in his *carnets* of 1917, Picasso made Olga into the principal motif of his art. The daughter of a colonel in the Imperial Russian army, she had been a member of Diaghilev's company for six years when Picasso met her in Rome. One of the first oil portraits of his new lover, *Olga Khokhlova* [cat. 67], painted late in 1917 in Montrouge, to which the couple moved, depicts

Fig. 3
Pablo Picasso
Olga posing for her portrait in the Montrouge studio, early 1918
Photograph, 9 ¼ x 6 ½ in. (23.5 x 16.4 cm)
Musée Picasso, Paris

Fig. 4
Pablo Picasso
Preparatory sketch for *Portrait of the Artist's Wife (Olga)*, 1923
Charcoal, 12 ⅝ x 9 ¾ in. (32 x 24.7 cm)
Private collection, London

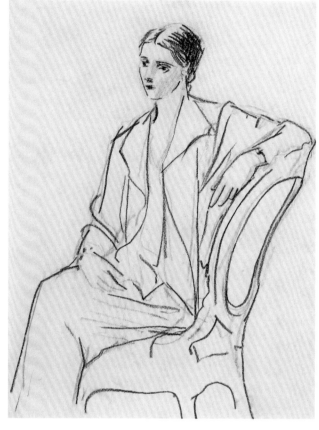

4 Lipchitz 1972, p. 60.

5 Francisco Calvo Serraller, "Picasso frente a la historia," in Madrid 2006, pp. 42–43.

6 Cowling 2002, p. 393.

7 See Michael C. FitzGerald, "The Modernists' Dilemma: Neoclassicism and the Portrayal of Olga Khokhlova," in New York/Paris 1996–1997, pp. 297–335.

8 FitzGerald in New York/Paris 1996–1997, p. 322.

9 Daix 1994, p. 159.

the dancer in a thoughtful, dreamy pose. While the work clearly refers to the portraits of Ingres, particularly those of the Comtesse d'Haussonville [fig. 2], its classicism is combined with elements derived from both Cubism and primitivism. The flatness of the surface and the exaggeration of the visual rhythms of the figure derive from Cubism, while the archaic reductions and the disproportionate size of the arms and hands look to "primitive" art.

Olga would sit for Picasso in a wide variety of poses and costumes [fig. 3].[7] The present exhibition includes two memorable portraits of 1923: *Olga with a Fur Gollar* [cat. 68] and *Portrait of the Artist's Wife (Olga)* [cat. 69], both painted on the rue de la Boétie, in the elegant new residence into which the artist and his wife moved following their marriage in 1918. The first of these works is a *grisaille* in oil on canvas that x-radiographs at the Musée Picasso show to have been painted over a Cubist composition. The portrait is truly a display of Picasso's technical brilliance. His exceptionally delicate brushstroke gives the work an almost pastel-like

quality, while the firmness of the black outlines of the figure and armchair are of such purity that they create the effect of an ink drawing. In the second portrait Olga wears a gray-brown dress and poses, seated, with her left arm leaning on the back of a chair in an attitude clearly reminiscent of Ingres [fig. 4 shows a preparatory sketch]. Picasso casts his wife as a classical type, both in the regularity and perfection of her features, dress, and hairstyle, and in her reserved and serene character. Although some writers have considered the sitter's expression to be excessively distant and restrained as a result of the couple's looming matrimonial crisis,[8] the impression that this masterpiece creates is best summed up in the words of Pierre Daix: "Picasso would get Olga into the Louvre."[9]

In *Harlequin with a Mirror* [cat. 71], painted at the end of 1923, Picasso brought his classical period to a close and revived the tradition of portraiture. As Tomàs Llorens recently revealed, referring to an x-radiograph, Picasso approached the work in the manner of a self-portrait: "The face, which was

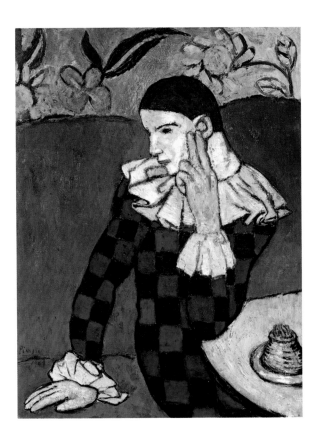

Fig. 6
Pablo Picasso
The Lovers, 1923
Oil on linen, 51 ¼ x 38 ¼ in. (130.2 x 97.2 cm)
National Gallery of Art, Washington.
Chester Dale Collection (1963.10.192)

Fig. 5
Pablo Picasso
Harlequin, 1901
Oil on canvas, 32 ⅝ x 24 ⅛ in. (82.9 x 61.3 cm)
The Metropolitan Museum of Art, New York.
Gift of Mr. and Mrs. John L. Loeb, 1960 (60.87)

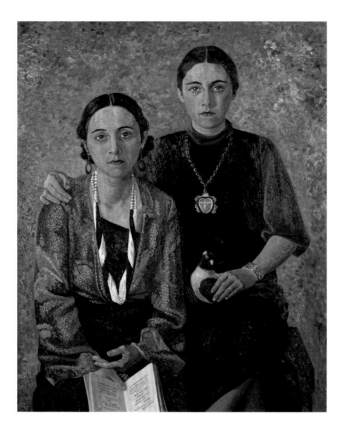

Fig. 7
Gino Severini
The Artist's Wife and Daughter, 1935
Oil on canvas, 57 ⁷/₈ x 45 ¹/₄ in. (147 x 115 cm)
Centre Pompidou, Paris. Musée national d'art moderne/
Centre de création industrielle

marginalized figures [fig. 5], to the monumental Cubist *Harlequin* painted in 1915 on the death of Eva Gouel, Picasso repeated this figure with some regularity. But it was now, in his classical period, that it became a recurrent motif.

William Rubin, Pierre Daix, and other writers have linked *Harlequin with a Mirror* to Picasso's ambitious classical-period painting *The Pipes of Pan*,[11] relating it to his frustrated affair with the American Sara Murphy at Cap d'Antibes during the summer of 1923.[12] Her figure appears in a veiled form in many of the drawings and paintings of this time, including *Woman in White*[13] and *The Lovers* [fig. 6]. This group of works represented the culmination of Picasso's classical period but also its end. In the late autumn of 1923 the artist focused his energies on a series of still lifes in a style that has been described as "curvilinear Cubism" and which would gradually lead to his Surrealist phase.

Among other modern artists interested in the iconography of the *commedia dell'arte*, particular mention should be made of the Italian Futurist Gino Severini. Like his friend Picasso, Severini developed a more classical mode of painting, and in 1916 he surprised the Parisian art world with a *Mother and Child* painted in a manner close to the Tuscan primitives. *The Painter's Family* of 1936 [cat. 87] belongs to a group of family portraits that he produced in the second half of the 1930s [fig. 7]. Here he shows himself, holding a dove, along with his wife, Jeanne Fort, and their daughter Gina. The extreme frontality and almost sacramental solemnity of the painting recall the mosaics at Ravenna or Fayum mummy portraits.[14]

The renewed interest in portraiture during the interwar years also led Salvador Dalí to paint various family members, particularly his father and his sister Anna María.[15] The *Portrait of My Father* of 1925 [cat. 76] was among the works included in the artist's first solo exhibition, held in November 1925 at the Galeries Dalmau in Barcelona, the city's main center for the promotion of contemporary and international art. This is one of Dalí's most important works of the period, during which his rejection of the avant-garde led him to revive Italian pictorial traditions and study the work of Ingres. Indeed, he dedicated this first exhibition to Ingres, some of whose ideas on art (including his famous statement that "Drawing is the probity of art") were quoted in the accompanying catalogue.

In this impressive composition, undoubtedly indebted to Ingres's portrait of Bertin, Dalí depicts his father with a restrained color scheme and a pronounced classicism in

10 Tomàs Llorens: "Máscaras y retratos," in Madrid 2002, p. 136.

11 Pablo Picasso, *The Pipes of Pan*, 1923. Musée Picasso, Paris.

12 Rubin 1994 and Pierre Daix, "El arlequín con espejo, Sara Murphy y el fin del clasicismo de Picasso," in Madrid 1995.

13 Pablo Picasso, *Woman in White*, 1923. The Museum of Modern Art, New York.

14 This relationship is mentioned by Renato Barilli in Florence 1983.

15 For these early portraits, see Barcelona 1995.

originally a self-portrait, acquires the impersonal aspect of a mask in the finished work."[10] This symbolic self-portrait suggests the presence of various characters from the world of the circus and the *commedia dell'arte*, to whom Picasso felt a particular attraction. The two-cornered hat is a clear reference to Harlequin, while the costume suggests the world of acrobats and tightrope walkers, and the mask into which Picasso converts the face is that of Pierrot, Columbine's scorned lover. The young man indulges his melancholy by looking at his image in the mirror, an attribute of deception and *vanitas*. Picasso considered that in many respects he and Harlequin were alike, and depicted himself in character as Harlequin on numerous occasions throughout his life, generally for some emotional reason. From his earliest depictions of Harlequins and acrobats, when the theme involved elements of social critique and identification with

Paloma Alarcó

Fig. 8
Salvador Dalí
Galarina, 1945
Oil on canvas, 25 ¹/₄ x 19 ³/₄ in. (64.1 x 50.2 cm)
Fundació Gala-Salvador Dalí, Figueres, Spain

together a heterogeneous group of artists who shared a desire to break away from Expressionism through a new mode of figuration that was often tinged with a mordant cynicism.

Otto Dix, one of the leading names associated with the Neue Sachlichkeit movement, had freed himself from the nightmares of war that had previously tormented him and gradually modified his social criticism and revolutionary stance, convinced that art could no longer change society. In the 1920s he created a unique gallery of portraits of Berlin society, both middle-class and bohemian, and his images of the ballerina Anita Berber [fig. 9], the journalist Sylvia von Harden, the abstract art dealer Alfred Flechtheim, and the poet Ivar von Lücken have come to represent this whole period of twentieth-century history.

From 1925 onward Dix almost always used panel as his support and on occasion deployed a mixed technique of tempera and oil, imitating the practice of German Renaissance artists such as Dürer, Cranach, and Baldung Grien, as described in Max Doerner's book *The Materials of Painting*, published in 1921. His *Venus of the Capitalist Era* [cat. 74] may refer in particular to the Venus paintings of Cranach. It was painted in about 1923, the year that Dix faced trial for obscenity in Darmstadt after exhibiting *The Drawing Room II* of 1921, a highly lascivious painting of a brothel. His portrait of an elderly prostitute, naked except for a hat, shoes, and stockings that are falling down, is a highly caricatural and unflattering image, particularly given the model's advanced age. This grotesque figure shows how Dix's exaggerated realism and brutal satire of German society went together at times with a clear desire to *épater les bourgeois*.

By contrast, his portrait of the businessman Max Roesberg of 1922 [cat. 73] lacks any such critical element and presents a generally sympathetic account of the sitter. The owner of a metal-founding business, Roesberg collected works by young Dresden artists and owned a number by Dix. He is shown in a three-quarters position, wearing a suit and tie, and standing in front of his desk as though on a normal working day. Another Dix portrait, that of the lawyer Hugo Simons [cat. 72], painted in 1925 in oil and tempera, tends more toward the caricatural. Simons, who acted for the artist in his numerous lawsuits and trials, appears sitting on a wooden chair and wearing a febrile expression. The true focus of the composition is his expressively twisted hand gesture, which lends the image an extraordinary tension.

the mass and monumentality of the figure. With his flair for technical perfection and virtuoso draftsmanship—the clean, modulated line that would define all his oeuvre—Dalí was naturally suited to the adoption of an Ingres-like style [fig. 8]. His father, Salvador Dalí i Cusí (1872–1950), husband of Felipa Domènech Ferrés and a notary in the small town of Figueras, was a man of progressive ideas and a highly temperamental character. As his friend the writer Josep Pla noted, following the Spanish Civil War he became "one of the most fanatical Catholics and one of the most prominent reactionaries."[16] Although he initially supported Dalí's decision to become an artist, the father-son relationship was full of conflict and would end in complete rupture.

The revival of realism took on particular characteristics within German art of the Weimar Republic. The heightened interest in the image of mankind went together naturally with a rediscovery of portraiture, and Germany's most important contribution to art of the interwar years was arguably in this genre.[17] The year 1925 saw the public debut of the movement known as Neue Sachlichkeit (New Objectivity). It brought

16 Pla 1984, p. 76.

17 See the recent exhibition *Glitter and Doom: German Portraits from the 1920s*, curated by Sabine Rewald: New York 2006.

Fig. 9
Otto Dix
Portrait of the Dancer Anita Berber, 1925
Tempera and oil on plywood, 47 ¼ x 25 ⅝ in. (120 x 65 cm)
Kunstmuseum Stuttgart

Fig. 10
Otto Dix
Sketch for the *Portrait of Hugo Erfurth*, 1926
Chalk on brown paper, 32 ⅝ x 38 ⅝ in. (83 x 98 cm)
Kupferstichkabinet, Staatliche Museen Preußischer
Kulturbesitz, Berlin

Dix painted the *Portrait of the Photographer Hugo Erfurth with Dog* [cat. 75] on his arrival in Berlin in 1926. The photographer Hugo Erfurth, whom Dix had painted the year before holding a wide-angled lens, had acquired a certain fame for his photographic portraits of the wealthiest members of German society. In this second portrait Dix shows him not with one of the attributes of his profession but with a huge dog, a symbol of his elevated social status. In this portrait and the earlier one, as well as the preparatory drawings for both [fig. 10], Dix pays particular attention to the treatment of the face and hands. He achieves a remarkable physical likeness, paying meticulous attention to detail and texture, yet imparts a distancing effect that cues us to look beyond the sitter's appearance to his personality.

Though working for most of his career in Italy, the German painter Christian Schad remained close to the spirit of the new German realism. Initially associated with Expressionism, and later with the Dada movement in Zurich, Schad transformed his way of painting after World War I. He explained his reasons in the following terms:

At first, when I arrived in Munich, in a Germany that had been abandoned to its fate, I wanted to continue with the mechanical transposition of images,[18] but the context had changed and everything seemed to have suddenly become worthless.[19]

During his artistic maturity Schad devoted himself entirely to portraiture, two major examples of which are in the present exhibition: the *Portrait of Josef Matthias Hauer* of 1927 [cat. 77] and the *Portrait of Dr. Haustein* of 1928 [cat. 78].

The Austrian musician Josef Matthias Hauer (1883–1959), creator of an atonal method of composition, is depicted in front of part of the Eiffel Tower, the legendary monument that appears in the background of numerous portraits of the period. Schad uses this industrial background as a foil for the privacy and intimacy of the portrait itself. Wearing a dark suit and tie, Hauer has a tropical flower in his buttonhole, a detail that might seem unimportant given its size but which immediately catches the eye. The *Portrait of Dr. Haustein* is a powerful image of Hans Haustein (1894–1933), a prestigious Jewish dermatologist who specialized in venereal diseases.

18 The reference is to his experimental photographs or *schadographs*.

19 Quoted in Lebeer 1979, p. 75.

Paloma Alarcó

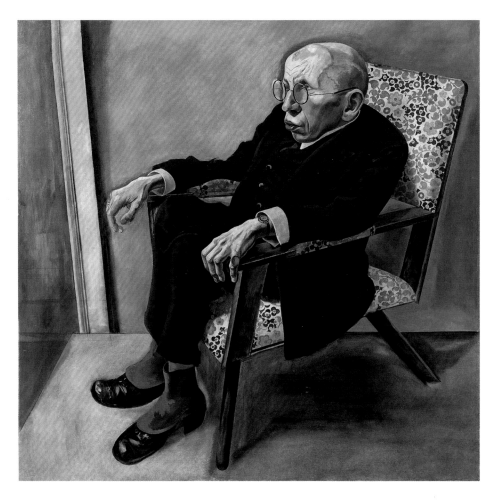

Fig. 11
George Grosz
Portrait of the Poet Herrmann-Neisse, 1925
Oil on canvas, 39 ³/₈ x 40 in. (100 x 101.5 cm)
Städtische Kunsthalle, Mannheim

On his arrival in Berlin in 1928, Schad was introduced by his friend the journalist Felix Bryk to the literary and political salon, that Haustein's wife Friedel had made a meeting-place for leading personalities of the day. Schad remembered it for its "atmosphere of unprejudiced freedom, both intellectual and erotic, typical of Berlin in the 1920s."[20] According to the artist's own account, the shadow on the wall behind the sitter, which recalls the dramatic use of shadows in German Expressionist cinema, was that of Sonja, a model with whom Haustein had fallen in love and whom Schad would portray that same year.[21] In the light of coming events, the shadow becomes a grim premonition: Friedel Haustein eventually committed suicide because of her husband's infidelity and Haustein killed himself with cyanide when arrested by the Gestapo in 1933.

The painter George Grosz placed great emphasis on portraiture during this period and, in parallel with many of his contemporaries, moved away from an acidic and merciless earlier style. His *Self-Portrait Giving a Warning* of 1927 [cat. 79] dates from his later, milder phase. Though still moralizing, the artist's expression lacks the heavy critical charge of earlier works; there is an air of frankness and vulnerability about both the face and the figure.

Conrad Felixmüller's portrait of a Miss Longmuir [cat. 80] is an important example of the highly naturalistic style that characterized this Dresden artist's painting in the second half of the 1920s. He painted the work on the back of the canvas of his *Portrait of Elfriede Hausmann*, executed around 1917 in the Cubist-influenced style of his earlier career. Closer to Grosz's quiet realism of this time than to the more acerbic manner of Dix or Schad, the painting typifies the transformation that took place in Felixmüller's work between his Cubist phase and the realism of the Weimar period.

A unique figure in German painting after World War I, and indeed one of the giants of modern art, Max Beckmann is an artist whose work, with all its hidden meanings, has yet to be definitively studied and analyzed. While he was among the artists featured in the 1925 exhibition, Beckmann did not consider himself aligned with the ideas of the Neue Sachlichkeit and was never convinced by its rigid formulas. During both his years in Germany and his exile in Paris, he developed a highly personal pictorial language and symbol-laden imagery that offered allegories of human existence.

For Beckmann the self-portrait was a form of ritual in which the artist—alone in front of the mirror—conveyed his vision of modern identity with total freedom. James Burke

Fig. 12
Hugo Erfurth
Mathilde (Quappi) Beckmann, 1928
Photograph
Archive Maja Beckmann, Murnau

Fig. 13
Max Beckmann
Quappi in a Pink Sweater, 1935
(detail of cat. 84)

20 Quoted in Vergo 1992, p. 341.

21 Christian Schad, *Sonja*, 1928. Sataatliche Museen zu Berlin, Nationalgalerie.

22 James D. Burke, "Max Beckmann: An Introduction to the Self-Portraits," in Saint Louis 1984, p. 53.

defined his self-portraits as "an epic journey of discovery in which our guide is the artist himself."[22] Like a caustic jester, Beckmann assumes a wide variety of roles, hiding behind multiple masks. He forges a new mythology of society through a fresh and highly individual iconography in which reality and illusion fuse together in perfect synthesis. In *Self-Portrait in Front of Red Curtain* [cat. 82] of 1923 he presents himself standing, holding a cigar, and cutting a distinguished figure in a bowler hat. In one of his last ventures into self-portraiture, *Self-Portrait in a Blue Jacket* [cat. 85], painted in New York in 1950, the fully mature artist shows himself in an emphatically virile manner, his attention absorbed by an object beyond the frame.

In *Double Portrait of Frau Swarzenski and Carola Netter*, painted in 1923 [cat. 81], Beckmann showed his wry sense of humor by painting, side by side, the wife and the mistress of Georg Swarzenski, director since 1906 of the Städel Museum in Frankfurt. It would seem that Swarzenski appreciated the joke since he immediately purchased the painting for his museum's collection. For obvious reasons, the women never posed together in reality. They sit together in an artificial proximity that emphasizes the lack of communication between them. Marie Swarzenski (1889–1967), daughter of the Frankfurt politician Viktor Mössinger, appears on the right, wearing a pink dress and holding a fan; the younger Carola Netter, to the left, wears a black dress and holds her dog in her lap, producing something of the effect of a mirror image. Georg Swarzenski emigrated to the U.S. in 1938 (as Beckmann did in 1947) and continued his museum career at the Museum of Fine Arts, Boston, until 1957.

Among the many personalities of the day photographed by Hugo Erfurth was Mathilde von Kaulbach, known to her friends as Quappi, a young woman of striking features who always dressed in the latest fashions [figs. 12 and 13]. The daughter of the German painter Friedrich August von Kaulbach, Quappi was also an excellent violinist. She was Beckmann's second wife and his faithful companion until his death. Beckmann depicted her on numerous occasions, presenting her as the strong-minded, confident, modern woman who is a common type in the art of this period. As Quappi herself commented, many of her portraits, for instance *Quappi in Blue on the Boat* (1926–1950), *Quappi in a White Fur Jacket* (1937), *Quappi in Blue and Grey* (1944), and *Quappi in a Green Blouse* (1946), were painted to focus on a particular piece of clothing. According to the artist, his obsession with

such things arose from his desire "to capture the magic of reality and transform it into paint."

In *Quappi in a Pink Sweater* [cat. 84] the sitter appears frontally, seated in a blue armchair with her legs crossed, and dressed in a striking pink knitted sweater that matches the cloche hat of the same color that she had just purchased in Frankfurt. Her pose is sensual, and she smokes a cigarette with that indefinable air of modernity that has led people occasionally to mistitle the painting *The American Woman*. More interested in the basic lines of the composition than in the minute representation of details, Beckmann executed the work in a rapid technique, using his characteristic black outlines over which to work various subsequent layers of paint. He painted it in two phases.[23] He almost finished it in Frankfurt in 1932 but two years later, during the couple's stay in Berlin, made some changes and corrected the date; the change to the date is clearly visible. We know from Stephen Lackner, the painting's first owner and a good friend of the artist,[24] that Quappi was originally shown with a broader smile. Between the time Beckmann began the portrait and the time of its completion, the Beckmanns' life was radically transformed: the Nazis forced him to abandon his post as a professor at the Frankfurt Academy and the couple went into semihiding in Berlin.

Since 1929 Beckmann had lived primarily in Paris, although he frequently traveled to Frankfurt to give his classes. In his impressive group portrait of 1931 entitled *Paris Society* [cat. 83], he shows a disparate group of people, including emigrés, intellectuals, aristocrats, and businessmen, at a party at the German embassy in Paris in the years leading up to the establishment of the Third Reich. Among the guests (some of whom were identified years later by Quappi) are the musicologist Paul Hirsch, seated on the far left; the French fashion designer Paul Poiret, in the center; the Frankfurt banker Albert Kahn on the far right; and, next to him, the German ambassador, Leopold von Hoesch, seated and leaning his head on his hand. The painting offers a mordant vision of modern society in which nothing is what it seems and all appearances deceptive. In contrast to the work of his fellow-German artists such as Dix and Grosz, Beckmann's satire is moral rather than political. Hence this somber, ambiguous painting, created at a moment when the artist and his work were under attack in Germany, becomes a presentiment of the threat hanging over European society as a whole.

Like Beckmann, Balthus was an independent artist who stood apart from all the artistic movements taking place around him—with the aim, as he noted on various occasions, of creating a timeless realism. Deploying the techniques of the old masters, he conjures up an apparently inoffensive vision of the world that turns out, on closer inspection, to be one charged with ambiguous and disturbing content. For him the portrait was "a fragment of the soul that is captured, an incursion into the unknown . . . , an alchemy that requires great concentration, great resistance to the outside world."[25] His portrait sitters are stripped of any mask and presented to us as vulnerable beings.

In the 1930s Balthus painted various figures from the world of art, including André Derain,[26] the dealer Pierre Matisse,[27] and Joan Miró. For the portrait entitled *Joan Miró and His Daughter Dolores* [cat. 88], painted to a commission from Pierre Loeb for the great Surrealist painter's 45th-birthday exhibition at the Galerie Pierre in Paris in 1938, Miró posed for Balthus between October 1937 and January 1938. Four years before this Balthus had held his first solo exhibition at the Galerie Pierre, and the eroticism of his paintings had caused a great scandal. Here he shows Miró in a rigid and unstable pose, seated next to his daughter Dolores, who looks fixedly at the viewer. The absence of communication between father and daughter produces an effect as cold as Balthus's pictorial style, which is one of sober naturalism. By representing Miró and his daughter as clinging to each other in the middle of an empty, gloomy space, he brilliantly captures the disquieting mood of the time.

As a form of neoclassicism arose in French and Italian painting, and Neue Sachlichkeit in German, a parallel development took place in the later work of the English painter Walter Sickert—one that would be of particular importance for the future of modern portraiture. In his innovative way of approaching portraits of figures from public life, which was to choose photographs and press cuttings and enlarge them onto his canvases by transfer techniques, Sickert is now considered a forerunner of later artists such as Bacon, Hockney, and Kitaj.[28] He painted the monumental portrait of William Maxwell Aitken, 1st Baron Beaverbrook [cat. 86], in 1935, from a photograph now in the archives of the House of Lords. For Sickert, the camera was a completely reliable witness; as for his own work in transferring the image to canvas, he felt that "while it adds to the spontaneous charm of the copy, by introducing freely the inevitable

23 See Göpel/Göpel 1976, no. 404.

24 See Vergo 1992, p. 37.

25 Vircondelet 2001.

26 Balthus, *André Derain*, 1936. The Museum of Modern Art, New York.

27 Balthus, *Pierre Matisse*, 1938. The Metropolitan Museum of Art, New York.

28 See Richard Morphet, "Late Sickert, Then and Now," in London 1982, pp. 8–22.

personal coefficient, [it] spells a degree of distortion. The face in the original is a *ramassé* little face. In the copy, it becomes, as also does the whole figure, elongated in the vertical sense."[29] Here Lord Beaverbrook (1879–1964), a prominent figure in business and politics, is depicted as a kind of colossus, arranged in a strong frontal pose, with his hands in his pockets, before a sea view.

In contrast to Sickert, Stanley Spencer painted people from his everyday surroundings. His portrait of Daphne Spencer of 1951 [cat. 90] is one of four portraits of a niece—the daughter of his brother Harold, a distinguished musician who moved to Belfast.[30] Painted during one of Spencer's visits to Ulster, the portrait is a remarkable example of his most serene realist style, far removed from the more dramatic and disturbing images of earlier years.[31] Nonetheless, the way in which he pitilessly emphasizes the sitter's glass eye introduces a troubling element into his image of this otherwise attractive young woman.

On occasion critics have associated the English painter Lucian Freud with the Neue Sachlichkeit movement, but the artist himself has denied the connection: "My method is so arduous that it has never left me much room for absorbing external influences."[32] From the period of his earliest works, with their primitivist use of minute detail and a certain Neo-Romantic and Surrealist feeling, Freud has consistently opted for figurative art as opposed to the prevailing tendencies of the day toward abstraction. His *Girl with Roses* of 1947–1948 [cat. 91] is an early portrait of his first wife, Kitty Garman, daughter of Kathleen Garman and the sculptor Jacob Epstein. It is painted in a highly detailed, realistic idiom characteristic of Freud's early portraits. The artist used fine, sable-hair brushes that allowed him to work with small, concise brushstrokes in the manner of the early Netherlandish painters and Dürer. Every detail is telling: the reflection of the window in the pupils of the sitter's eyes, the hand with which she holds the thorny stalk of the rose, and so on. Her stiff figure, slightly shifted to the left of center, conveys a tension that is haunting. Cedric Morris, the young Freud's teacher at the East Anglian School of Painting and Drawing in Essex, impressed upon him the idea that a portrait must be revealing to the point of indecency and Freud has followed his advice ever since.

29 Walter Sickert, *The Daily Telegraph*, 6 April 1929. Quoted in Sickert 2000, p. 578.

30 The other three portraits of Daphne are in Melbourne, London, and Belfast. My thanks to Martin Anglesea, Keeper of the Ulster Museum, for the information he provided on this work.

31 See chapter 9.

32 Freud 1954, pp. 23–24.

Paloma Alarcó

Cat. 67 Pablo Picasso
Olga Khokhlova, 1917
Oil on canvas, 47 ⅓ x 29 ½ in. (120 x 75 cm)
Private collection. Courtesy of Galerie
Jean Krugier & Cie., Geneva

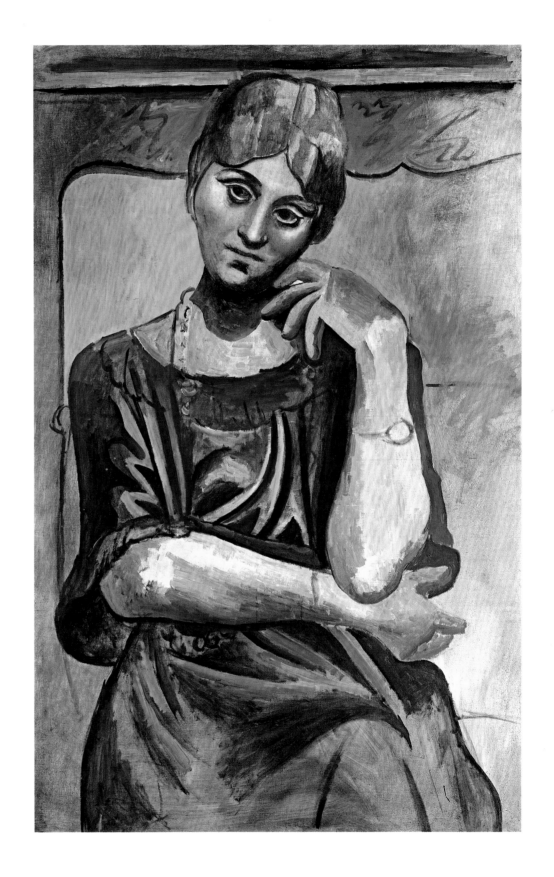

Cat. 68 Pablo Picasso
Olga with a Fur Collar, 1923
Oil on canvas, 45 ⅞ x 31 ⅞ in. (116 x 80.5 cm)
Musée Picasso, Paris. On deposit
at the Musée des Beaux-Arts, Lille

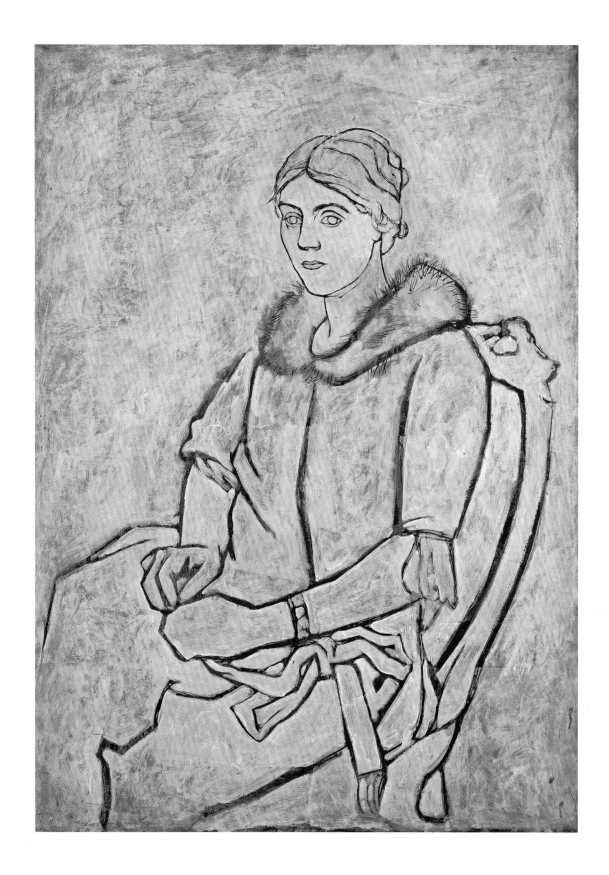

Cat. 69 Pablo Picasso
Portrait of the Artist's Wife (Olga), 1923
Oil on canvas, 51 x 38 ¼ in. (129.5 x 97 cm)
Private collection, London

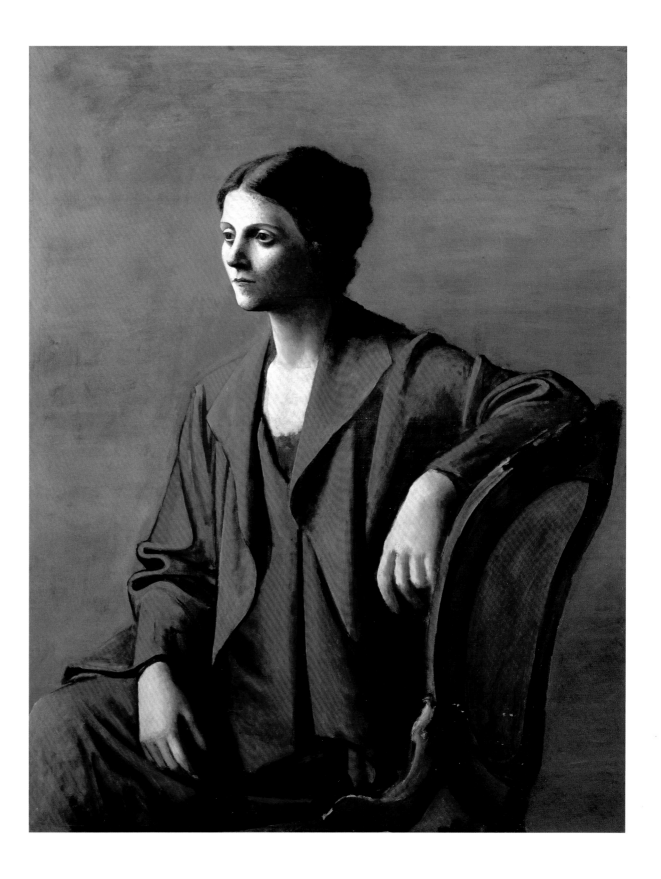

Cat. 71 Pablo Picasso
Harlequin with a Mirror, 1923
Oil on canvas, 39 ⅜ x 31 ⅞ in. (100 x 81 cm)
Museo Thyssen-Bornemisza, Madrid

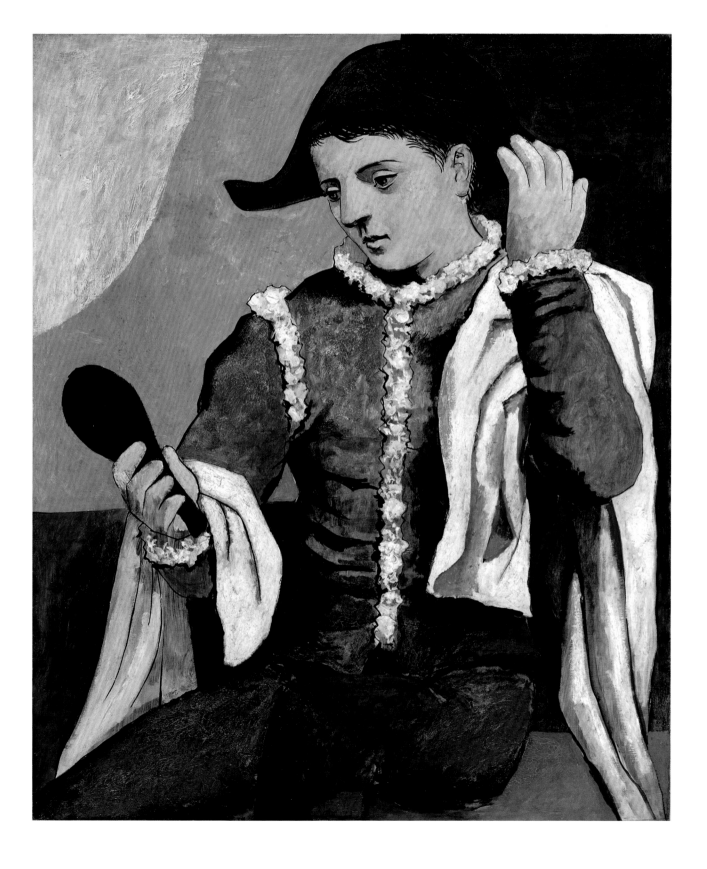

Cat. 72 Otto Dix
Portrait of the Lawyer Hugo Simons, 1925
Tempera and oil on wood, 39 ⅔ x 27 ⅔ in. (100.3 x 70.3 cm)
The Montreal Museum of Fine Arts

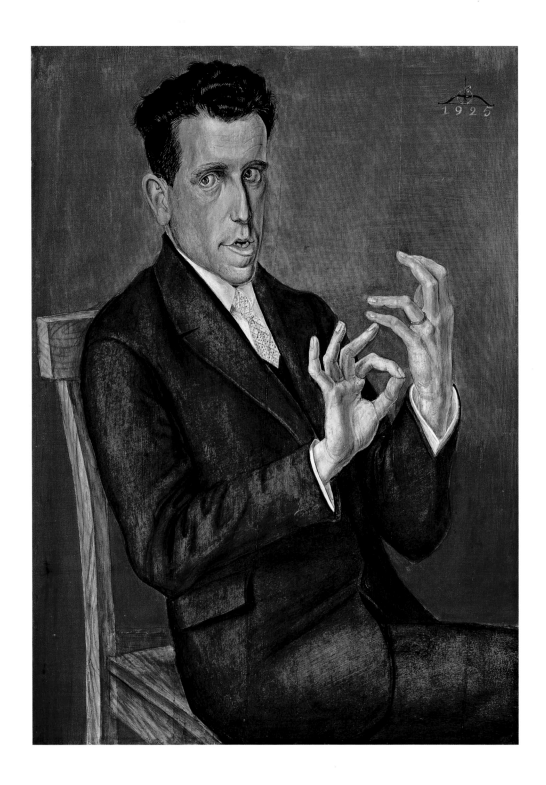

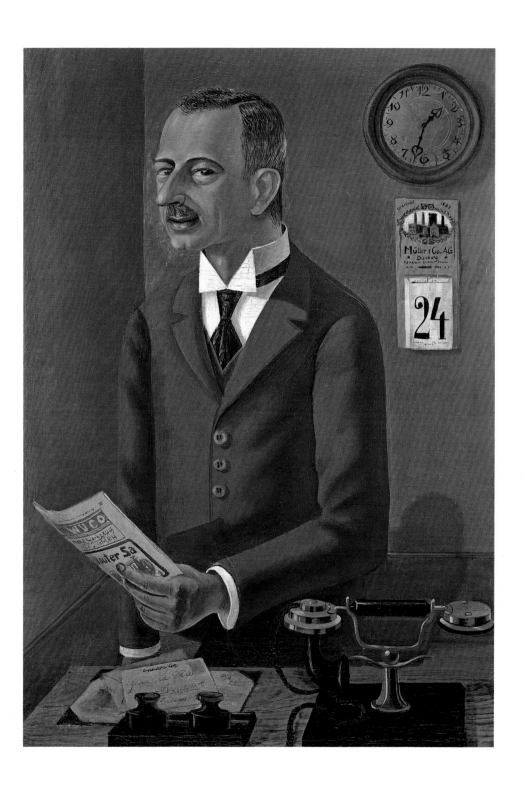

Cat. 74 Otto Dix
Venus of the Capitalist Era, 1923
Oil on hardboard, 50 ⅜ x 19 ⅝ in. (128 x 50 cm)
Private collection. Courtesy MaxmArt, Mendrisio, Switzerland

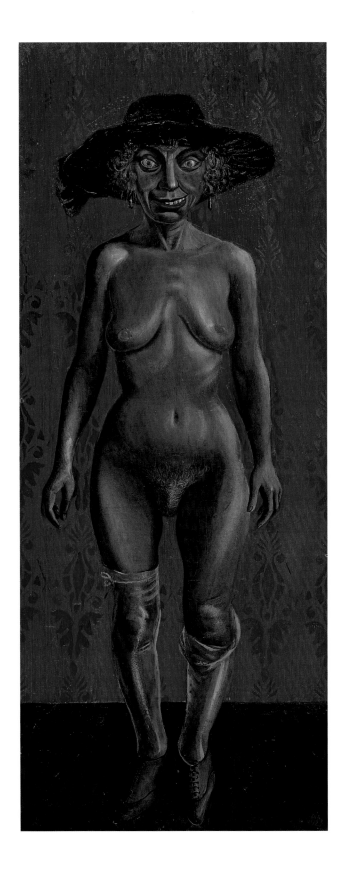

Cat. 75 Otto Dix
Portrait of the Photographer Hugo Erfurth with Dog, 1926
Tempera and oil on board, 31 ⅛ x 39 ⅜ in (80 x 100 cm)
Museo Thyssen-Bornemisza, Madrid

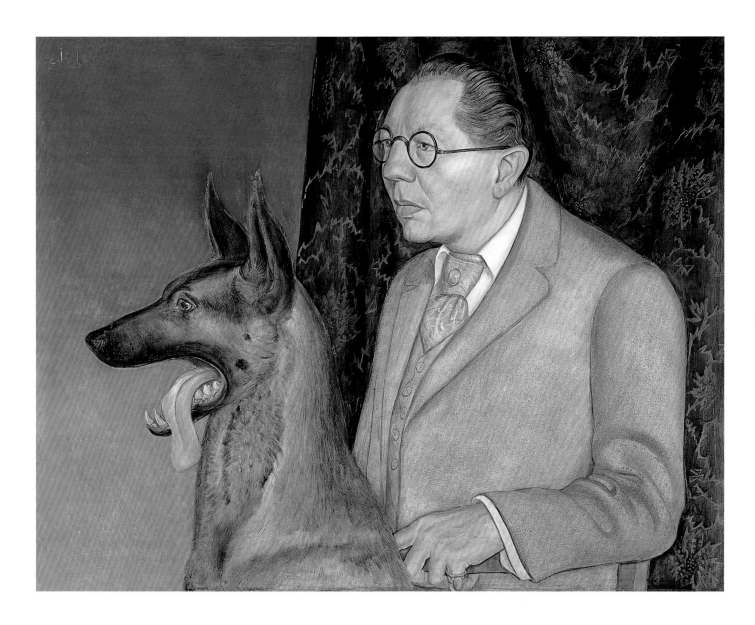

Cat. 76 Salvador Dalí
 Portrait of My Father, 1925
 Oil on canvas, 41 ⅛ x 41 ⅛ in. (104.5 x 104.5 cm)
 MNAC. Museu Nacional d'Art de Catalunya, Barcelona

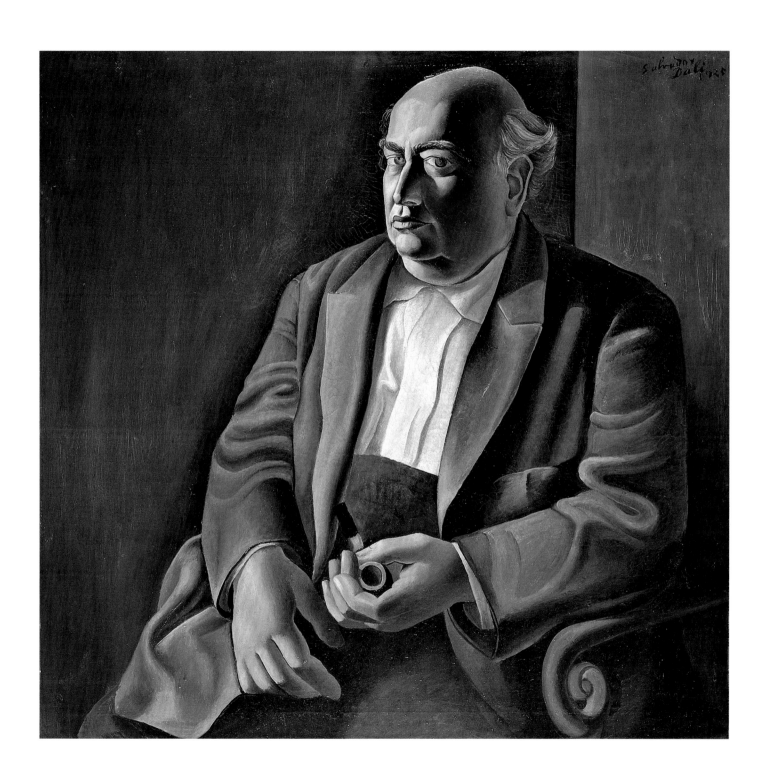

Cat. 77 Christian Schad
Portrait of Josef Matthias Hauer, 1927
Oil on board, 24 x 19 ⅞ in. (61 x 50 cm)
Private collection. Courtesy MaxmArt, Mendrisio, Switzerland

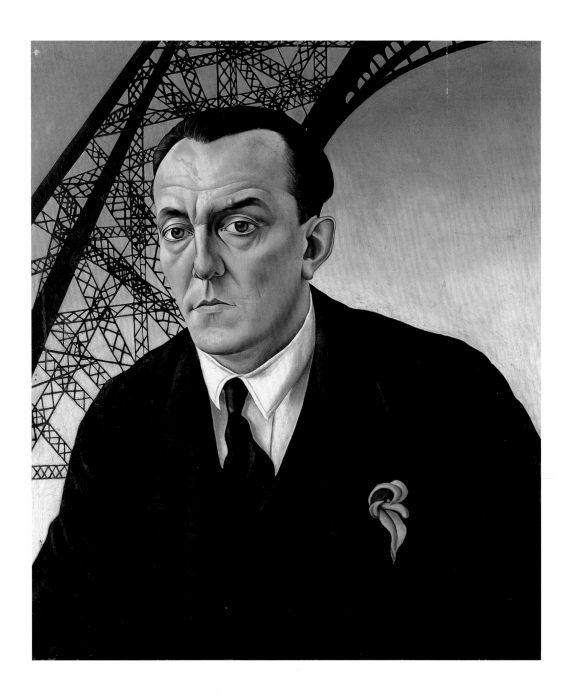

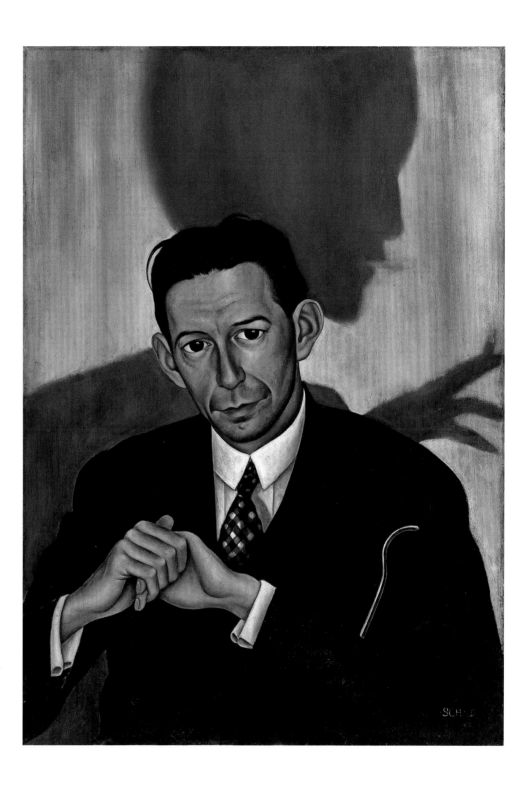

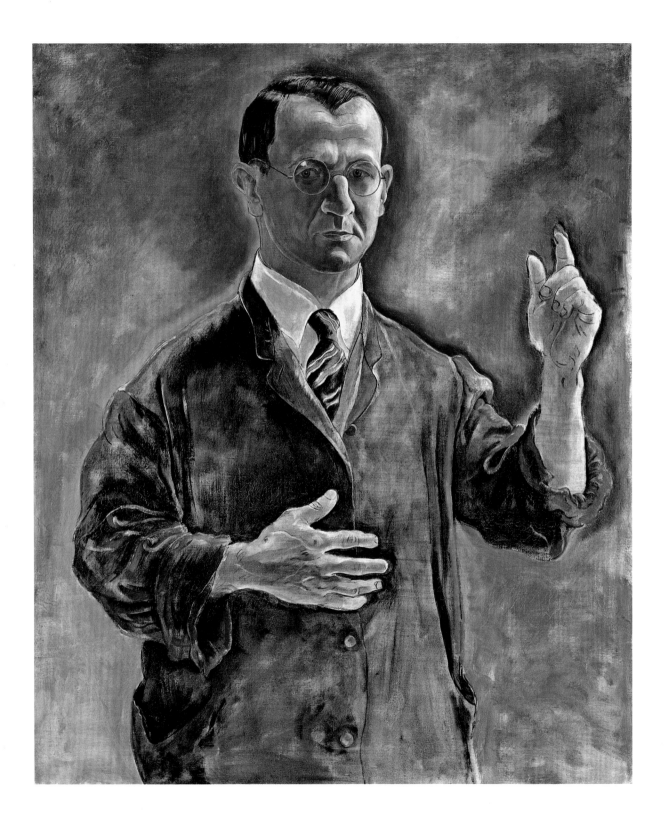

Cat. 80 Conrad Felixmüller
Portrait of a Young Scottish Woman (Miss Longmuir), 1929
Oil on canvas, 30 ⅛ x 21 ⅛ in. (76.5 x 53.7 cm)
Carmen Thyssen-Bornemisza Collection on loan
to the Museo Thyssen-Bornemisza, Madrid

Cat. 81 Max Beckmann
 Double Portrait of Frau Swarzenski and Carola Netter, 1923
 Oil on canvas, 31 ⅞ x 25 ⅝ in. (80.5 x 65 cm)
 Städel Museum, Frankfurt

Cat. 82 Max Beckmann
Self-Portrait in Front of Red Curtain, 1923
Oil on canvas, 43 ⅜ x 23 ⅜ in. (110.2 x 59.2 cm)
Private collection. Courtesy of the Neue Galerie, New York

Cat. 83 Max Beckmann
Paris Society, 1931
Oil on canvas, 43 x 69 ⅛ in. (109.2 x 175.6 cm)
Solomon R. Guggenheim Museum, New York
(70.1927)

Cat. 84 Max Beckmann
Quappi in a Pink Sweater, 1935
Oil on canvas, 41 ⅜ x 28 ¾ in. (105 x 73 cm)
Museo Thyssen-Bornemisza, Madrid

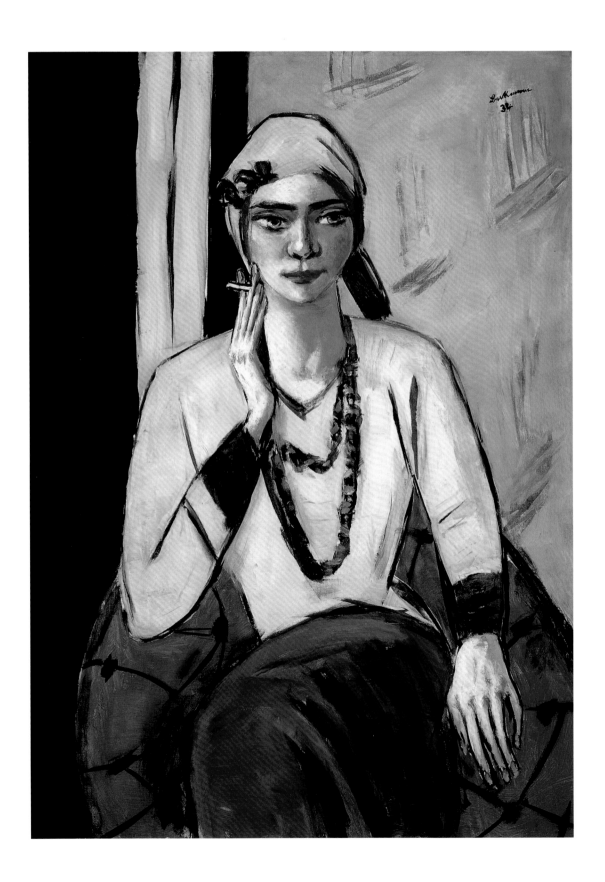

Cat. 85 Max Beckmann
Self-Portrait in a Blue Jacket, 1950
Oil on canvas, 55 ⅛ x 36 in. (140 x 91.4 cm)
Saint Louis Art Museum. Bequest of Morton D. May

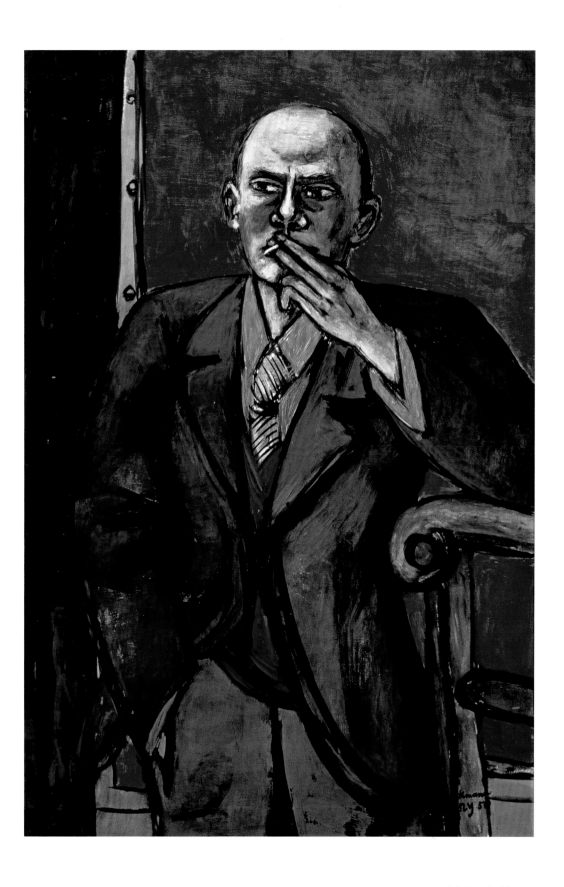

Cat. 86 Walter Sickert
William Maxwell Aitken, 1st Baron Beaverbrook, 1935
Oil on canvas, 69 ⅞ x 42 ¼ in. (176.2 x 107.3 cm)
National Portrait Gallery, London

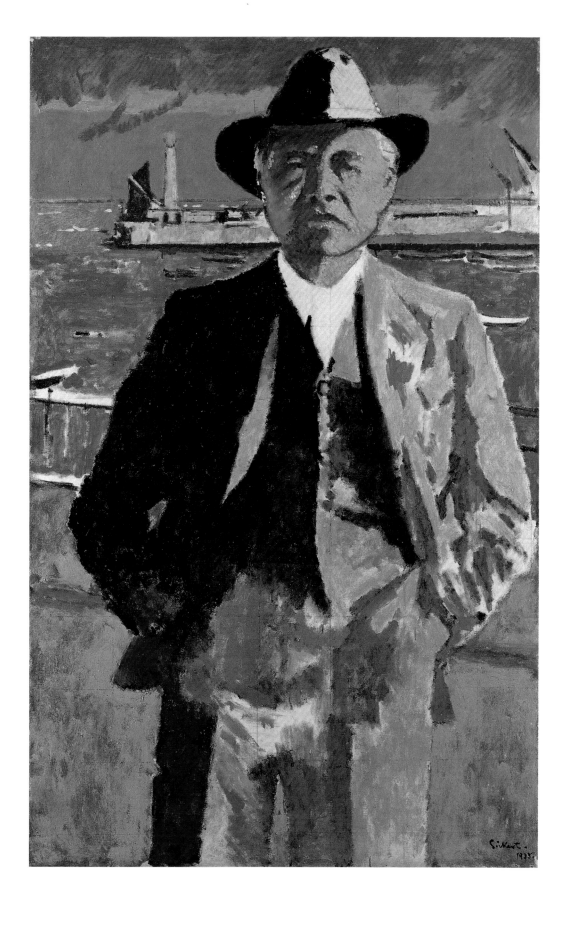

Cat. 87 Gino Severini
The Painter's Family, 1936
Oil on canvas, 68 ⅞ x 46 ½ in. (174 x 118 cm)
Musée des Beaux-Arts de Lyon

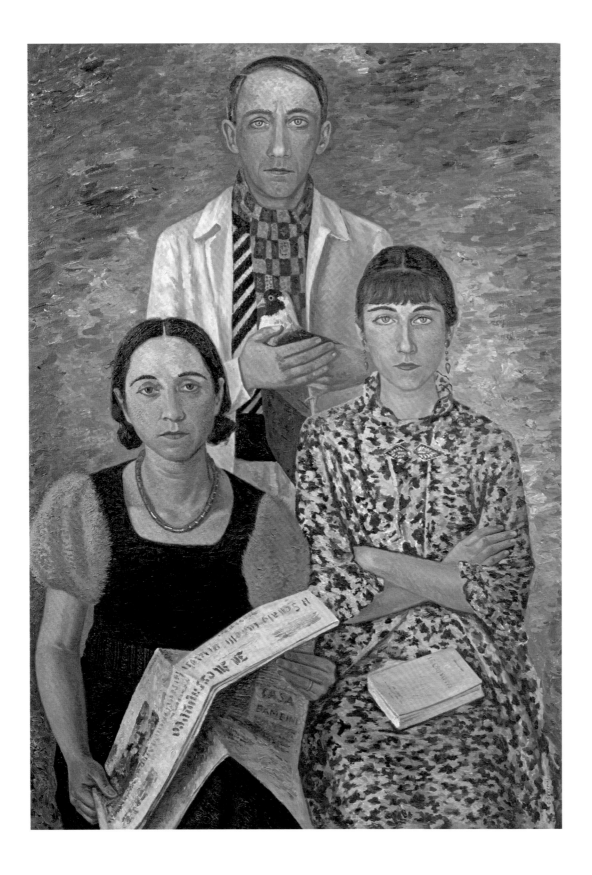

Cat. 88 Balthus
Joan Miró and His Daughter Dolores, 1937–1938
Oil on canvas, 51 ¼ x 35 in. (130.2 x 88.9 cm)
The Museum of Modern Art, New York.
Abby Aldrich Rockefeller Fund (398 1938)

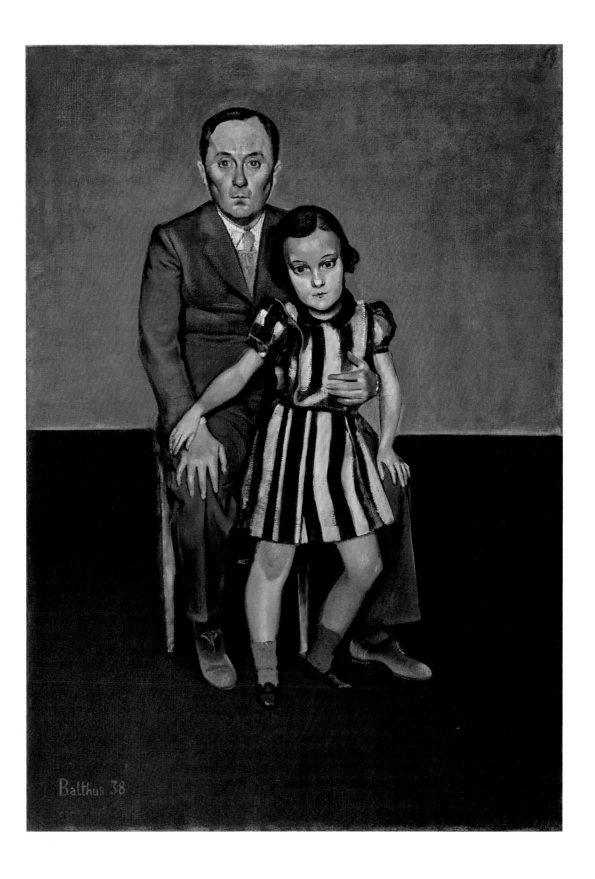

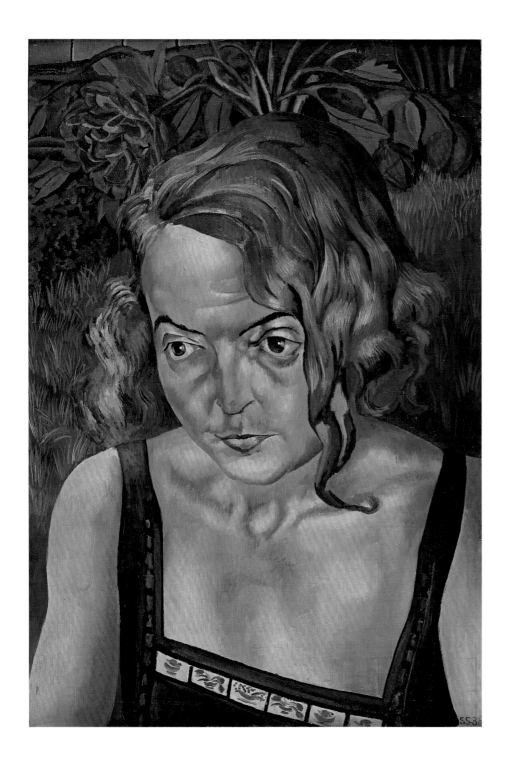

Cat. 90 Stanley Spencer
Daphne Spencer, 1951
Oil on canvas, 36 / x 24 / in. (92.3 x 61.6 cm)
Ulster Museum, National Museums
and Galleries of Northern Ireland, Belfast

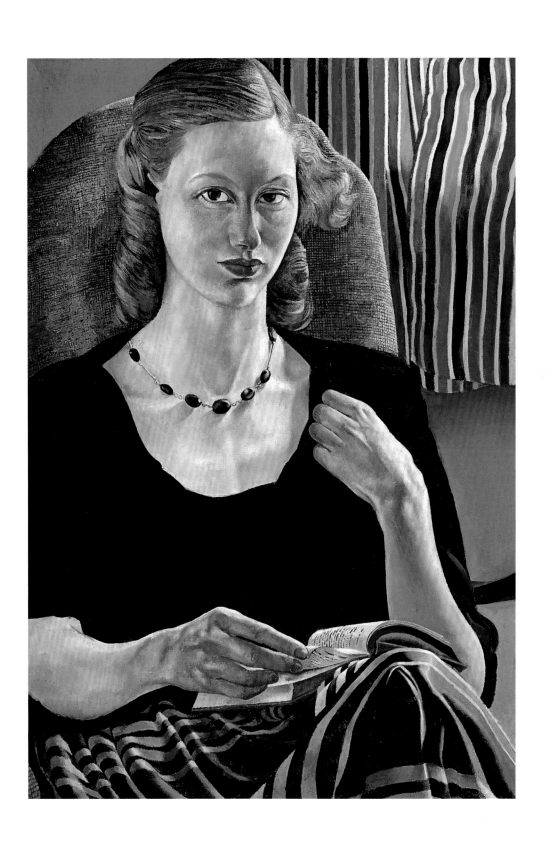

Cat. 91 Lucian Freud
Girl with Roses, 1947–1948
Oil on canvas, 41 ¾ x 29 ¾ in. (106 x 75.6 cm)
British Council, London

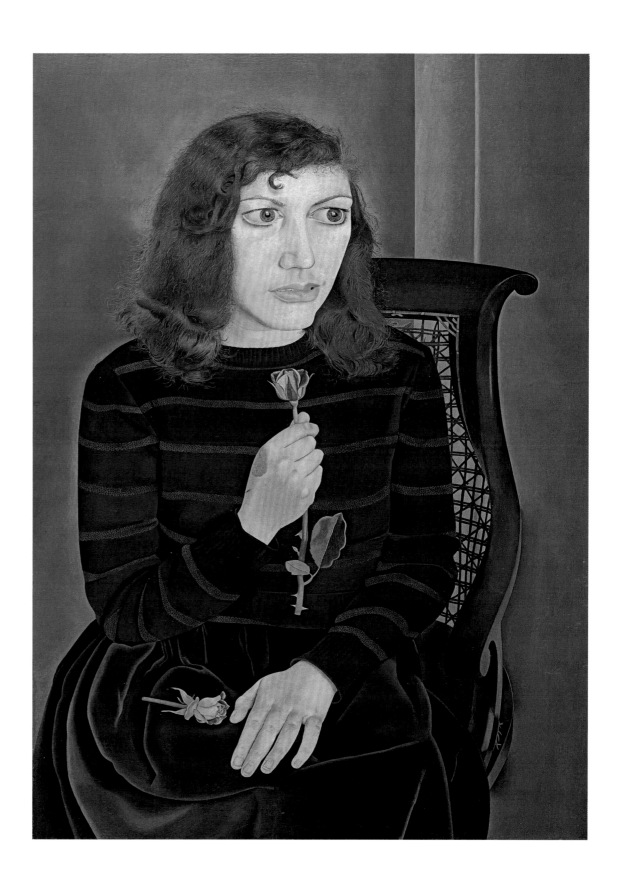

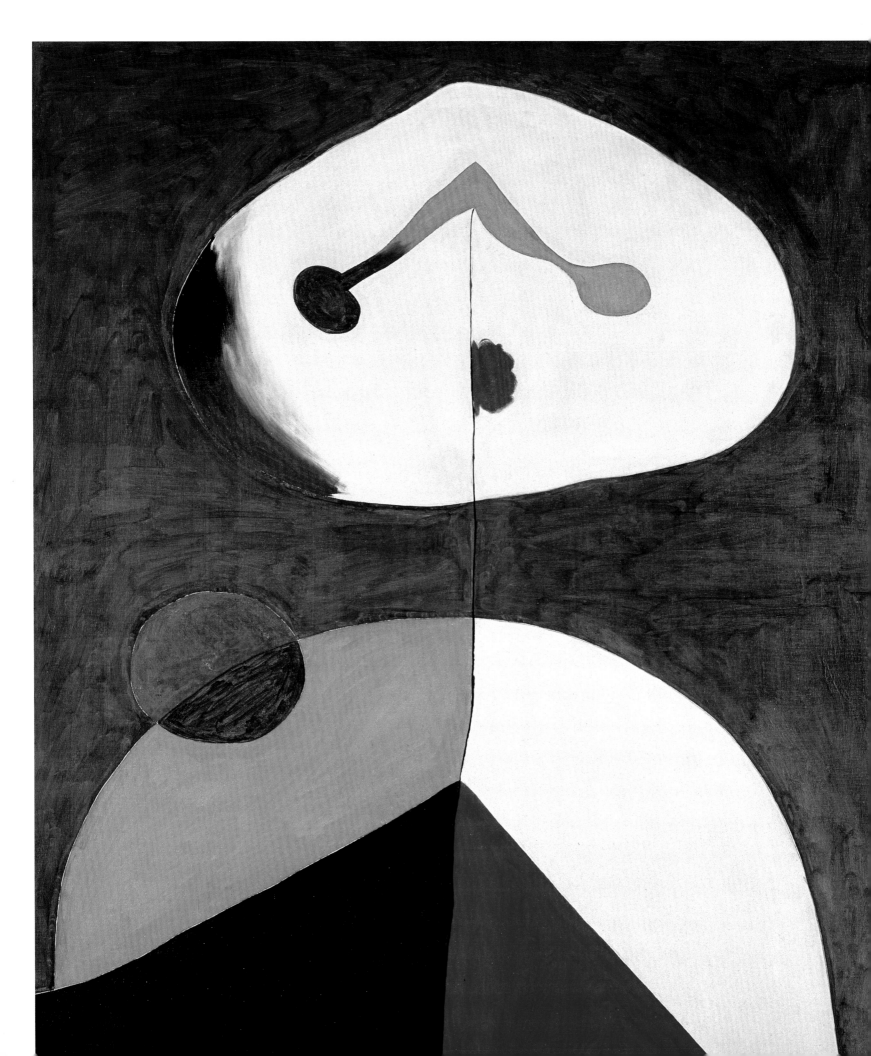

7 DREAM AND NIGHTMARE

In the winter of 1937, at the time he was posing in the studio of Balthus for his portrait with his daughter Dolores [cat. 88], Joan Miró painted his *Self-Portrait I* [fig. 1]. According to a letter to his dealer Pierre Matisse, he expected the work to be "the most sensational thing I have ever done."[1] Meanwhile, Europe stood on the threshold of worldwide conflict and Miró was trapped in Paris, unable to return to Spain because of the Civil War, circumstances that undoubtedly made themselves felt in his self-portrait.

Working in pencil with touches of color in oil, the artist shows his face on a monumental scale; according to his own account, he used a concave mirror.[2] The face is enlarged and distorted to the point of seeming inhuman– a quite different effect from that of Parmigianino's well known *Self-Portrait in a Convex Mirror* [fig. 7 on p. 233], in which the only distorted element of the body is the right arm in the foreground. Miró's monstrous head, covered in volcanoes and stars, has been related to a van Gogh self-portrait of 1889 [fig. 2] that appeared in the van Gogh exhibition held in Paris from June to October 1937 to coincide with the Universal Exhibition. Given that Miró began his self-portrait in the month of October, it is very possible that he took the van Gogh as his starting-point.[3] In the *carnet* that includes the preparatory drawings for this work, now in the Fundación Miró in Barcelona, the artist noted that he had not been able to paint a landscape of Mont-Roig as he had planned, adding, "what I can do is, in the next self-portrait, a head-landscape, with human elements that recall the landscape from here, metamorphosing myself into it."[4]

Miró set great value on this portrait. Once it was finished, before sending it to Pierre Matisse, he made a pencil copy for future use, perhaps to transfer the image to another canvas if he so desired. The artist returned to this drawing in 1960 and painted another self-portrait over it [cat. 95], creating a double self-portrait from two widely separated moments in the artist's career. The minute detail of the first image, which forms the background of the work, contrasts with the gestural and freely inventive idiom of the second. This latter is a spontaneous scribble, executed in black paint with touches of red, yellow, and purple. Miró described the image as follows: "The eyes are sparks, in one there is a star, in the other a sun; here, like a bird, on the tie, like a flower, while the hairs are like flames."[5]

The self-portrait and the portrait are genres to which Miró returned with some regularity. In *Portrait II* of 1938 [cat. 96] he reveals his highly individual way of suggesting a sitter's interior life, using his own distinctive surreal language of lines, colors, and forms. Surrealism opened the way for him to create a highly associative art charged with poetic imagery and signs from his boundless imagination.

The revival of classicism had been, to some degree, a means of escape for artists who had experienced World War I. But soon it was evident that Arcadia could not survive. In an unstable Europe, menaced by Fascism, Surrealism would become a formula for evasion; it aspired to change the world by releasing the inner impulses of mankind that had been repressed by civilization. In his *Second Surrealist Manifesto* of 1930 Breton defined the surreal as the reconciliation of reality and dreams. In accordance with this idea, the Surrealists proclaimed the creation of a new, interior reality. Despite their break with reality in the conventional sense, however, they did not abandon the genre of portraiture. Instead they invented new forms of portrait filled with symbols and metaphors, cryptic images in line with the doctrine of irrational associations.

While Cubist portraits subjugate the sitter to the style, such works as Miró's Surrealist portraits and Picabia's "symbolic portraits" [fig. 3] stand as metaphors of the sitters, in which faces and bodies have been replaced by a series of signs or objects. Surrealist portraiture has sometimes been seen as a revival of traditions of religious art in which specific figures

1 Joan Miró, letter to Pierre Matisse, Paris, 4 March 1938, in Rowell 1987, p. 157.

2 Rowell 1987, p. 257.

3 See David Lomas, "Inscribing Alterity: Transactions of Self and Other in Miró Self-Portraits," in Woodall 1997, pp. 167–186.

4 Carnet FJM 4398–4437, Fundación Joan Miró, Barcelona. Quoted in Barcelona 1993, p. 356.

5 Quoted in Raillard 1977, p. 87.

Paloma Alarcó

Fig. 1
Joan Miró
Self-Portrait I, 1937–1938
Pencil, crayon, and oil on canvas, 57 ⅞ x 38 ¼ in.
(146.1 x 97.2 cm)
The Museum of Modern Art, New York.
James Thrall Soby Bequest (1283.1979)

Fig. 2
Vincent van Gogh
Self-Portrait, 1889
Oil on canvas, 25 ⅝ x 21 ½ in. (65 x 54.5 cm)
Musée d'Orsay, Paris

Fig. 3
Francis Picabia
Portrait of Max Jacob, 1915
Musée d'Orsay, Paris

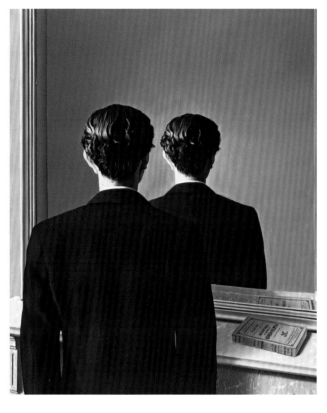

Fig. 4
René Magritte
Not to Be Reproduced, 1937
Oil on canvas, 31 ⅞ x 25 ⅝ in. (81 x 65 cm)
Museum Boijmans Van Beuningen, Rotterdam

such as saints are represented by attributes. The difference was that now the association between symbol and identity was up to the artist, not conditioned by any existing text or pictorial tradition.

A classic example is René Magritte's *The Portrait* of 1935 [cat. 97]. By way of an explanation, Magritte wrote on the painting's catalogue card: "LE PORTRAIT (est correct)."[6] If not for the title and explanation, we would be unlikely to interpret the painting as anything other than a still life. In his emphasis on the intellectual idea behind the image over the image itself, Magritte anticipates conceptual art of the 1960s. Magritte's investigations into the unconscious, his deployment of strange and thought-provoking combinations of figures and objects to create a world turned upside-down, made for highly original ventures into portraiture. He submitted the portrait, one of his favorite motifs, to transformations that

subverted the traditional norms of the genre. Indeed much of his work could be considered a parody of portraiture, though often only identifiable as such thanks to the artist's annotations. Among the most memorable examples is *Not to Be Reproduced* [fig. 4], one of Magritte's most famous works, in which he portrays his friend Edward James from behind, facing a mirror in which his back rather than his face is reflected.

In the late 1920s Picasso's art changed direction as a result of his association with the Surrealists. Like the tendency toward abstraction within Cubism, classical idealization had led him to a dead end. Though never a convinced Surrealist, he was able to make use of certain elements of the psychological theories promoted by the movement. Between 1927 and 1928 he made a series of remarkable geometrical paintings employing the Surrealist technique of linear automatism and for the first time introduced the shadow

6 Sylvester/Witfield 1992, vol. II, p. 204.

Fig. 6
Pablo Picasso
Painter and Model, Paris, 1928
Oil on canvas, 51 ⅛ x 64 ⅛ in. (129.8 x 163 cm)
The Museum of Modern Art, New York.
The Sidney and Harriet Janis Collection (644.1967)

of a profile—his own profile, based on one of his photographs
[fig. 5].[7] This type of self-portrait generally appears next to
a monstrous female figure, a toothed amoeba that probably
refers to Olga, with whom the artist maintained a tormented
relationship [fig. 6]. The self-portrait as shadow had certain
precedents in the art of other painters, including Munch and
Kees van Dongen [fig. 7], as well as in various photographic
portraits, but it would be Picasso who made its use widespread.[8]
In representing himself as a shadow—which, like a reflection
in a mirror, reduced him to a phantom—Picasso aimed to
symbolize his isolation.

In *Figure and Profile* of 1928 [cat. 93] the silhouette of
Picasso's face occupies the left part of the painting, with
the image of a toothed figure (an abstraction of Olga) and

Fig. 7
Kees van Dongen
Self-Portrait, 1895
Oil on canvas, 36 ⅜ x 23 ½ in. (92.5 x 59.8 cm)
Centre Pompidou, Paris. Musée national d'art moderne/
Centre de création industrielle

Paris the Surrealists wished to bring him into their orbit but, though influenced by them to some degree, he remained faithful to the ancestral mysteries of classical mythology that were his constant source of inspiration. The *Self-Portrait with the Head of Mercury* of 1923 [cat. 92] repeats the composition of most of his self-portraits with classical sculpture. The effect of the sculpture is to add an ambiguous symbolic suggestiveness to the image. Here de Chirico pairs himself with the Roman god Mercury (Hermes in Greek), the messenger between the gods and mankind, setting up counterpoints between the classical and the modern, the mythic and the real. The statue is set apart from the artist in time but also physically, perhaps to suggest that real communication between them is impossible.

The Surrealists welcomed Salvador Dalí into their ranks shortly after his arrival in Paris; he was fascinated by their belief in the free association of ideas and the role of chance in art. The Surreal world that Dalí created in his work depended upon the "critical paranoiac method," an irrational association of images that gave rise to new meanings—an approach quite distinct from the psychic automatism promoted by André Breton. He painted the *Portrait of Paul Eluard* of 1929 [cat. 98] while the Surrealist poet was staying in Cadaqués with his wife, Gala, who was soon to be Dalí's own partner and muse [fig. 9]. Eluard's head, his facial features portrayed fairly realistically judging from photographs of the time, flies over a desert landscape accompanied by strange objects and animals.

As is well known, Dalí had an almost lifelong obsession with Picasso,[9] who appears in some of his paintings and writings. In his *Vida secreta* [Secret Life] he notes that when he went to Paris for the first time in 1926 the first thing he did was to visit Picasso. The young Dalí announced: "I have come to see you before going to the Louvre," to which Picasso apparently replied: "You did very well."[10] During the visit Dalí showed Picasso his painting *Girl from Figueres*, which Picasso studied in great detail without making any comment before showing Dalí the paintings of his own that he had in the studio at the time. In 1935 Dalí wrote the story *Les Pantoufles de Picasso*, in which he applied his paranoiac-critical method to a text by Sacher-Masoch, replacing some words with others in order to create multiple new readings. Years later, in 1951, he gave a lecture entitled "Picasso and I" in the Teatro María Guerrero in Madrid, beginning with the much-quoted phrase: "Picasso is a Communist, me neither."

another more schematic profile on the right. The rectangle around these last could be interpreted as a mirror on the wall, in which the artist's face is reflected. Like Miró in the self-portrait discussed above, Picasso creates a double image of himself—through the shadow that transforms identity into otherness and the mirror image that transforms identity into reflection. Miró's *Painting (Portrait and Shadow)* [cat. 94], in which this same doubling effect appears, would lend itself to a similar interpretation.

Giorgio de Chirico used the image of the shadow in his *Premonitory Portrait of Guillaume Apollinaire* of 1914 [fig. 8]; the shadow of the poet's profile forms a counterpart to a classical bust. But the significance of this kind of doubling in de Chirico's portraits is quite different. During his time in

7 See Paris 1994, p. 83.

8 For a study of the self-portrait as shadow, see Stoichita 1997.

9 A recent publication has brought together all the numerous (unanswered) letters sent by Dalí to Picasso, edited by Laurence Madeline. See Dalí 2005.

10 Dalí 1942.

Paloma Alarcó

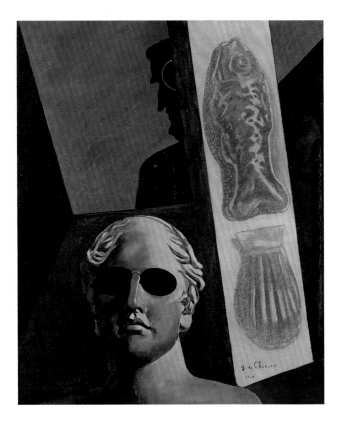

Fig. 8
Giorgio de Chirico
Premonitory Portrait of Guillaume Apollinaire, 1914
Oil on canvas, 32 x 25 ⅝ in. (81.2 x 65 cm)
Centre Pompidou, Paris. Musée national d'art moderne/
Centre de création industrielle

Perhaps the most important reference to Picasso in Dalí's work is the *Portrait of Pablo Picasso in the 21st Century*, painted in California in 1947 [cat. 99], which belongs to a series of portraits of geniuses, including Homer, Freud, Christopher Columbus, William Tell, and Dalí himself. The figure, which resembles a huge piece of meat on a butcher's counter, combines different objects like a painting by Archimboldo. It is an enigmatic image filled with symbols that are difficult to interpret. Robert Descharnes believed that "Picasso's pronounced intellectualism is indicated by the brain escaping from his mouth to transform itself into a spoon."[11] The image of the exaggeratedly large, chewing-gum-like spoon had appeared in various earlier paintings by Dalí as part of his exploration of soft-hard juxtapositions. For Michael Taylor, the spoon "expresses Dalí's theories on psychic cannibalism and edible beauty," and he aptly relates it to a line from Shakespeare's *A Comedy of Errors*: "He must have a long spoon that must eat with the devil."[12] This faithfully reflects Dalí's feelings towards Picasso.

The work of the Mexican painter Frida Kahlo, with its primitivist style and charge of symbolism, led Breton to champion her as a Surrealist painter. Kahlo's numerous self-portraits are expressions of her life, a superimposition of autobiographical and psychological elements, and a cathartic liberation of her emotions. The sometimes brutal images of her body, damaged in an horrific accident, and the myth that grew up around her unhappy marital life with Diego Rivera, have made Kahlo into an icon of anguish and female suffering. In her *Self-Portrait with Thorn Necklace and Hummingbird* of 1940 [cat. 100], she depicts herself in a highly frontal manner as if she were painting on a mirror. The necklace of thorns from which the painting takes its title adds an enigmatic note, which is heightened by the appearance of a monkey and a cat on her shoulders.

Charley Toorop, daughter of the Dutch Symbolist artist Jan Toorop, was closely associated with the Neue Sachlichkeit aesthetic in Holland. Her painting *Three Generations* [cat. 102] is a sort of dynastic self-portrait in which she immortalizes herself along with her family. On the right we see her son and immediately behind her father, in the form of a gigantic bronze head. The picture surface and the mirror in which the artist studies her image become one and the same; she touches it with the tip of her brush. The visual conundrum that Toorop sets up, the interplay of ambiguities between the artist in front of the mirror and

Fig. 9
Cecil Beaton
Salvador Dalí and Gala Dalí, 1936
Vintage bromide print, 9 ½ x 7 ½ in.
(24.1 x 19.2 cm)
National Portrait Gallery, London

the viewer before the canvas, gives the whole painting a highly Surrealistic air.

To conclude this chapter, we should turn to the work of Käthe Kollwitz and Felix Nussbaum, each a reminder that, for many artists, the dreamlike world of Surrealism was no escape in the end from the nightmare that was spreading ever more widely through Europe. A society that had seemed in principle to be civilized was revealing itself to contain individuals ready to devour each other. The dark atmosphere of Germany at this time is reflected in portraits of disillusionment gradually turning to terror.

Despite supporting realism in her writings on art, Käthe Kollwitz assimilated much from the German Expressionists, including an ability to convey emotion powerfully through expression. In her numerous self-portraits, which together form a graphic autobiography, she represents herself without pity or any trace of vanity or self-indulgence. Her self-portrait in relief entitled *The Lament (Self-Portrait)* [cat. 101], which she made after the memorial service for her friend the sculptor Ernst Barlach in October 1938, was her way of mourning his death and silently denouncing the injustices that he had endured under the Nazi regime.[13] The drama of the face and the melancholy expression speak of death and the gathering gloom in the world around her.

Felix Nussbaum's self-portraits are a further instance of how an artist could respond to tragic events and a life deprived of liberty. In the years in which he took refuge from Nazi persecution in Brussels, haunted by the anguish of this enforced hiding, he painted numerous self-portraits that embody the shock and nightmare that all the "degenerate" artists were experiencing at that time. They include *Self-Portrait in a Shroud (Group Portrait)* of 1942 [cat. 103] and *Self-Portrait with Jewish Identity Card*, probably painted in late 1943 [cat. 104]. In the latter, the expression of anxiety on the artist's face sums up the experience of an entire generation. In June 1944 Nussbaum and his wife, Felka Platek, were arrested by the Gestapo. In August they were sent to Auschwitz, where they were murdered two months later.

11 Descharnes 1989, p. 308.

12 Quoted in Venice 2004, p. 168.

13 Kollwitz herself had been expelled from the Berlin Fine Arts Academy in February 1933.

Cat. 92 Giorgio de Chirico
Self-Portrait with the Head of Mercury, 1923
Tempera on canvas, 25 ⅗ x 19 ⅗ in. (65 x 50 cm)
Private collection. Courtesy MaxmArt, Mendrisio, Switzerland

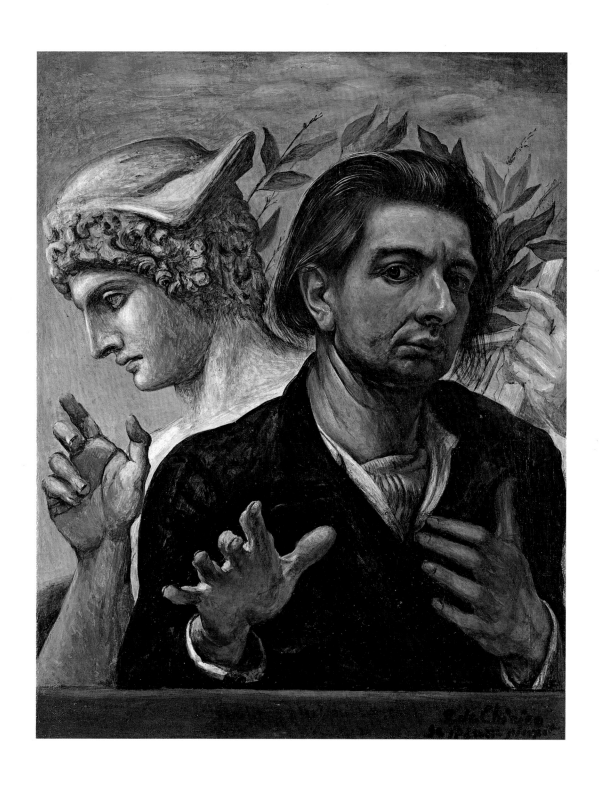

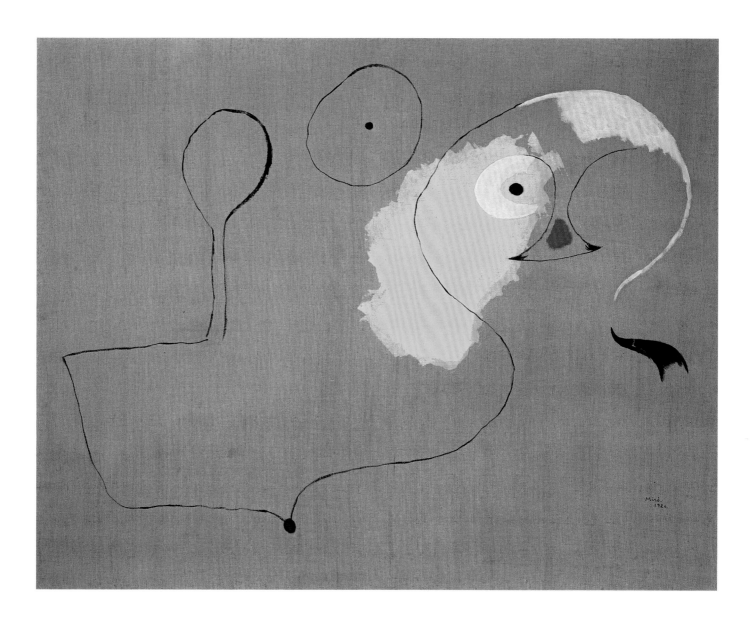

Cat. 95 Joan Miró
Self-Portrait, 1960 (on an autograph copy of *Self-Portrait I*, 1937–1938)
Pencil and oil on canvas, 57 ⅖ x 38 ⅛ in. (146 x 97 cm)
E. Fernández Miró Collection

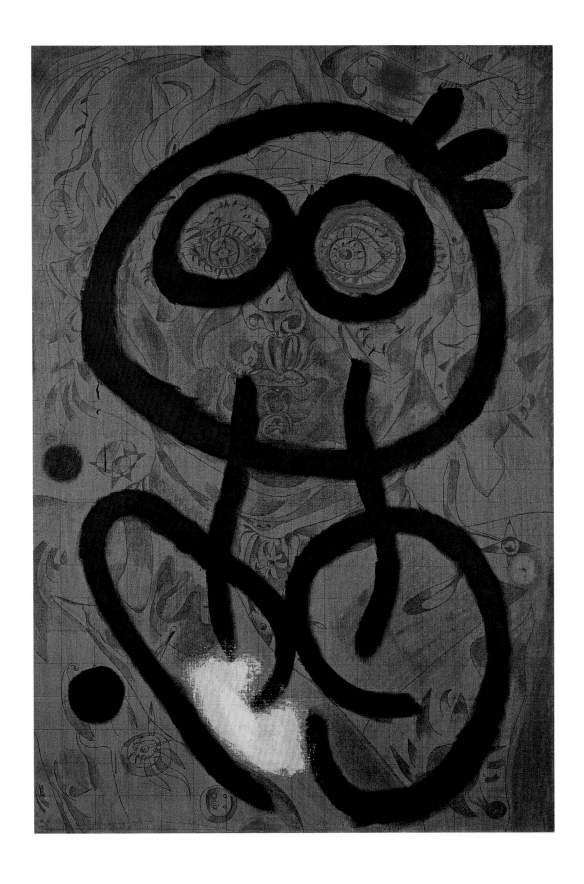

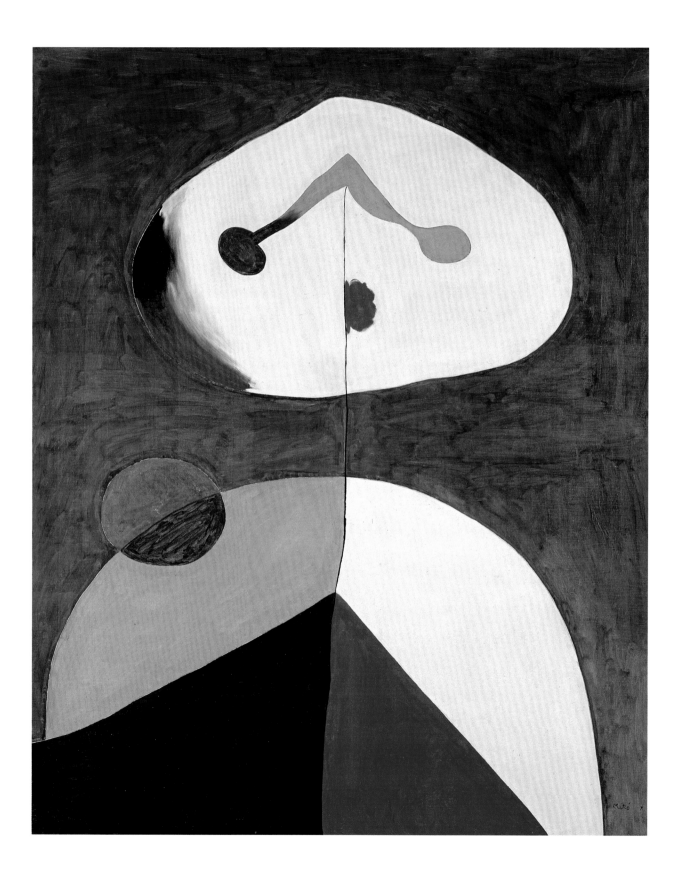

Cat. 97 René Magritte
The Portrait, 1935
Oil on canvas, 28 ⅞ x 19 ¾ in. (73.3 x 50.2 cm)
The Museum of Modern Art, New York.
Gift of Kay Sage Tanguy (574.1956)

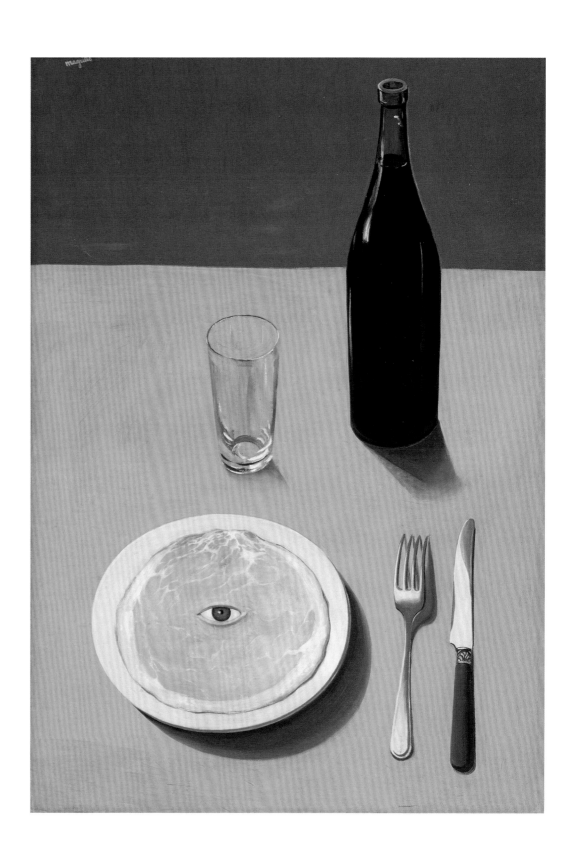

Cat. 98 Salvador Dalí
 Portrait of Paul Eluard, 1929
 Oil on canvas, 9 ⅞ x 12 ¾ in. (32.5 x 25 cm)
 Courtesy of the Fondation Pierre Gianadda, Martigny, Switzerland

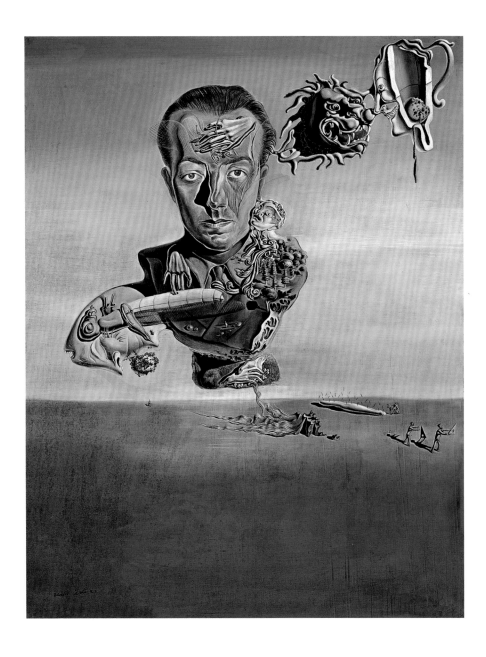

Cat. 99 Salvador Dalí
Portrait of Pablo Picasso in the 21st Century (One of a Series of Portraits
of Genius: Homer, Dalí, Freud, Christopher Columbus, William Tell, etc.), 1947
Oil on canvas, 25 ⅞ x 22 in. (65.5 x 56 cm)
Fundación Gala-Salvador Dalí

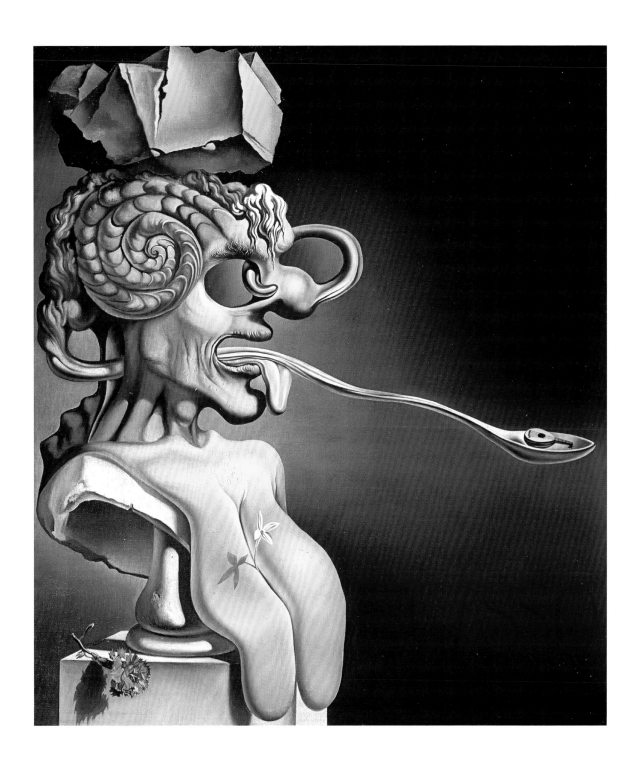

Cat. 100 Frida Kahlo
Self-Portrait with Thorn Necklace and Hummingbird, 1940
Oil on canvas mounted on Masonite, 24 ⅛ x 19 in. (62.2 x 48.3 cm)
Harry Ransom Center, The University of Texas at Austin.
Nickolas Muray Collection

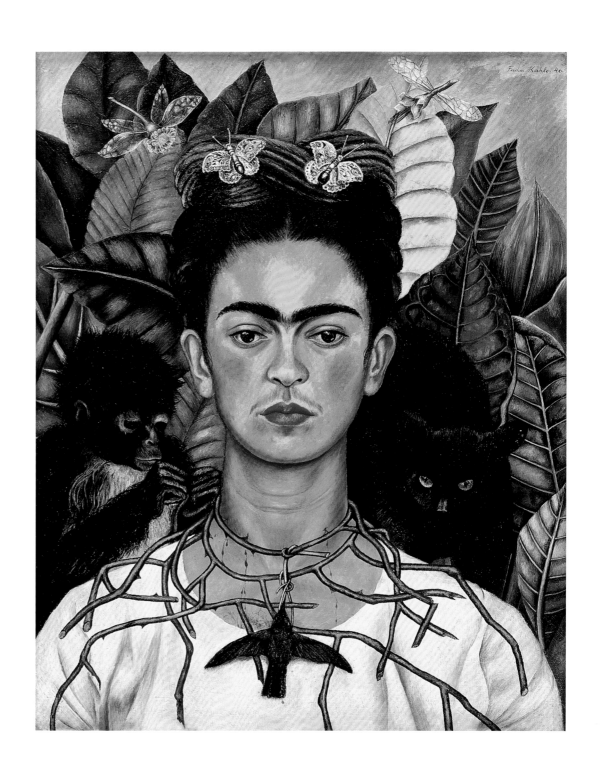

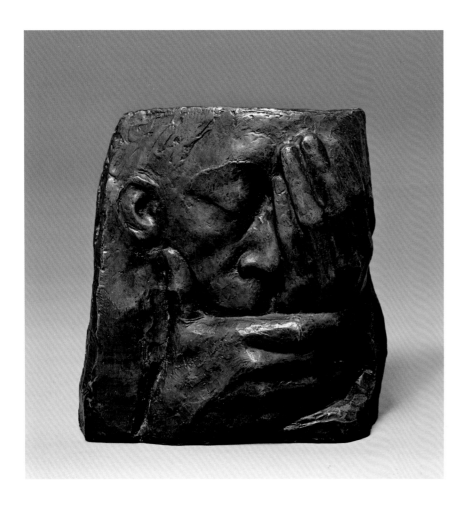

Cat 102 Charley Toorop
 Three Generations, 1941–1950
 Oil on canvas, 78 ⅞ x 47 ⅝ in.
 (200 x 121 cm)
 Museum Boijmans Van Beuningen,
 Rotterdam

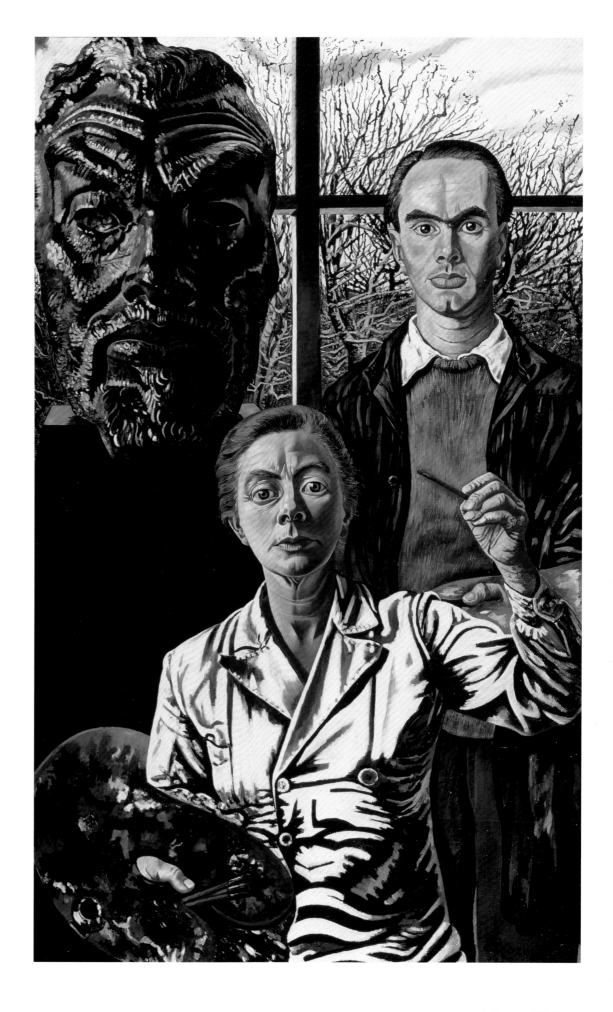

Cat. 103 Felix Nussbaum
Self-Portrait in a Shroud (Group Portrait), 1942
Oil on canvas, 19 ⅝ x 31 ⅝ in. (50 x 80.5 cm)
Berlinische Galerie, Landesmuseum für Moderne Kunst,
Fotografie und Architektur, Berlin

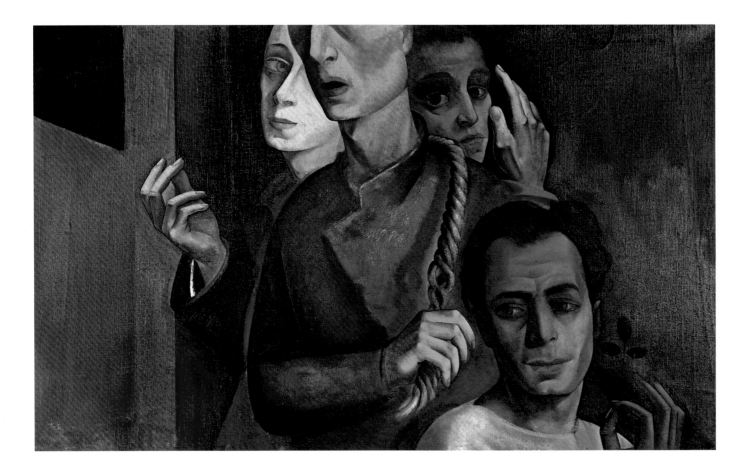

Cat. 104 Felix Nussbaum
Self-Portrait with Jewish Identity Card, 1943
Oil on canvas, 22 x 19 ⅟₄ in. (56 x 49 cm)
Felix-Nussbaum-Haus Osnabrück mit der Sammlung der
Niedersächsischen Sparkassenstiftung, Osnabrück, Germany

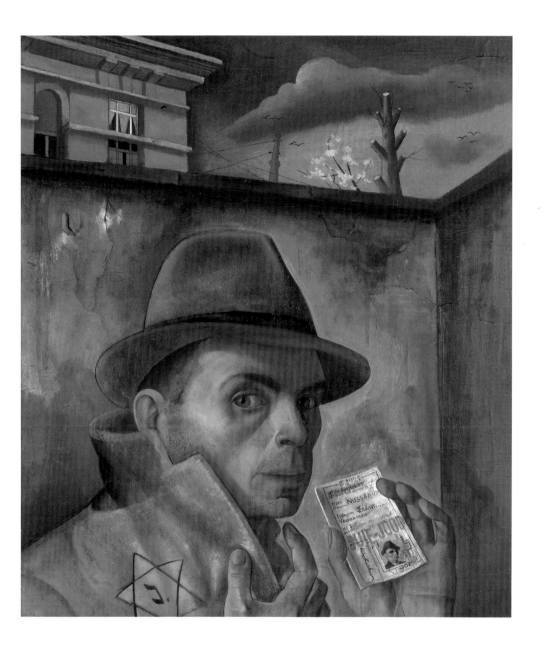

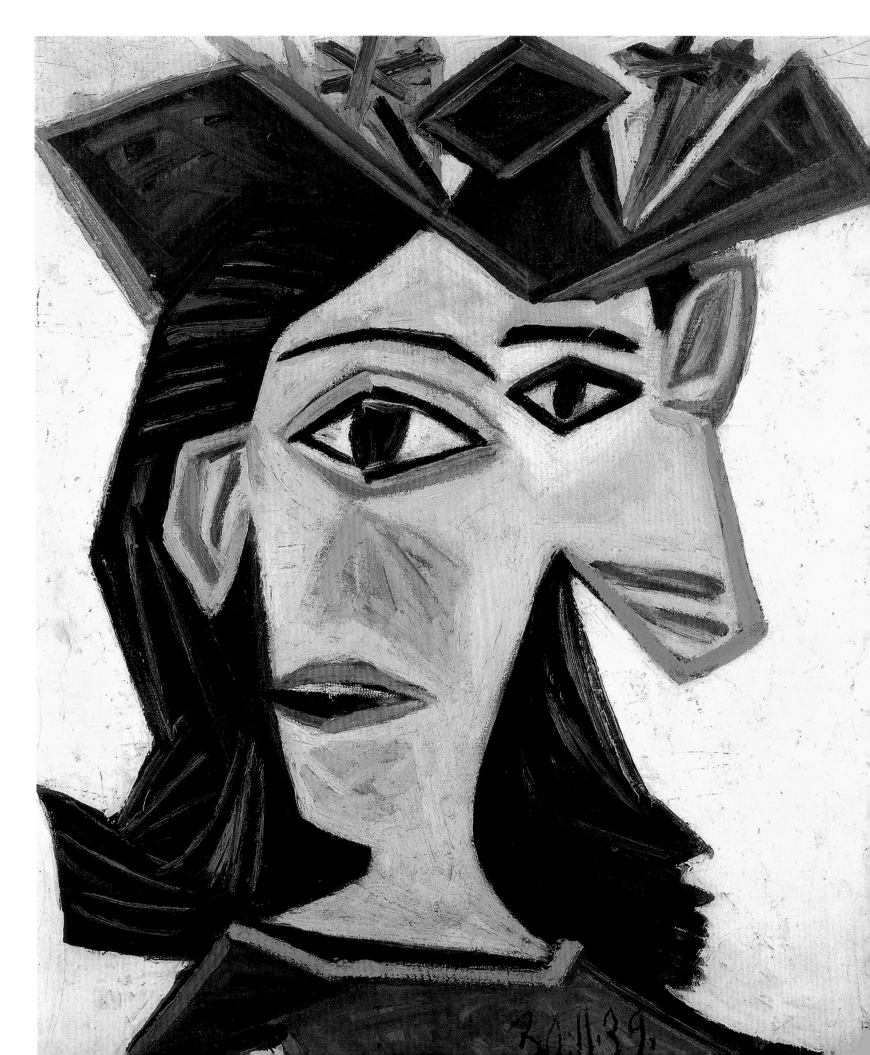

8 METAPHORICAL IDENTITIES

On 15 November 1939, the Museum of Modern Art in New York opened the exhibition *Picasso: Forty Years of His Art*. Organized by the museum's director, Alfred H. Barr, the exhibition brought together more than 300 works and attracted 15,000 visitors a week. The event marked the complete recognition of Picasso's status as the great master of modern art. As a result of the exhibition, he became, in the words of Michael FitzGerald, "the first modern artist to step from the relative isolation of the avant-garde into the mainstream of society and assume a role of moral conscience in contemporary life."[1] The last works on display were *Guernica*, which Picasso had lent for the occasion, and various portraits of Dora Maar, all examples of the impact on his art of the horrors of war. Dora's emotional instability allowed the artist to symbolize the instability of the world through her image, which Picasso subjected to an extreme degree of distortion.[2] His intention in the portraits of Dora went beyond expressing the anguish of the war, however; they satisfied his almost erotic appetite for visual gratification. Dora had inspired him with a new creative vitality and also responded to his way of seeing her: "For years I have painted her in tortured forms, not through sadism, and not with pleasure either, just obeying a vision that forced itself on me. It was the deep reality, not the superficial one."[3]

Dora Maar was the name used by Henriette Teodora Markovitch (1907–1997), a noted photographer associated with the Surrealists and a woman of great beauty and forceful personality. Picasso met her in 1936, through Paul Eluard, in the Café Les Deux Magots in the Saint-Germain-des-Prés quarter in Paris. Their relationship lasted seven years. In his numerous portraits of Dora, Picasso generally shows her seated, with her body and features dislocated into a double profile format [figs. 1 and 2]. In *Dora Maar Seated* of 1938 [cat. 105] she appears as an intelligent, independent, and self-confident woman, her hands on her lap in a pose that

recurs frequently in his portraits. The unfinished appearance and dark tonality give the work a note of drama. Picasso had abandoned the pastel shades he had used in his portraits of Marie-Thérèse Walter and returned to chromatic ranges that were either brighter and purer, or more gray and earthy. The face—in which the eyes, with their deep gaze, are particularly striking—is not as distorted as it is in other Dora portraits. In *Bust of a Woman* of 1939 [cat. 106] and *Bust of a Woman with Hat (Dora)*, painted in Royan in November of the same year [cat. 107], Picasso subjected his sitter to more radical metamorphoses.

In September 1939, during the first days of World War II, Picasso and Dora, accompanied by Jaime Sabartès, moved into the Hôtel du Tigre in Royan. They stayed there for the rest of the year. In this town on the French Atlantic coast, where Marie-Thérèse regularly spent the summer with her daughter Maya, Picasso painted numerous portraits of Dora in which her features and body are dislocated to an extreme degree. In the aggressively colored *Bust of a Woman with Hat (Dora)*, her face is shown from two different viewpoints and her right eye is created from two eyes in profile. As a result, she looks at us frontally while also looking toward the outside word.

In 1943, while still involved with Dora, Picasso met the painter Françoise Gilot, who was twenty years younger than Dora and forty years younger than he. Gilot became his companion for the next ten years and the mother of his two children, Claude and Paloma, born in 1947 and 1949. During the years following the end of the war, Picasso painted many political subjects and many portraits of his new muse and their two children. The portraits express the great *joie-de-vivre* that Françoise, his *Woman-Flower* [fig. 3], brought to Picasso's life. The present exhibition includes the painting *Woman in Blue Seated in an Armchair (Françoise)* of 1949 [cat. 108] and the sculpture *Head of a Woman (Françoise)* of 1951 [cat. 109]. The painting, which Picasso made on 23

1 Michael C. FitzGerald: "A Triangle of Ambitions: Art, Politics, and Family during the Postwar Years with Françoise Gilot," in New York/Paris 1996–1997, p. 409.

2 For the influence of Dora Maar on Picasso's art, see Caws 2000a. For a biography of her, see Caws 2000b; also Paris/Melbourne 2006.

3 Quoted in Gilot/Lake 1964, p. 122.

Paloma Alarcó

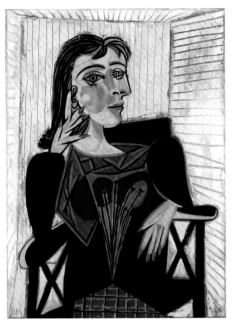

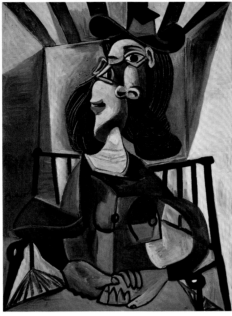

Fig. 1
Pablo Picasso
Portrait of Dora Maar, 1937
Oil on canvas, 36 ⅕ x 25 ⅗ in. (92 x 65 cm)
Musée Picasso, Paris

Fig. 2
Pablo Picasso
Woman with a Hat in a Chair (Dora), 1941–1942
Oil on canvas, 51 ⅖ x 38 ⅜ in. (130.5 x 97.5 cm)
Kunstmuseum Basel

March 1949, a month before the birth of Paloma, shows various affinities with the paper cut-outs of Matisse, whom Picasso had begun to see again thanks to Françoise's admiration for him. Instead of using scissors, however, Picasso recreated the effect of collage by using planes of color put together as in a puzzle. The head, painted in a highly calligraphic style, relates to the etchings that the artist had produced a year before to illustrate an edition of *Twenty Poems* by Góngora, and even more closely to the *Françoise en soleil* lithographs printed by Fernand Mourlot in 1946.

In her book *Life with Picasso*, Françoise Gilot published a photograph by Douglas Glass in which we see the artist with the original plaster of *Head of a Woman (Françoise)* [fig. 4]. Françoise gave an interesting account of the creation of this work, which Picasso molded in a diamond-shaped box that originally held almond cakes called *calissons*, which he would buy every time he went to Aix:

He often used such a mold for the base, but in 1951, in doing a portrait of me called simply *Woman's Head*, he formed the face by molding plaster in the cover of one of these boxes. Once the form was dry, he filed the edges to give it a bit more relief and make it lose the strict angularity it originally had. He set into that a triangular piece of plaster he had previously molded between two pieces of cardboard. That became the nose. At that time I wore my hair drawn back tightly into a bun. To emphasize that feature, the face in the sculpture is projected forward onto a separate plane, and the head and hair are grouped in a mass behind. This secondary mass Pablo formed from a damaged pottery vase he had picked up in the scrap heap. The cylinder of the neck, below this mass, has no contact with the face. He modeled the neck from plaster and set it into a rounded jar. The base he made by molding plaster inside a rectangular candy box.[4]

The Matisse-like color and the air of happiness evident in all Picasso's works related to Françoise would be clouded by two events that took place in succession in March 1953 and which resulted in a sudden change in the artist's life, in both public and private aspects. In the midst of the controversy over the publication of his portrait of Stalin in *Les Lettres françaises* [fig. 1 on p. 37], which earned him the condemnation of the French Communist party, Françoise left Paris for good with Claude and Paloma. From then on Picasso took refuge in his studio and remained apart from any public activities. Shortly afterwards he met his next companion, the beautiful Jacqueline Roque (1927–1986), who would become the principal focus of his attention for the rest of his creative life—during which Picasso devoted himself to rethinking and reworking the creations of his earlier career as well as the art of the past.

The double head of Jacqueline on display in the present exhibition [cat. 110] is created from sheet metal, a material that Picasso had started to use around 1954. He first experimented with what Werner Spies has called "flat sculpture" in a series of portraits of the young Sylvette David, whom he had met in Vallauris. The artist was captivated by her modern looks, especially her ponytail, and in addition to the metal sculptures made around forty painted portraits of her in a wide variety of poses. In his portraits of both Sylvette and Jacqueline, Picasso achieved a perfect combination of sculptural modeling and a mode of pictorial representation derived from Cubism. The schematic, angular profiles, recalling figures from classical Greek ceramics, could hardly

4 Gilot/Lake 1964, p. 320.

Fig. 3
Pablo Picasso
Woman-Flower (Françoise), 1946
Oil on canvas, 57 ⅟₂ x 35 in. (146 x 89 cm)
Private collection. Courtesy Thomas Ammann
Fine Art, Zurich

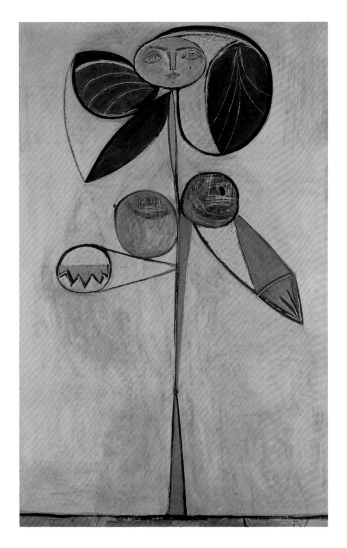

Fig. 4
Picasso with plaster of *Head of a Woman*
(Françoise), 1951

be further removed from the dislocated forms in the images of Dora Maar.

Today Picasso's portraits of Dora—some of the most violent of all his works—are considered among his most important achievements. According to Brigitte Léal, in the catalogue of the exhibition *Picasso and Portraiture*: "The fascination that the image of this admirable but suffering and alienated face exerts on us incontestably ensues from its coinciding with our modern consciousness of the body in its three-fold dimension of precariousness, ambiguity, and monstrosity."[5]

The new paradigm of beauty represented in the Dora portraits would be crucial for the generation of artists emerging from World War II, a generation marked by pessimism and anxiety. The highly influential philosophy of Existentialism offered a pessimistic worldview that led artists to dwell (sometimes in violent terms) on human suffering and alienation. Inventing new figurative artistic languages, which coexisted with more abstract and formalist movements, they forged new images of modern man; they looked back to the gestural idioms of the Expressionists and to the automatism of the Surrealists for models of expressive liberty. The face was no longer necessarily a recognizable element. Its severe distortion, combined at times with the metamorphosis of the body, made the sense of individual identity all but unachievable. The alienated body could be crushed, as in the paintings of Dubuffet; it could be otherwise damaged, like the inhuman beings of Francis Bacon; it could be disintegrated, like the transient figures of Alberto Giacometti.

5 Brigitte Léal, "'For Charming Dora': Portraits of Dora Maar," in New York/Paris 1996–1997, p. 385.

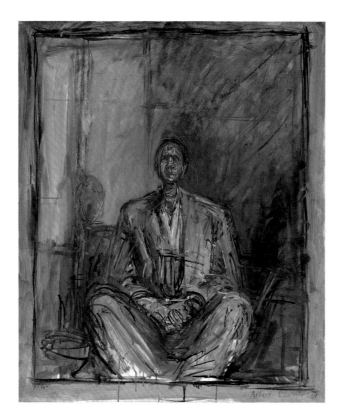

Fig. 5
Alberto Giacometti
Portrait of Jean Genet, 1954–1955
Oil on canvas, 28 ⅞ x 23 ⅝ in. (73 x 60 cm)
Centre Pompidou, Paris
Musée national d'art moderne/Centre de création industrielle

Giacometti was one of the artists who most closely identified with Existentialist thinking. Jean-Paul Sartre considered his solitary figures to be the perfect visual translation of his own ideas on the isolation and sense-lessness of the human condition.[6] From his beginnings as a sculptor, Giacometti almost always focused on the human figure, and in the mid-1940s, leaving a Surrealist phase behind him, he pursued his interest in painting from life into the genre of portraiture. His main points of reference were the self-portraits of Rembrandt, the sad, restrained funerary images from ancient El Fayum, and the portraiture of El Greco. His most frequent models were the people closest to him: his brother Diego, with whom he shared a studio on rue Hyppolyte-Maindron; his wife Annette; his friends David Sylvester, James Lord, Isaku Yanaihara, and Jean Genet; and his mistress, the Parisian prostitute Carolina. One of them, the Paris-based American writer James Lord, wrote a detailed account of the long and silent sittings for Giacometti's portrait of him.[7] The Existentialist playwright Jean Genet posed for various portraits between 1954 and 1958 [fig. 5] and wrote *L'Atelier*, a series of notes and comments, in diaristic form, on his conversations in the artist's studio. For Genet, Giacometti strove "to discover the secret pain within every person and even within every object, with the intention of illuminating them."[8]

The 1947 bust of Diane Bataille, wife of the French intellectual Georges Bataille [cat. 113], and the *Bust of Diego* of 1954 [cat. 115] are sculptures modeled from life in which Giacometti's aim was to reproduce reality through the acuteness and sincerity of his visual perception. Conscious of the inadequacy of outline to convey the chance features of the human form, he repeatedly reworked his images. Rather than increasing the realism, however, he made his sitters' identities still more elusive: "A fully resolved sculpture would be no more than a medium for speaking to others, to communicate what I see."[9]

Giacometti was both a sculptor and a painter, taking up painting after a long hiatus on his return to Paris in 1946. From January 1942 until the end of the war, he had lived in a small room in the Hôtel de Rive in Geneva—the city where he met Annette Arm, who would soon become his muse and principal model. *Annette in the Studio* of 1961 [cat. 114] repeats the formal arrangement of most of his portraits: the figure occupies the center of the composition, looking straight ahead, and the surrounding space seems to transform the

physical presence into a spiritual one. The range of gray tones and the sketchy handling contribute to a feeling of soulful isolation about the figure. Annette is sitting on a chair, with her legs crossed, in the barely sketched-in setting of the artist's studio. *Portrait of a Woman* of 1965 [cat. 116] follows a similar composition, although the figure is seen from a closer viewpoint.

If the moral context of Giacometti's art was Existentialism, that of the portraits of Jean Dubuffet was a society aware of its own decline. His vision of mankind combines human vulnerability with a sense of the dignity that enables us to survive in the face of any adverse circumstance. From his anti-artistic and anti-intellectual stance, Dubuffet roundly rejected the traditional portrait: for him the irrational, the unconscious, and caricature were the only valid means with which to approach the genre. "For a portrait to work really well for me, I need it scarcely to be a portrait; it should be on the borderline of ceasing to be one," he remarked.

Dubuffet's interest in texture led him to use a technique that emphasized the material nature of the paint; this and his desire to give expressive value to the surface of his paintings resulted in the creation in 1945 of what he called *hautes pâtes*. These were works of a heavy impasto (composed of tar, asphalt, and lead, to which he sometimes added cement, sand, stones, glass, and straw) that acted as a base on which to inscribe the image in the form of *graffiti*—in the spirit of the street *graffiti* to be seen in occupied Paris as photographed by Brassaï. The presentation of these scatological images in the exhibition *Mirobolus, Macadam & Cie, Hautes pâtes*, held at the Galerie René Drouin in Paris in 1946, caused a sensation. Works of this type, at times related to the writings of Georges Bataille, Jean Paulhan, Francis Ponge, or Jean-Paul Sartre, are a perfect synthesis of images from the unconscious of the kind cherished by the Surrealists, the use of "low" materials rediscovered by Dada, and the materiality of textures championed by the prevailing *Art Informel* movement.

Florence Gould was an American based in Paris who would invite leading writers and artists to her house every week during the German occupation. Her guests included Jean Paulhan, Paul Léautaud, Henri Michaux, Francis Ponge, Georges Limbour, Marcel Jouhandeau, and Jean Fautrier. At Gould's request Dubuffet painted portraits of many of them and exhibited them together in 1947 with an advertisement that was as anti-artistic as his painting:

Les gens sont plus beaux qu'ils croient. Vive leur vraie figure; à la galerie Drouin, 17, place Vendôme. PORTRAITS à ressemblance extraite, à ressemblance cuite et confite dans la mémoire, à ressemblance, éclatée dans la mémoire de M. JEAN DUBUFFET, Peintre.[10]

Through this mockery of portraiture Dubuffet launched an offensive against beauty and lifelikeness, merely hinting at the presence of a sitter by means of a rudimentary image scribbled on the thick impasto of the surface. *Paul Léautaud in a Caned Chair* of 1946 [cat. 111] and *Bertelé as a Blossoming Bouquet, Sideshow Portrait* of 1947 [cat. 112] show him rejecting rationality and tradition and focusing on the unconscious aspect of the sitter. For all their caricatural and childlike qualities, the portraits do suggest certain distinctive characteristics in the sitters; these do not refer to the sitters' actual appearance in the conventional way, however, but arise from the tension between form and paint.

Dubuffet and the other artists grouped together by Michel Tapié under the banner of *Un autre art* had a marked influence on the Spanish painter Antonio Saura following his trip to Paris in 1953. Like Dubuffet, Saura relished portraiture. In all his portraits he transformed his sitters, using a violent and gestural brushstroke and a limited palette of blacks and grays that enhances their expressive power. In *Brigitte Bardot* of 1957 [cat. 117], the looks of the sitter, the leading sex symbol of the day, are so distorted by his highly gestural, Informalist technique that the work has been interpreted as satirical. The *Mirta* of 1959 [cat. 118] belongs to a series of paintings in black and white whose titles are women's names and in which Saura depicts a full-length female figure. The parallels between these works and Willem de Kooning's paintings of women of the early 1950s [fig. 6] are obvious. In the 1980s, Saura devoted a series of large canvases to Dora Maar [cat. 123] in which, as in all his imaginary portraits, he aimed "to illuminate the present with presences from the past." In interpreting Picasso's image of Dora for himself he transformed it: "The presence ceases to belong to history in order to fully belong to us."[11]

Some of Saura's portraits focus on the head and bear the title of *Self-Portrait* [cats. 119–122]. He explained his decision to use such a title as follows: "If I decided to use the generic title of *Self-Portrait* for this lengthy series begun in Paris in 1956, it was obviously not from any narcissistic concerns —nor, I should say, from a masochistic attitude toward my

6 In 1948 Jean-Paul Sartre wrote "La Recherche de l'Absolu" as an introduction to a Giacometti exhibition at the Pierre Matisse Gallery in New York. In it he referred to a new "existential reality" in Giacometti's work.

7 See Lord 1980.

8 Genet 1957.

9 Giacometti 2001, p. 127.

10 "People are much more beautiful than they think. Long live their real looks; at the galerie Drouin, 17, place Vendôme. PORTRAITS of a likeness extracted, of a likeness cooked and preserved in the memory, of a likeness that burst in the memory of Mr. JEAN DUBUFFET, painter."

11 Saura 1992, p. 73.

Fig. 6
Willem de Kooning
Marilyn Monroe, 1954
Oil on canvas, 50 x 30 in. (127 x 76.2 cm)
Collection Neuberger Museum of Art, Purchase College,
State University of New York. Gift of Roy R. Neuberger

own face. It would have been more correct to have entitled them *Anti-Portraits* or *Portrait-Landscapes*, but the first title seemed to me too remote and the second could have led to pantheistic interpretations which I was far from at that point. Given that they do not refer to any particular face and that they arose from my own hand, I thought that they must reflect something about me and opted for this ambiguous title, which still moves me to a certain demystifying glee."[12]

The present chapter also covers portraits by a mixed group of artists rooted in the British figurative tradition: Graham Sutherland, Francis Bacon, Lucian Freud, Frank Auerbach, and Leon Kossoff.

Graham Sutherland made his first portrait at the request of the writer Somerset Maugham, whom he painted in 1949,[13] and following its public showing he received various further portrait commissions. One was for a portrait of Lord Beaverbrook, which he carried out in 1951 [cat. 124]. As was normally the case, Sutherland worked from a large number of preparatory drawings executed from life before starting the final painted portrait. The rigid figure of this newspaper tycoon and politician suggests a presence of imperturbable power. Beaverbrook is seen seated and wearing a purple suit that stands out vividly against the dark green background. For an earlier portrait of him by Sickert, see cat. 86.

Sutherland's status as a portrait painter has to a large extent been overshadowed by the achievements of Francis Bacon. Playing down the specifics of appearance and emphasizing instead the harsh reality of individual existence, Bacon formulated a highly original approach to portraiture. The essential idea in Bacon's portraits is that of the body as flesh. He seems at times to turn his figures inside-out, showing their very innards, at the same time deforming their faces in order to penetrate their souls. His way of representing the body shows a tension between representation and alienation similar to that found in the famous self-portrait by the sixteenth-century painter Parmigianino [fig. 7], an image altered anti-naturalistically thanks to a convex mirror.

Through a personal and instinctive iconography, he aimed to capture "an instant of life in all its violence and beauty." He succeeded in conveying the most sordid and terrifying aspects of the human condition; indeed, his art can be considered as a somewhat extravagant interpretation of Existentialism. The distortions to which he subjected the body can be related to the cruelty and violence of Picasso's most dislocated portraits of the mid-century. It was not by chance

Fig. 7
Parmigianino
Self-Portrait in a Convex Mirror, c. 1524
Oil on panel, diameter: 9 ⅝ in. (24.4 cm)
Kunsthistorisches Museum, Vienna

that Bacon decided to devote himself to painting after visiting a Picasso exhibition at the Galerie Rosenberg in Paris in 1927.

"I hate my face. . . . I only paint self-portraits when I haven't got anyone else to paint," Bacon told David Sylvester in 1975.[14] Despite this protestation, Bacon did paint himself on numerous occasions. In his first self-portrait, executed in early 1956 [cat. 125], he repeats the compositional arrangement of other portraits of this period. Sitting in a dark and empty space, the artist appears with his body crumpled up into itself, his hands on his knees, conveying a strong sense of instability and fragility. His face is dislocated, with his mouth open to reveal his teeth, his grimace suggesting a frozen smile rather than the scream emitted by other characters in his paintings of this period.

George Dyer (1934–1991) [fig. 8] was an almost illiterate former criminal who was Bacon's lover for some years until killing himself with a drug overdose in 1972. The *Portrait of George Dyer in a Mirror* [cat. 127] shows him isolated in space like all Bacon's portrait subjects. He sits in a swivel chair opposite his own image reflected in a mirror that stands on a curious piece of furniture with a pedestal, a mixture of television set and x-ray machine. The violence and brutality of the scene—Dyer's face contorts in an apparent spasm and

his body seems subject to forces beyond his control—is caught in a circular halo of light that comes from an outside source. The image of the face in the mirror, split in two by a strip of luminous space that seems to be an accident of reflection, is not subjected to Bacon's usual degree of distortion; indeed, by bringing together the two halves we could reconstruct a comparatively naturalistic likeness of Dyer—the angular profile of his hooked nose and the expression that seems to combine desire and death. Bacon used an unconventional, Expressionistic technique involving paint applied with the brush and then worked with the fingers. His technical adventurousness and relish for what he called "instinctive accidents" paid off in disconcerting effects such as the thick white brushstrokes brutally splashed over the image.

The same kind of splashes, like vehicles of some secret meaning, feature in his *Study for the Head of Isabel Rawsthorne* of 1967 [cat. 126]. They bring out that sense of the workings of fate that Bacon wished to maintain throughout his paintings. "My ideal," he said, "would be to take a handful of paint and throw it at the canvas with the hope that the portrait might be there." The numerous portraits that Bacon made of his friend Isabel Rawsthorne (1912–1992) have little to do with her actual appearance [fig. 9]. Rawsthorne, whose real name was Isabel Nicholas, was a woman who produced a forceful impression on everyone who met her. She was born in London and worked as a painter and designer of ballet sets. In her youth she had been the sculptor Jacob Epstein's assistant, and in 1933 she sat to him for a bust in which she is shown bare-breasted and wearing huge earrings. During the years that she spent in Paris, Rawsthorne also posed for André Derain and Alberto Giacometti, became friends with Georges Bataille, and even aroused a certain interest on the part of Picasso.

In contrast to Freud and Auerbach, who always paint from life, Bacon made use of his memory and photographs, feeling inhibited by the idea of working with the sitter present: "They inhibit me because if I like them I don't want to inflict on them the damage that my painting does in their presence."[15] Both the triple portrait of his lover George Dyer [cat. 128] and that of the photographer Peter Beard [cat. 129] use a format that Bacon picked up from contact strips [fig. 10] and from the studies of the body in motion made by the nineteenth-century photographer Eadweard Muybridge.

Bacon also produced numerous triptychs on a large scale. The present exhibition includes his *Triptych* of 1986–1987

12 Saura 1992, pp. 28–29.

13 Graham Sutherland, *Somerset Maugham*, 1949. Tate, London.

14 Sylvester 1975, p. 249.

15 Sylvester 1975, p. 41.

Fig. 8
John Deakin
George Dyer in Francis Bacon's Studio at 7 Reece Mews, c. 1964
Dublin City Gallery The Hugh Lane

Fig. 9
John Deakin
Isabel Rawsthorne on Dean Street, Soho, c. 1965
Dublin City Gallery The Hugh Lane

[cat. 130], in which the subject of each panel is unrelated to those of the other two. Bacon unifies them through color and through certain compositional elements such as the black rectangles behind each of the images and the line of the floor in the outer panels. In the center we see the naked figure of the artist's lover John Edwards on what seems to be a tombstone. Bacon had met Edwards, who owned two pubs in the East End of London, in 1974. As in other portraits of him from the 1980s, he is a more serene presence—perhaps a reflection of his personality—than we find in the violent Bacons of earlier decades. The side panels refer to two dark moments in twentieth-century history. On the left is a portrait of U.S. President Woodrow Wilson (1856–1924) based on a photograph of him leaving the building in which the Treaty of Versailles was signed on 28 June 1919. On the right Bacon metaphorically depicts the brutal assassination of Leon Trotsky, which took place on 20 August 1940, in Coyoacan, on the outskirts of Mexico City. He took the objects—a reading-stand covered with a blood-stained white sheet and a lamp—from a photograph of Trotsky's study after the event.

Both Lucian Freud and Frank Auerbach share Bacon's interest in expressing the isolation of human existence through the motif of the body. While Bacon subjected his figures to a formal metamorphosis that left them bruised and battered, however, Freud has remained more within the traditional canons of figure painting, and Auerbach and Kossoff have combined figurative content with a visual language closely linked to painterly abstraction. As the critic David Sylvester noted in 1955, the most obvious difference between the art of the second half of the century and that of the interwar period was that "rough surfaces have taken the place of smooth ones."[16] "I do not disapprove of abstraction," Auerbach remarked in a radio interview with Richard Cork. "All painting is abstraction."[17]

Auerbach's painting revolves around the representation of the human figure in the portrait format, and its distinguishing feature is the importance given to paint in its own right. The artist wishes us to read his paint not merely as a symbol of something else but as a vehicle for seeing reality, and his way of applying it—layer on layer, and so thickly that it seems like

16 David Sylvester, "End of the Streamlined Era in Painting and Sculpture," *The Times*, 2 August 1955, quoted in Sylvester 1996, p. 49.

17 Quoted in Dawn Ades, "The School of London," in London 1987, p. 308.

Fig. 10
Strip of passport photographs of Francis Bacon attached to paper fragments
Dublin City Gallery The Hugh Lane

a low relief—is a way of suggesting the inescapable material nature of the world. Like the late paintings of Giacometti, Auerbach's portraits are more about realizing a painting by means of the model than realizing the model's image; this takes its form entirely from the artist's gesture as he fashions the impasted surface. The model's identity remains concealed beneath a thick blanket that envelops figure and background—and, as though to enhance the effect, his or her name is concealed behind initials in the title. The *Head of E. O. W. IV* of 1961 [cat. 133], for example, is one of Auerbach's numerous paintings of Estella West. Fifteen years his senior, she maintained a stormy relationship with the artist and on occasion posed for him nude. Behind the *Head of J. Y. M.* of 1978 [cat. 134] and the *Head of J. Y. M. I* of 1981 [cat. 135], we find the professional model Juliet Yardley Mills, whom Auerbach also painted frequently.

Like Auerbach, Leon Kossoff has made the human figure the principal motif of his work and devoted much of his energy to portraiture. For him the observation of the model has become an obsession, and all his portraits are preceded by numerous preparatory drawings. His *Head of Seedo* of 1959 [cat. 136] is one of many portraits of the writer N. M. Seedo, a friend of the artist, in which the sitter's image gradually transforms itself from painting to painting.

Over time Kossoff's painting has become less impasted, as can be seen in the latest of his works displayed in the exhibition, the portrait of the painter John Lessore of 1993 [cat. 138]. Despite this stylistic evolution, however, his working method has remained the same. As he himself explained, "A painter is engaged in a working process and the work is concerned with making the paint relate to his experience of seeing and being in the world."[18]

18 Leon Kossoff, "Nothing Is Ever the Same," in Venice 1995b.

Cat. 105 Pablo Picasso
Dora Maar Seated, 1938
Mixed media on paper laid on canvas, 27 ⅛ x 24 ⅝ in. (68.9 x 62.5 cm)
Tate, London. Purchased 1960

Cat. 106 Pablo Picasso
Bust of a Woman, 1939
Oil on canvas, 31 ⅞ x 25 ⅝ in. (81 x 65 cm)
Museo Picasso, Málaga

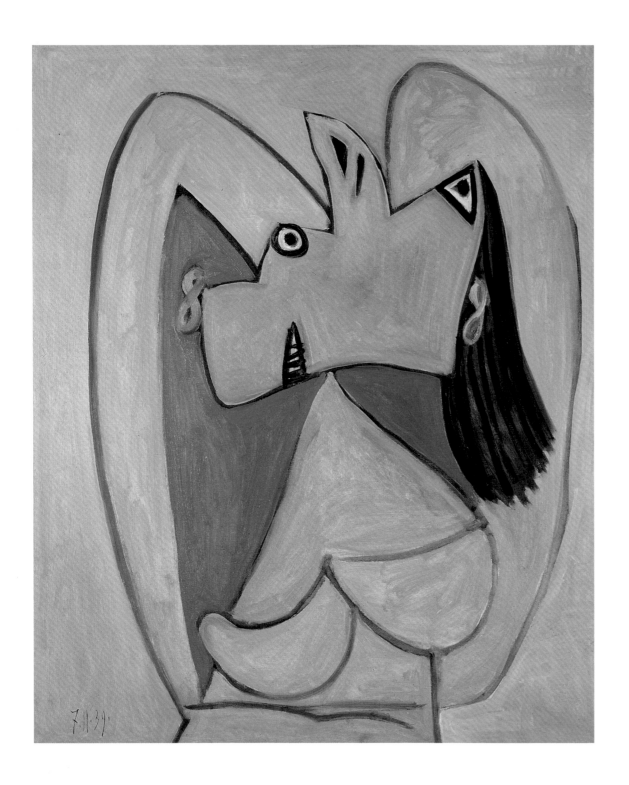

Cat. 107 Pablo Picasso
Bust of a Woman with Hat (Dora), 1939
Oil on canvas, 21 ⅞ x 18 ¼ in. (55 x 46.5 cm)
Fondation Beyeler, Riehen/Basel, Switzerland

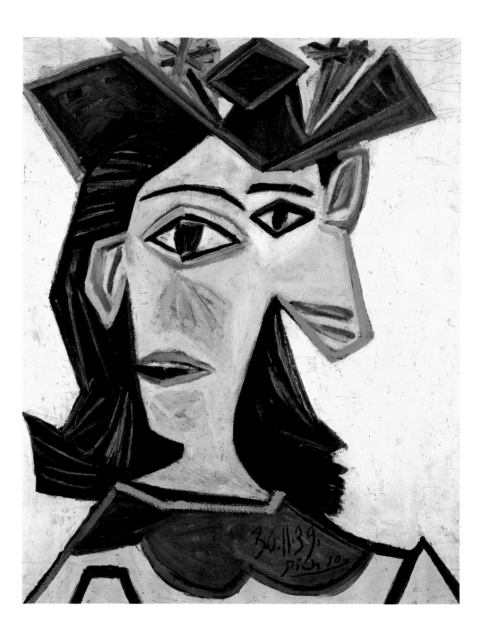

Cat. 108 Pablo Picasso
Woman in Blue Seated in an Armchair (Françoise), 1949
Oil on canvas, 45 ⁄ x 35 in. (116 x 89 cm)
Private collection, New York

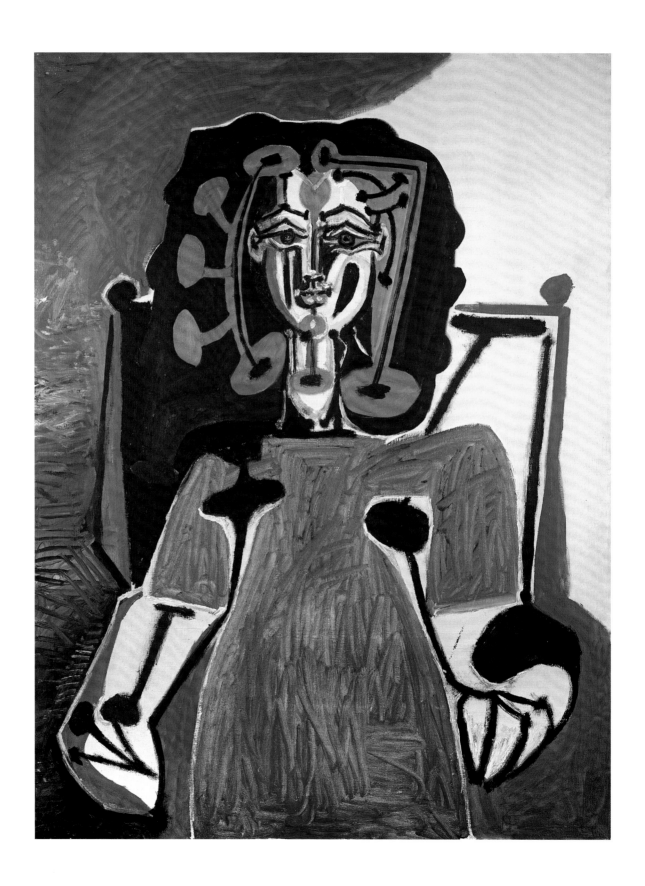

Cat. 109 Pablo Picasso
Head of a Woman (Françoise), 1951
Bronze, 21 ⅛ x 13 ⅞ x 7 ½ in. (54 x 35 x 19 cm)
Private collection, New York

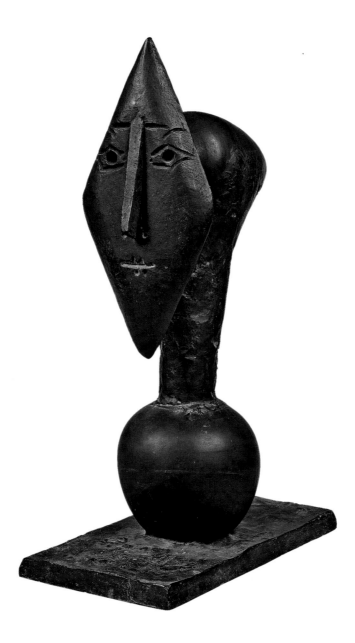

Cat. 110 Pablo Picasso
Head of a Woman (Jacqueline), 1957
Painted steel, 30 ⁷⁄₁₆ x 13 ³⁄₄ x 10 ⁷⁄₈ in. (77.2 x 34.9 x 25.7 cm)
Raymond and Patsy Nasher Collection, Dallas

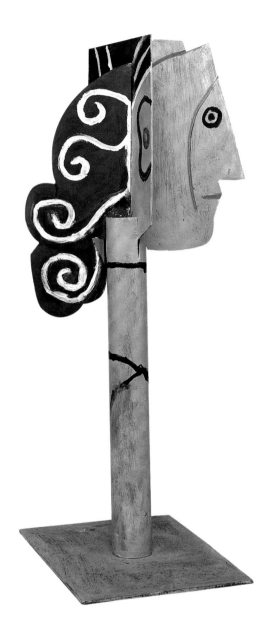

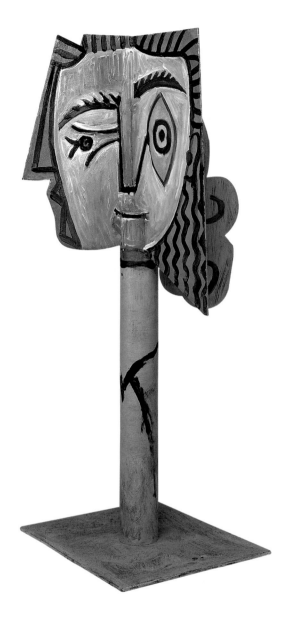

Cat. 111 Jean Dubuffet
Paul Léautaud in a Caned Chair, 1946
Oil and sand on canvas, 51 ¼ x 38 ⅛ in. (130.1 x 96.8 cm)
New Orleans Museum of Art. Bequest of Victor K. Kiam (77.287)

Cat. 112 Jean Dubuffet
Bertelé as a Blossoming Bouquet, Sideshow Portrait, 1947
Oil, plaster, and sand on canvas, 45 1/2 x 35 1/2 in. (116 x 89 cm)
National Gallery of Art, Washington, D.C.
The Stephen Hahn Family Collection (Partial and Promised Gift) (1995.29.5)

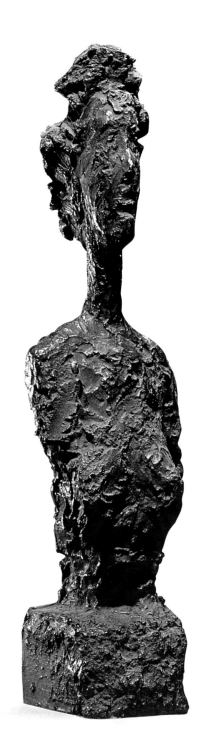

Cat. 114 Alberto Giacometti
Annette in the Studio, 1961
Oil on canvas, 57 ⅛ x 38 ⅛ in (146 x 97 cm)
Hamburger Kunsthalle, Hamburg.
Permanent loan from the Stiftung zur
Förderung der Hamburgischen
Kunstsammlungen

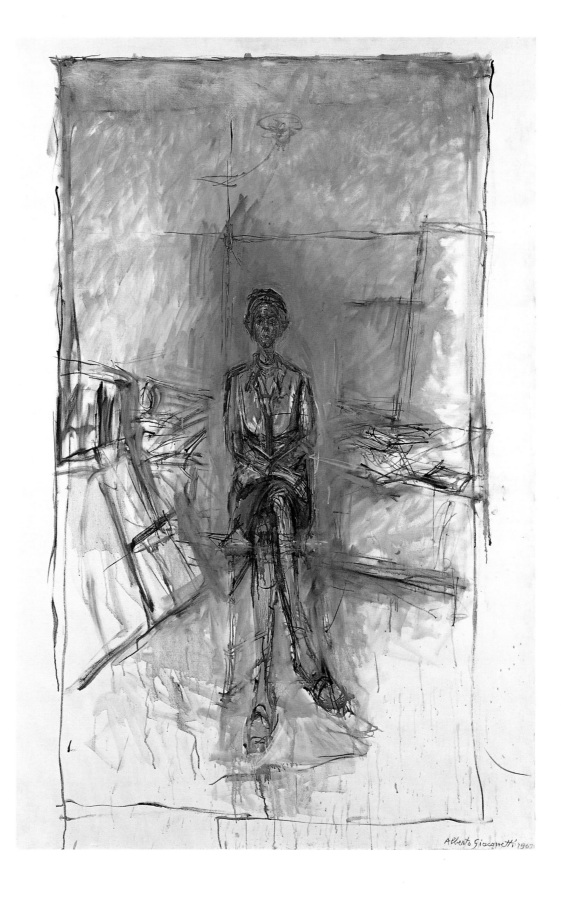

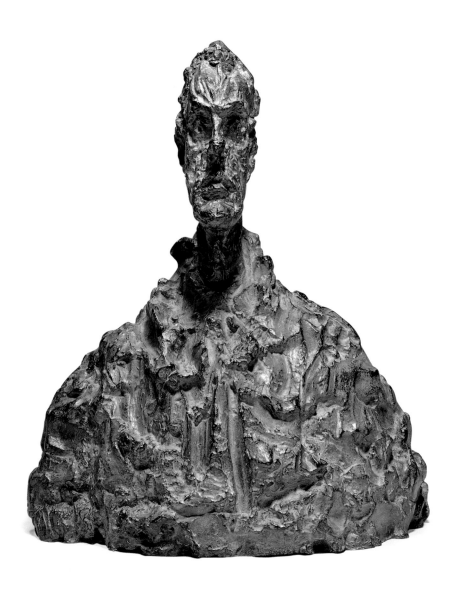

Cat. 116 Alberto Giacometti
Portrait of a Woman, 1965
Oil on canvas, 33 / x 25 / in (86 x 65 cm)
Museo Thyssen-Bornemisza, Madrid

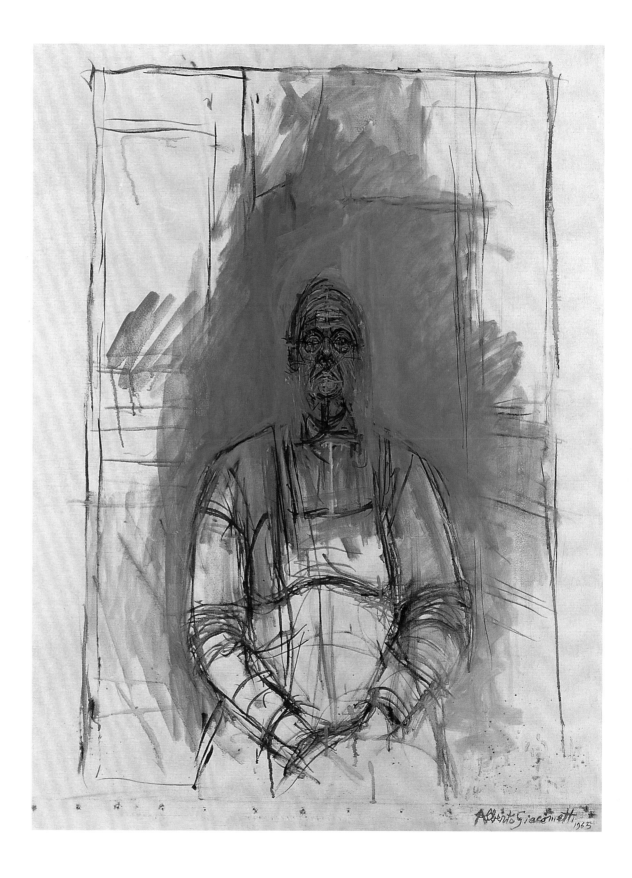

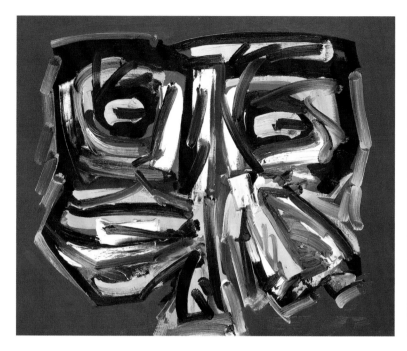

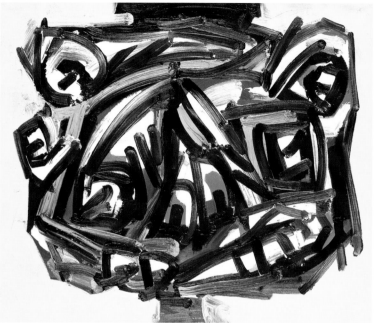

Cat. 123 Antonio Saura
Dora Maar 20.5.85, 1985
Oil on canvas, 76 7/4 x 62 7/8 in. (195 x 159 cm)
Private collection

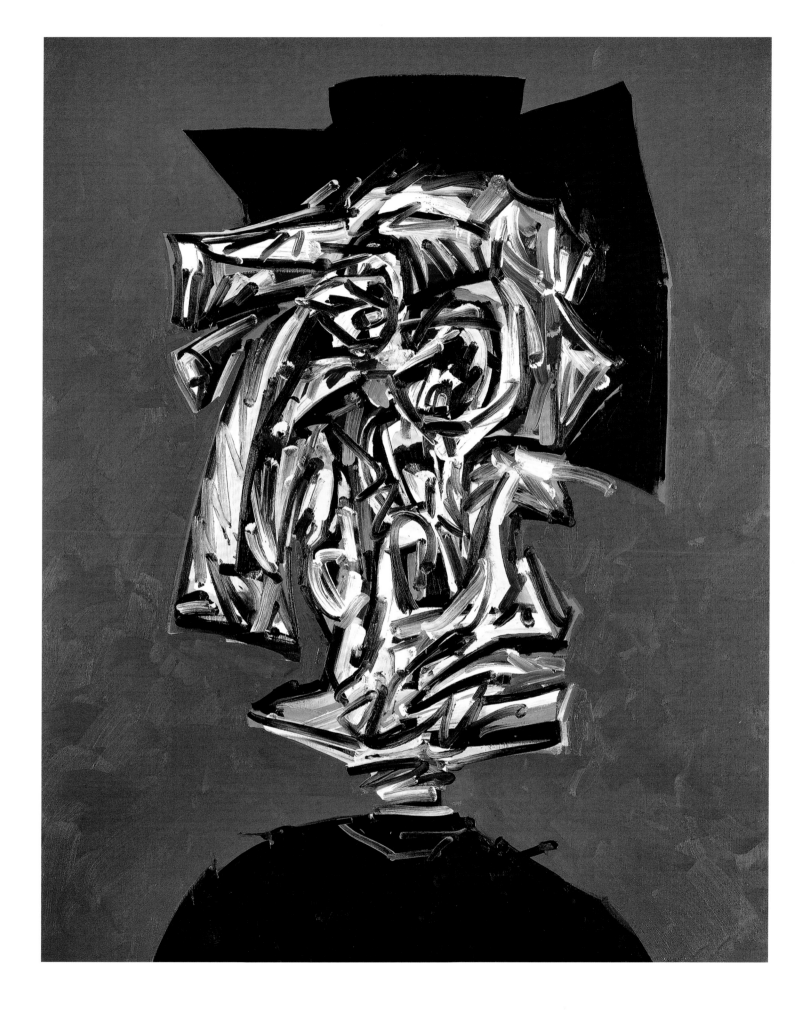

Cat. 124 Graham Vivian Sutherland
William Maxwell Aitken, 1st Baron Beaverbrook, 1951
Oil over conté crayon on canvas, 68 ⅞ x 36 ¾ in. (174.3 x 93.4 cm)
Beaverbrook Art Gallery, Fredericton, New Brunswick, Canada.
Bequest of The Dowager Lady Beaverbrook

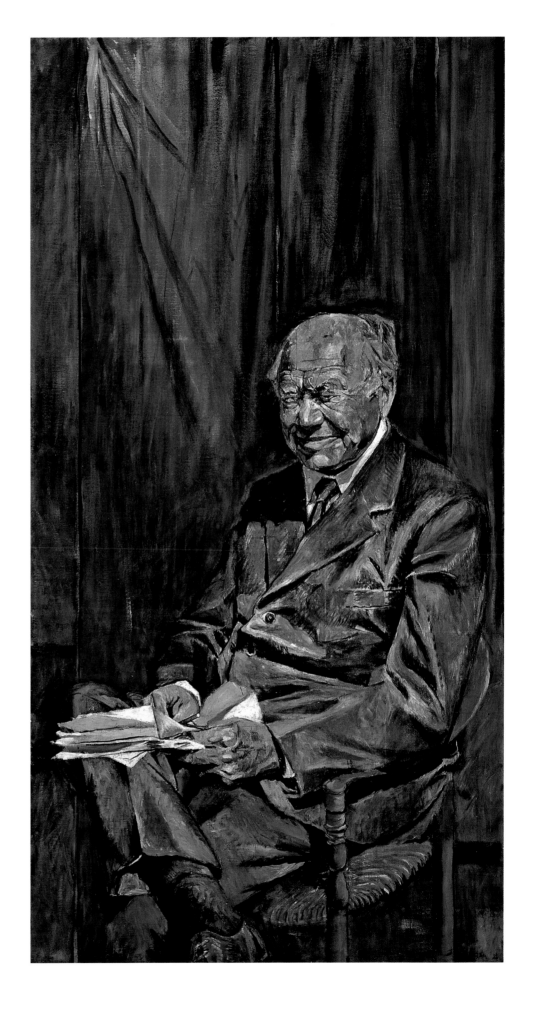

Cat. 125 Francis Bacon
Self-Portrait, 1956
Oil on canvas, 78 x 54 in. (198.1 x 137.2 cm)
Modern Art Museum of Fort Worth.
Gift of The Burnett Foundation in honor of Marla Price

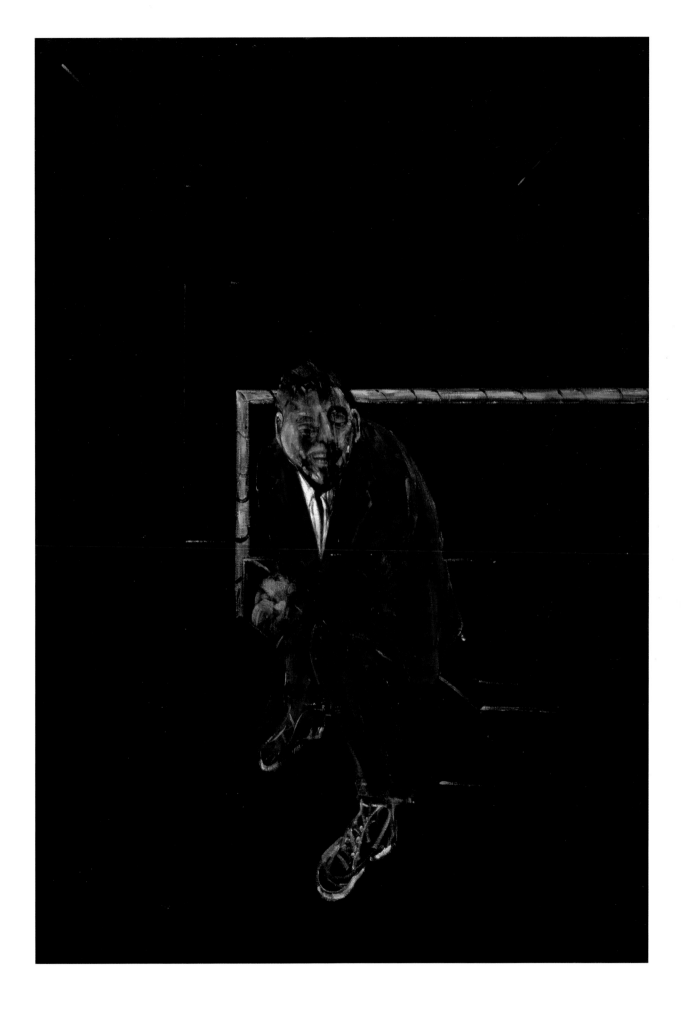

Cat. 126 Francis Bacon
Study for the Head of Isabel Rawsthorne, 1967
Oil on canvas, 14 x 12 in. (35.5 x 30.5 cm)
Private collection. Courtesy MaxmArt, Mendrisio, Switzerland

Cat. 127 Francis Bacon
Portrait of George Dyer in a Mirror, 1968
Oil on canvas, 78 x 57 ⅞ in. (198 x 147 cm)
Museo Thyssen-Bornemisza, Madrid

Cat. 126 Francis Bacon
Study for the Head of Isabel Rawsthorne, 1967
Oil on canvas, 14 x 12 in. (35.5 x 30.5 cm)
Private collection. Courtesy MaxmArt, Mendrisio, Switzerland

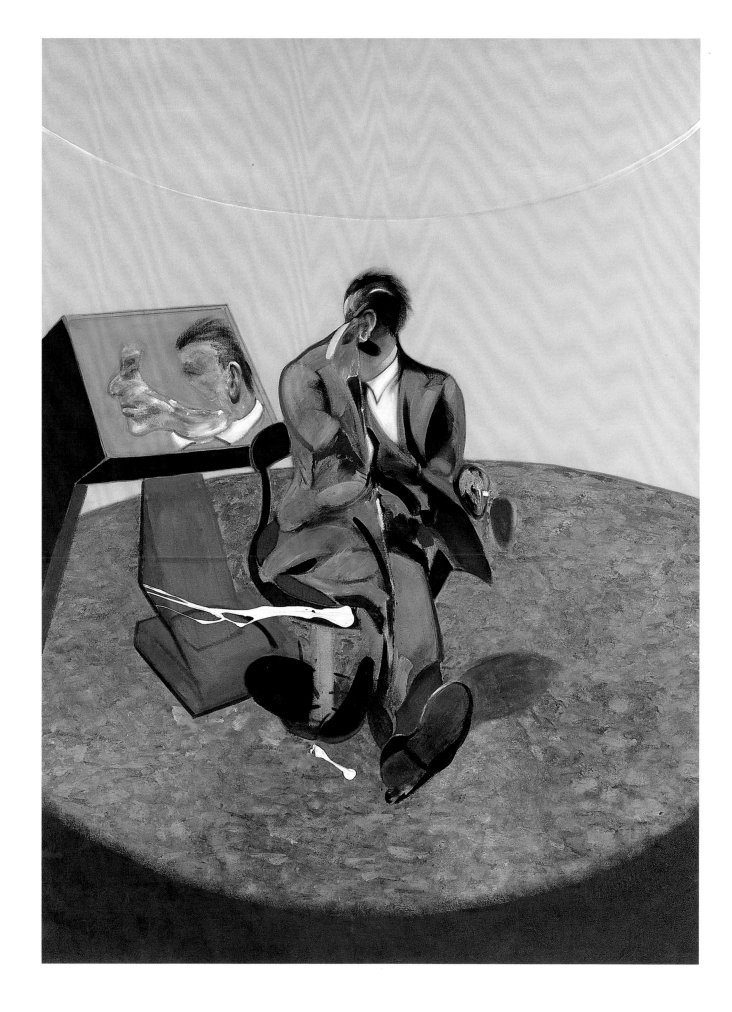

Cat. 128 Francis Bacon
Three Studies of George Dyer, 1969
Oil on canvas, each 14 ⅛ x 12 in. (36 x 30.5 cm)
Louisiana Museum of Modern Art, Humlebæk, Denmark.
Donation: The New Carlsberg Foundation

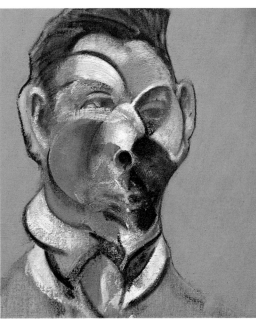
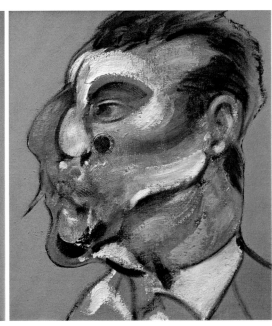

Cat. 129 Francis Bacon
 Three Studies for a Portrait of Peter Beard, 1975
 Oil on board, each 14 x 12 in. (35.5 x 30.5 cm)
 Juan Abelló Collection

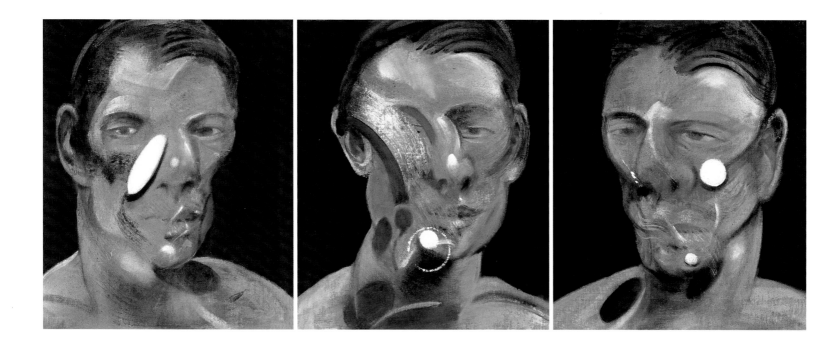

Cat. 130 Francis Bacon
Triptych, 1986–1987
Oil and pastel on canvas, each 78 x 58 ⅛ in. (198 x 147.5 cm)
Marlborough International Fine Art

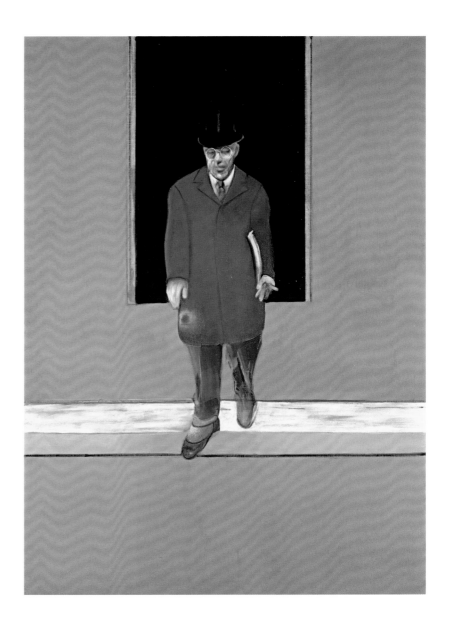

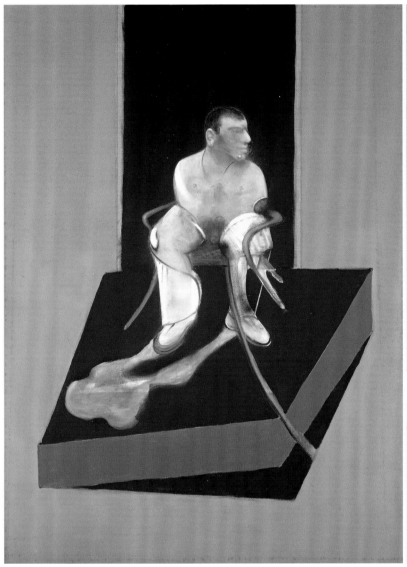

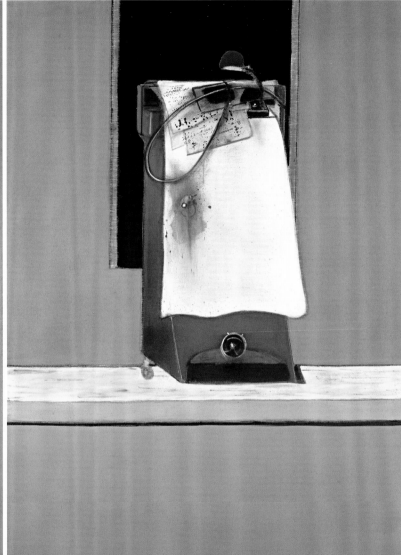

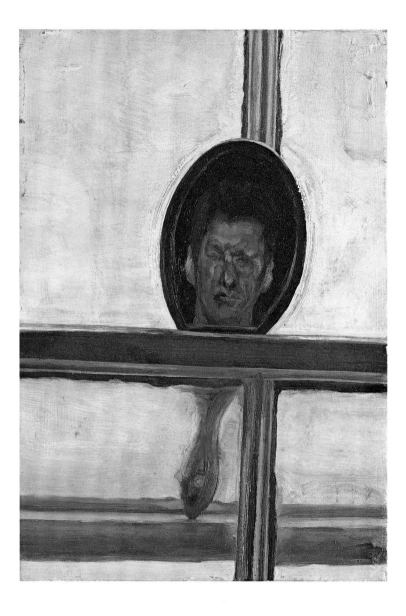

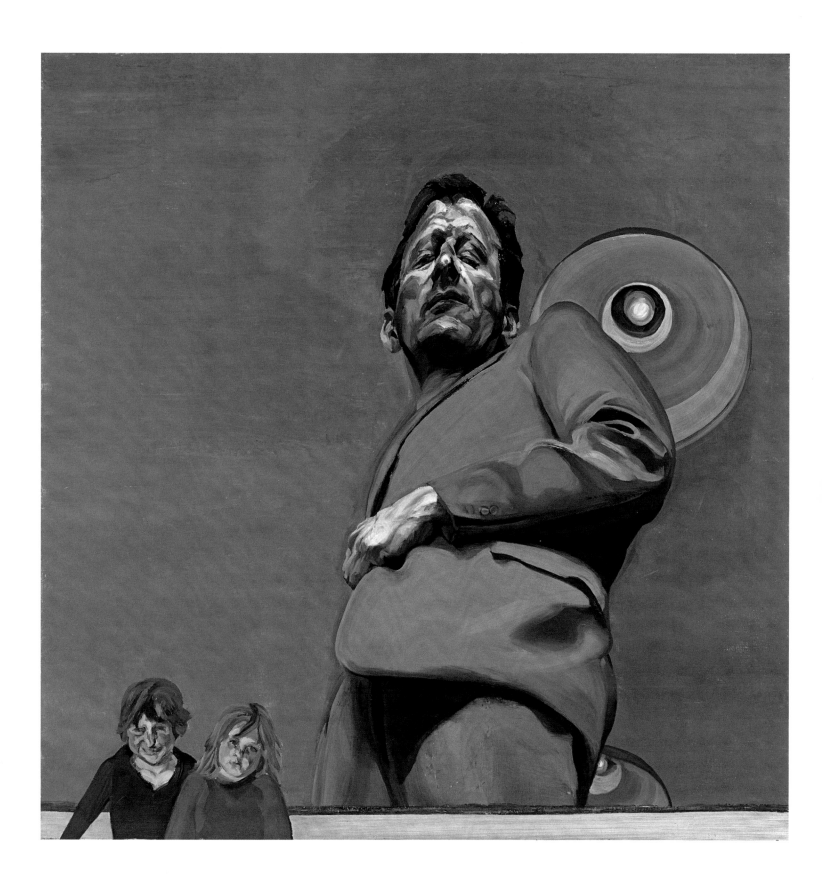

Cat. 133 Frank Auerbach
Head of E. O. W. IV, 1961
Oil on board, 23 ⅗ x 22 in. (59.7 x 55.9 cm)
Scottish National Gallery of Modern Art, Edinburgh.
Purchased 1976

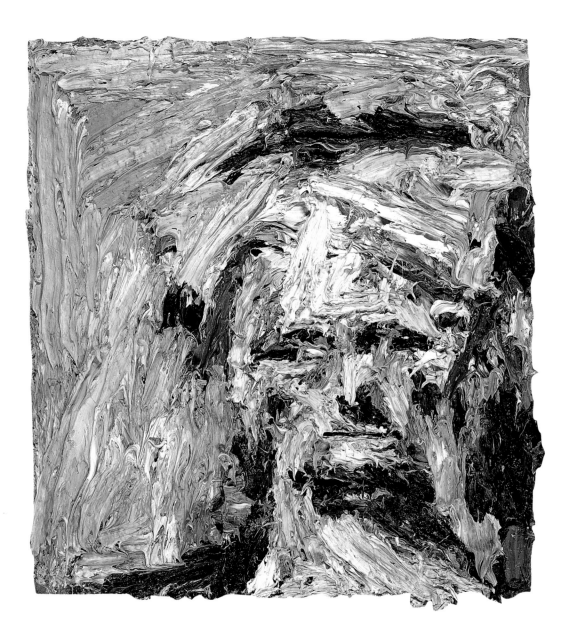

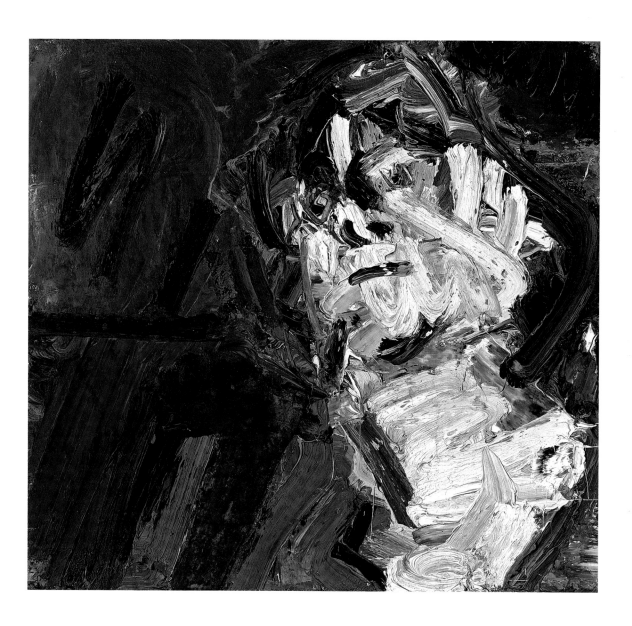

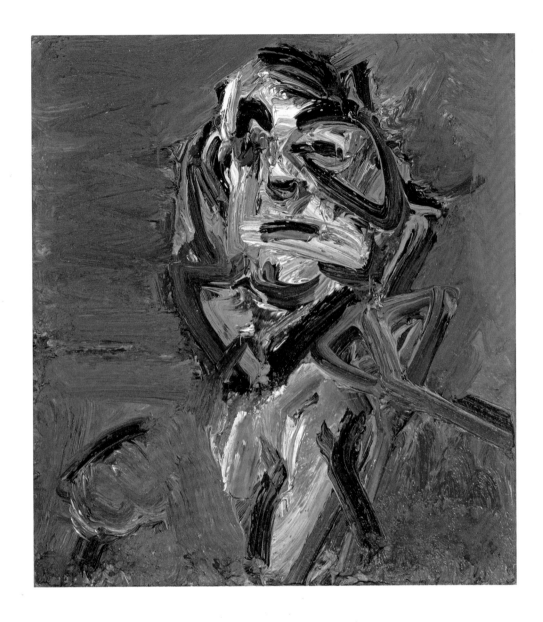

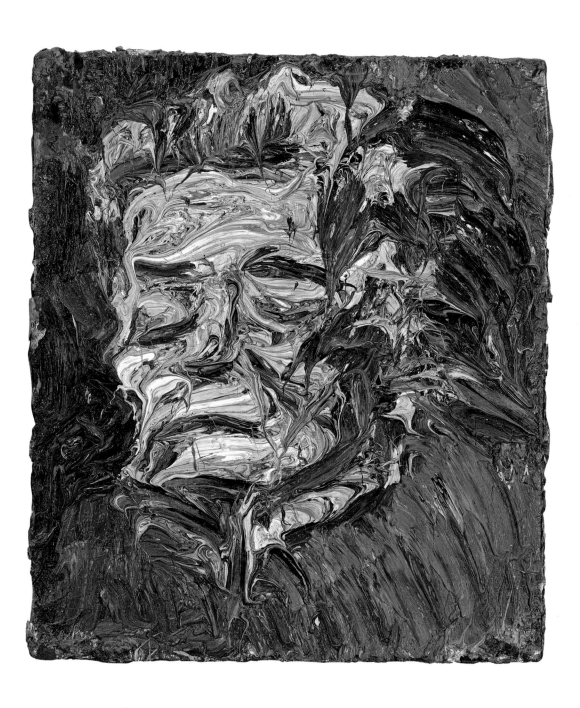

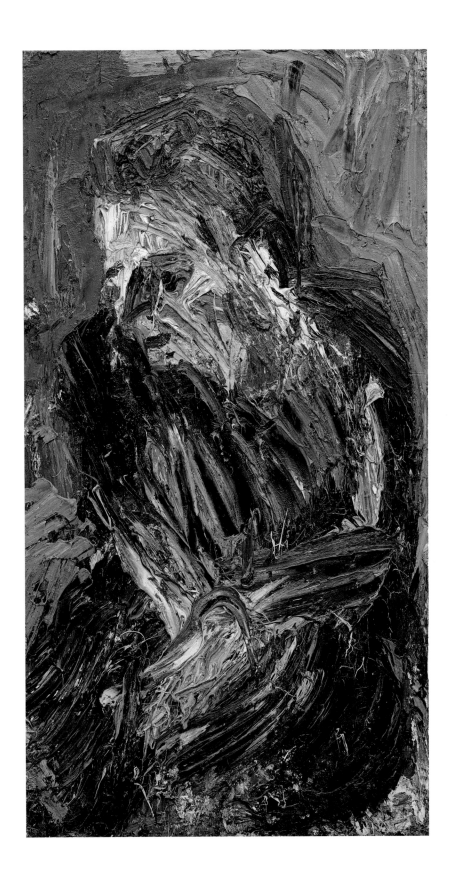

Cat. 138 Leon Kossoff
Portrait of John Lessore, 1993
Oil on board, 55 x 37 ½ in. (139.7 x 95.3 cm)
Courtesy of the artist and the LA Louver Gallery, Venice, California

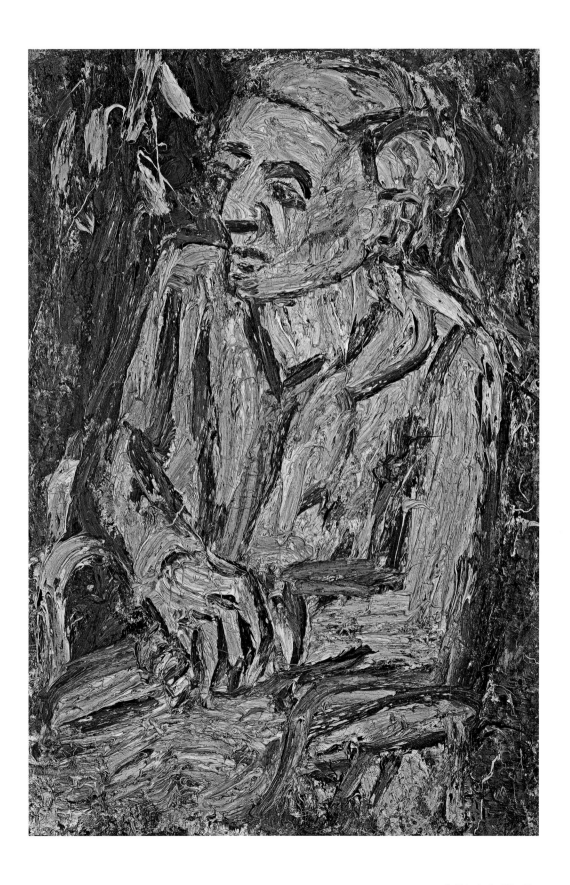

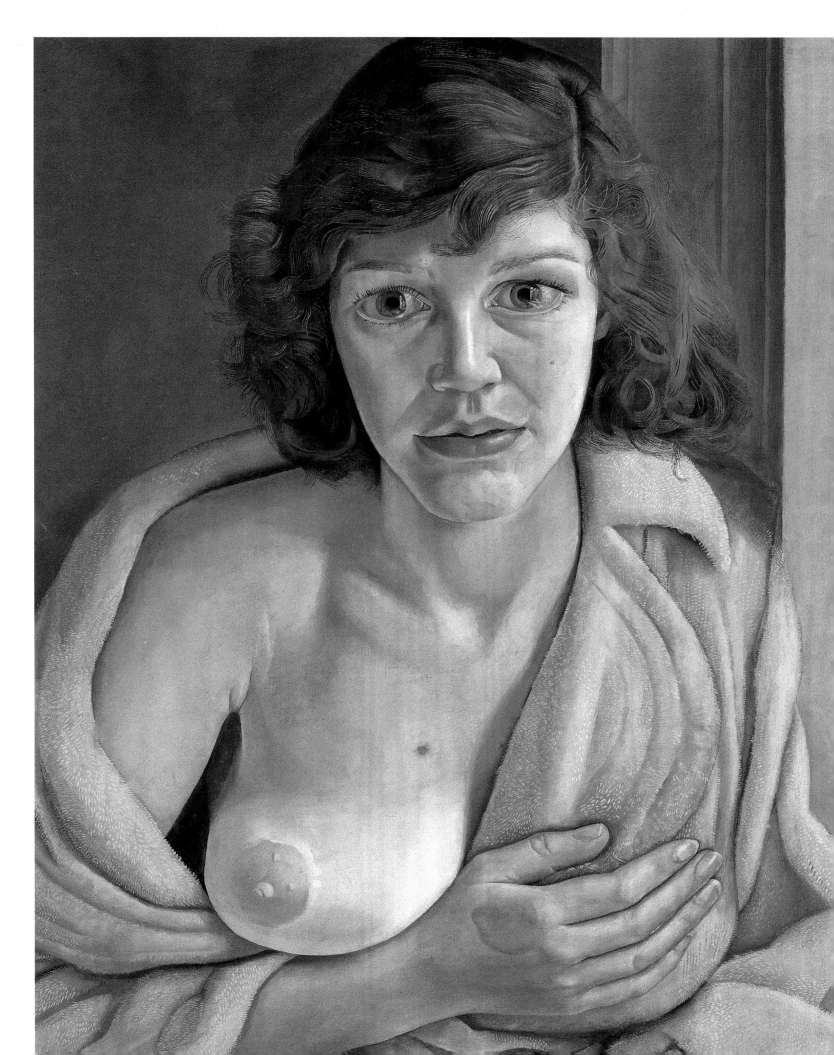

9 THE HUMAN CLAY

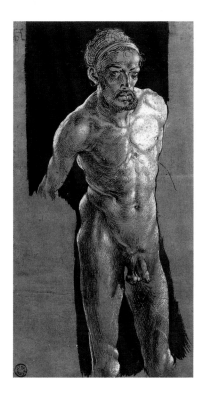

Fig. 1
Albrecht Dürer
Nude Self-Portrait,
c. 1503–1505
Pen and wash,
11 ⅞ x 5 ⅞ in. (29 x 15 cm)
Schlossmuseum Weimar

symbolically represents himself as a Hercules) until the end of the nineteenth century, when the idea of the naked body as part of a person's identity became more acceptable, the nude portrait was a rarity in European art. At the beginning of the twentieth century, as sexuality became more and more the subject of serious and original research, artists such as Pierre Bonnard [fig. 2], Edvard Munch, Gustav Klimt, Egon Schiele, and Richard Gerstl [fig. 3] used the erotic exaggeration of the naked body to convey feeling in their portraits. Artists' growing preoccupation with the nude extended not only to the female but also to the male body, which took on some changed associations. As Joanna Woodall has pointed out,

> the etymological relationship between the words *genital*, *genius*, *ingenious* and *generation* establishes a connection between the male sexual organs and creative powers, alongside the negative, confessional view of them as grotesque agents of disease and carnal lust, posing a threat to reason and even life itself.[1]

In his determination to represent the body without reference to normal canons of beauty and in uninhibited poses charged with erotic content, the British artist Stanley Spencer, a portraitist-cum-painter of religious subjects, took up the challenge presented by Egon Schiele. Having left his first wife, the painter Hilda Carline, Spencer took up with Patricia Preece, another student at the Slade School; his relationship with Preece was short and stormy, in part because of his homosexuality. Spencer painted her on numerous occasions, both dressed, as in *Portrait in a Garden (Patricia Preece)* [cat. 89], and nude, as in *Self-Portrait with Patricia Preece* of 1937 [cat. 139], in wich he included a nude portrait of himself between her and the viewer.

By painting himself with his wife in such a highly intimate situation, Spencer defied social convention and introduced an autobiographical element not without a certain irony, given

In portraiture, the body has always played a secondary role to the face, the traditional vehicle for showing the characteristics of an individual's identity. During the second half of the twentieth century, however, the body began to acquire greater importance, with a resulting increase in the portrait nude. Most of the present chapter will be devoted to this sub-genre, so different from other forms of portraiture in that the sitter appears before us in such an extremely vulnerable state.

From the revival of serious artistic and scientific interest in the human body in the Renaissance and the associated dichotomy between the ideal and the naturalistic (see Dürer's *Nude Self-Portrait* [fig. 1], in which the German master

1 Joanna Woodall, "'Every Painter Paints Himself': Self-Portraiture and Creativity," in London/ Sydney 2005–2006, p. 25.

Paloma Alarcó

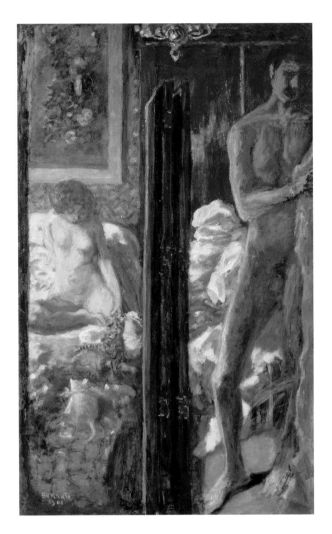

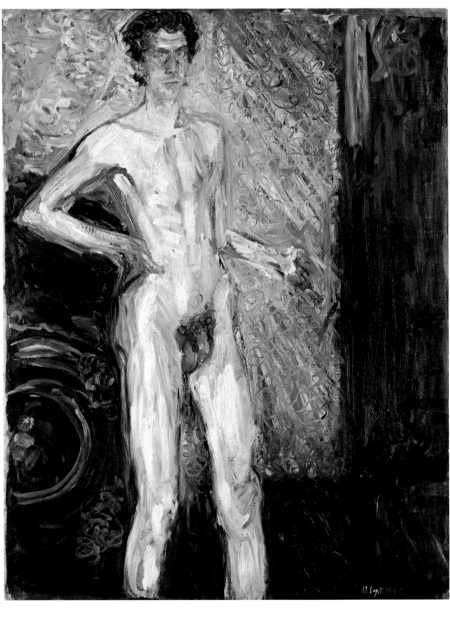

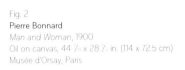

Fig. 2
Pierre Bonnard
Man and Woman, 1900
Oil on canvas, 44 ⅞ x 28 ½ in. (114 x 72.5 cm)
Musée d'Orsay, Paris

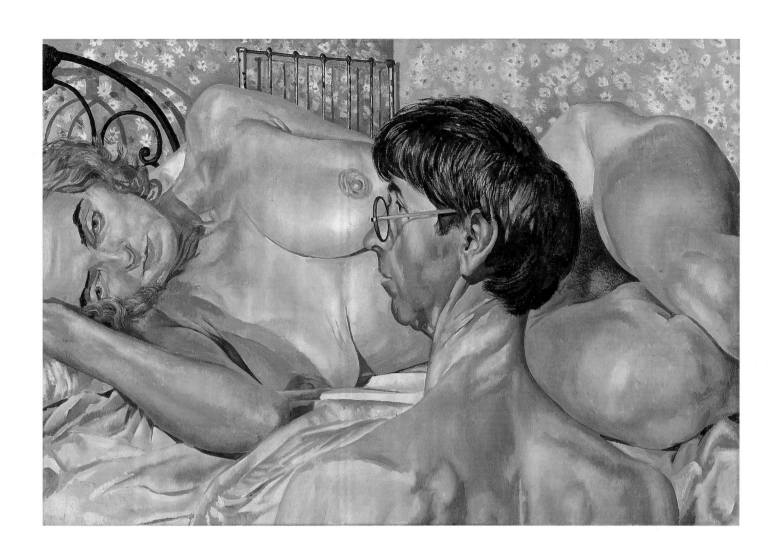

Cat. 141 Lucian Freud
Girl with a White Dog, 1950–1951
Oil on canvas, 30 x 40 in. (76.2 x 101.6 cm)
Tate, London. Purchased 1952

Cat. 144 Lucian Freud
Reflection (Self-Portrait), 1981–1982
Oil on canvas, 12 x 10 in. (30.5 x 25.4 cm)
Private collection

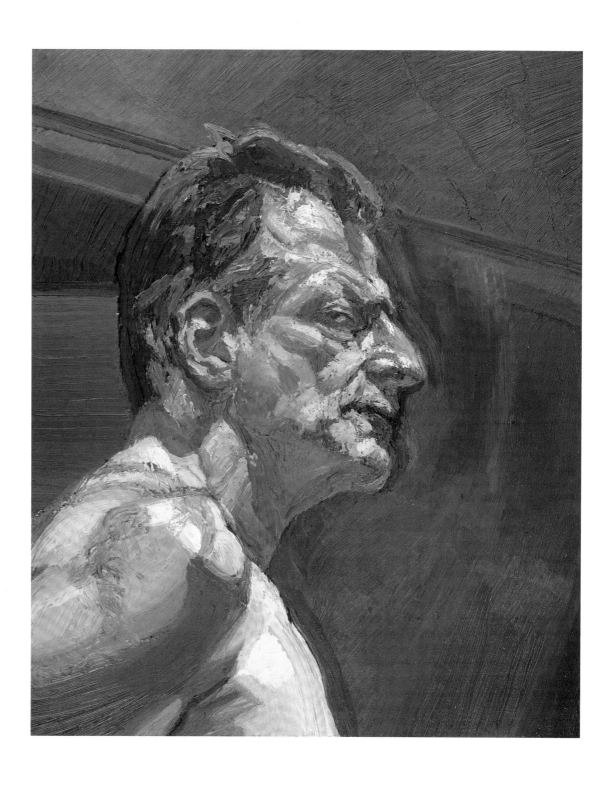

Cat. 145 Lucian Freud
Night Portrait, 1977–1978
Oil on canvas, 28 x 28 in. (71 x 71 cm)
Private collection

Cat. 146 Lucian Freud
The Painter Is Surprised by a Naked Admirer, 2004–2005
Oil on canvas, 64 x 52 in. (162.5 x 132 cm)
Private collection

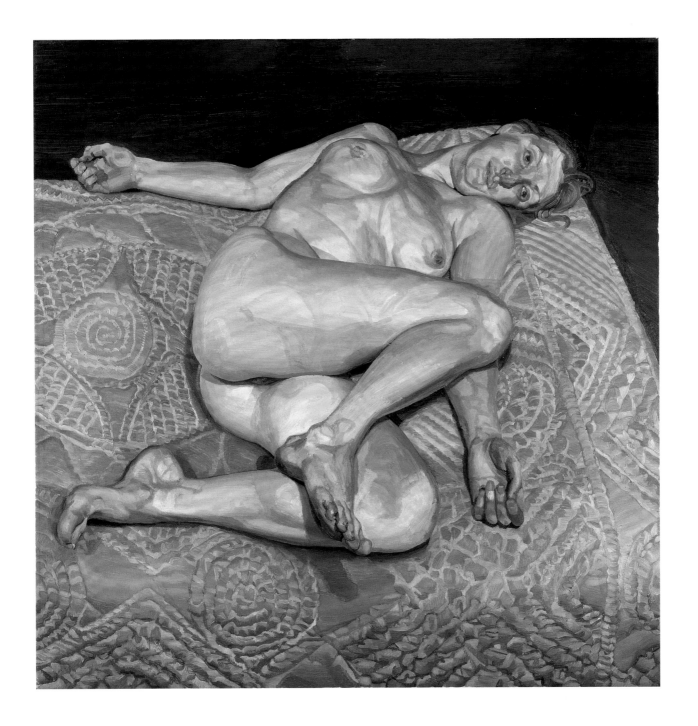

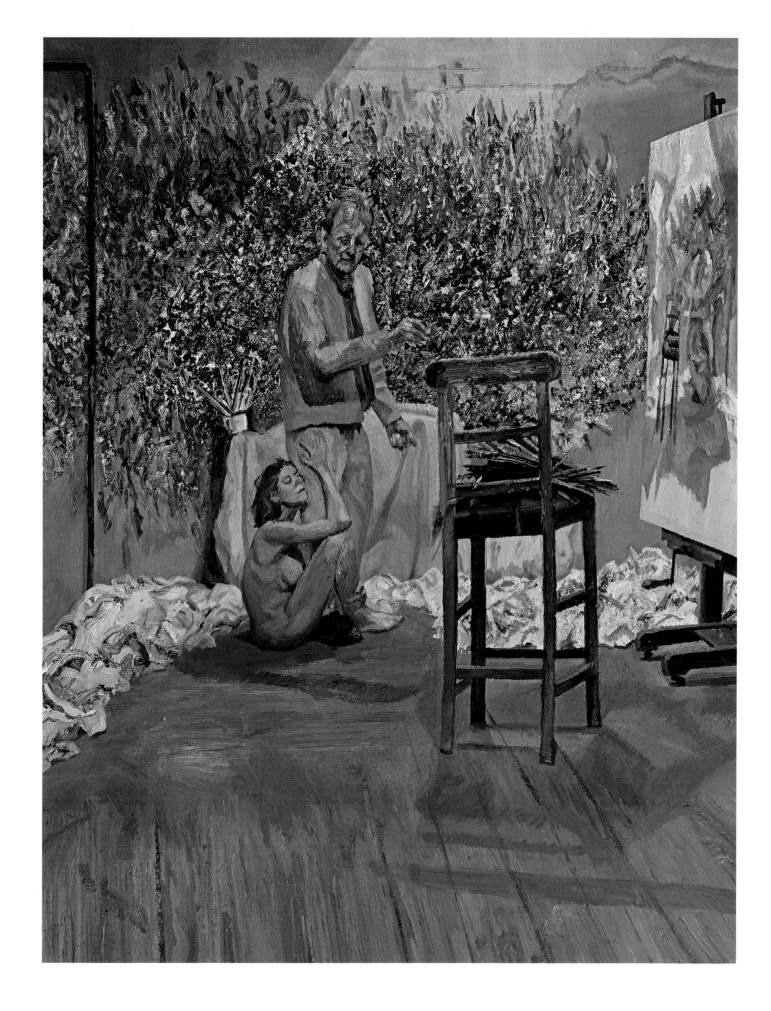

Cat. 147 Antonio López
Self-Portrait, 1967
Pencil, watercolor, charcoal, and wax, 14 ⅛ x 12 ¾ in. (36 x 32.5 cm)
Marqués de la Romana Collection

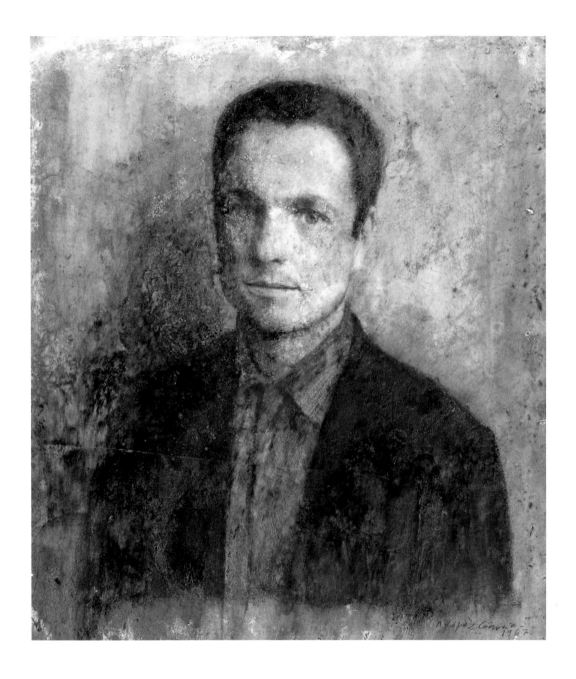

Cat 148 Avigdor Arikha
Mirror in the Studio, 1987
Oil on canvas, 63 ⅞ x 51 ⅛ in. (162 x 130 cm)
Musée Cantini, Marseilles. Acquired 1988

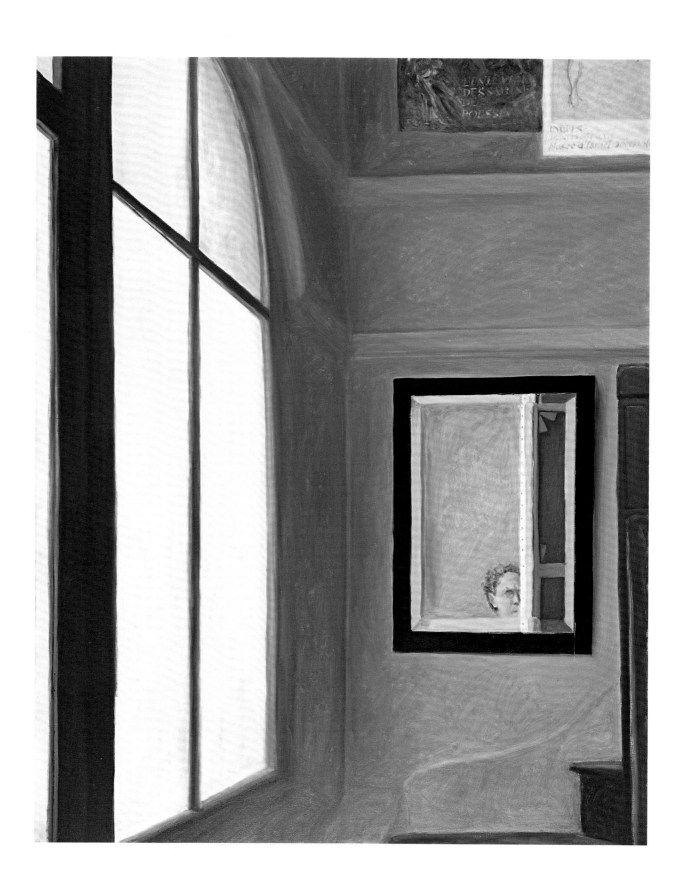

Cat. 149 Antonio López
 José María, 1981
 Pencil, 80 ⅜ x 40 ⅛ in. (204 x 102 cm)
 Museo de Bellas Artes de Bilbao

Cat. 150 Antonio López
 Manuel, 1985
 Pencil, 72 ⅞ x 36 ¼ in. (185 x 92 cm)
 Museo Nacional Centro de Arte Reina Sofía, Madrid

Cat. 151 Antonio López
 Man, 2003
 Bronze, 77 ½ x 23 ⅝ x 15 in. (197 x 60 x 38 cm)
 Grupo Urvasco

10 MIRRORED IMAGES

The last third of the twentieth century was a time of reconsideration and recapitulation in art generally, and not least in portraiture. In a radical transformation, comparable to the overthrow of traditional canons of the genre in the early years of the century, artists expanded the borders of originality and experimented with images formed from other images, engaging self-consciously with the very idea of the image. The present chapter, which closes our survey of portraiture in the modern age, will look at three artists whose work shows this tendency—in different forms—and also an evident desire to adapt portraiture to changing times. They are R. B. Kitaj, David Hockney, and Andy Warhol.

The American artist Ronald Brooks Kitaj lived in London for many years but is now based in Los Angeles. He has always been a controversial figure, emphatically set apart from any particular trend or fashion in art. In his portraits of his contemporaries, Kitaj has investigated relationships between the visual and the poetic through a subtle combination of photographic images, references to personal experiences, and allusions to literature and popular culture. Like the paintings of Bacon, Auerbach, and Freud, Kitaj's work focuses on the human figure—though always, as he himself has noted, within a literary context: "I like the idea that it is possible to invent a character in painting, a personality, in the same way that novelists are able to do."

Smyrna Greek (Nikos) of 1976–1977 [cat. 158] is an outstanding example of how rooted in literature Kitaj's painting is—not only in that it concerns two poets, but also in its narrative quality. In the foreground, we see the poet and publisher Nikos Stangos (1936–2004), a Greek based in London, who appears walking indifferently past a prostitute at the door of a brothel. As we shall see, he has assumed the identity of his compatriot, the poet Constantin Cavafy, whose work he had translated into English. Inside the building is a staircase with a man coming down with a distracted or perhaps satisfied air; this figure represents Kitaj himself, underlining the fact that his art is based on a personal experience. In a short explanation of the work, Kitaj stated:

> This portrait of my friend Nikos Stangos was inspired by his fellow Greek poet Cavafy, who described his daily walk past the brothels in the port of Alexandria. I had just returned to London from my only trip to Greece, which lasted very few days, and while he posed for me in that walking position I told Nikos about my bizarre and unconsummated wander down the port of Piraeus, as if in imitation of C. P. Cavafy. So the painting is about the two poets and me.[1]

Smyrna Greek (Nikos) belongs to a group of portraits of large and unusually elongated proportions that depict intellectuals and friends of the artist. The group also includes *The Hispanist (Nissa Torrents)*, painted in 1977–1978 [cat. 159]. Since 1957, when he visited Sant Feliu de Guíxols on the Costa Brava, Kitaj has maintained a strong interest in Spain and Spanish culture. He has made numerous portraits of the friends that he made in Catalonia, and one of these was Nissa Torrents (1937–1992), a professor at the University of London. Here she poses seated in an Alvar Aalto chair in Kitaj's London studio. The cats suspended behind her are a reference to the mobile in the famous Barcelona cafe Els Quatre Gats, which has been attributed to Picasso.[2]

Marco Livingstone[3] tells how Kitaj was much surprised to discover, on reading his close friend Philip Roth's novel *Sabbath's Theater* (published in 1996), that his life had provided the inspiration for the main character. Roth's novel tells the story of a failed puppeteer whose youthful experiences in brothels are a literal recounting of Kitaj's own, as told by him to Roth in confidence. Thus the artist who wished to invent characters in the same way as a novelist became a character in a novel—one whose desperate search for sex is nothing but a way of combating the anguish of death.

1 Quoted in London/Los Angeles/ New York 1994, p. 217.

2 See Bilbao 2004, no. 11.

3 See Marco Livingstone in Oslo/. . . /Hannover 1998.

Paloma Alarcó

Fig. 1
Ronald B. Kitaj
Two London Painters: Frank Auerbach and Sandra Fisher, 1979
Pastel and charcoal, 22 ⅛ x 30 ⅞ in. (56.2 x 78.4 cm)
Los Angeles County Museum of Art.
Michael and Dorothy Blankfort Bequest

Fig. 2
David Hockney
*Peter Posing for Model with
Unfinished Self-Portrait*, 1977
Collection of the artist

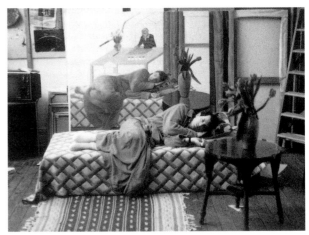

Once a fellow-student of Kitaj's at the Royal College of Art in London, the Los Angeles-based British artist David Hockney has devoted much of his work to portraiture. Like Kitaj, he rarely makes portraits on commission and usually paints people from his own circle: his parents, lovers, and friends. Almost all of Hockney's portraits contain an element of autobiography. His *Portrait Surrounded by Artistic Devices* of 1965 [cat. 154] is a portrait of his father, Kenneth Hockney. This eccentric provincial accountant sits within an arch of colors beside a pile of Cubistic tubular elements that call to mind the work of Léger. Hockney has never aimed to delve into his sitter's emotions; the image he offers us is always based on his own feelings. But on this occasion the sitter seems to wear an expression of indulgence, possibly his feeling about being a visitor in his son's world. From the row of brushstrokes-like objects in the upper part of the composition to the naturalistic figure, a display of the artist's virtuoso technique, the portrait typifies Hockney's flair for combining diverse stylistic elements.

After Hockney first moved to Los Angeles in 1964, the main subject of his paintings became his lover, the young painter Peter Schlesinger. In *Peter Schlesinger with Polaroid Camera* of 1977 [cat. 156], a work painted after their relationship had ended, he shows his sitter in an almost empty setting, accompanied by one of the basic tools of his own work as a portraitist, a Polaroid camera on a tripod. Hockney's use of Polaroid snapshots as the basis for his portraits is reflected in an overt way in the square format of his compositions of this period—as we see not only in the portrait of Schlesinger but also in *Henry and Eugene* [cat. 155]

and *Model with Unfinished Self-Portrait* [cat. 157], all dating from 1977. *Henry and Eugene* is a double portrait showing Hockney's friend the art historian and critic Henry Geldzahler (1935–1994) in conversation with a young man seated on the ground next to him. For Hockney, double portraits, following in the tradition of the English "Conversation Piece," have been a fruitful pretext for studying the mystery of human relations.[4]

In *Model with Unfinished Self-Portrait*, Hockney establishes a play of ambiguities between reality and the painted image. The model, asleep in the foreground, is painted with a minutely detailed realism; behind, the artist shows himself at work as though perhaps making a preparatory study for this very work. The self-portrait is not an image of reality but an unfinished painting-within-the-painting. Hockney used two different models for the recumbent figure, initially Peter Schlesinger and then, after the break-up of their relationship, Gregory Evans. In a photograph in which Schlesinger appears in front of the painting, lying in the same pose [fig. 2], Hockney makes even more explicit the effect of pictorial multiplication that he wished to achieve.

Andy Warhol used photography more overtly still. Taking images from the mass media, he created a form of populist art that ran contrary to the elitist and intellectual character of the Abstract Expressionists. Rather than making portraits, Warhol created icons, transforming his sitters' identities (and his own) into a frozen and depersonalized image through his manipulation of the photograph. Warhol's method of transferring enlarged photographs onto his canvases through the technique of silkscreen applied to the support with a synthetic polymer allowed him to eliminate all subjectivity

4 See Mark Glazebrook,
"A Cultured Rebel,"
in Boston/Los Angeles/London
2006–2007, pp. 20–33.

Fig. 3
Andy Warhol
Self-Portrait, 1981
4 Polaroids, each 3 ⅜ x 4 ¼ in. (8.6 x 10.8 cm)
The Andy Warhol Museum, Pittsburgh. Founding Collection,
Contribution The Andy Warhol Foundation for the Visual Arts, Inc.

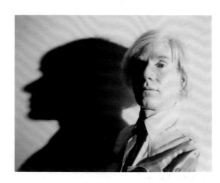

blond wig. His self-portrait of 1967 [cat. 160], the earliest in the exhibition, belongs to a series based on a photograph taken by a professional photographer, in which he appears looking impassively at the camera with his hand on his face. The most recent [cat. 166] forms part of a lengthy series of images of the artist with his hair standing on end that were exhibited at the Anthony d'Offay Gallery in New York in 1986, a few months before his death.

Also included in the present exhibition is a series of self-portraits based on the theme of the profile shadow: *The Shadow* [cats. 161, 162, and 165] and *Shadow with Glasses* [cats. 163 and 164]. In this group, also based on a photograph [fig. 3], the artist's real face is only half present and his vague, mysterious shadow acquires the most important role in the composition. This may be to emphasize the unabashed superficiality that Warhol always aimed to convey: "If you want to know all about Andy Warhol, just look at the surface of my paintings and films, and me, there I am. There's nothing behind it."[5] The practice of doubling, already used by earlier modern artists including Picasso and de Chirico,[6] acquires a particular meaning in Warhol's work. He was always interested in the visual and metaphorical value of shadows, their inconsistency and strangeness as well as their ambiguity. He used them to create images in which the figure and its double are full of symbolic suggestion.

Warhol marks a turning-point in portraiture, after which the sitter fades to a shadow and is transformed into a virtual image. Through his cynical devotion to the credo of superficiality, Warhol laid the ground for postmodernism, in which representation no longer follows reality but precedes it. From this point on, in the innumerable faces that we see in more recent contemporary art, there is no longer a real subject behind the image; the portrait becomes a simulacrum, several times removed from the original. "I'm sure I'm going to look in the mirror and see nothing. People are always calling me a mirror and if a mirror looks into a mirror, what is there to see?"[7]

from the artistic process; he himself could be absent from the work, his interventions limited to giving instructions to others who made it for him. In this way Warhol eliminated the traditional artist's role as manual creator of the image and at the same time canceled out—or reduced to a ghostlike presence—the personality of the sitter.

In his innumerable self-portraits, some examples of which conclude the present exhibition, Warhol hid himself behind a mask that replaced reality. After moving from his native Pittsburgh to New York, he vanquished all trace of Andrew Warhola, his true identity, and created a new, tailor-made version of himself. Not only did he change his name, he also canceled out his past and transformed his physical appearance, with his omnipresent black suit and platinum

5 Quoted in Honnef 2000, p. 45.

6 See chapter 7 of this catalogue.

7 Warhol 1975, p. 7.

Cat. 154 David Hockney
Portrait Surrounded by Artistic Devices, 1965
Acrylic on canvas, 60 x 72 in. (152.5 x 182.9 cm)
Arts Council Collection, Hayward Gallery,
South Bank Centre, London

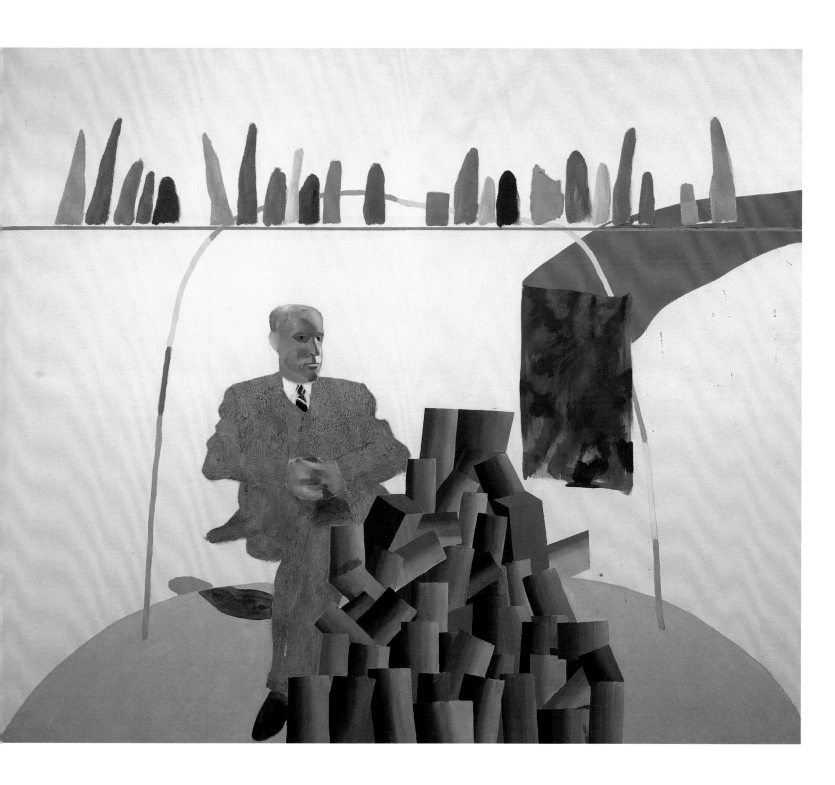

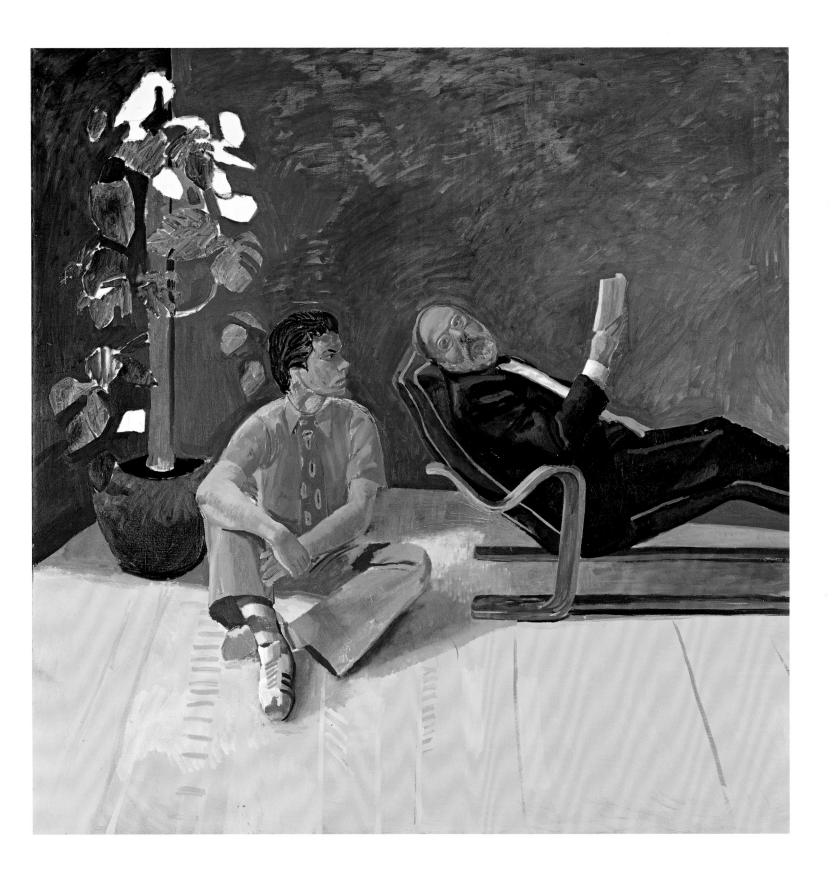

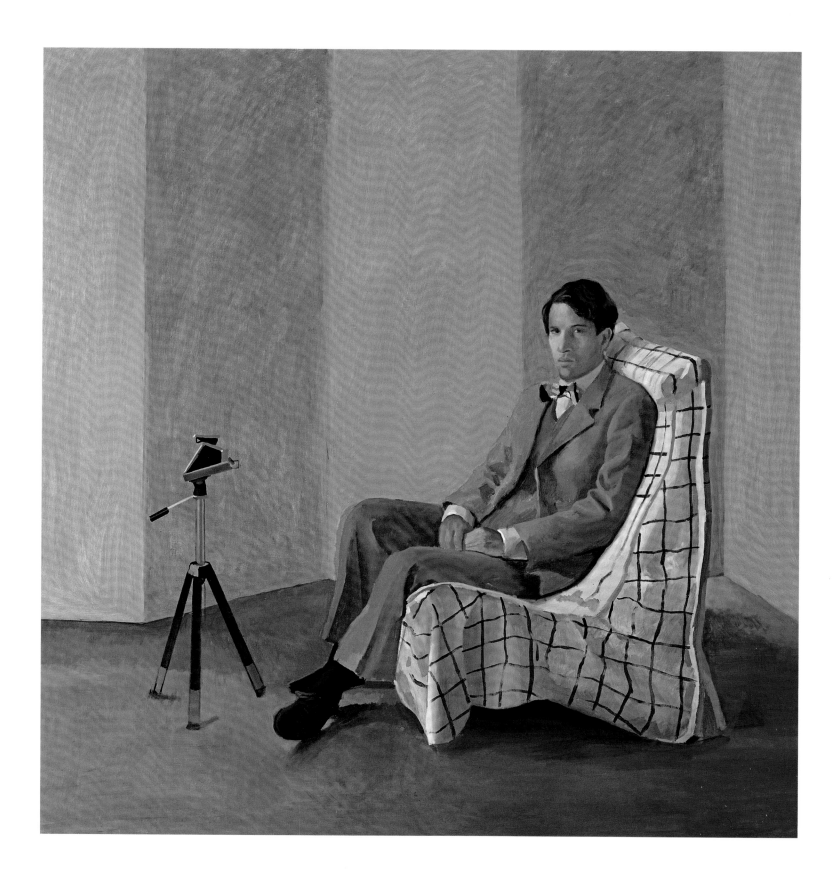

Cat. 157 David Hockney
Model with Unfinished Self-Portrait, 1977
Acrylic on canvas, 60 x 60 in. (152.4 x 152.4 cm)
Private collection

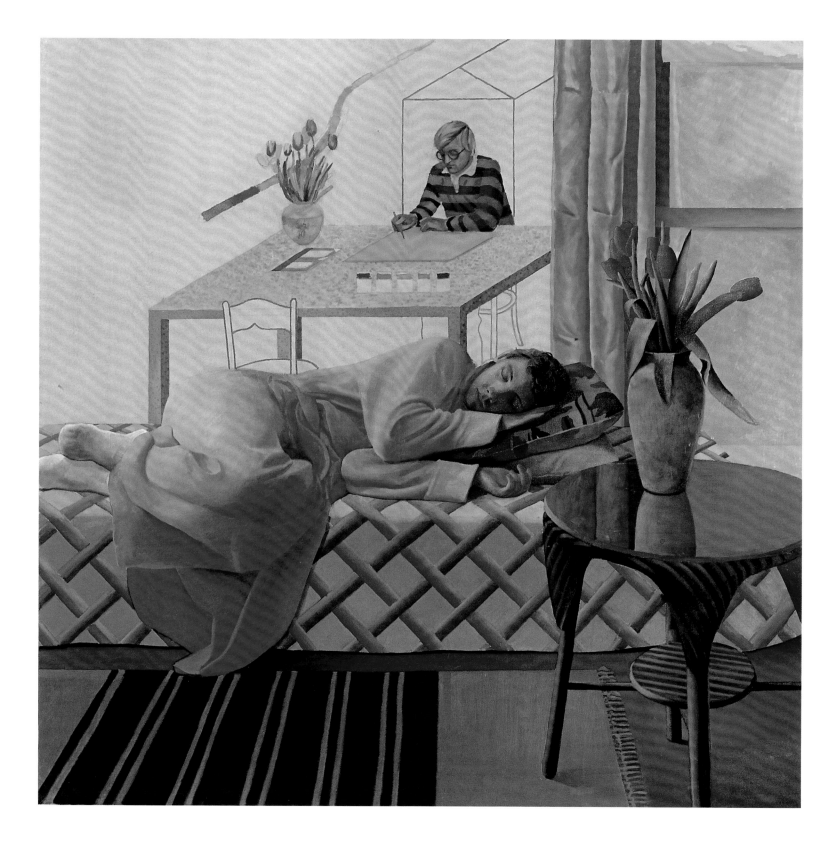

Cat. 158 Ronald B. Kitaj
Smyrna Greek (Nikos), 1976–1977
Oil on canvas, 96 x 30 in. (243.8 x 76.2 cm)
Museo Thyssen-Bornemisza, Madrid

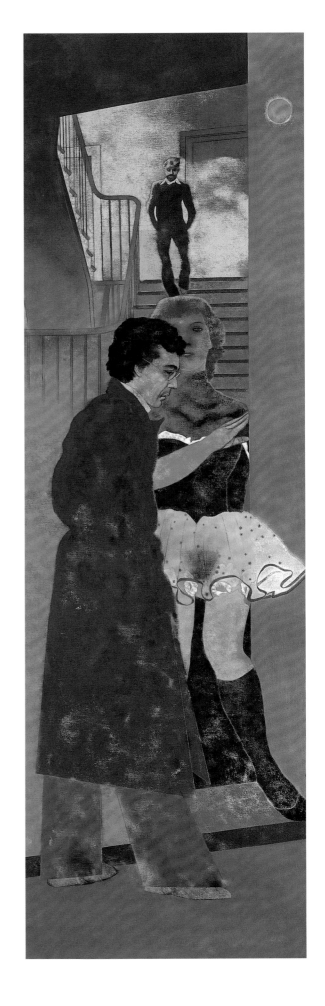

Cat. 159 Ronald B. Kitaj
The Hispanist (Nissa Torrents), 1977–1978
Oil on canvas, 96 ⅛ x 30 in (244.2 x 76.2 cm)
Museo de Bellas Artes de Bilbao

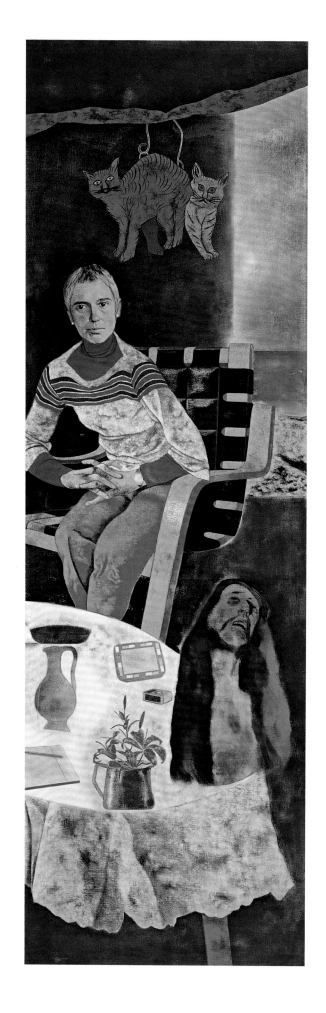

Cat. 160 Andy Warhol
Self-Portrait, 1967
Screenprint on silver-coated paper, 22 x 20 ⅞ in. (56 x 53 cm)
Wilhelm-Hack-Museum, Ludwigshafen, Germany

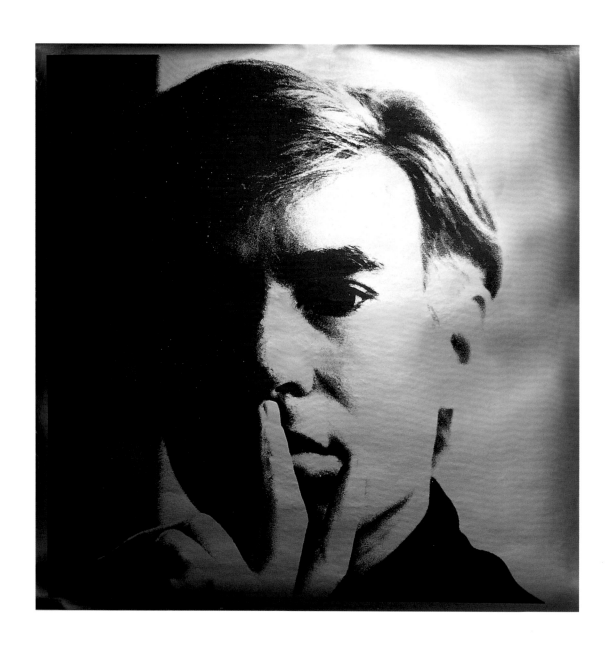

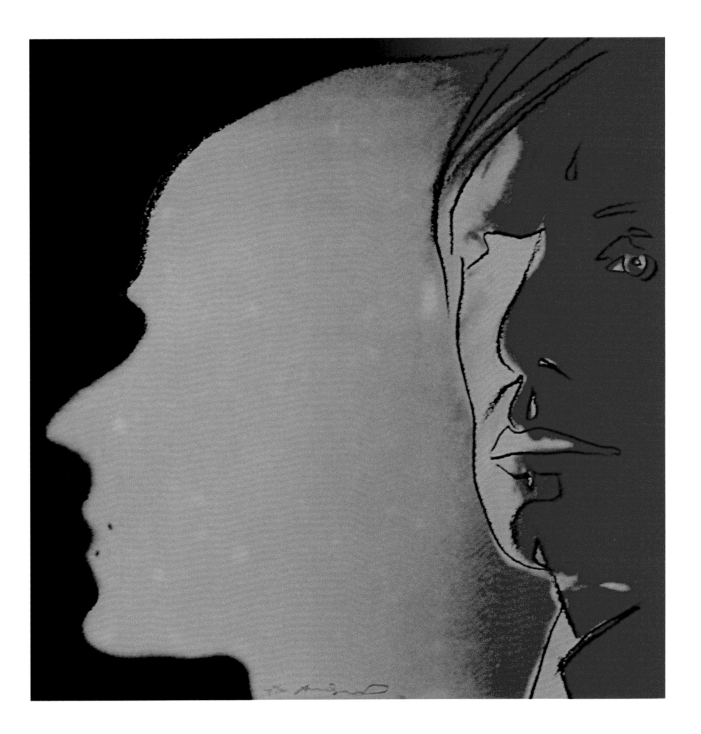

Cat. 162 Andy Warhol
The Shadow, 1981
Screenprint, 38 x 38 in. (96.5 x 96.5 cm)
Courtesy Ronald Feldman Fine Arts, New York

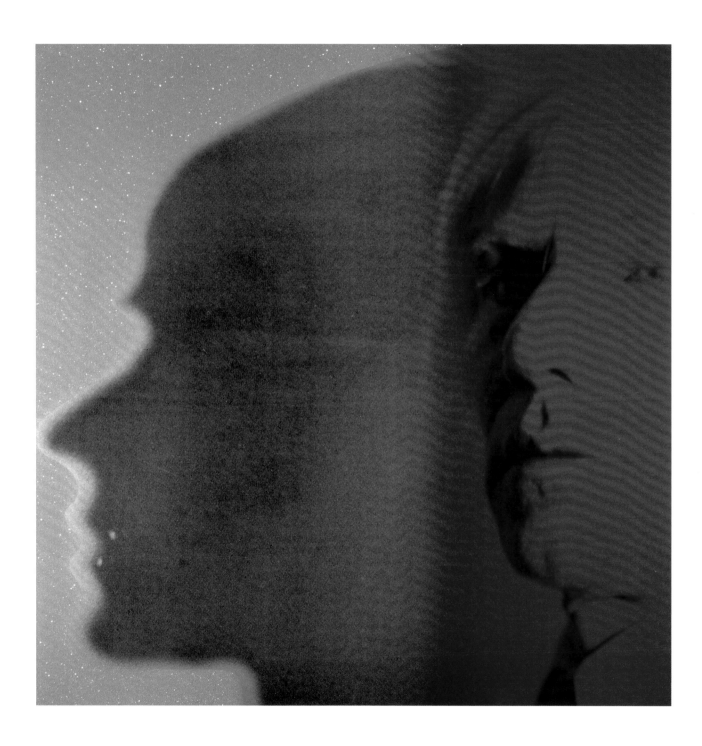

Cat. 163 Andy Warhol
Shadow with Glasses, 1981
Screenprint, 38 x 38 in. (96.5 x 96.5 cm)
Courtesy Ronald Feldman Fine Arts, New York

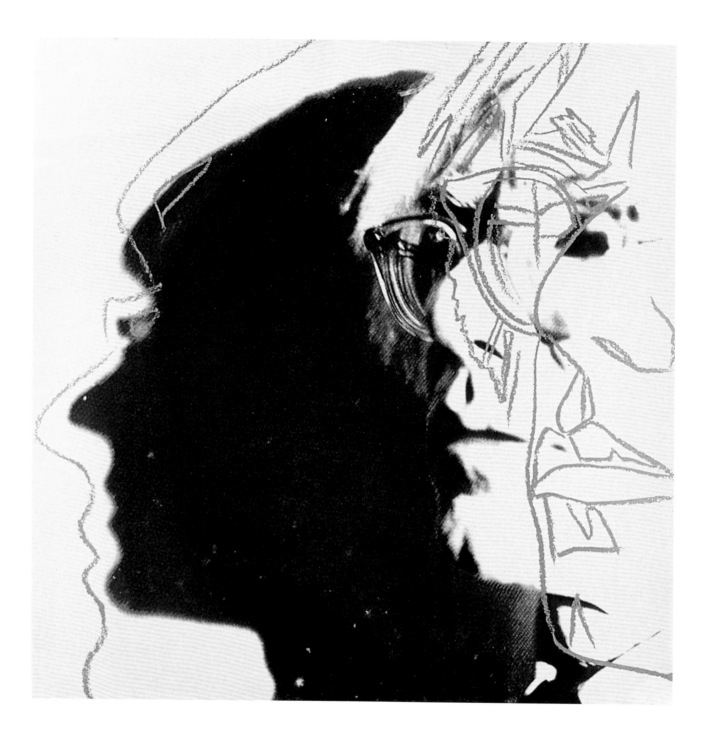

Cat. 166 Andy Warhol
Self-Portrait, 1986
Synthetic polymer paint and silkscreen ink
on canvas, 22 x 22 in. (55.9 x 55.9 cm)
Courtesy Van de Weghe Fine Art, New York

APPENDIX

LIST OF WORKS

*Exhibited in Madrid only
(Museo Thyssen-Bornemisza and Fundación Caja Madrid)

**Exhibited in Fort Worth only
(Kimbell Art Museum)

The works without asterisks are exhibited in both cities

Avigdor Arikha (Israeli, born 1929)

Cat. 148 *Mirror in the Studio*, 1987
Oil on canvas, 63 ³/₄ x 51 ¹/₈ in.
(162 x 130 cm)
Musée Cantini, Marseille. Acquired 1988
(p. 291)*

Cat. 153 *Daydream*, 1993
Oil on canvas, 38 ¹/₈ x 51 ¹/₈ in.
(97 x 130 cm)
Marlborough International Fine Art
(p. 295)*

Cat. 152 *Nudity*, 1999
Pencil, 24 ³/₈ x 22 ⁵/₈ in. (57.7 x 63.3 cm)
Marlborough International Fine Art
(p. 294)*

Frank Auerbach (British, born 1931)

Cat. 133 *Head of E. O. W. IV*, 1961
Oil on board, 23 ¹/₂ x 22 in.
(59.7 x 55.9 cm)
Scottish National Gallery of Modern Art,
Edinburgh. Purchased 1976
(p. 268)

Cat. 134 *Head of J. Y. M.*, 1978
Oil on canvas, 24 x 26 in. (61 x 66 cm)
Museo Thyssen-Bornemisza, Madrid
(p. 269)*

Cat. 135 *J. Y. M. I*, 1981
Oil on board, 22 x 20 in. (56 x 50.8 cm)
Southampton City Art Gallery
(p. 270)*

Francis Bacon (British, 1909-1992)

Cat. 125 *Self-Portrait*, 1956
Oil on canvas, 78 x 54 in.
(198.1 x 137.2 cm)
Modern Art Museum of Fort Worth.
Gift of The Burnett Foundation in honor
of Marla Price
(pp. 258-259)**

Cat. 126 *Study for the Head of Isabel Rawsthorne*,
1967
Oil on canvas, 14 x 12 in. (35.5 x 30.5 cm)
Private collection. Courtesy MaxmArt,
Mendrisio, Switzerland
(p. 260)

Cat. 127 *Portrait of George Dyer in a Mirror*, 1968
Oil on canvas, 78 x 57 ⁷/₈ in. (198 x 147 cm)
Museo Thyssen-Bornemisza, Madrid
(pp. 260-261)

Cat. 128 *Three Studies of George Dyer*, 1969
Oil on canvas, each 14 ¹/₈ x 12 in.
(36 x 30.5 cm)
Louisiana Museum of Modern Art,
Humlebæk, Denmark.
Donation: The New Carlsberg Foundation
(p. 262)

Cat. 129 *Three Studies for a Portrait of Peter
Beard*, 1975
Oil on board, each 14 x 12 in.
(35.5 x 30.5 cm)
Juan Abelló Collection
(p. 263)*

Cat. 130 *Triptych*, 1986-1987
Oil and pastel on canvas, each
78 x 58 ¹/₈ in. (198 x 147.5 cm)
Marlborough International Fine Art
(pp. 264-265)*

Balthus [Balthazar Klossowski de Rola]
(French, 1908-2001)

Cat. 88 *Joan Miró and His Daughter Dolores*,
1937-1938
Oil on canvas, 51 ¹/₄ x 35 in.
(130.2 x 88.9 cm)
Monnier/Clair 1999, no. P111
The Museum of Modern Art, New York.
Abby Aldrich Rockefeller Fund (398.1938)
(p. 197)*

Max Beckmann (German, 1884-1950)

Cat. 6 *Self-Portrait with Raised Hand*, 1908
Oil on canvas, 21 ⁵/₈ x 17 ³/₄ in.
(55 x 45 cm)
Göpel/Göpel 1976, no. 99
Museo Thyssen-Bornemisza, Madrid
(p. 58)

Cat. 81 *Double Portrait of Frau Swarzenski
and Carola Netter*, 1923
Oil on canvas, 31 ⁵/₈ x 25 ⁵/₈ in.
(80.5 x 65 cm)
Göpel/Göpel 1976, no. 222
Städel Museum, Frankfurt
(p. 188)**

Cat. 82 *Self-Portrait in Front of Red Curtain*, 1923
Oil on canvas, 43 ³/₈ x 23 ⁵/₁₆ in.
(110.2 x 59.2 cm)
Göpel/Göpel 1976, no. 218
Private collection. Courtesy of the Neue
Galerie, New York
(p. 189)*

Cat. 83 *Paris Society*, 1931
Oil on canvas, 43 x 69 ¹/₈ in.
(109.2 x 175.6 cm)
Göpel/Göpel 1976, no. 346
Solomon R. Guggenheim Museum,
New York (70.1927)
(pp. 190-191)*

Cat. 84 *Quappi in a Pink Sweater*, 1935
Oil on canvas, 41 ³/₈ x 28 ³/₄ in.
(105 x 73 cm)
Göpel/Göpel 1976, no. 404
Museo Thyssen-Bornemisza, Madrid
(p. 192)

Cat. 85 *Self-Portrait in a Blue Jacket*, 1950
Oil on canvas, 55 ¹/₈ x 36 in.
(140 x 91.4 cm)
Göpel/Göpel 1976, no. 816
Saint Louis Art Museum. Bequest
of Morton D. May
(p. 193)

Vanessa Bell (British, 1879-1961)

Cat. 36 *Self-Portrait*, c. 1915
Oil on canvas laid on panel,
25 ¹/₈ x 18 ¹/₁₆ in. (63.8 x 45.9 cm)
Yale Center for British Art, New Haven.
Paul Mellon Fund
(p. 106)**

Georges Braque (French, 1882-1963)

Cat. 59 *Girl with a Cross*, 1911
Oil on canvas, 21 ³/₄ x 17 in. (55 x 43 cm)
Worms de Romilly/Laude 1982, no. 70
Kimbell Art Museum, Fort Worth
(p. 152)

Paul Cézanne (French, 1839-1906)

Cat. 40 *Madame Cézanne*, c. 1888
Oil on canvas, 39 ⁵/₈ x 32 in.
(100.6 x 81.3 cm)
Rewald 1996, no. 607
The Detroit Institute of Arts. Bequest
of Robert H. Tannahill
(pp. 120-121)**

Cat. 41 *Madame Cézanne in a Yellow Chair*,
1888-1890
Oil on canvas, 31 ⁵/₈ x 25 ⁵/₈ in.
(80.2 x 64.2 cm)
Rewald 1996, no. 651
Fondation Beyeler, Riehen/Basel,
Switzerland
(p. 122)*

Cat. 42 *Madame Cézanne in Blue*, 1888-1890
Oil on canvas, 29 ¹/₂ x 24 in.
(74.1 x 61 cm)
Rewald 1996, no. 650
The Museum of Fine Arts, Houston.
The Robert Lee Blaffer Memorial
Collection, gift of Sarah Campbell Blaffer
(p. 123)**

Cat. 1 *Man in a Blue Smock*, c. 1897
Oil on canvas, 32 ¹/₈ x 25 ¹/₂ in.
(81.5 x 64.8 cm)
Rewald 1996, no. 826
Kimbell Art Museum, Fort Worth.
Acquired in 1980, in memory of Richard
F. Brown, the Kimbell Art Museum's first
director, by the Kimbell Board of Trustees,
assisted by the gifts of many friends
(pp. 52-53)

Giorgio de Chirico (Italian, 1888–1978)

Cat. 92 *Self-Portrait with the Head of Mercury*,
1923
Tempera on canvas, 25 ⁵/₈ x 19 ⁵/₈ in.
(65 x 50 cm)
Bruni 1971–1987, no. 59
Private collection. Courtesy MaxmArt,
Mendrisio, Switzerland
(pp. 210–211)

Lovis Corinth (German, 1858–1925)

Cat. 23 *Alfred Kuhn*, 1923
Oil on cardboard, 24 ¹/₂ x 20 ¹/₄ in.
(62.2 x 51.6 cm)
Berend-Corinth 1958, no. 915
Leopold Museum, Vienna
(p. 84)*

Salvador Dalí (Spanish, 1904–1989)

Cat. 66 *Cubist Self-Portrait*, 1923
Oil and collage on cardboard laid
on wood, 41 x 29 ¹/₂ in. (104 x 75 cm)
Descharnes/Néret 1993, vol. I, no. 170;
Santos Torroella 2005, no. 65
Museo Nacional Centro de Arte Reina
Sofía, Madrid
(p. 159)*

Cat. 76 *Portrait of My Father*, 1925
Oil on canvas, 41 ¹/₈ x 41 ¹/₈ in.
(104.5 x 104.5 cm)
Descharnes/Néret 1993, vol. I, no. 202
MNAC. Museu Nacional d'Art de
Catalunya, Barcelona
(p. 182–183)*

Cat. 98 *Portrait of Paul Eluard*, 1929
Oil on canvas, 9 ⁷/₈ x 12 ¹/₄ in.
(32.5 x 25 cm)
Descharnes/Néret 1993, vol. I, no. 306;
Santos Torroella 2005, no. 164
Courtesy of the Fondation Pierre
Gianadda, Martigny, Switzerland
(p. 218)*

Cat. 99 *Portrait of Pablo Picasso in the 21st
Century (One of a Series of Portraits
of Genius: Homer, Dalí, Freud, Christopher
Columbus, William Tell, etc.)*, 1947
Oil on canvas, 25 ³/₄ x 22 in.
(65.5 x 56 cm)
Descharnes/Néret 1993, vol. II, no. 911
Fundació Gala-Salvador Dalí
(p. 219)*

André Derain (French, 1880–1954)

Cat. 50 *Portrait of a Girl*, 1914
Oil on canvas, 24 x 19 ⁵/₈ in. (61 x 50 cm)
Kellermann 1992–1999, no. 415
Musée Picasso, Paris
(p. 133)

Otto Dix (German, 1891–1969)

Cat. 73 *The Businessman Max Roesberg,
Dresden*, 1922
Oil on canvas, 37 x 25 in. (94 x 63.5 cm)
Löffler 1981, no. 1922/9
The Metropolitan Museum of Art,
New York. Purchase, Lila Acheson
Wallace Gift, 1992 (1992.146)
(p. 179)**

Cat. 74 *Venus of the Capitalist Era*, 1923
Oil on hardboard, 50 ³/₈ x 19 ⁵/₈ in.
(128 x 50 cm)
Löffler 1981, no. 1923/5
Private collection. Courtesy MaxmArt,
Mendrisio, Switzerland
(p. 180)*

Cat. 72 *Portrait of the Lawyer Hugo Simons*, 1925
Tempera and oil on wood,
39 ¹/₂ x 27 ⁵/₈ in. (100.3 x 70.3 cm)
Löffler 1981, no. 1925/11
The Montreal Museum of Fine Arts.
Purchase, grant from the Government of
Canada under the terms of the Cultural
Property Export and Import Act, gifts
of the Succession J.A. DeSčve, Charles
and Andrea Bronfman, Nahum Gelber and
Dr. Sheila Gelber, Phyllis Lambert, the
Volunteer Association and the Junior
Associates of the Montreal Museum
of Fine Arts, Louise L. Lamarre, Pierre
Théberge, the Museum's acquisition
fund; and the Horsley and Annie
Townsend Bequest
(p. 178)

Cat. 75 *Portrait of the Photographer Hugo Erfurth
with Dog*, 1926
Tempera and oil on board,
31 ¹/₂ x 39 ³/₈ in. (80 x 100 cm)
Löffler 1981, no. 1926/14
Museo Thyssen-Bornemisza, Madrid
(p. 181)**

Jean Dubuffet (French, 1901–1985)

Cat. 111 *Paul Léautaud à la chaise canée*, 1946
(Paul Léautaud in a Caned Chair)
Oil and sand on canvas, 51 ¹/₄ x 38 ¹/₈ in.
(130.1 x 96.8 cm)
New Orleans Museum of Art. Bequest
of Victor K. Kiam (77.287)
(p. 244)

Cat. 112 *Bertelé bouquet fleury, Portrait de Parade*,
1947 *(Bertelé as a Blossoming Bouquet.
Sideshow Portrait)*
Oil, plaster, and sand on canvas,
45 ⁹/₁₆ x 35 ³/₁₆ in. (116 x 89 cm)
National Gallery of Art, Washington, D.C.
The Stephen Hahn Family Collection
(Partial and Promised Gift) (1995.29.5)
(p. 245)

James Ensor (Belgian, 1860–1949)

Cat. 5 *My Portrait with Masks*, 1937
Oil on canvas, 12 ¹/₄ x 9 ⁵/₈ in.
(31.1 x 24.5 cm)
Tricot 1992, no. 732
Philadelphia Museum of Art. The Louis
E. Stern Collection, 1963
(p. 57)**

Jacob Epstein (British, 1880–1959)

Cat. 142 *Lucian Freud*, 1949
Bronze, height 15 ³/₄ in. (40 cm)
National Portrait Gallery, London
(p. 284)

Conrad Felixmüller (German, 1897–1977)

Cat. 80 *Portrait of a Young Scottish Woman
(Miss Longmuir)*, 1929
Oil on canvas, 30 ¹/₈ x 21 ¹/₈ in.
(76.5 x 53.7 cm)
Carmen Thyssen-Bornemisza Collection
on loan to the Museo Thyssen-Bornemisza,
Madrid
(p. 187)**

Lucian Freud (British, born 1922)

Cat. 140 *Leaning Head*, 1947
Pencil, 11 ³/₄ x 15 ³/₄ in. (29 x 40 cm)
Anna Gamazo Hohenlohe Collection
(p. 282)*

Cat. 91 *Girl with Roses*, 1947–1948
Oil on canvas, 41 ³/₄ x 29 ³/₄ in.
(106 x 75.6 cm)
British Council, London
(pp. 200–201)

Cat. 141 *Girl with a White Dog*, 1950–1951
Oil on canvas, 30 x 40 in.
(76.2 x 101.6 cm)
Tate, London. Purchased 1952
(p. 283)

Cat. 143 *Man's Head (Self-Portrait)*, 1963
Oil on canvas, 21 x 20 in. (53.3 x 50.8 cm)
The Whitworth Art Gallery, The University
of Manchester
(p. 285)*

Cat. 132 *Reflection with Two Children
(Self-Portrait)*, 1965
Oil on canvas, 35 ⁷/₈ x 35 ⁷/₈ in.
(91 x 91 cm)
Museo Thyssen-Bornemisza, Madrid
(p. 267)

Cat. 131 *Interior with Hand Mirror (Self-Portrait)*,
1967
Oil on canvas, 10 x 7 in. (25.5 x 17.8 cm)
Private collection
(p. 266)

Cat. 145 *Night Portrait*, 1977–1978
Oil on canvas, 28 x 28 in. (71 x 71 cm)
Private collection
(p. 288)*

Cat. 144 *Reflection (Self-Portrait)*, 1981–1982
Oil on canvas, 12 x 10 in. (30.5 x 25.4 cm)
Private collection
(pp. 286–287) *

Cat. 146 *The Painter Is Surprised by a Naked
Admirer*, 2004–2005
Oil on canvas, 64 x 52 in. (162.5 x 132 cm)
Private collection
(pp. 288–289)*

Pablo Gargallo (Spanish, 1881–1934)

Cat. 49 *Mask of Picasso*, 1913
Bronze, 8 7/8 x 8 1/4 x 5 1/2 in.
(22.5 x 21 x 13.8 cm)
Gargallo-Anguera 1998, no. 49a
A. Surroca Collection
(p. 132)

Paul Gauguin (French, 1848–1903)

Cat. 3 *Self-Portrait*, 1885
Oil on canvas, 25 5/8 x 21 3/8 in.
(65.2 x 54.3 cm)
Wildenstein 1964, vol. I, no. 138;
Wildenstein 2001, vol. I, no. 165
Kimbell Art Museum, Fort Worth
(p. 55)

Cat. 43 *Portrait of a Young Woman: Vaïté
(Jeanne) Goupil*, 1896
Oil on canvas, 29 1/2 x 25 5/8 in.
(75 x 65 cm)
Wildenstein 1964, vol. I, no. 535
Ordrupgaard, Copenhagen
(pp. 124–125)*

Richard Gerstl (Austrian, 1883–1908)

Cat. 9 *Self-Portrait against Blue Background*,
1904–1905
Oil on canvas, 62 5/8 x 42 7/8 in.
(159 x 109 cm)
Leopold Museum, Vienna
(p. 68)*

Alberto Giacometti (Swiss, 1901–1966)

Cat. 113 *Bust of Diane Bataille*, 1947
Bronze, 18 3/4 x 4 7/8 x 5 1/4 in.
(47.5 x 12.5 x 13.5 cm)
Collection Fondation Pierre Gianadda,
Martigny, Switzerland
(p. 246)

Cat. 115 *Bust of Diego*, 1954
Painted bronze, 15 1/2 x 13 1/4 x 8 1/4 in.
(39.4 x 33.7 x 21 cm)

Raymond and Patsy Nasher Collection,
Dallas
(p. 248)**

Cat. 114 *Annette in the Studio*, 1961
Oil on canvas, 57 1/2 x 38 1/8 in.
(146 x 97 cm)
Hamburger Kunsthalle, Hamburg.
Permanent loan from the Stiftung
zur Förderung der Hamburgischen
Kunstsammlungen
(p. 247)

Cat. 116 *Portrait of a Woman*, 1965
Oil on canvas, 33 7/8 x 25 5/8 in.
(86 x 65 cm)
Museo Thyssen-Bornemisza, Madrid
(p. 249)

Harold Gilman (British, 1876–1919)

Cat. 37 *Mrs. Mounter*, 1916–1917
Oil on canvas, 36 1/4 x 24 3/8 in.
(92 x 61.8 cm)
National Museums Liverpool,
Walker Art Gallery
(p. 107)**

Albert Gleizes (French, 1881–1953)

Cat. 64 *Eugène Figuière*, 1913
Oil on canvas, 56 1/2 x 40 in.
(143.5 x 101.5 cm)
Varichon 1998, no. 423
Musée des Beaux-Arts de Lyon
(p. 157)

Vincent van Gogh (Dutch, 1853–1890)

Cat. 2 *Self-Portrait*, 1887
Oil on canvas, 15 5/8 x 13 1/4 in.
(39.7 x 33.7 cm)
Faille 1970, no. 268; Hulsker 1996, no. 1299
Wadsworth Atheneum Museum of Art,
Hartford. Gift of Philip L. Goodwin in
memory of his mother, Josephine S.
Goodwin
(p. 54)

Cat. 27 *The Postman Joseph Roulin*, 1888
Oil on canvas, 25 5/8 x 21 1/4 in.
(65 x 54 cm)
Faille 1970, no. 434; Hulsker 1996, no. 1647
Kunstmuseum Winterthur. Presented
by the heirs of Georg Reinhart, 1955
(pp. 94–95)*

Juan Gris (Spanish, 1887–1927)

Cat. 61 *The Smoker (Frank Burty Haviland)*, 1913
Oil on canvas, 28 3/4 x 21 1/4 in.
(73 x 54 cm)
Cooper 1977, no. 51
Museo Thyssen-Bornemisza, Madrid
(p. 154)

Cat. 62 *Seated Woman (Josette Gris)*, 1917
Oil on panel, 45 5/8 x 28 3/4 in.
(116 x 73 cm)
Cooper 1977, no. 223
Carmen Thyssen-Bornemisza
Collection on loan to the Museo
Thyssen-Bornemisza, Madrid
(p. 155)**

George Grosz (German, 1893–1959)

Cat. 79 *Self-Portrait Giving a Warning*, 1927
Oil on canvas, 38 5/8 x 31 1/8 in.
(98 x 79 cm)
Berlinische Galerie, Landesmuseum
für Moderne Kunst, Fotografie und
Architektur, Berlin
(p. 186)

David Hockney (British, born 1937)

Cat. 154 *Portrait Surrounded by Artistic Devices*,
1965
Acrylic on canvas, 60 x 72 in.
(152.5 x 182.9 cm)
Arts Council Collection, Hayward Gallery,
South Bank Centre, London
(pp. 300–301)*

Cat. 155 *Henry and Eugene*, 1977
Acrylic on canvas, 72 x 72 in.
(182.9 x 182.9 cm)
Private collection
(p. 302)

Cat. 156 *Peter Schlesinger with Polaroid Camera*,
1977
Oil on canvas, 60 x 60 in.
(152.4 x 152.4 cm)
Astrup Fearnley Collection, Oslo
(p. 303)

Cat. 157 *Model with Unfinished Self-Portrait*, 1977
Acrylic on canvas, 60 x 60 in.
(152.4 x 152.4 cm)
Private collection
(pp. 304–305)

Alexej von Jawlensky (Russian, 1864–1941)

Cat. 32 *Portrait of a Girl*, 1909
Oil on cardboard, 36 1/4 x 26 3/8 in.
(92 x 67.2 cm)
Jawlensky/Pieroni-Jawlensky 1991–1998,
vol. I, no. 241
Museum kunst palast, Dusseldorf
(p. 101)

Cat. 31 *Child with Doll (Andreas Jawlensky)*, 1910
Oil on board, 24 x 19 7/8 in. (61 x 50.5 cm)
Jawlensky/Pieroni-Jawlensky 1991–1998,
vol. I, no. 324
Thyssen-Bornemisza Collections
(p. 100)

Frida Kahlo (Mexican, 1907–1954)

Cat. 100 *Self-Portrait with Thorn Necklace and Hummingbird*, 1940
Oil on canvas mounted on Masonite, 24 ¹/₂ x 19 in. (62.2 x 48.3 cm)
Harry Ransom Center, The University of Texas at Austin. Nickolas Muray Collection
(pp. 220–221)

Ernst Ludwig Kirchner (German, 1880–1938)

Cat. 33 *Fränzi in Front of a Carved Chair*, 1910
Oil on canvas, 28 x 19 ¹/₂ in. (71 x 49.5 cm)
Gordon 1968, no. 122
Museo Thyssen-Bornemisza, Madrid
(pp. 102–103)

Cat. 34 *Artist: Marcella*, 1910
Oil on canvas, 39 ³/₄ x 29 ⁷/₈ in. (101 x 76 cm)
Gordon 1968, no. 125
Brücke-Museum, Berlin
(p. 104)*

Cat. 35 *Self-Portrait*, 1914
Oil on canvas, 25 ⁵/₈ x 18 ¹/₂ in. (65 x 47 cm)
Gordon 1968, no. 421
Brücke-Museum, Berlin
(p. 105)

Ronald B. Kitaj (American, born 1932)

Cat. 158 *Smyrna Greek (Nikos)*, 1976–1977
Oil on canvas, 96 x 30 in. (243.8 x 76.2 cm)
Museo Thyssen-Bornemisza, Madrid
(p. 306)*

Cat. 159 *The Hispanist (Nissa Torrents)*, 1977–1978
Oil on canvas, 96 ¹/₈ x 30 in. (244.2 x 76.2 cm)
Museo de Bellas Artes de Bilbao
(p. 307)

Gustav Klimt (Austrian, 1862–1918)

Cat. 8 *Ria Munk on Her Deathbed*, 1912
Oil on canvas, 19 ⁷/₈ x 19 ⁷/₈ in. (50 x 50.5 cm)
Novotny/Dobai 1967, no. 170
Private collection. Courtesy of Richard Nagy Ltd., London
(pp. 66–67)

Oskar Kokoschka (Austrian, 1886–1980)

Cat. 15 *Lotte Franzos*, 1909
Oil on canvas, 45 ¹/₄ x 31 ¹/₄ in. (114.9 x 79.4 cm)
Winkler/Erling 1995, no. 34

The Phillips Collection, Washington, D.C.
(pp. 74–75)**

Cat. 16 *Martha Hirsch*, 1909
Oil on canvas, 35 ³/₈ x 28 in. (90 x 71 cm)
Winkler/Erling 1995, no. 23
Private collection. Courtesy Neue Galerie, New York
(p. 76)

Cat. 17 *Victoire de Montesquiou-Fezensac*, 1910
Oil on canvas, 37 ¹/₄ x 19 ¹/₄ in. (94.6 x 48.9 cm)
Winkler/Erling 1995, no. 42
Cincinnati Art Museum. Bequest of Paul E. Geier
(p. 77)

Cat. 18 *Max Schmidt*, 1914
Oil on canvas, 35 ³/₈ x 22 ⁵/₈ in. (90 x 57.5 cm)
Winkler/Erling 1995, no. 102
Museo Thyssen-Bornemisza, Madrid
(p. 78)**

Cat. 19 *Nell Walden*, 1916
Oil on canvas, 39 ³/₈ x 31 ¹/₂ in. (100 x 80 cm)
Winkler/Erling 1995, no. 122
Private collection. On deposit at the Berlinische Galerie, Landesmuseum für Moderne Kunst, Fotografie und Architektur, Berlin
(p. 79)*

Cat. 20 *Knight Errant*, 1915
Oil on canvas, 35 ¹/₄ x 70 ⁷/₈ in. (89.5 x 180 cm)
Winkler/Erling 1995, no. 115
Solomon R. Guggenheim Museum, New York (48.1172.380)
(pp. 80–81)

Cat. 21 *Self-Portrait*, 1917
Oil on canvas, 31 ¹/₈ x 24 ³/₄ in. (79 x 63 cm)
Winkler/Erling 1995, no. 125
Von der Heydt-Museum, Wuppertal, Germany
(p. 82)*

Cat. 22 *Karl Kraus*, 1925
Oil on canvas, 25 ⁵/₈ x 39 ³/₄ in. (65 x 100 cm)
Winkler/Erling 1995, no. 185
Museum Moderner Kunst Stiftung Ludwig Wien, Vienna
(p. 83)

Käthe Kollwitz (German, 1867–1945)

Cat. 101 *The Lament (Self-Portrait)*, 1938–1940
Bronze, 10 ¹/₄ x 10 ¹/₄ x 4 in. (26 x 26 x 10 cm)
Käthe Kollwitz Museum Köln, Cologne. Kreissparkasse Köln
(p. 222)

Leon Kossoff (British, born 1926)

Cat. 136 *Head of Seedo*, 1959
Oil on board, 30 ³/₈ x 22 ⁷/₈ in. (77 x 58 cm)
Private collection
(p. 271)

Cat. 137 *Portrait of Philip II*, 1962
Oil on panel, 56 ¹/₂ x 30 ¹/₂ in. (143.5 x 77.6 cm)
Private collection
(p. 272)

Cat. 138 *Portrait of John Lessore*, 1993
Oil on board, 55 x 37 ¹/₂ in. (139.7 x 95.3 cm)
Courtesy of the artist and the LA Louver Gallery, Venice, California
(p. 273)*

Jacques Lipchitz (French, 1891–1973)

Cat. 70 *Raymond Radiguet*, 1920
Plaster, 12 ¹/₄ x 7 ⁷/₈ x 9 in. (31 x 20 x 23 cm)
Wilkinson 1996, vol. I, no. 117
IVAM. Institut Valencià d'Art Modern, Generalitat Valenciana, Valencia. Donation: Jacques and Yulla Lipchitz Foundation, Inc.
(p. 176)

Antonio López (Spanish, born 1936)

Cat. 147 *Self-Portrait*, 1967
Pencil, watercolor, charcoal, and wax, 14 ¹/₈ x 12 ³/₄ in. (36 x 32.5 cm)
Marqués de la Romana Collection
(p. 290)*

Cat. 149 *José María*, 1981
Pencil, 80 ³/₈ x 40 ¹/₈ in. (204 x 102 cm)
Museo de Bellas Artes de Bilbao
(pp. 292–293)*

Cat. 150 *Manuel*, 1985
Pencil, 72 ⁷/₈ x 36 ¹/₄ in. (185 x 92 cm)
Museo Nacional Centro de Arte Reina Sofía, Madrid
(pp. 292–293)*

Cat. 151 *Man*, 2003
Bronze, 77 ¹/₂ x 23 ⁵/₈ x 15 in. (197 x 60 x 38 cm)
Grupo Urvasco
(p. 293)*

René Magritte (Belgian, 1898–1967)

Cat. 97 *The Portrait*, 1935
Oil on canvas, 28 ⁷/₈ x 19 ³/₄ in. (73.3 x 50.2 cm)
Sylvester/Whitfield 1992–, vol. II, no. 379
The Museum of Modern Art, New York. Gift of Kay Sage Tanguy (574.1956)
(pp. 216–217)**

Henri Matisse (French, 1869–1954)

Cat. 29 *The Girl with Green Eyes*, 1908
Oil on canvas, 26 x 20 in. (66 x 50.8 cm)
San Francisco Museum of Modern Art.
Bequest of Harriet Lane Levy
(p. 97)

Cat. 30 *Olga Merson*, 1911
Oil on canvas, 39 1/4 x 31 3/4 in.
(99.7 x 80.7 cm)
The Museum of Fine Arts, Houston.
Museum purchase with funds provided by
the Agnes Cullen Arnold Endowment
Fund
(pp. 98–99)**

Cat. 51 *Yvonne Landsberg*, 1914
Oil on canvas, 58 x 38 3/8 in.
(147.3 x 97.5 cm)
Philadelphia Museum of Art. The Louise
and Walter Arensberg Collection, 1950
(pp. 134–135)

Cat. 52 *Self-Portrait*, 1918
Oil on canvas, 25 5/8 x 21 1/4 in.
(65 x 54 cm)
Musée Départemental Matisse,
Le Cateau-Cambrésis, France
(pp. 136–137)

Joan Miró (Spanish, 1893–1983)

Cat. 38 *Heriberto Casany*, 1918
Oil on canvas, 27 5/8 x 24 3/8 in.
(70.2 x 62 cm)
Dupin/Lelong-Mainaud 1999–2003,
vol. I, no. 49
Kimbell Art Museum, Fort Worth
(p. 108)

Cat. 39 *Self-Portrait*, 1919
Oil on canvas, 28 3/4 x 23 5/8 in.
(73 x 60 cm)
Dupin/Lelong-Mainaud 1999–2003,
vol. I, no. 72
Musée Picasso, Paris
(p. 109)**

Cat. 94 *Painting (Portrait and Shadow)*, 1926
Oil on canvas, 31 7/8 x 39 3/8 in.
(81 x 100 cm)
Dupin/Lelong-Mainaud 1999–2003,
vol. I, no. 215
Chrisalis Trustees (Guernsey) Limited
as Trustee of the Magic Trust
(p. 213)

Cat. 96 *Portrait II*, 1938
Oil on canvas, 63 3/4 x 51 1/8 in.
(162 x 130 cm)
Dupin/Lelong-Mainaud 1999–2003,
vol. II, no. 585
Museo Nacional Centro de Arte Reina
Sofía, Madrid
(p. 215)

Cat. 95 *Self-Portrait*, 1960 (on an autograph
copy of *Self-Portrait I*, 1937–1938)
Pencil and oil on canvas, 57 1/2 x 38 1/8 in.
(146 x 97 cm)
Dupin/Lelong-Mainaud 1999–2003,
vol. IV, no. 1080
E. Fernández Miró Collection
(p. 214)*

Paula Modersohn-Becker (German, 1876–1907)

Cat. 45 *Self-Portrait with Amber Necklace*,
c. 1905
Oil on canvas, 13 5/8 x 10 3/4 in.
(34.5 x 27.3 cm)
Busch/Werner 1998, no. 535
Paula Modersohn-Becker Stiftung,
Bremen
(p. 127)

Cat. 44 *Rainer Maria Rilke*, 1906
Oil on cardboard laid on wood,
12 3/4 x 10 in. (32.3 x 25.4 cm)
Busch/Werner 1998, no. 643
Private collection. On loan to the Paula
Modersohn-Becker Stiftung, Bremen
(p. 126)

Amedeo Modigliani (Italian, 1884–1920)

Cat. 54 *Antonia*, c. 1915
Oil on canvas, 32 1/4 x 18 1/8 in.
(82 x 46 cm)
Lanthemann 1970, no. 75, Parisot 1990–,
vol. II, no. 7/1915
Musée de l'Orangerie, Paris. Jean Walter
and Paul Guillaume Collection
(p. 139)

Cat. 53 *Max Jacob*, 1916
Oil on canvas, 28 3/4 x 23 5/8 in.
(73 x 60 cm)
Lanthemann 1970, no. 67, Parisot 1990–,
vol. II, no. 5/1916
Kunstsammlung Nordrhein-Westfalen,
Dusseldorf
(p. 138)

Cat. 55 *Portrait of a Young Woman*, 1918–1919
Oil on canvas, 24 x 18 in. (61 x 45.8 cm)
Lanthemann 1970, no. 263
New Orleans Museum of Art. Gift
of Marjorie Fry Davis and Walter Davis, Jr.
through the Davis Family Fund, 92.68
(p. 140)

Edvard Munch (Norwegian, 1863–1944)

Cat. 4 *Self-Portrait: The Night Wanderer*,
1923–1924
Oil on canvas, 35 1/4 x 26 5/8 in.
(89.5 x 67.5 cm)
Munch Museum, Oslo
(p. 56)*

Felix Nussbaum (German, 1904–1944)

Cat. 103 *Self-Portrait in a Shroud (Group Portrait)*,
1942
Oil on canvas, 19 5/8 x 31 1/2 in.
(50 x 80.5 cm)
Berlinische Galerie, Landesmuseum
für Moderne Kunst, Fotografie und
Architektur, Berlin
(p. 224)

Cat. 104 *Self-Portrait with Jewish Identity Card*, 1943
Oil on canvas, 22 x 19 1/4 in. (56 x 49 cm)
Felix-Nussbaum-Haus Osnabrück
mit der Sammlung der
Niedersächsischen Sparkassenstiftung,
Osnabrück, Germany
(p. 225)

Pablo Picasso (Spanish, 1881–1973)

Cat. 7 *Self-Portrait with Wig*, c. 1897
Oil on canvas, 22 x 16 7/8 in. (55.8 x 43 cm)
Zervos 1932–1978, vol. I, no. 48;
Palau 1980, no. 149
Museu Picasso, Barcelona
(p. 59)*

Cat. 48 *Nude Combing Her Hair (Fernande)*, 1906
Oil on canvas, 41 1/2 x 32 in.
(105.4 x 81.3 cm)
Zervos 1932–1978, vol. I, no. 344
Kimbell Art Museum, Fort Worth
(p. 131)

Cat. 47 *Mask of a Woman*, 1908
Bronze, 7 1/8 x 6 1/4 x 4 3/4 in.
(18 x 16 x 12 cm)
Spies 1983, no. 22 II
A. Surroca Collection
(p. 130)

Cat. 57 *Head of a Woman (Fernande)*, 1909
Oil on canvas, 25 5/8 x 21 5/8 in.
(65 x 55 cm)
Zervos 1932–1978, vol. II A, no. 169;
Daix 1979, no. 294
Städel Museum, Frankfurt. Property of
the Städelscher Museums-Verein e.V.
(pp. 148–149)*

Cat. 58 *Head of a Woman (Fernande)*, 1909
Plaster, 18 1/2 x 14 1/8 x 13 3/4 in.
(47 x 35.9 x 34.9 cm)
Spies 1983, no. 24 I
Raymond and Patsy Nasher Collection,
Dallas
(pp. 150–151)**

Cat. 60 *Man with a Pipe*, 1911
Oil on canvas, 35 3/4 x 27 7/8 in.
(90.7 x 71 cm)
Zervos 1932–1978, vol. II B, no. 738;
Daix 1979, no. 422
Kimbell Art Museum, Fort Worth
(p. 153)

Cat. 67 *Olga Khokhlova*, 1917
Oil on canvas, 47 ¹/₄ x 29 ¹/₂ in.
(120 x 75 cm)
Zervos 1932–1978, vol. VI, no. 1335
Private collection. Courtesy of Galerie
Jan Krugier & Cie., Geneva
(pp. 172–173)*

Cat. 68 *Olga with a Fur Collar*, 1923
Oil on canvas, 45 ⁵/₈ x 31 ⁵/₈ in.
(116 x 80.5 cm)
Musée Picasso, Paris. On deposit
at the Musée des Beaux-Arts, Lille
(p. 174)

Cat. 69 *Portrait of the Artist's Wife (Olga)*, 1923
Oil on canvas, 51 x 38 ¹/₄ in.
(129.5 x 97 cm)
Zervos 1932–1978, vol. V, no. 53
Private collection, London
(p. 175)

Cat. 71 *Harlequin with a Mirror*, 1923
Oil on canvas, 39 ³/₈ x 31 ⁷/₈ in.
(100 x 81 cm)
Zervos 1932–1978, vol. V, no. 142
Museo Thyssen-Bornemisza, Madrid
(p. 177)

Cat. 93 *Figure and Profile*, 1928
Oil on canvas, 28 ³/₈ x 23 ⁵/₈ in.
(72 x 60 cm)
Zervos 1932–1978, vol. VII, no. 129
Musée Picasso, Paris
(p. 212)

Cat. 105 *Dora Maar Seated*, 1938
Mixed media on paper laid on canvas,
27 ¹/₈ x 24 ⁵/₈ in. (68.9 x 62.5 cm)
Zervos 1932–1978, vol. IX, no. 152
Tate, London. Purchased 1960
(pp. 236–237)

Cat. 106 *Bust of a Woman*, 1939
Oil on canvas, 31 ⁷/₈ x 25 ⁵/₈ in.
(81 x 65 cm)
Zervos 1932–1978, vol. IX, no. 371
Museo Picasso, Málaga
(p. 238)

Cat. 107 *Bust of a Woman with Hat (Dora)*, 1939
Oil on canvas, 21 ⁵/₈ x 18 ¹/₄ in.
(55 x 46.5 cm)
Fondation Beyeler, Riehen/Basel,
Switzerland
(p. 239)

Cat. 56 *Nusch Eluard*, 1941
Oil on canvas, 28 ³/₄ x 23 ⁵/₈ in.
(73 x 60 cm)
Zervos 1932–1978, vol. XI, no. 274
Centre Pompidou, Paris.
Musée national d'art moderne/
Centre de création industrielle.
On deposit at the Musée Picasso,
Paris (12–9–1985).
Gift of Paul Eluard, 1947
(p. 141)

Cat. 108 *Woman in Blue Seated in an Armchair
(Françoise)*, 1949
Oil on canvas, 45 ¹/₂ x 35 in.
(116 x 89 cm)
Zervos 1932–1978, vol. XV, no. 141
Private collection, New York
(pp. 240–241)

Cat. 109 *Head of a Woman (Françoise)*, 1951
Bronze, 21 ¹/₄ x 13 ³/₄ x 7 ¹/₂ in.
(54 x 35 x 19 cm)
Spies 1983, no. 411 II
Private collection, New York
(p. 242)

Cat. 110 *Head of a Woman (Jacqueline)*, 1957
Painted steel, 30 ⁵/₁₆ x 13 ³/₄ x 10 ¹/₈ in.
(77.2 x 34.9 x 25.7 cm)
Spies 1983, no. 492
Raymond and Patsy Nasher Collection,
Dallas
(p. 243)

Diego Rivera (Mexican, 1886–1957)

Cat. 65 *Ramón Gómez de la Serna*, 1915
Oil on canvas, 43 ¹/₈ x 35 ¹/₂ in.
(109.6 x 90.2 cm)
Rivera 1989, no. 146
Malba-Collection Costantini, Buenos Aires
(p. 158)*

Henri Rousseau (French, 1844–1910)

Cat. 46 *Portrait of Monsieur X (Pierre Loti)*, 1906
Oil on canvas, 24 x 19 ⁵/₈ in. (61 x 50 cm)
Certigny 1984, no. 233
Kunsthaus Zürich
(pp. 128–129)

Antonio Saura (Spanish, 1930–1998)

Cat. 117 *Brigitte Bardot*, 1957
Ink on cardboard, 25 x 19 ¹/₈ in.
(63.5 x 48.5 cm)
Art Collection Caja Madrid
(p. 250)*

Cat. 118 *Mirta*, 1959
Oil on canvas, 76 ³/₄ x 38 ¹/₈ in.
(195 x 97 cm)
Art Collection Caja Madrid
(p. 251)*

Cat. 119 *Self-Portrait*, 1960
Oil on canvas, 23 ⁵/₈ x 28 ³/₄ in.
(60 x 73 cm)
Private collection
(p. 252)

Cat. 120 *Portrait 5c (Self-Portrait)*, 1962
Oil on canvas, 23 ⁵/₈ x 28 ³/₄ in.
(60 x 73 cm)
Private collection
(p. 252)*

Cat. 123 *Dora Maar 20.5.85*, 1985
Oil on canvas, 76 ³/₄ x 62 ⁵/₈ in.
(195 x 159 cm)
Private collection
(pp. 254–255)*

Cat. 121 *Self-Portrait*, 1986
Oil on canvas, 23 ⁵/₈ x 28 ³/₄ in.
(60 x 73 cm)
Private collection
(p. 253)*

Cat. 122 *Self-Portrait 2/90*, 1990
Oil on canvas, 23 ⁵/₈ x 28 ³/₄ in.
(60 x 73 cm)
Private collection
(p. 253)*

Christian Schad (German, 1894–1982)

Cat. 77 *Portrait of Josef Matthias Hauer*, 1927
Oil on board, 24 x 19 ⁵/₈ in.
(61 x 50 cm)
Private collection. Courtesy MaxmArt,
Mendrisio, Switzerland
(p. 184)*

Cat. 78 *Portrait of Dr. Haustein*, 1928
Oil on canvas, 31 ⁵/₈ x 21 ⁵/₈ in.
(80.5 x 55 cm)
Museo Thyssen-Bornemisza, Madrid
(p. 185)

Egon Schiele (Austrian, 1890–1918)

Cat. 10 *The Poet*, 1911
Oil on canvas, 31 ¹/₂ x 31 ¹/₂ in.
(80.5 x 80 cm)
Kallir 1990, no. 192
Leopold Museum, Vienna
(p. 69)*

Cat. 11 *Self-Portrait with Lowered Head*, 1912
Oil on board, 16 ⁵/₈ x 13 ¹/₄ in.
(42.2 x 33.7 cm)
Kallir 1990, no. 228
Leopold Museum, Vienna
(p. 70)*

Cat. 12 *Self-Portrait with Chinese Lantern
Plant*, 1912
Oil and gouache on board,
12 ³/₄ x 15 ⁷/₈ in.
(32.4 x 40.2 cm)
Kallir 1990, no. 233
Leopold Museum, Vienna
(p. 71)*

Cat. 13 *Edith Schiele, Seated*, 1915
Pencil, watercolor, and gouache,
20 x 15 ⁷/₈ in.
(50.8 x 40.2 cm)
Kallir 1990, no. 1717
Leopold Museum, Vienna
(p. 72)*

Cat. 14 *Edith Schiele, Standing*, 1915
Oil on canvas, 71 x 43 ³/₈ in.
(180.2 x 110.1 cm)
Kallir 1990, no. 290
Gemeentemuseum, The Hague
(p. 73)**

Gino Severini (Italian, 1883–1966)

Cat. 87 *The Painter's Family*, 1936
Oil on canvas, 68 ¹/₂ x 46 ¹/₂ in.
(174 x 118 cm)
Fonti 1988, no. 572
Musée des Beaux-Arts de Lyon
(p. 196)**

Cat. 63 *Self-Portrait*, 1960
(replica of a work of 1912)
Oil on canvas, 21 ⁵/₈ x 18 ¹/₄ in.
(55 x 46.3 cm)
Fonti 1988, no. 103B
Centre Pompidou, Paris.
Musée national d'art moderne/
Centre de création industrielle.
Gift of Mme Severini and her daughters,
1967
(p. 156)

Walter Sickert (British, 1860–1942)

Cat. 86 *William Maxwell Aitken, 1st Baron
Beaverbrook*, 1935
Oil on canvas, 69 ³/₈ x 42 ⁷/₄ in.
(176.2 x 107.3 cm)
National Portrait Gallery, London
(pp. 194–195)

Chaïm Soutine (Russian [Belarus], 1893–1943)

Cat. 24 *Portrait of a Man with a Felt Hat*,
c. 1921–1922
Oil on canvas, 36 x 28 in. (91.4 x 71.1 cm)
Tuchman/Dunow/Perls 1993, no. 52
Private collection, U.S.A.
(p. 85)

Cat. 25 *Woman in Red*, c. 1923–1924
Oil on canvas, 36 x 25 in.
(91.4 x 63.5 cm)
Tuchman/Dunow/Perls 1993, no. 66
Private collection
(p. 86)

Cat. 26 *Madeleine Castaing*, c. 1929
Oil on canvas, 39 ³/₈ x 28 ⁷/₈ in.

(100 x 73.3 cm)
Tuchman/Dunow/Perls 1993, no. 138
The Metropolitan Museum of Art,
New York. Bequest of Miss Adelaide
Milton de Groot (1876–1967), 1967
(67.187.107)
(p. 87)

Stanley Spencer (British, 1891–1959)

Cat. 89 *Portrait in a Garden (Patricia Preece)*,
1936
Oil on canvas, 30 x 20 in.
(76.2 x 50.8 cm)
Bell 1999, no. 187
Private collection. Courtesy of Ivor Braka
Limited
(p. 198)

Cat. 139 *Self-Portrait with Patricia Preece*, 1937
Oil on canvas, 24 x 35 ¹/₈ in.
(61 x 91.2 cm)
Bell 1999, no. 223
The Syndics of the Fitzwilliam Museum,
Cambridge
(pp. 280–281)

Cat. 90 *Daphne Spencer*, 1951
Oil on canvas, 36 ³/₈ x 24 ¹/₄ in.
(92.3 x 61.6 cm)
Bell 1999, no. 370
Ulster Museum, National Museums
and Galleries of Northern Ireland, Belfast
(p. 199)

Graham Vivian Sutherland (British, 1903–1980)

Cat. 124 *William Maxwell Aitken, 1st Baron
Beaverbrook*, 1951
Oil over conté crayon on canvas,
68 ⁵/₈ x 36 ³/₄ in. (174.3 x 93.4 cm)
Beaverbrook Art Gallery, Fredericton,
New Brunswick, Canada. Bequest
of The Dowager Lady Beaverbrook
(pp. 256–257)

Charley Toorop (Dutch, 1891–1955)

Cat. 102 *Three Generations*, 1941–1950
Oil on canvas, 78 ³/₄ x 47 ⁵/₈ in.
(200 x 121 cm)
Museum Boijmans Van Beuningen,
Rotterdam
(p. 223)

Maurice de Vlaminck (French, 1876–1958)

Cat. 28 *André Derain*, 1906
Oil on cardboard, 10 ⁵/₈ x 8 ³/₄ in.
(27 x 22.2 cm)
The Metropolitan Museum of Art,
New York. Jacques and Natasha Gelman
Collection, 1998 (1999.363.83)
(p. 96)

Andy Warhol (American, 1928–1987)

Cat. 160 *Self-Portrait*, 1967
Screenprint on silver-coated paper,
22 x 20 ⁷/₈ in. (56 x 53 cm)
Wilhelm-Hack-Museum, Ludwigshafen,
Germany
(pp. 308–309)*

Cat. 161 *The Shadow*, 1981
Screenprint, 38 x 38 in.
(96.5 x 96.5 cm)
Courtesy Ronald Feldman Fine Arts,
New York
(p. 310)*

Cat. 162 *The Shadow*, 1981
Screenprint, 38 x 38 in. (96.5 x 96.5 cm)
Courtesy Ronald Feldman Fine Arts,
New York
(p. 311)*

Cat. 163 *Shadow with Glasses*, 1981
Screenprint, 38 x 38 in.
(96.5 x 96.5 cm)
Courtesy Ronald Feldman Fine Arts,
New York
(p. 312)*

Cat. 164 *Shadow with Glasses*, 1981
Screenprint, 38 x 38 in. (96.5 x 96.5 cm)
Courtesy Ronald Feldman Fine Arts,
New York
(p. 313)*

Cat. 165 *The Shadow*, 1981
Charcoal, 31 ¹/₂ x 23 ¹/₂ in. (80 x 59.7 cm)
Courtesy of Paul Kasmin Gallery,
New York
(p. 314)*

Cat. 166 *Self-Portrait*, 1986
Synthetic polymer paint and silkscreen ink
on canvas, 22 x 22 in.
(55.9 x 55.9 cm)
Courtesy Van de Weghe Fine Art,
New York
(p. 315)*

BIBLIOGRAPHY

Artaud 1947
Antonin Artaud. *Van Gogh: Le Suicideé de la société.* Paris: K éditeur, 1947.

Baltimore/Houston/Cleveland 1999–2000
Sona Johnston. *Faces of Impressionism: Portraits from American Collectors.* (Exh. cat. The Baltimore Museum of Art; The Museum of Fine Arts, Houston; The Cleveland Museum of Art, 1999–2000.) Baltimore: The Baltimore Museum of Art; New York: Rizzoli International Publications, 1999.

Bahr 1916
Hermann Bahr. *Expressionismus.* Munich, 1916.

Barcelona 1993
Rosa Maria Malet, ed. *Joan Miró: 1893–1993.* (Exh. cat.) Barcelona: Fundación Joan Miró, 1993.

Barcelona 1995
Dalí: Els anys joves (1918–1930). (Exh. cat. Palau Robert, Barcelona.) Barcelona: Generalitat de Catalunya, 1995.

Barkan/Bush 1995
Elazar Barkan and Ronald Bush, eds. *Prehistories of the Future: The Primitivist Project and the Culture of Modernism.* Stanford: Stanford University Press, 1995.

Barr 1951
Alfred H. Barr. *Matisse: His Art and His Public.* New York: Museum of Modern Art, 1951.

Barthes 1981
Roland Barthes. *Camera Lucida: Reflections on Photography.* New York: Hill and Wang, 1981.

Barthes 1985
Roland Barthes. *The Responsibility of Forms.* New York: Hill and Wang, 1985.

Basel 1999
Face to Face to Cyberspace. (Exh. cat.) Basel: Fondation Beyeler, 1999.

Basel 2005
Anne Baldassari. *Picasso surréaliste.* (Exh. cat. Fondation Beyeler, Basel.) Paris: Flammarion, 2005.

Bell 1999
Keith Bell. *Stanley Spencer.* London: Phaidon, 1999.

Belloli 1999
Lucy Belloli. "The Evolution of Picasso's Portrait of Gertrude Stein." *The Burlington Magazine* 141, no. 1150 (January 1999): 12–18.

Benjamin 1978
Walter Benjamin. "The Work of Art in the Age of Mechanical Reproduction." In *Illuminations.* New York: Schocken, 1978, pp. 217–251.

Berend-Corinth 1958
Charlotte Berend-Corinth. *Die Gemälde von Lovis Corinth: Werkkatalog.* Röthel: Hans Konrad; Munich: F. Bruckmann, 1958.

Berenson 1948
Bernard Berenson. *Aesthetics and History in the Visual Arts.* New York: Pantheon, 1948.

Berger 1969
John Berger. "The Changing View of Man in the Portrait." In *The Moment of Cubism and Other Essays.* New York: Pantheon-Random, 1969.

Berger 1994
Harry Berger Jr. "Fictions of the Pose, Facing the Gaze of Early Modern Portraiture." *Representations,* no. 46 (Spring 1994): 87–120.

Berlin 1997
Christos M. Joachimides and Norman Rosenthal, eds. *The Age of Modernism: Art in the 20th Century.* (Exh. cat. Martin Gropius-Bau, Berlin, 1997.) Berlin and New York, 1997.

Bilbao 2004
Kitaj, retrato de un hispanista. (Exh. cat.) Bilbao: Museo de Bellas Artes de Bilbao, 2004.

Birmingham (Ala.) 1988
Heather McPherson. *Fin-de-Siècle Faces: Portraiture in the Age of Proust.* (Exh. cat.) Birmingham, Ala.: Visual Arts Gallery, University of Alabama, 1988.

Bois 1990
Yve-Alain Bois. *Painting as Model.* Cambridge, Mass.: MIT Press, 1990.

Bonafoux 1985
Pascal Bonafoux. *Portraits of the Artist: The Self-Portrait in Painting.* New York: Skira-Rizzoli, 1985.

Bonafoux 1992
Pascal Bonafoux. *Van Gogh, le soleil en face.* Paris: Gallimard, 1992.

Bonafoux 1995
Pascal Bonafoux. *Cézanne: Portrait.* Paris: Hazan, 1995.

Borràs 1985
María Luisa Borràs. *Picabia.* New York: Rizzoli, 1985.

Boston/Los Angeles/London 2006–2007
Sarah Howgate and Barbara Stern Shapiro. *David Hockney Portraits.* (Exh. cat. Museum of Fine Arts, Boston; Los Angeles County Museum of Art; National Portrait Gallery, London.) London: National Portrait Gallery, 2006.

Bozal 1987
Valeriano Bozal. *Mimesis, las imágenes y las cosas.* Madrid: Visor, 1987.

Brassaï 1997
Brassaï. *Conversations avec Picasso.* Paris: Gallimard, 1997.

Brilliant 1987
Richard Brilliant, ed. "Portraits: The Limitations of Likeness." *Art Journal* (special issue), no. 46 (Autumn 1987).

Brilliant 1991
Richard Brilliant. *Portraiture.* Cambridge, Mass.: Harvard University Press; London: Reaktion Books, 1991.

Bristow 2005
Joseph Bristow, ed. *The Complete Works of Oscar Wilde.* Oxford, 2005.

Brooks 1995
Linda Marie Brooks, ed. *Alternative Identities: The Self in Literature, History, Theory.* New York and London: Garland, 1995.

Bruni 1971–1987
Claudio Bruni. *Catalogo generale Giorgio De Chirico.* 8 vols. Milan: Electa, 1971.

Buffalo/Fort Worth/Los Angeles 2002–2003
Kenneth Wayne. *Modigliani and the Artists of Montparnasse.* (Exh. cat. Albright-Knox Art Gallery, Buffalo; Kimbell Art Museum, Fort Worth; Los Angeles County Museum of Art.) New York and London: Harry N. Abrams; Buffalo: Albright-Knox Art Gallery, 2002.

Busch/Reinken 1990
Günter Busch and Lisselotte von Reinken. *Paula Modersohn-Becker, the Letters and Journals.* Evanston, Ill.: Northwestern University Press, 1990.

Busch/Werner 1998
Günter Busch and Wolfgang Werner. *Paula Modersohn-Becker 1876-1907: Werkverzeichnis der Gemälde.* Munich: Hirmer Verlag, 1998.

Calvo Serraller 2005
Francisco Calvo Serraller. *Los géneros de la pintura.* Madrid: Taurus, 2005.

Carrier 1996
David Carrier. "Poussin's Cartesian Meditations, Self and Other in the Self Portraits of Poussin and Matisse." *Source,* no. 15 (Spring 1996): 28–35.

Cars 2003
Laurence des Cars. "Between Tradition and Transgression: Vuillard and Modern Portrait Painting." *The Musée d'Orsay Review,* no. 17 (Autumn 2003).

Caws 2000a
Mary Ann Caws. *Picasso's Weeping Woman: The Life and Art of Dora Maar.* Boston: Little Brown, 2000.

Caws 2000b
Mary Ann Caws. *Dora Maar with and without Picasso: A Biography*. London: Thames and Hudson, 2000.

Certigny 1984
Henry Certigny. *Le Douanier Rousseau en son temps: Biographie et catalogue raisonné*. Tokyo: Bunkazai Kenkyujyo, 1984.

Clair 1996
Jean Clair. *Eloge du visible: Fondements imaginaires de la science*. Paris: Gallimard, 1996.

Clair 2005
Jean Clair. *Une Leçon d'abîme: Neuf approches de Picasso*. Paris: Gallimard, 2005.

Cleveland 1963
Rémy G. Saisselin. *Style, Truth and the Portrait*. (Exh. cat.) Cleveland: The Cleveland Museum of Art, 1963.

Cocteau 1926
Jean Cocteau. *Le Rappel à l'ordre 1918–1926*. Paris: Librairie Stock, 1926.

Comini 1974
Alessandra Comini. *Egon Schiele Portraits*. Berkeley: University of California Press, 1974.

Cooper 1977
Douglas Cooper. *Juan Gris: Catalogue raisonné de l'œuvre peint*. Paris: Berggruen éditeur, 1977.

Copenhagen/Fort Worth 2005–2006
Richard R. Brettell and Anne-Birgitte Fonsmark. *Gauguin and Impressionism*. (Exh. cat. Copenhagen: Odrupgaard; Fort Worth: Kimbell Art Museum, 2005–2006.) Kimbell Art Museum, Fort Worth; New Haven and London: Yale University Press, 2005.

Cowling 2002
Elizabeth Cowling. *Picasso: Style and Meaning*. New York: Phaidon, 2002.

Crego 2004
Charo Crego. *Geografía de una península: La representación del rostro en la pintura*. Madrid: Abada, 2004.

Chicago/Amsterdam 2001–2002
Douglas W. Druick and Peter Kort Zegers. *Van Gogh and Gauguin: The Studio of the South*. (Exh. cat. Art Institute of Chicago; Van Gogh Museum, 2001–2002). London and New York: Thames and Hudson, 2001.

Daix 1977
Pierre Daix. *La Vie de peintre de Pablo Picasso*. Paris: Seuil, 1977.

Daix 1987
Pierre Daix. *Picasso Créateur*. Paris: Editions Seuil, 1987.

Daix 1990
Pierre Daix. *Picasso*. Paris: Editions du Chêne, 1990.

Daix 1994
Pierre Daix. *Picasso: Life and Art*. London: Thames and Hudson, 1994.

Daix 1995
Pierre Daix. *Dictionnaire Picasso*. Paris: Éditions Robert Laffont, 1995.

Daix/Rosselet 1979
Pierre Daix and Joan Rosselet. *Le Cubisme de Picasso: Catalogue raisonné de l'œuvre peint 1907–1916*. Neuchâtel: Ides et Calendes, 1979.

Dalí 1942
Salvador Dalí. *The Secret Life of Salvador Dalí*. New York: Dial Press, 1942.

Dalí 2005
Salvador Dalí. *Lettres à Picasso*. Edited by Laurence Madeline. Paris: Gallimard, 2005.

Dean 1992
Caroline Dean. *The Self and Its Pleasures: Bataille, Lacan, and the History of Decentered Subject*. Ithaca and London: Cornell University Press, 1992.

Descharnes 1989
Robert Descharnes. *Dalí: La obra y el hombre*. Barcelona: Tusquets Editores, 1989.

Descharnes/Néret 1993
Robert Descharnes and Gilles Néret. *Salvador Dalí 1904–1989: L'Œuvre peint*. Cologne: Benedikt Taschen, 1993.

Detroit/Philadelphia/Boston 2000
Van Gogh Face to Face: The Portraits. (Exh. cat. The Detroit Institute of Arts; Museum of Fine Arts, Boston.) London: Thames and Hudson, 2000.

Doran 2001
Michael Doran, ed. *Conversations with Cézanne*. Berkeley and London: University of California Press, 2001.

Duncan 1996
David Douglas Duncan. *Picasso Paints a Portrait*. New York: Harry N. Abrams, 1996.

Dupin/Lelong-Mainaud 1999–2003
Jacques Dupin and Ariane Lelong-Mainaud. *Joan Miró: Catalogue raisonné, Paintings*. Paris: Daniel Lelong and Sucessió Miró, 1999–2003.

Eckhardt 1956
W. Eckhardt. *Van Gogh und Deutschland*. Heidelberg, 1956.

Edson 2005
Gary Edson. *Masks and Masking: Faces of Tradition and Belief Worldwide*. Jefferson, N.C., and London: McFarland, 2005.

Ensor 1944
Les escrits de James Ensor. Brussels, 1944.

Essen 2004–2005
Felix A. Baumann, Walter Feilchenfeldt, and Hubertus Gassner. *Cézanne and the Dawn of Modern Art*. (Exh. cat. Museum Folkwang, Essen, 2004–2005.) Ostfildern: Hatje Cantz, 2004.

Faille 1970
J.-B. de la Faille. *The Works of Vincent van Gogh: His Paintings and Drawings*. Amsterdam: Meulenhoff International, 1970.

Feilchenfeldt 1988
W. Feilchenfeldt. *Vincent van Gogh and Paul Cassirer Berlin: The Reception of Van Gogh in Germany from 1901 to 1914*. Amsterdam: Zwolle, 1988.

FitzGerald 1995
Michael C. FitzGerald. *Making Modernism: Picasso and the Creation of the Market for Twentieth-Century Art*. New York: Farrar, Straus, and Giroux, 1995.

Florence 1983
Renato Barilli. *Severini*. (Exh. cat. Palazzo Pitti, Florence.) Milan: Electa, 1983.

Fonti 1988
Daniela Fonti. *Gino Severini: Catalogo ragionato*. Milan: Arnoldo Mondadori, 1988.

Foster 2004
Hal Foster et al. *Art since 1900: Modernism, Antimodernism, Postmodernism*. London: Thames and Hudson, 2004.

Frankfurt/Vienna 2005
Tobias G. Natter and M. Hollein. *The Naked Truth: Klimt, Schiele, Kokoschka and Other Scandals*. (Exh. cat. Schirn Kunsthalle, Frankfurt; Vienna, Leopold Museum.) Munich: Prestel, 2005.

Freud 1954
Lucian Freud. "Some Thoughts on Painting." *Encounter* 3, no. 1 (July 1954).

Furst 1927
H. E. A. Furst. *Portrait Painting, Its Nature and Function*. London: John Lane, 1927.

Gabilondo 2001
Angel Gabilondo. *La vuelta del otro, diferencia, identidad y alteridad*. Madrid: Editorial Trotta, S.A., 2001.

Galassi 1996
Susan Grace Galassi. *Picasso's Variations on the Masters: Confrontations with the Past*. New York: Harry N. Abrams, 1996.

Galligan 1998
Gregory Galligan. "The Self Pictured: Manet, the Mirror, and the Occupation of the Realist Painting." *Art Bulletin*, no. 80 (March 1998): 139–171.

García Gual

Carlos García Gual. "Rostros para la eternidad." *El retrato en el Museo del Prado*. Madrid: Anaya, 1994.

Gardiner 1992

Stephen Gardiner. *Epstein: Artist Against the Establishment*. London: M. Joseph, 1992.

Gargallo-Anguera 1998

Pierrette Gargallo-Anguera. *Pablo Gargallo: Catalogue Raisonné*. Philippe Dagen. Paris: Editions de l'Amateur, 1998.

Gasquet 1991

John Rewald and Richard Shiff, eds. *Joachim Gasquet's Cézanne, a Memoir with Conversations*. London: Thames and Hudson, 1991.

Gauguin P. 1937

Pola Gauguin. *My Father Paul Gauguin*. New York: A. A. Knopf, 1937.

Genet 1957

Jean Genet. *L'Atelier d'Alberto Giacometti: Derrière le miroir*, no. 98 (June 1957), Paris.

Geneva 2006

Picasso, l'homme aux mille masques. (Exh. cat. Musée Barbier-Mueller, Geneva.) Paris: Somogy, 2006.

Giacometti 2001

Michel Leiris and Jacques Dupin, eds. *Alberto Giacometti: Écrits*. Paris: Hermann, 2001.

Gilot/Lake 1964

Françoise Gilot and Carlton Lake. *Life with Picasso*. New York: McGraw-Hill, 1964.

Gombrich 1973

Ernst H. Gombrich et al. *Art, Perception, and Reality (Thalheimer Lectures)*. Baltimore: The Johns Hopkins University Press, 1973.

Gombrich 1982

Ernst H. Gombrich. *The Image and the Eye: Further Studies in the Psychology of Pictorial Representation*. Oxford: Phaidon, 1982.

González García/Calvo Serraller/Marchán Fiz 1979

A. González García, F. Calvo Serraller, and S. Marchán Fiz. *Escritos de Arte de vanguardia: 1900-1945*. Madrid: Ediciones Turner-Fundación F. Orbegozo, 1979.

Göpel/Göpel 1976

Erhard Göpel and Barbara Göpel. *Max Beckmann: Katalog der Gemälde*. Bern: Kornfeld and Cie., 1976.

Gopnik 1983

Adam Gopnik. "High and Low: Caricature, Primitivism, and the Cubist Portrait." *Art Journal*, no. 43 (Winter 1983): 371-376.

Gordon 1968

Donald E. Gordon. *Ernst Ludwig Kirchner*. Cambridge, Mass.: Harvard University Press, 1968. German edition, Munich, 1968.

Gowing 1982

Lawrence Gowing. *Lucian Freud*. London: Thames and Hudson, 1982.

Green 1995

Christopher Green. *Thyssen-Bornemisza Collection. The European Avant-Gardes: Art in France and Western Europe, 1904-c. 1945*. London: Zwemmer, 1995.

Honnef 2000

Klaus Honnef. *Warhol*. Cologne: Taschen, 2000.

Houston 1986

George T. M. Shackelford and Mary Taverner Holmes. *A Magic Mirror: The Portrait in France, 1700-1900*. (Exh. cat.) Houston: Museum of Fine Arts, 1986.

Hughes 1988

Robert Hughes. *Lucian Freud Paintings*. London: Thames and Hudson, 1988. (New York: Thames and Hudson, 1987).

Hughes 1990

Robert Hughes. *Frank Auerbach*. London: Thames and Hudson, 1990.

Hulsker 1996

Jan Hulsker. *The New Complete Van Gogh: Paintings, Drawings, Sketches; Revised and Enlarged Edition of the Catalogue Raisonné of the Works of Vincent van Gogh*. Amsterdam and Philadelphia: John Benjamins Pub. Co., 1996.

Jawlensky/Pieroni-Jawlensky 1991-1998

Maria Jawlensky, Lucia Pieroni-Jawlensky, and Angelica Jawlensky. *Alexej von Jawlensky: Catalogue Raisonné of the Oil Paintings*. London: Sotheby's Publications, 1991-1998.

Jay 1984

Paul Jay. *Being in the Text: Self-Representation from Wordsworth to Roland Barthes*. Ithaca and London: Cornell University Press, 1984.

Jerusalem/Edinburgh 1998-1999

Avigdor Arikha: Selected Paintings 1953-1997. (Exh. cat. Ayala Zacks Abramov Pavilion for Israel Art, Jerusalem; Scottish National Gallery of Modern Art, Edinburgh, 1998-1999.) Jerusalem: The Israel Museum, 1998.

Kahnweiler 1920 (1949)

Daniel H. Kahnweiler. *Der Weg zum Kubismus*. Munich, 1920. English edition, *The Rise of Cubism* (New York, 1949).

Kahnweiler 1963

Daniel H Kahnweiler. *Confessions esthétiques*. Paris: Gallimard, 1963.

Kallir 1990

Jane Kallir. *Egon Schiele: The Complete Works*. New York: Harry N. Abrams, 1998.

Kellermann 1992-1999

Michel Kellermann. *André Derain: Catalogue raisonné de l'œuvre peint*. Paris: Editions Galerie Schmit, 1992-1999.

Kelly/Lucie-Smith 1987

Sean Kelly and Edward Lucie-Smith. *The Self-Portrait: A Modern View*. London: Sarema Press, 1987.

Klein 2001

John Klein. *Matisse Portraits*. New Haven and London: Yale University Press, 2001.

Kokoschka 1971 (1974)

Oskar Kokoschka. *Mein Leben*. Munich, 1971. English edition, *My Life* (London and New York, 1974).

Kornfeld 1979

Eberhard W. Kornfeld. *Ernst Ludwig Kirchner: Nachzeichnung seines Lebens*. Bern: Kornfeld, 1979.

Kramer 1996

Hilton Kramer. "Picasso: Portraits or Masks?" New *Criterion*, 14 June 1996: 5-9.

Kuhn 1925

Alfred von Kuhn. *Lovis Corinth*. Berlin: Propyläen-Verlag, 1925.

Lanthemann 1970

J. Lanthemann. *Modigliani 1884-1920: Catalogue raisonné; Sa vie, son œuvre complet, son art*. Barcelona: Gráficas Condal, 1970.

Lausanne 1977

L'Identite et ses Visages. (Exh. cat.) Lausanne: Musée Cantonal des Beaux-Arts, 1977.

Lausanne 1985

L'Autoportrait à l'âge de la photographie: Peintres et photographes en dialogue avec leur propre image. (Exh. cat.) Lausanne: Musée Cantonal des Beaux-Arts, 1985.

Lavin 1981

Maud Lavin. "An Analysis of Henri Matisse's 1914 Portrait of Mlle Yvonne Landsberg." Master's thesis, University of Pennsylvania, Philadelphia, 1981.

Lebeer 1979

I. Lebeer. *Entretien avec Christian Schad*. Paris: Cahiers du musée national d'art moderne, no. 79-1 (July–September 1979).

Lesko 1985

Diane Lesko. *James Ensor, the Creative Years*. Princeton: Princeton University Press, 1985.

Levine 1994
Steven Z. Levine. *Monet, Narcissus, and Self-Reflection: The Modernist Myth of the Self.* Chicago and London: University of Chicago Press, 1994.

Lévy 1990
Lorraine Lévy. *Picasso.* Introduction by Pierre Daix. London: Barrie and Jenkins, 1991.

Limbour 1953
Georges Limbour. *Tableau bon levain à vous de cuire la pâte: L'Art brut de Jean Dubuffet.* Paris: R. Drouin; New York 1953.

Lipchitz 1972
Jacques Lipchitz. *My Life in Sculpture.* New York: Viking Press, 1972.

Löffler 1981
Fritz Löfler. *Otto Dix 1891-1969: Œuvre der Gemälde.* Recklinghausen: Aurel Bongers, 1981.

London 1974
Lucian Freud. (Exh. cat.) London: Hayward Gallery, 1974.

London 1978
Robin Gibson. *20th Century Portraits.* (Exh. cat.) London: National Portrait Gallery, 1978.

London 1981
Marianne Hollis. *Late Sickert: Paintings 1927 to 1942.* (Exh. cat. Hayward Gallery, London.) London: Arts Council, 1981.

London 1986
Oskar Kokoschka. 1886-1980. (Exh. cat.) London: Tate Gallery, 1986.

London/Los Angeles/New York 1994
Richard Morphet. *R. B. Kitaj: A Retrospective.* (Exh. cat. Tate Gallery, London; Los Angeles County Museum of Art; The Metropolitan Museum of Art, New York, 1994-1995.) London: Tate Gallery, 1994.

London 1987
Susan Compton, ed. *British Art in the 20th Century: The Modern Movement.* (Exh. cat. Royal Academy of Art, London.) Munich: Prestel-Verlag, 1987.

London 1996
Paul Moorhouse. *Leon Kossoff.* (Exh. cat.) London: Tate Gallery, 1996.

London 2000
Robin Gibson, ed. *Painting the Century: 101 Portrait Masterpieces, 1900-2000.* (Exh. cat.) London: National Portrait Gallery, 2000.

London 2002
William Feaver. *Lucian Freud.* (Exh. cat. Tate Britain, London.) London: Tate Publishing, 2002.

London 2006
Alexander Sturgis. *Rebels and Martyrs: The Image of the Artist in the Nineteenth Century.* (Exh. cat.) London: National Gallery, 2006.

London/Paris/New York 2002-2003
Matisse Picasso. (Exh. cat. Tate, London; Galeries du Grand Palais, Paris; The Museum of Modern Art, New York, 2002-2003.) London: Tate Publishing; Paris: Réunion des musées nationaux; New York: Museum of Modern Art, 2002.

London/Sydney 2005-2006
Anthony Bond and Joanna Woodall, eds. *Self Portrait: Renaissance to Contemporary.* (Exh. cat. National Portrait Gallery, London; Sydney Art Gallery of New South Wales, 2005-2006.) London: National Portrait Gallery, 2005.

Lord 1980
James Lord. *Giacometti Portrait.* 1965. Reprint, New York: The Noonday Press and Farrar, Straus, and Giroux, 1980.

Lubar 1997
Robert S. Lubar. "Unmasking Pablo's Gertrude, Queer Desire and the Subject of Portraiture." *Art Bulletin,* no. 79 (March 1997): 57-84.

Madrid 1993
Antonio López: Pintura, Escultura, Dibujo. (Exh. cat.) Madrid: Museo Nacional Centro de Arte Reina Sofía, 1993.

Madrid 1995
Picasso 1923: Arlequín con espejo y La flauta de Pan; Contextos de la Colección Permanente no. 1. (Exh. cat.) Madrid: Museo Thyssen-Bornemisza, 1995.

Madrid 2001-2002
Paloma Alarcó. *Kokoschka, Max Schmidt, Adolf Loos y sus amigos: Contextos de la colección permanente 11.* (Exh. cat.) Madrid: Museo Thyssen-Bornemisza, 2001-2002.

Madrid 2002
Tomàs Llorens. *Forma: El ideal clásico en el arte moderno.* (Exh. cat.) Madrid: Museo Thyssen-Bornemisza, 2002.

Madrid 2004-2005
Guillermo Solana. *Gauguin y los orígenes del simbolismo.* (Exh. cat.) Madrid: Museo Thyssen-Bornemisza, 2004-2005.

Madrid 2005
Javier Arnaldo and Magdalena M. Moeller. *Brücke: El nacimiento del expresionismo alemán.* (Exh. cat.) Madrid: Museo Thyssen-Bornemisza and Fundación Caja Madrid, 2005.

Madrid 2005-2006
Tomàs Llorens. *Mimesis: Realismos modernos, 1918-45.* (Exh. cat.) Madrid: Museo Thyssen-Bornemisza and Fundación Caja Madrid, 2005-2006.

Madrid 2006
Francisco Calvo Serraller and Carmen Jiménez. *Picasso: Tradición y vanguardia.* (Exh. cat.) Madrid: Museo del Prado and Museo Nacional Centro de Arte Reina Sofía, 2006.

Malaga 2006
Picasso: Musas y modelos. (Exh. cat.) Málaga: Museo Picasso, 2006.

Malraux 1974
André Malraux. *La Tête d'obsidienne.* Paris: Gallimard, 1974.

Malraux 1976
André Malraux. *Picasso's Masks.* New York: Holt, Rinehart, and Winston, 1976.

Matisse 1973
Jack D. Flam, ed. *Matisse on Art.* New York: Phaidon, 1973. Rev. ed., Berkeley, 1995.

McPherson 1988
Heather McPherson. *Fin-de-Siècle Faces: Portraiture in the Age of Proust.* Birmingham, Ala.: Visual Arts Gallery, 1988.

McPherson 2001
Heather McPherson. *The Modern Portrait in Nineteenth-Century France.* Cambridge and New York: Cambridge University Press, 2001.

Merlhès 1984
Victor Merlhès, ed. *Correspondance de Paul Gauguin.* 2 vols. Paris: Fondation Singer-Polignac, 1984.

Meskimmon 1996
Marsha Meskimmon. *The Art of Reflection: Women Artists' Self-Portraiture in the Twentieth Century.* New York: Columbia University Press, London: Scarlet Press, 1996.

Milwaukee 1997
Marc J. Ackerman. *Identity Crisis: Self-Portraiture at the End of the Century.* (Exh. cat.) Milwaukee: Milwaukee Art Museum, 1997.

Monnier/Clair 1999
Virginie Monnier and Jean Clair. *Balthus: Catalogue raisonné de l'œuvre complet.* Paris: Gallimard, 1999.

Montagu 1994
Jennifer Montagu. *The Expression of the Passions.* New Haven and London: Yale University Press, 1994.

Musil 1995
Robert Musil. *The Man without Qualities.* 2 vols. Translated by Sophie Wilkins. New York: A. A. Knopf, 1995.

Nancy 2000
Jean-Luc Nancy. *Le Regard du Portrait.* Paris: Galilé, 2000.

Napier 1986
David A. Napier. *Masks, Transformation, and Paradox.* Berkeley and Los Angeles: University of California Press, 1986.

Novotny/Dobai 1967
Fritz Novotny and Johannes Dobai. *Gustav Klimt*. Salzburg: Verlag Galerie Welz, 1967.

New York 1952
John Rewald. *Les Fauves*. (Exh. cat.) New York: The Museum of Modern Art, 1952.

New York 1976
J. Kirk T. Varnedoe. *Modern Portraits: The Self and Others*. (Exh. cat. Wildenstein, New York.) New York: Department of Art History and Archaeology of Columbia University, 1976.

New York 1984
William Rubin, ed. *Primitivism in 20th Century Art*. (Exh. cat.) New York: The Museum of Modern Art, 1984.

New York 2000
Robert Rosenblum, Maryanne Stevens, and Ann Dumas. *1900: Art at the Crossroads*. (Exh. cat. Royal Academy of Arts, London; Solomon R. Guggenheim Museum, New York, 2000.) New York: Abrams, 2000.

New York 2004
Mason Klein, ed. *Modigliani: Beyond the Myth*. (Exh. cat. Jewish Museum, New York.) New Haven and London: Yale University Press, 2004.

New York 2006
Sabine Rewald. *Glitter and Doom: German Portraits from the 1920s*. (Exh. cat.) New York: The Metropolitan Museum of Art, 2006.

New York/Hamburg 2002
Tobias G. Natter, ed. *Oskar Kokoschka: Early Portraits from Vienna and Berlin, 1909–1914*. (Exh. cat. Neue Galerie, New York; Kunsthalle Hamburg.) New York: Neue Galerie, Cologne: DuMont Literatur und Kunst Verlag, 2002.

New York/Paris 1996–1997
William Rubin, ed. *Picasso and Portraiture: Representation and Transformation*. (Exh. cat. The Museum of Modern Art, New York; Grand Palais, Paris, 1996–1997.) London: Thames and Hudson, 1996.

Nunley/McCarty 1999
John W. Nunley and Cara McCarty. *Masks: Faces of Culture*. New York: Abrams, 1999.

Ocampo 1985
Estela Ocampo. *Apolo y la máscara: La estética occidental frente a las prácticas artísticas de otras culturas*. Barcelona: Icaria, 1985.

O'Connor 1985
Francis V. O'Connor. "The Psychodynamics of the Frontal Self-Portrait." *Psychoanalytic Perspectives on Art*, no. 1 (1985): 169–221.

Olivier 1933
Fernande Olivier. *Picasso et ses amis*. Paris: Stock, 1933.

Olivier 1988
Fernande Olivier. *Souvenirs intimes*. Paris: Calmann-Lévy, 1988.

Ollinger-Zinque 1976
Gisèle Ollinger-Zinque. *Ensor by Himself*. Brussels: Laconti, 1976.

Ormond 1970
Richard Ormond. *John Singer Sargent: Paintings, Drawings, Watercolors*. London: Phaidon, 1970.

Ormond/Rogers 1979–1981
Richard Ormond and Malcolm Rogers, eds. *Dictionary of British Portraiture*. London: B. T. Batsford and National Portrait Gallery, 1979–1981.

Oslo/.../Hannover 1998
Marco Livingstone, ed. *R. B. Kitaj: An American in Europe*. (Exh. cat. Oslo: Astup Fearnley Museet for Moderne Kunst; Madrid: Museo Nacional Centro de Arte Reina Sofía; Vienna: Jüdische Museum der Stadt; Sprengel Museum Hannover, 1998.)

Ottawa 1997
Colin B. Bailey, ed. *Renoir's Portraits: Impressions of an Age*. (Exh. cat. National Gallery of Canada, Ottawa; The Art Institute of Chicago, Kimbell Art Museum, Fort Worth, 1997–1998.) New Haven and London: Yale University Press, 1997.

Pacini 1986
Piero Pacini. *Gli autoritratti di Gino Severini*. Cortona: Calosci, 1986.

Palau 1975
Josep Palau i Fabre. *Picasso en Cataluña*. Barcelona: Polígrafa, 1975.

Palau 1980
Josep Palau i Fabre. *Picasso vivo (1881-1907)*. Barcelona: Ediciones Polígrafa, 1980.

Paris 1986
Françoise Heilbrun and Philippe Néagu. *Portraits d'artistes*. (Exh. cat. Musée d'Orsay, Paris.) Paris: Editions des Musées Nationaux, Les Dossiers du Musée d'Orsay, 1986.

Paris 1994
Anne Baldassari. *Picasso photographe: 1901-1916*. (Exh. cat. Musée Picasso, Paris.) Paris: Réunion des Musées Nationaux, 1994.

Paris 1997
Anne Baldassari. *Le Miroir noir: Picasso, sources photographiques, 1900-1928*. (Exh. cat. Musée Picasso, Paris.) Paris: Réunion des Musées Nationaux, 1997.

Paris 2000
Anne Baldassari. *Brassaï/Picasso: Conversations avec la lumière*. (Exh. cat. Musée Picasso, Paris.) Paris: Réunion des Musées Nationaux, 2000.

Paris 2002–2003
Marc Restellini. *Modigliani l'ange au visage grave*. (Exh. cat. Musée du Luxemburg, Paris, 2002–2003.) Milan: Skira, 2002.

Paris 2004
Pascal Bonafoux. *Moi! Autoportraits du XXème siècle*. (Exh. cat. Musée du Luxembourg, Paris; Palazzo Strozzi, Florence, 2005.) Milan: Skira, 2004.

Paris 2005
Anne Baldassari. *Bacon, Picasso, la vie des images*. (Exh. cat. Musée Picasso, Paris.) Paris: Flammarion and Réunion des Musées Nationaux, 2005.

Paris/Melbourne 2006
Anne Baldassari. *Picasso/Dora Maar: Il faisait tellement noir . . .* (Exh. cat. Musée Picasso, Paris; National Gallery of Victoria, Melbourne.) Paris: Flammarion and Réunion des Musées Nationaux, 2006.

Parisot 1990–
Christian Parisot. *Modigliani: Catalogue raisonné, peintures, dessins, aquarelles*. Livorno: Graphis Arte, 1990–.

Parmelin 1965
Hélène Parmelin. *Picasso: Le Peintre et son modèle*. Paris: Editions Cercle d'art, 1965.

Penrose 1958
Roland Penrose. *Picasso: His Life and Work*. London: Gollancz, 1958.

Pernet 1992
Henry Pernet. *Ritual Masks: Deceptions and Revelations*. Columbia, S.C.: University of South Carolina Press, 1992.

Philadelphia 2004–2005
Dawn Ades and Michael R. Taylor, eds. *Dalí*. (Exh. cat. Philadelphia Museum of Art, 2004–2005.) New York: Rizzoli, Philadelphia: Philadelphia Museum of Art, 2004.

Philadelphia/Washington 1937
E. M. Benson. *Problems of Portraiture*. (Exh. cat. Pennsylvania Museum of Art, Philadelphia; Phillips Memorial Gallery, Washington, D.C.) Washington, D.C.: The American Federation of Arts, 1937.

Pla 1984
Josep Pla. *Obra completa*. Barcelona, 1984.

Raillard 1977
Georges Raillard. *Joan Miró: Ceci est la couleur de mes rêves*. Paris: Seuil, 1977.

Rewald 1986
John Rewald. *Cézanne: A Biography.* New York:
H. N. Abrams, 1986.

Rewald 1996
John Rewald. *The Paintings of Paul Cézanne:
A Catalogue Raisonné.* 2 vols. New York: Harry
N. Abrams, 1996.

Richardson 1991
John Richardson. *A Life of Picasso: The Early Years,
1881-1906.* New York: Random House, 1991.

Richter 1955
Gisela M. A. Richter. *Greek Portraits.* Berchem-
Bruxelles: Latomus, Revue d'études latines, 1955.

Richter 1965
Gisela M. A. Richter. *The Portraits of the Greeks.*
London: Phaidon Press, 1965.

Rilke 1985 (2002)
Rainer Maria Rilke. *Letters on Cézanne.* Edited by
Clara Rilke. New York: Fromm International Pub.
Corp., 1985. 2nd ed., New York, 2002. Translated
by Joel Agee.

Rivera 1989
*Diego Rivera: Catálogo General de Obra de
caballete.* Mexico: Instituto Nacional de Bellas Artes,
1989.

Rosset 1993
Clément Rosset. *Lo real y su doble.* Barcelona:
Tusquets, 1993.

Rowell 1986 (1987)
Margit Rowell, ed. *Joan Miró: Selected Writings
and Interviews.* Boston: G. K. Hall, 1986. 2nd ed.,
London: Thames and Hudson, 1987.

Rubin 1989
William Rubin. *Picasso and Braque: Pioneering
Cubism.* New York: Museum of Modern Art, 1989.

Rubin 1994
William Rubin. "The Pipes of Pan: Picasso's Aborted
Love Song to Sara Murphy." *Art News* (May 1994).

San Diego 2001
Hugh M. Davies. *Francis Bacon: The Papal Portraits
of 1953.* (Exh. cat.) San Diego: Museum of
Contemporary Art, 2001.

Santos Torroella 1994
Rafael Santos Torroella. *Dalí: Época de Madrid.*
Madrid: Residencia de Estudiantes-Consejo
Superior de Investigaciones Científicas, 1994.

Santos Torroella 2005
Rafael Santos Torroella. *El primer Dalí 1918-1929:
Catálogo razonado.* Valencia: IVAM; Madrid:
Publicaciones de la Residencia de Estudiantes,
2005.

Saura 1992
Antonio Saura. *Note Book (memoria del tiempo).*
Murcia, 1992.

Schmalenbach 1990
Werner Schmalenbach. *Modigliani.* Munich: Prestel,
1990.

Schneider 2002
Pierre Schneider. *Matisse.* Paris: Flammarion, 2002.

Seville 1994-1995
Antonio López: Proceso de un trabajo.
(Exh. cat. Hospital Los Venerables de Sevilla,
1994-1995.) Seville: Fundación Fondo de Cultura
de Sevilla (FOCUS), 1994.

Sickert 1947
Walter Sickert. *A Free House!* Edited by Osbert
Sitwell. London: Macmillan, 1947.

Sickert 2000
Walter Sickert: The Complete Writings on Art.
Edited by Anna Gruetzner Robins. London and
New York: Oxford University Press, 2000.

Simmel 1919
Georg Simmel. *Rembrandt; Ein
Kunstphilosophischer.* Leipzig: K. Wolff, 1919.

Simmel 1984
Georg Simmel. *Das Individuum and die Freiheit.
Essais.* Berlin: K. Wagenbach, 1984.

Simmel 2005
Georg Simmel. *Rembrandt: An Essay in the
Philosophy of Art.* Translated and edited by Alan
Scott and Helmut Staubmann. New York:
Routledge, 2005.

Solana 2004
Guillermo Solana. *Gauguin.* Madrid: Arlanza, 2004.

Soussloff 2006
Catherine M. Soussloff. *The Subject in Art:
Portraiture and the Birth of the Modern.* Durham,
N.C.: Duke University Press, 2006.

Spies 1971
Werner Spies. *Picasso Sculpture, with a Complete
Catalogue.* London: Thames and Hudson, 1971.

Spies 1983
Werner Spies. *Picasso: Das Plastische Werk;
Werkverzeichnis der Skulpturen.* Christine Piot.
Stuttgart: Gerd Hatje, 1983.

St. Louis 1984
Carla Schulz-Hoffmann and Judith C. Weiss. *Max
Beckmann Retrospective.* (Exh. cat. Munich, Berlin,
Saint Louis, Los Angeles.) Saint Louis: Saint Louis
Art Museum; Munich: Prestel-Verlag, 1984.

St. Louis 1999
John W. Nunley and Cara McCarty. *Masks: Faces
of Culture.* (Exh. cat. Saint Louis Art Museum.)
New York: Abrams, 1999.

Starobinski 2004
Jean Starobinski. *Portrait de l'artiste en
saltimbanque.* Paris: Gallimard, 2004.

Stein 1933
Gertrude Stein. *The Autobiography of Alice
B. Toklas.* New York, 1933.

Stein 1938
Gertrude Stein. *Picasso.* London: B. T. Batsford,
Ltd., 1938.

Stein 1961
Gertrude Stein. *The Autobiography of Alice
B. Toklas.* New York: Vintage, 1961.

Steiner 1989
George Steiner. *Real Presences.* Chicago: University
of Chicago Press, 1989.

Stepan 2006
Peter Stepan. *Picasso's Collection of African and
Oceanic Art: Masters of Metamorphosis.* Munich:
Prestel, 2006.

Stockholm/Oslo/London 2005
Iris Muller-Westermann. *Munch by Himself.*
(Exh. cat. Moderna Museet, Stockholm; Munch-
Museet, Oslo; Royal Academy of Arts, London,
2005.) London: Royal Academy; New York: H. N.
Abrams, 2005.

Stoichita 1997
Victor I. Stoichita. *The Short History of the Shadow.*
London: Reaktion Books, 1997.

Swansea 1995
Alison Lloyd, ed. *Intimate Portraits: Contemporary
Responses to the Theme of Portraiture by Writers
and Artists.* (Exh. cat. Glynn Vivian Art Gallery,
Swansea.) Bridgend, Wales: Seren, 1995.

Sylvester 1975
David Sylvester. *Interviews with Francis Bacon.*
London: Thames and Hudson, 1975.

Sylvester 1996
David Sylvester. *About Modern Art: Critical Essays,
1948-96.* London: Chatto & Windus, 1996.

Sylvester/Whitfield 1992–
David Sylvester and Sarah Whitfield. *René Magritte:
Catalogue Raisonné.* London: Philip Wilson, 1992–.

Tagg 1988
John Tagg. *The Burden of Representation: Essays
on Photographies and Histories.* Amherst:
University of Massachusetts Press, 1988.

Taylor 1989
Charles Taylor. *Sources of the Self: The Making
of the Modern Identity.* Cambridge, Mass.: Harvard
University Press, 1989.

Todorov 2000
Tzvetan Todorov. *Éloge de l'individu: Essai sur la peinture flamande de la Renaissance.* Paris: Adam Biro, 2000.

Torgovnick 1990
Marianna Torgovnick. *Gone Primitive: Savage Intellects, Modern Lives.* Chicago and London: University of Chicago Press, 1990.

Tricot 1992
Xavier Tricot. *James Ensor. Catalogue Raisonné of the Paintings.* Antwerp: Pandora and Ortelius, 1992. 2 vols. London: Philip Wilson, 1992.

Tübingen 2001
Götz Adriani. *Henri Rousseau.* (Exh. cat. Kunsthalle Tübingen.) Cologne: DuMont Buchverlag; New Haven and London: Yale University Press, 2001.

Tuchman/Dunow/Perls 1993
Maurice Tuchman, Esti Dunow, and Klaus Perls. *Chaim Soutine (1893-1943): Catalogue Raisonné. Werkverzeichnis.* 2 vols. Cologne: Benedikt Taschen Verlag, 1993.

Uhde 1914
Wilhelm Uhde. *Henri Rousseau.* Düsseldorf, 1914.

Van Gogh Letters 1999
The Complete Letters of Vincent Van Gogh. 1958. Reprint, London: Thames and Hudson, 1999.

Varichon 1998
Anne Varichon. *Albert Gleizes. Catalogue raisonné.* Paris: Somogy Éditions d'Art and Fondation Albert Gleizes, 1998.

Venice 1987
Pontus Hulten, ed. *The Arcimboldo Effect: Transformations of the Face from the 16th to the 20th Century.* (Exh. cat. Palazzo Grassi, Venice.) New York: Abbeville Press, 1987.

Venice 1995a
Jean Clair. *Identity and Alterity: Figures of the Body, 1895-1995.* (Exh. cat. La Biennale di Venezia 46.) Venice: La Biennale and Marsilio, 1995.

Venice 1995b
Leon Kossoff. (Exh. cat. *Venice Biennale,* British pavilion *XLVI.*) London: British Council, 1995.

Venice 2004
Dawn Ades, ed. *Dalí.* (Exh. cat. Palazzo Grassi, Venice, 2004.) Venice: Bompiani, 2004.

Venice 2005
William Feaver. *Lucian Freud.* (Exh. cat. Museo Correr, Venice.) Milan: Electa, 2005.

Venturi 1991
Lionello Venturi. *Cézanne.* Milan: Skira, 1991.

Vergo 1992
Peter Vergo. *The Thyssen-Bornemisza Collection: Twentieth-Century German Painting.* London: Sotheby's Publications, 1992.

Vienna 1991
Klaus Albrecht Schröder and Johann Winkler. *Oskar Kokoschka.* (Exh. cat. Kunstforum Landerbank Wien, Vienna, 1991.) Munich: Prestel-Verlag, 1991.

Vienna 2005
Egon Schiele. (Exh. cat. Albertina, Vienna, 2005.) New York: Prestel, 2005.

Vienna/Zurich 2000
Felix Baumann. *Cézanne: Finished Unfinished.* (Exh. cat. Kunstforum, Vienna; Kunsthaus, Zürich.) Ostfildern-Ruit: Hatje Canz, 2000.

Vircondelet 2001
Alain Vircondelet. *Memoires de Balthus.* Paris, 2001.

Vollard 1984
Ambroise Vollard. *Cézanne.* New York: Dover, 1984.

Warhol 1975
The Philosophy of Andy Warhol: From A to B and Back Again. New York: Harcourt Brace Jovanovich, 1975.

Warner 1979
Malcolm Warner. *Portrait Painting in the History of Art.* London: Mayflower Association, 1979.

Warner 1996
Malcolm Warner. *The Victorians: British Painting, 1837-1901.* (Exh. cat.) Washington, D.C.: National Gallery of Art, 1996.

Washington 1993
James T. Demetrion et al. *Jean Dubuffet, 1943-1963: Paintings, Sculptures, Assemblages.* (Exh. cat.) Washington, D.C.: Hirshhorn Museum and Sculpture Garden, 1993.

Washington/Dallas 2003-2004
Jeffrey S. Weiss, ed. *Picasso: The Cubist Portraits of Fernande Olivier.* (Exh. cat. National Gallery of Art, Washington, D.C.; Nasher Sculpture Center, Dallas, 2003-2004.) Princeton and Oxford: Princeton University Press, 2003.

West 2004
Shearer West. *Portraiture.* Oxford and New York: Oxford University Press, 2004.

Whitford 1997
Frank Whitford. *Expressionist Portraits.* New York: Abbeville Press, 1987.

Wildenstein 1964
Georges Wildenstein. *Gauguin.* Paris: Les Beaux-Arts, 1964.

Wildenstein 2001 (2002)
Daniel Wildenstein. *Gauguin: Premier itinéraire d'un sauvage; Catalogue de l'œuvre peint (1873-1888).* 2 vols. Paris: Wildenstein Institute; Milan: Skira, 2001. English edition, *Gauguin: A Savage in the Making; Catalogue Raisonné of the Paintings (1873-1888)* (Milan: Skira; Paris: Wildenstein Institute, 2002).

Wilkinson 1996
Jacques Wilkinson. *The Sculpture of Jacques Lipchitz: A Catalogue Raisonné.* London: Thames and Hudson, 1996.

Winkler/Erling 1995
Johann Winkler and Katharina Erling. *Oskar Kokoschka: Die Gemälde 1906-1929.* Salzburg: Verlag Galerie Welz, 1995.

Woodall 1997
Joanna Woodall, ed. *Portraiture: Facing the Subject.* Manchester and New York: Manchester University Press, 1997.

Worms de Romilly/Laude 1982
Nicole Worms de Romilly and Jean Laude. *Braque: Cubism 1907-1914.* Paris: Maeght, 1982.

Zander Rudenstein 1976
Angelica Zander Rudenstein. *The Guggenheim Museum Collection: Paintings 1880-1945.* New York, 1976.

Zemel 1997
Carol Zemel. *Van Gogh's Progress: Utopia, Modernity, and Late-Nineteenth-Century Art.* Berkeley: University of California Press, 1997.

Zervos 1932-1978
Christian Zervos. *Pablo Picasso.* 33 vols. Paris: Cahiers d'Art, 1932-1978.

Zurich/Tübingen 1994-1995
Felix Baumann and Marianne Karabelnik. *Degas Portraits.* (Exh. cat. Kunsthaus Zurich; Kunsthalle Tübingen.) London: Merrell Holberton, 1994.

Zweig 1964
Stefan Zweig. *The World of Yesterday: An Autobiography.* 1943. Reprint, Lincoln, Nebr.: University of Nebraska Press, 1964.

INDEX
OF
NAMES

PHOTOGRAPH CREDITS

The Mirror and the Mask: Portraiture in the Age of Picasso

Museo Thyssen-Bornemisza-Fundación Caja Madrid
6 From 6 February to 20 20 May, 2007

Kimbell Art Museum, Fort Worth
17 From 17 June to 16 September 16, 2007

Editings
Museo Thyssen-Bornemisza-Fundación Caja Madrid
Kimbell Art Museum, Fort Worth
Yale University Press, New Haven

Catalogue Project Directors
Paloma Alarcó
Malcolm Warner

Assisted by
Marta Ruiz del Árbol and Samantha Sizemore

Editorial Coordination
Nerea Sagredo, Wendy Gottlieb, and Kate Zanzucchi

Translations
Amaya Bozal
Laura Suffield

Production
Ediciones El Viso

Index of Names
Irene Molina

Graphic Design
Carrió Sánchez Lacasta

Layout and Color Separation
Lucam

Printing
Brizzolis

Binding
Ramos

© Edition: Fundación Colección Thyssen-Bornemisza and Kimbell Art Museum, 2007
© Texts: "The Spirit Behind the Mask", Francisco Calvo Serrraller; "Portraits About Portraiture", Malcolm Warner; "The Mask as Image and Strategy", John Klein; "A Name, a Wretched Picture & a Worse Bust", William Feaver; "The Mirror & the Mask. The Exhibition", Paloma Alarcó, 2007.
© Translations: Amaya Bozal and Laura Suffield
© Successió Miró, 2007
© R. B. Kitaj, courtesy, Marlborough Gallery, New York
© by Ingeborg & Dr. Wolfgang Henze-Ketterer, Wichtrach/Bern
© 2007 Banco de México Diego Rivera & Frida Kahlo Museums Trust. Av. Cinco de Mayo No. 2, Col. Centro, Del. Cuauhtémoc 06059, México, D.F.

© Authorized reproductions. VEGAP. Madrid, 2007
© The Munch Museum/The Munch-Ellingsen Group, VEGAP, Madrid, 2007
© Succession H. Matisse/VEGAP/2007
© Sucesión Pablo Picasso. VEGAP. Madrid, 2007
© Salvador Dalí. Fundación Gala – Salvador Dalí. VEGAP. Madrid, 2007
© Christian Schad Stiftung Aschaffenburg/VEGAP. Madrid, 2007
© Succession Antonio Saura/www.antoniosaura.org, VEGAP. 2007
© The Estate of Francis Bacon/VEGAP. Madrid, 2007
© Andy Warhol Foundation for the Visual Arts. VEGAP. Madrid, 2007
© The Willem de Kooning Foundation, New York/VEGAP/2007
© Avigdor Arikha, Cecil Beaton, Frank Auerbach, Vanessa Bell, David Dawson, John Deakin, Jacob Epstein, Lucian Freud, David Hockney, Leon Kossoff, Graham Vivian Sutherland and Anton Josef Trčka, 2007
© Galerie Leiris, 2007

ISBN 978-84-96233-43-0 (paperback)
ISBN 978-0-300-12251-0 (hardcover)
DL M-5247-2007

Printed in Spain

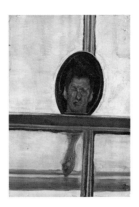

The present catalogue,
published to accompany the exhibition
*The Mirror and the Mask:
Portraiture in the Age of Picasso,*
was printed in January 2007